SOCIAL WORKS

With admirable clarity and impressively rich material of concrete examples and detailed case studies, Shannon Jackson's study outlines the tensions and vectors in the very nerve centre of contemporary theorizing of theatre, art and performance as "social art" or as social practice. . . . Everybody studying experimental theatre, contemporary art and performance will gratefully rely on Shannon Jackson's book.

Hans-Thies Lehmann, *Goethe-University, Germany*

Over the last decade many critics in the arts have struggled to find words to describe the new interactive-participatory-relational art. Shannon Jackson, with her keen analysis of performative practices and deep perception of social structures is uniquely qualified to do so. *Social Works* is a game-changer, a must-read for scholars, students and artists alike.

Tom Finkelpearl, *Author of Dialogues in Public Art*

With her characteristic clarity and keenness of mind, Shannon Jackson gives shape to this vibrant but notoriously amorphous field we call performance studies. More importantly, she compels us to grapple with performance's internal social work.

Anne A. Cheng, *Princeton University, USA*

Exploring the limits of what she aptly calls "aesthetic conviviality," the "social turn" in contemporary art and performance, in *Social Works* Shannon Jackson once again writes a vivid and clear analysis of a key aspect of performative and visual cultures. Jackson interrogates this shift in practice to explore the limits of art's engagement with sociality itself—there could be no more important topic today, nor a sharper interlocutor. *Social Works* should be required reading for anyone interested in how and why art can be political today.

Amelia Jones, *McGill University, USA*

At a time when artworld critics and curators heavily debate the social, and when community organizers and civic activists are reconsidering the role of aesthetics in social reform, this book makes explicit some of the contradictions and competing stakes of contemporary experimental art-making.

Social Works is an interdisciplinary approach to the forms, goals, and histories of innovative social practice in both contemporary performance and visual art. Shannon Jackson uses a range of case studies and contemporary methodologies to mediate between the fields of visual and performance studies. The result is a brilliant analysis that not only incorporates current political and aesthetic discourses but also provides a practical understanding of social practice.

Shannon Jackson is the director of the Arts Research Center at the University of California, Berkeley, USA where she is also Professor of Rhetoric and of Theater, Dance, and Performance Studies. Her award-winning previous publications include *Professing Performance* (2004) and *Lines of Activity* (2000).

SOCIAL WORKS

Performing Art, Supporting Publics

Shannon Jackson

Routledge
Taylor & Francis Group

NEW YORK AND LONDON

First published 2011
by Routledge
2 Park Square, Milton Park, Abingdon, Oxon OX14 4RN

Simultaneously published in the USA and Canada
By Routledge
711 Third Avenue, New York, NY 10017

Routledge is an imprint of the Taylor & Francis Group, an informa business

Social Works: Performing Art, Supporting Publics

© 2011 Shannon Jackson
The right of Shannon Jackson to be identified as the author
of this work has been asserted by her in accordance with sections
77 and 78 of the Copyright, Designs and Patents Act, 1988.

Typeset in Galliard by
Florence Production Ltd, Stoodleigh, Devon, UK
Printed and bound in Great Britain by
CPI Antony Rowe, Chippenham, Wiltshire

British Library Cataloguing in Publication Data
A catalogue record for this book is available from the British Library

Library of Congress Cataloging in Publication Data
Jackson, Shannon, 1967–.
Social works: performing art, supporting publics/Shannon Jackson.
p. cm.
Includes bibliographical references and index.
1. Arts and society—History—20th century. 2. Arts and
society—History—21st century. 3. Arts audiences—History—
20th century. 4. Arts audiences—History—21st century.
I. Title.
NX180.S6J325 2011
700.1′03—dc22 2010028217

ISBN: 978-0-415-48600-2 (hbk)
ISBN: 978-0-415-48601-9 (pbk)
ISBN: 978-0-203-85289-7 (ebk)

FOR JACK AND DAPHNE

CONTENTS

FIGURES

Cover image: Temporary Services—"11 People 16 Spaces/How To Guerilla Art," 2006. Image features students at Columbia College, Chicago: Gary Amerine, PJ Borowiec, Claire Bruhn, Mary Carroll, Leanne Eicher, Allyson Gaston, Wesley Hall, Young-Sun Kim, Teresa Melzer, Mark Moleski, Melissa Peifer, William Owens, Cheryl Sellers, Darian Tyler, and Lukasz Wyszkowski. Image courtesy of Temporary Services.

PROLOGUE
Pacing in Public

It was extremely refreshing to work with artists that weren't
necessarily concerned with the production of images and objects.
We had had a big wave of pictures, and a lot of talk about
representation. These artists had absorbed those discussions but
moved on, and they were not so much concerned with objects
but rather with performative structures.

> Maria Lind, "Relations in Real Time:
> A Conversation with Maria Lind"[1]

It is no coincidence that many practitioners of postdramatic
theatre started out in the visual arts.

> Hans-Thies Lehmann, *Postdramatic
> Theatre*[2]

In recent decades, artists and art critics have tried to make sense of a
variety of performative turns. Many see performative work as a variant
of "post-studio" and "post-optical" art-making, joining terms such as
social practice and relational aesthetics to others such as live art, time-
based art, or group art to characterize what Claire Doherty calls a new
kind of "situationism."[3] Key artists serve as critical indexes of a relational
turn in a post-optical visual art world: Rirkrit Tiravanija and his cooking
installations, Santiago Sierra and his hiring of local people to pose as
living sculptures, Ann Carlson's scripted scenarios with "Real People,"
the potlucks and parades of Istanbul-based Oda Projesi, Tino Sehgal's
constructed situations, Jeremy Deller who staged a re-enactment of a
1984 miners' strike in working-class England, and many other artists
who, in the words of French critic Nicolas Bourriaud, conceive of "inter-
subjective exchange" as the "substrate" for their work.[4] Meanwhile, theatre
artists and critics have been grappling with new kinds of site-specific and

1

technologically engaged work concerned with "performative structures."
While such pieces are supported by theatres, they simultaneously unsettle
the fundamental conventions of dramatic composition and of the
theatrical relation. "Postdramatic theatre" is Hans-Thies Lehmann's
roomy term for a brand of experimentation that resists cathartic narrative,
that deconstructs canonical texts, that replaces dramatic characters with
sculptural figures, that moves outside of a proscenium space, and that
approaches politics from a post-Brechtian stance that re-imagines rather
than rejects the signature forms of the culture industry.

There are, of course, many artistic genealogies that contribute to what
we might very generically call "experimental performance" in the late
twentieth and early twenty-first centuries. In my opening epigraphs, we
find an example of two trajectories that may occasionally find themselves
in the same room. Curator and art critic Maria Lind has become less
interested in the static object, gathering artists who introduce the
performative into the space of the gallery; meanwhile, theatre art scholar
Hans-Thies Lehmann notices how often visual artists have re-imagined
the theatrical event. From Lind we learn that visual artists have begun
to refuse the static object conventions of visual art, exploring the
durational, embodied, social, and extended spatiality of theatrical forms.
From Lehmann we learn that theatrical experimenters have renewed a
Maeterlinkian preoccupation with the "static" to stall the temporal
conventions of dramatic theatre, approaching the static, all-at-once,
juxtapositive condition that art philosophers from Lessing to Reynolds
have associated with painting.[5] To be reductive but rhetorical, we might
discern a kind of experimental chiasmus across the arts; a movement
toward painting and sculpture underpins post-dramatic theatre, but a
movement toward theatre also underpins post-studio art. In such a
chiasmus, breaking the traditions of one medium means welcoming
the traditions of another. Experimental art performances use visual,
embodied, collective, durational, and spatial systems, but a critical sense
of their innovation will differ depending upon what medium they
understand themselves to be disrupting, i.e. which medium is on the
other end of whose "post."

Social Works is my attempt to offer some critical traction to an
increasingly complex field of experimentation in art performance. As I
continue, you will also see me joining formal questions of aesthetic
experimentation to socio-political questions as well. Indeed, one way of
characterizing the "performative turn" in art practice is to foreground
its fundamental interest in the nature of sociality. It is my hope that a
widened discourse of performance helps us to understand the stakes and
limits of this social turn, especially when we foreground performance as

a site of group coordination in space and over time. I am well aware, however, that there are as many tensions as there are opportunities in imagining links between contemporary relational art and the non-contemporary, some might say anachronistic, forms of theatrical art. By casting "the visual" and "the theatrical" as interlocutors, there is, too, a risk of reinstalling traditions about the scope of their meaning. I have found the act of placing different genealogies in conversation, however, to be helpfully defamiliarizing, exposing as it does some of the critical assumptions, lingering resistances, and perceptual habits that continue to lurk in the practice of performance criticism and the practice of visual art criticism.

Let me share a brief personal example to suggest what I mean about the resilience of critical assumptions and the perceptions that buoy them. I am thinking here of my first encounter with Samuel Beckett's *Rockaby*. I am imagining myself twenty years ago when I first saw that piece, sitting as I was in a seat in a darkened theatre. I waited, as we do conventionally in the theatre, for something to happen, that is, for something to unfold in time. Accustomed as I was to that convention—one where my commitment to seated status is counterbalanced by the theatre's commitment to temporal movement—I found the piece to be in marked violation of my expectations. I remember the pauses between voiced-over text; I remember the unimaginable slowness of the rocking and its persistent repetition. I remember feeling trapped by the pace and by the unending repetition and wanting to jump out of my seat. Some twenty years later, I saw another incarnation of *Rockaby*, this one lodged inside an evening of works that were part performance and part "installation." Indeed, we were invited to walk as receivers throughout the space to encounter other pieces mounted and projected on the walls—white box comportment inside a black box theatre—before finally sitting down in a chair to watch *Rockaby*. In this iteration—where I was a moving spectator before being a seated one and, probably more importantly, after I had been reading for several years in the field of visual art history—my experience of the piece was completely different. I found myself quite at ease with the presentation of the stage image and with the staggered, delayed timing of its voice-over. But in this case, I actually found the chair to be rocking, quite frankly, too fast. Its scraping rhythm back and forth across the floorboards seemed scandalizingly fast, in fact. I almost called out to have it slowed down, unnerved and undone by the excess of movement. When I think about the difference in my two encounters with the piece, I am less inclined to believe that the rocking chairs were actually moving at different speeds. Rather, I think that my perceptual apparatus was differently attuned, prompted to measure the first iteration

from theatre and to measure the second from sculpture. This is only a fleeting example, but I use it to suggest the contingency of perception. Our evaluations of work depend not only upon critical histories but also upon disciplinary perceptual habits that can make for drastically different understandings of what we are in fact encountering. Perceptions of stasis and durationality, passivity and activity, stillness and action, might well be in the eye (and body) of the beholder.

I would wager that a socio-political sense of what we are encountering will differ as well. We might, for instance, find a similarly provocative chiasmus when we move these medium-specific questions into the realm of socio-political engagement. Consider the inhabitants of the gallery who measured politically engaged art's distance from the static art object; from such a position, "action" signified a turn to the political. Then consider a theatre maker such as Bertolt Brecht, someone for whom dramatic "action" was already conventional; for him, then, political engagement occurred in the theatre only when the action stopped. With such thoughts in mind, let me move backward historically and forward critically to think a bit more about the socio-politics of our perceptions of stasis and action, of what counts as slow and what as fast. I am thinking now of Petra Kuppers's introduction to her book *Disability and Performance*, where she conducts a micro-reading of Walter Benjamin reading Charles Baudelaire on the pace of a turtle in early avant-garde art practice. Calling it "a brief glimpse of an absurd practice that queers the whole of the arcade," she quotes Walter Benjamin:

> Around 1840 it was briefly fashionable to take turtles for a walk in the arcades. The *flâneurs* liked to have the turtles set the pace for them. If they had their way, progress would have been obliged to accommodate itself to this pace.[6]

Rereading this brief passage through the lens of disability studies, Kuppers is interested in the resonances of the turtle's pace:

> The turtle walk as a public figure brings something private, from the hot-house of the terrarium, into the great open marketplace of modernity . . . Similar to the slow walk of the turtle walker disrupting the flow of the city, creating a different rhythm, the performances I investigate in this study often insert their difference as a matter of formal elements, rather than new, or "positive" images. They question ways of doing, ways of knowing, as time slows or space expands. . . . The turtle traverses an environment not built for short, stubby legs, its agency is in question, and yet it converses with the alien environment with

every step it takes—no other option is open to it. In uneasy alignment, dialogues of being in space develop. Within the larger gameplan of city life, turtle walking in the city is a minor, tactical insert into the systemic whole.[7]

In Kuppers's hands, the turtle walk offers another opportunity to think about the social aesthetics of pace. The substitution of a walked turtle for a walked dog makes uncanny the relation between animal and human normalized in the Pet/Owner dyad. Meanwhile, the pace of the turtle slows the walker down; the *flâneur* does not so much walk the animal as he is walked *by* the animal, a relation that requires a change of internal odometer. Most crucially, such micro-provocations engage our perception of wider social scales; a new "dialogue of being in space" is created by this change of pace. From a disability perspective, such traversals expose the formal and systemic contingencies of environments that take certain embodiments for granted. Disability comes forward not only as a factor through which identities are "othered" but more radically as an impulse to reckon with human contingency in "the systemic whole." Fellow inhabitants of this public space must reckon with a change in motion, adjusting the swing of the gait, stopping short to avoid collision, re-calibrating their objectives and the time it will take to reach them. The alteration in public mobility thus brings the enabling conditions of mobility into view, asking fellow walkers not only to register the difference of this figure but also to register new possibilities for "being in space" that had always been there.

The turtle walk is a cross-disciplinary art performance—one that combines spectacle, choreography, and theatre into a site-specific performance that was "post-studio" before the word was coined. The turtle walk is also a performance that is systemically engaged—one that exposes a "systemic whole" that supports the normativity of some bodies over others. As *Social Works* proceeds, I will be most interested in sites where these aesthetic and social provocations coincide. The mutual revision of art genres, objects, and sites prompts the shift in perception; the perception of the turtle's slowness becomes more acute when he is out of the terrarium. But if the aesthetic mélange shifts perception, then we also need frames that show the social stakes of that perceptual shift. If normative spatial motion disavows the fragile contingency of bodily ability, then citizens need reminders that bodily capacity can be stopped short at any time. As cultural critic Vivian Sobchack reminds us, it can be tricky to expose systemic contingency precisely because enabling systems often go unregistered in the moment that we use them. Sobchack came to feel this paradox more acutely when meditating upon the old and new capacities she developed after the amputation of her leg:

As we go about our various projects in the world, insofar as we have learned to use them, we incorporate our prostheses and tools and—unless there's a function problem or they become of interest "in themselves"—they are experienced as subordinate to our focus on our goals and projects; that is, they are generally the ground of our intentional movement and acts, not the figure.[8]

Sobchack borrowed the phenomenological phrase "echo focus" to describe this backgrounded awareness of the tools and bodily rhythms one uses to move through the world. The social world is in fact a large systemic prosthesis for the normative bodies its structures support. If, however, this social prosthesis is "subordinate to our focus and goals," then it requires a break or deviation for us to remember that it is there. For the "differently abled," writes Sobchack, it means realizing "—whether suddenly or routinely—that the world is not your dance floor."[9] When the pace slows, when everyday objects are not in reach, or when collision cannot be avoided, we register the contingency of the "ground" that supports our everyday acts of self-figuration.

As this book unfolds, other kinds of social "systems" will come into view, including those that coordinate our relation to the environment, kinship, labor, public infrastructure, and social welfare. By selecting sites that use performative structures to provoke reflection on larger systemic assemblages, my hope is to raise the stakes of aesthetic conviviality. Once again, the trick will be to place social systems in the foreground of analysis despite the fact that they usually occupy the background of experience. But it will also mean reckoning with our phenomenological experience of them as "echo" or, to use a psychoanalytic language, as occasionally "disavowed." This movement between recognition and disavowal, foreground and background, is messy and inconsistent. Sobchack says as much when she juxtaposes her conscious experience of her own slow and deliberate pace crossing a street with her less than self-conscious experience of other slow and deliberate street crossers:

When I am four-wheeled in my car, for all my prosthetic experience, I still find myself residually resenting elderly people —with canes—crossing the street so slowly that I know I will have to wait to go even after the light has changed. In my car, my spatial embodiment and motility are stable and transcendent, my intentionality is only inhibited by the ebb and flow of cars and traffic lights, and my unity with my surroundings is continuous.[10]

6

Just as Kuppers found herself politicizing Baudelaire, so Sobchack politicizes phenomenology. Phenomenology's "synchrony" of space and self in fact depends upon proprioceptive entitlement. It is precisely for that reason that the reception of turtle walkers—and elderly walkers— often does not result in a felicitous and expansive decision to take up systemic reflection. Rather, such invitations are often unceremoniously ignored or rejected. The vague resentments and annoyances lodged at the overly encumbered come most often from those who, for the moment at least, have no problem navigating the dance floor. To the propriocept- ively entitled, the encumbrances of others are just another inconvenience.

Finally, to anticipate the range of issues and sites addressed in this book, let me take one more interpretive tack and widen the lens, starting with our view of Sobchack in her car. If Sobchack feels her body to be in unity with her surroundings when she is in a car, we could also think about what other backgrounded dimensions of social life support her experience as a driver, on a street, before a light. If that synchrony is supported by the prosthesis of a car, we can also expand to think about how such synchrony is in turn dependent upon a system of automotive labor inside a precariously globalized industry. If that synchrony is also supported by traffic lights that manage the "ebb and flow" of a street, we can take our attention in another direction to wonder about the urban regulators who installed the light as well as the city, state, or federal taxes that helped to pave the street. Such wider apparatuses of labor and infrastructure support our self-figuration, but often it is only when there is a break in their service that we register their presence. The "government" or "state" comes into view as a negative presence when the traffic light breaks or when we encounter a pothole in the paved street. State entities may try to encourage a sense of our interdependent relation to such systems with, for instance, the road signs at highway construction sites that say "Your tax dollars at work." But often their uptake is unreliable as well. For many, there is something discomforting or anachronistic about this federal mode of second-person address. Recall Robert Smithson's sense that such signs in fact mark the "*rise into ruin*" of public infrastructures before they are built.[11] The road signs are a type of representational practice that reminds their addressees of a mutually supporting relation between themselves and a largely back- grounded public operation. However, they often appear when traffic is blocked; that is, the sign is an infrastructural reminder that usually occurs when one is feeling privately inconvenienced rather than publicly grateful for that relation. Indeed, in what we have come to call our contemporary neoliberal society, the tendency to feel inconvenienced by supporting operations is pervasive.

Attempts to expose the paradoxes of infrastructural avowal will populate a book that is itself indebted to the site that produced it. While my last two books were both published during my time at UC-Berkeley, *Lines of Activity* is really a product of being at Northwestern University in Chicago, and the ideas behind *Professing Performance* first hatched while teaching at Harvard University in Cambridge, Massachusetts. *Social Works* is a book that thoroughly belongs to UC-Berkeley. Its thinking is something that did not begin until I found myself among colleagues and graduate students who challenged my sense of what an inter-arts dialogue could be and extended my sense of what it meant to work in a public institution. From Anne Wagner's invitation to join a symposium on the "visual" and the "performative" to a second one organized by Marty Jay and Whitney Davis on the state of visual culture, I have found the space of performance differently challenged by visual art histories and newer aesthetic innovations. Other contexts at Berkeley were similarly illuminating and provocative—from a course co-taught with Whitney Davis and Charlie Altieri, to a later one co-taught with Judith Butler, to all kinds of gatherings at the Townsend Center, the Arts Research Center, the Berkeley Center for New Media, the Berkeley Art Museum, and more. Colleagues such as Janet Broughton, Wendy Brown, Judith Butler, Tony Cascardi, Karen Chapple, Raveevarn Choksombatchai, Tim Clark, Catherine Cole, Marianne Constable, Ken Goldberg, Colleen Lye, Saba Mahmood, Jeffrey Skoller, Anne Walsh, Linda Williams, and others, have continually challenged, buoyed, provoked, and sustained the thinking behind this book. *Social Works* is also a product of the high bar set for me by my graduate students with their own projects in contemporary performance and critical theory. Becoming an adequate guide meant learning with and from dissertation advisees and research assistants such as Patrick Anderson, Nilgun Bayraktar, Brooke Belisle, Shane Boyle, Renu Cappelli, Carrie Gaiser Casey, Joy Crosby, Reid Davis, Catherine Ming T'ien Duffly, Elizabeth Ferrell, Emine Fisek, Beth Hoffman, Julia Jarcho, Jennifer Johung, Laura Levin, Nina Billone Prieur, Kelly Rafferty, Bradley Rogers, Ariel Scott, Lara Shalson, Brandon Woolf, and especially Todd Barnes and Ragini Srinivasan who both supported the final stages of manuscript preparation.

The writing of *Social Works* happened at UC-Berkeley during a time of tremendous intellectual strength and a time of precarious public funding, a coincidence that made its questions all the more bracing and urgent. Like the *flâneur* in the park or the driver on the American highway, that coincidence has brought backgrounded questions of public support into the foreground. While UC faculty found ourselves calling for California citizens to acknowledge their interdependent relation to public education, we also had to come to terms with our own interdependence

with state operations. I had already been developing this book as a project that qualified critical impulses to equate radicality and progressivism with "anti-state" or "anti-institutional" resistance, and now that pursuit was brought uncomfortably home. If our critical language only values agency when it is resisting state structure, then we can find ourselves in an awkward position when we also want to call for the renewal of public institutions. In a less quoted portion of an oft quoted essay on the role of "counter-public spheres," Nancy Fraser once lodged a warning about such a dilemma. She wrote that, if public and counter-public spheres continue to insist upon their own "sharp separation" from the state, it "promotes what I shall call weak publics, publics whose deliberative practice consists exclusively in opinion formation and does not also encompass decision making." As a result, weak publics "are unable to imagine the forms of self-management, interpublic coordination, and political accountability that are essential to a democratic and egalitarian society."[12] Similarly, Michael Warner argues that the imagining of "public agency" might "need to be one with a different role for state-based thinking, because it might be only through its imaginary coupling with the state that a public acts."[13] While I remain committed to the cultivation of state-resistant spheres that Fraser somewhat normatively calls "weak," *Social Works* comes from my own concern that a generalized brand of anti-statist thinking has stalled this "imaginary coupling," oddly contributing to public disdain over the concept of public governance. But it also comes from my own sense of performance as an art of "interpublic coordination," and, as such, a reminder that no one can ever fully go it alone.

While this project is a product of my site of employment, it is also indebted to the many other sites where I had a chance to share my ideas. I thank audiences at ASTR, MLA, ATHE, IFTR, CCA, Performance Studies International, the Modernist Studies Association, University of Wales-Aberystwyth, Roehampton University, Bristol University, University of Leeds, Southern Illinois University, University of Warwick, New York's MoMA, University of Frankfurt, University of Brussels, Paris 8, University of Nice, the Maison des Sciences de l'Homme Nord, University of Tel Aviv, California College of the Arts, University of Minnesota, Colorado College, Princeton University, Northwestern University, UCLA, UC-Santa Cruz, and UC-Davis. I tried and seemed to have succeeded in not pre-publishing too much of this book, but I am grateful to the three publications where some of the prose was first published: *The Cambridge Handbook in Performance Studies*, *Performance Research*, and *Art Lies*. I am grateful to all of the artists and curators who agreed to speak with me along the way (even when I ended up not being able to write about them fully in this book) and who provided documentation of their work:

Moe Angelos, Marilyn Arsem, Paul Chan, Ingar Dragset, Michael Elmgreen, Tim Etchells, Shannon Flattery, Andrea Fraser, Matthew Ghoulish, Joe Goode, Helgard Haug, Pablo Helguera, Betti-Sue Hertz, Lyn Hixon, Stefan Kaegi, Suzanne Lacy, Riswan Mirza, Linda Mussman, Trevor Paglen, William Pope.L, Larry Rinder, Tino Sehgal, Allan Sekula, Santiago Sierra, Annie Sprinkle, Beth Stephens, Tina Takemoto, Liz Thomas, Nato Thompson, Mierle Laderman Ukeles, Hamza Walker, Marianne Weems, and Daniel Wetzel.

A sabbatical supported both by a Humanities Research Fellowship from UC-Berkeley and by an Erasmus-Mundus Fellowship in "Le Spectacle Vivant" in Paris and Brussels gave me the time to write it all up. Meanwhile, colleagues throughout North America and colleagues both inside and outside the European Union offered valuable conversation and editorial advice at different stages: Alex Alberro, Chris Balme, Claire Bishop, Jane Blocker, Steve Bottoms, Charlotte Canning, Sue-Ellen Case, Anne Cheng, Tracy Davis, Elin Diamond, Jennifer Doyle, Michel Feher, Hal Foster, Susan Foster, Nathalie Gauthard, Richard Gough, Judith Halberstam, Adrian Heathfield, André Helbo, Lynette Hunter, Patrick Johnson, Amelia Jones, Adrian Kear, Baz Kershaw, Suk-Young Kim, Petra Kuppers, Tirza Latimer, Pamela Lee, Hans-Thies Lehmann, Sharon Marcus, Jon McKenzie, José Esteban Muñoz, Jennifer Parker-Starbuck, Della Pollock, Jean-Marie Pradier, Martin Puchner, Alan Read, Janelle Reinelt, Nick Ridout, Shannon Rose Riley, Judith Rodenbeck, Freddie Rokem, David Romàn, Heike Roms, Rebecca Schneider, and Marquard Smith.

A smaller group of people knows exceedingly well how impossible it is for me to go it alone. John and Olga Korcuska, Harvey Zuckerman, Patricia Oliveri, and my mother Jackie Jackson, along with our friends, neighbors, our children's teachers, and babysitters in Berkeley and in Paris: all of you have sustained me and this work. The most loving of thanks goes out to Michael Korcuska for working out new ways for us to reciprocally sustain each other for over twenty years. And to the two social works who provide daily lessons in the pleasure, endurance, hazard, and privilege of interdependence, my heartfelt thanks to my buoyant dedicatés: Jack and Daphne.

1

PERFORMANCE, AESTHETICS, AND SUPPORT

A group of artists in Turkey rent an apartment together in a diverse, intergenerational neighborhood; instead of using the space to paint or display, they invite their neighbors to dinner, create a playroom for children, and organize a neighborhood parade. They call their work Oda Projesi or "The Room Project."

In a modest kiosk installed in New York's Times Square, Paul Ramírez Jonas distributes thousands of custom-based "keys to the city" of New York. Re-defining a ritual that is usually reserved for visiting luminaries, Jonas democratizes this civic honor, granting to everyday citizens special access to cultural landmarks throughout their city.

In a commissioned art piece in Zurich, the artist collective WochenKlausur invite sex-workers, politicians, journalists and activists to take a boat ride on Lake Zurich; gathered around the table of a main cabin, they are instructed to "have a conversation" in an "Intervention to Aid Drug-Addicted Women" that is both an art piece and a social process.

"Eleven people" explore "sixteen spaces" in the city of Chicago, roaming beneath highways and atop dumpsters, placing their bodies in different arrangements to find alternate modes of encounter with the city's public infrastructure. The actions of Temporary Services both highlight and exceed the planned design of civic service.

Much has been made recently of the "social turn" in contemporary art. As someone who comes to this discussion from the field of performance studies, this turn is perpetually intriguing. But what exactly does it mean? How do we know when we are in the presence of "social practice" in art? Is this turn in any way new? What histories, frameworks, and methods are most appropriate for understanding what social art works are and what they do? For some in the field of performance, the language

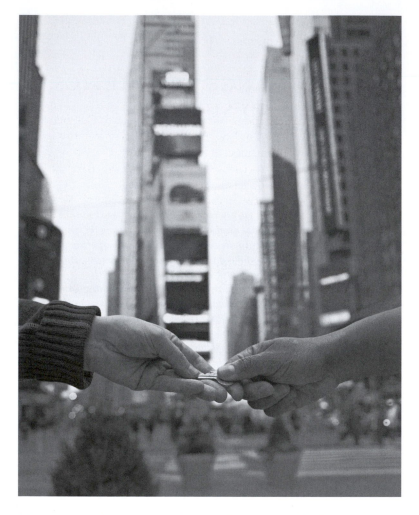

Figure 1.1 Paul Ramírez Jonas, *Key to the City*, presented by Creative Time in cooperation with the City of New York (2010)

Source: Image by Paul Ramírez Jonas, courtesy Creative Time.

of "social practice" seems to lie at the heart of our conceptions of the field. As a term that combines aesthetics and politics, as a term for art events that are inter-relational, embodied, and durational, the notion of "social practice" might well be a synonym for the goals and methods that many hope to find in the discipline of experimental theatre and performance studies. Social practice celebrates a degree of cross-disciplinarity

in art-making, paralleling the kind of cross-media collaboration across image, sound, movement, space, and text that we find in performance. It also gestures to the realm of the socio-political, recalling the activist and community-building ethic of socially engaged performance research.

Like the term "performance," however, the term "social practice" is resolutely imprecise. It joins other unwieldy vocabularies coined as catch-alls to help us understand a variety of "post-studio" practices in contemporary visual art as well as the "postdramatic" practices of con-temporary theatre.[1] I remember being at a festival in 2008 organized around the theme of "social practice" and finding myself amid an incredible range of practitioners. Performance artists Annie Sprinkle and Guillermo Gomez-Peña were on the same panel as California food artists Ted Purves and Susan Cockrell, vacillating between hyperbolic spoken-word spectacles on sex and race with quieter chronicles of neighborhood cooperation around the environmental values of local growing. Tina Takemoto was on the same panel as Josh Green, juxtaposing the former's theatrically costumed anti-Orientalist intervention at the opening of Matthew Barney's SFMoMA (San Francisco Museum of Modern Art) show next to Green's nearly anonymous, networked performances as a waiter who dispensed his tips as micro-grants to fellow artists. The Yes Men were there, and Linda Montano was there—occasionally asking but sometimes begging the question of whether the former's corporate mimicry paralleled in practice or politics the art/life endurance performances of the latter.

In our current moment, symposia, exhibitions, festivals, catalogues, biennials, community centers, and other contemporary venues routinely gather very different kinds of socially engaged artists. Within the same setting, we often find that assembled artists have quite different goals and different medium-specific skills. The "interdisciplinarity" of experi-mental art-making cannot ignore the fact that artists are often "disciplined" by previous training and, as a result, do not always share the same standards in craft, image-making, acting, or community organ-izing. Some social art practices emphasize shared, real-time presence as a necessary condition; others initiate their work through remote and digital means. Some call their objects craft; others call their objects sculpture; others call their objects props. Some create "characters"; others shun the idea. Some work addresses solo interlocutors in private rooms; others address the multitude. At the same time, it is often the case that these experimental artists find themselves treading on the expert territory of other art fields. Performers find themselves becoming fabricators; body artists are learning the language of new media; introverted studio inhabitants have become extroverted site performers.

In these contexts, the language of cross-arts collaboration means different things as projects integrate some art forms, revise other art forms, and often break from the traditions of their own art practice by resuscitating the art traditions of others.

This aesthetic heterogeneity is complicated further by what might be called the social heterogeneity of social practice. While a radical progressivism is often assumed in experimental art gatherings, a closer look reveals a number of questions about what social models such varied social practices actually imagine. Whereas for many the word "social" signifies an interest in explicit forms of political change, for other contemporary artists it refers more autonomously to the aesthetic exploration of time, collectivity, and embodiment as medium and material. Even when social practices address political issues, their stance and their forms differ explicitly in their themes and implicitly in their assumptions about the role of aesthetics in social inquiry. While some social art practice seeks to innovate around the concept of collaboration, others seek to ironize it. While some social art practice seeks to forge social bonds, many others define their artistic radicality by the degree to which they disrupt the social.

This book questions models of political engagement that measure artistic radicality by its degree of anti-institutionality. While the activist orientation of some social practice displays the importance of an anti-institutional stance in political art, I am equally interested in art forms that help us to imagine sustainable social institutions. In the projects that I consider, time and collectivity serve as medium and material for exploring forms of interdependent support—social systems of labor, sanitation, welfare, and urban planning that coordinate humans in groups and over time. For me, this is also where a performance perspective offers the discourse of social practice a certain kind of critical traction. Performance's historic place as a cross-disciplinary, time-based, group art form also means that it requires a degree of systemic coordination, a brand of stage management that must think deliberately but also speculatively about what it means to sustain human collaboration spatially and temporally. When a political art discourse too often celebrates social disruption at the expense of social coordination, we lose a more complex sense of how art practices contribute to inter-dependent social imagining. Whether cast in aesthetic or social terms, freedom and expression are not opposed to obligation and care, but in fact depend upon each other; this is the daily lesson of any theatrical ensemble.

To use the language of inter-dependence in the analysis of art practice is never a straightforward gesture, however. For many, such a language recalls the long and vexed history that surrounds the concept

of artistic autonomy. From such a view, an emphasis on the social inter-dependence of the art object risks censorship as much as it invites collaboration; an open-ness to the social can encumber the work of art as often as it activates it. Questions of autonomy and heteronomy will recur throughout a book that seeks to define social practice in relation to the complex questions of aesthetic and social support. But for the moment it might be useful to remind ourselves that autonomy, in both aesthetic and ethical discourses, is defined as "self-governing," opposing itself to objects and subjects who are heteronomously "governed by external rules." The risk of an interdependent language is that it might compromise an aesthetic practice, especially in the context of social engagement where art could find itself "governed" by the "external" claims of communities, special interests, audiences, governments, bureaucracies, and other social entities from whom it must properly stand apart. For those of us identified with performance, the language of autonomy is a conflicted one, as the art form's inter-dependence with ensembles, technologies, and audiences has always been hard to disavow. But to bemoan the compromises of performance's aesthetic interdependence is also to assume a clear division between the auton-omous performance event and its heteronomous environment. What if the formal challenge of performance lies in the ambiguity of such a division? What if, for instance, the formal parameters of the form include the audience relation, casting such inter-subjective exchange, not as the extraneous context that surrounds it, but as the material of performance itself? What if performance challenges strict divisions about where the art ends and the rest of the world begins?

To those who have tracked twentieth-century expanded art practice, such questions will have a familiar ring, central as they are to a history of aesthetic movements from Constructivism to Situationism to Min-imalism to institutional critique and now to social practices that have challenged the bounded integrity of the art object. Because performance, even in its traditional forms, has often had difficulty maintaining aesthetic boundaries, it seems important to track some of the ways that the performance project might respond to this expanded turn in visual art practice. If, as performance studies scholar Fred Moten suggests (in his re-reading of Derrida re-reading Kant), the *parergon* cannot be strictly divided from the *ergon* of aesthetic autonomy, then specious divisions between aesthetic insides and social outsides must go as well. The *parergon* becomes less a guarantor of an "extra-aesthetic" realm than a figure for the precarity of such a delineation. The *parergon*—and the widely heteronomous domain to which it is linked—is more resonantly "the exteriority that interiority can't do without, the co-operator."[2]

Throughout *Social Works*, I try to explore the social aspirations of socially engaged projects less as the extra-aesthetic milieu that legitimates or compromises the aesthetic act and more as the unraveling of the frame that would cast "the social" as "extra."

Questions of aesthetic autonomy gain an acute urgency when we consider what it means to sustain not only the life of art but also the lives of artists. In fact, the variation in content, form, and goal in social practice and experimental art subtly interacts with artists' differing sense of where they will find security of employment. In such heteronomous reflection, it becomes harder to argue for the purity of aesthetic autonomy. Who or what, after all, will be an artist's primary source of support and promotion? Will it be a curator? A booking agent? A director of a community center? A program officer at a foundation? An arts commissioner? A presenter? A collector? Such variation highlights the quite different economies and networks of commissioning, hiring, touring, granting, political mobilization, and do-gooding in which artistic practices are supported. Some performing artists know not to bother talking to the curators whose venues are not disposed toward theatrical presentation. Meanwhile, other artists never imagine their work to be transportable across the proscenium stages of a booking agent's national tour. Many wonder whether their livelihoods as social artists will come *in advance* from public art commissions or *ex post facto*, that is, by selling video and photographic documentation of their actions in a limited series. Some artists are represented by galleries, some by performance ensembles, some by agents; some are free agents who would never want an agent other than themselves. Some receive fellowships from other non-profits; some entice private collectors. Some form their own non-profits; others join nationally subsidized theatres and museums.

As we imagine sources of artistic support, we inevitably find ourselves widening the scale to understand how artistic livelihoods interact with larger governance models. US artists wonder whether they will have access to reliable federal support for the arts and public health. Non-US artists worry that the steady encroachment of "Americanized" or "Anglo-Saxon" social models of neoliberal government will mean the withdrawal of national art and health care funding in their own countries. These kinds of anxieties also inform my interest in relating art practice to questions of systemic coordination and public support. If progressive artists and critics unthinkingly echo a routinized language of anti-institutionalism and anti-statism, we can find ourselves unexpectedly colluding with neoliberal impulses that want to dismantle public institutions of human welfare. It seems no coincidence that Richard Sennett's

early prognosis in *The Fall of Public Man* worried most acutely about our diminishing capacity to imagine interdependent connection spatially and temporally to humans who will, for the most part, remain strangers to us.[3] It is also no coincidence that Sennett made substantial use of a theatrical analogy in defining public actors in expressive and systemic relation to people whom they do not know.

If the heterogeneity of social practice in art can be tracked and analyzed, it seems to me that it will come by examining two related forms of ambiguity in our contemporary conversation about art and politics. One has to do with the reach of interdisciplinary aesthetics, whether it can simultaneously account for the ways that interdisciplinary artists have in fact been disciplined—and skilled—by deep involvement in distinct art forms, art histories, and contexts of professionalization and fiscal support. The other has to do with whether a generalized leftism can adequately account for what we understand the social to be in social practice, particularly when community claims, public funding, private funding, and state welfare models differ so extraordinarily across regions and nations as well as across the political economies that finance particular arts fields. To my mind, the lack of clarity about the difference these differences make is the elephant in the room at every gathering on art and politics. *Social Works* will not force agreement or pretend to offer a single clarifying silver bullet. This book does seek to bring different genealogies into high relief and to foreground the conflicting assumptions behind key terms that animate both the aesthetic and the social field: collaboration, efficacy, intelligibility, freedom, collectivity, institution, action, the aesthetic, and the performative.

Across the Arts

Let us take another look at the term "social practice," or a phrase that is both more and less specific, "socially engaged art." Such terms have allegiances in a number of fields—experimental visual art, social movements, and theatre and performance studies to name a few.[4] Those allegiances bring to mind other terms that share some kinship with social practice: activist art, social work, protest performance, collaborative art, performance ethnography, community theatre, relational aesthetics, conversation pieces, action research, and other terms that signal a social turn in art-making as well as the representational dimensions of social and political formations. However, social practice also brings to mind a series of other terms that do not always enjoy triumphant celebration: literal art, functionalist art, dumbed-down art, social realist art, victim art, consumable art, and related terms that have been coined to lament

the capitulations to accessibility and intelligibility that can occur when art practice and social practice—aesthetics and politics—combine. Meanwhile, a similar skepticism comes from another direction, asking whether it is ever possible to conceive of any art form as free from social engagement. This last critique—akin to the "But isn't all art political?" question that has spurred and stalled politicized art movements for over a century—worries understandably about the unintended consequences of social or political designations. If some art is politically engaged, does that mean that other art does not have to be bothered with politics at all? If some art is presented as social, can other art forms present themselves as mercifully free of the encumbrances of sociality? As the book continues, you will see me most interested in asking how such questions can be channeled to engage a long history of debate on the relational autonomy and heteronomy of the art event, one that has implications for the medium-specific histories of aesthetics and, interestingly enough, for the medium-specific imaginings of social theory.

Before continuing then, let me also say a word on the medium-specificity and unspecificity of social practice. As noted above, to analyze social practice is inevitably to engage a range of artistic practices, including those that more and less self-consciously reinvent the territory of sculpture, painting, theatre, dance, film/video, photography, and more. As an umbrella term for practices that performatively extend inherited art forms in space, duration, embodiment, and collectivity, social practices can induce all varieties of responses and readings. It is my contention that these responses often depend upon different receivers' experiences with prior art forms. If, for instance, we understand a relational art work to be a revision of sculpture, we encounter it differently than if we understand it to be a revision of theatre or dance. Some may not understand the work to be a revision of anything. The inclusion of an artist's body in a gallery is formally innovative to some viewers; to others, it is just bad acting. To some, the dispersal of an art practice is an intriguing "de-materialization"; to others, it is an assembly of blocked site lines. To some, a durational experiment is tediously slow; to others, it is a meditation on the nature of human endurance. For some, the social is figural, for others, it is literal. One critic's sense of ground-breaking innovation is another critic's Emperor's New Clothes. The social extension of the art object also challenges inherited methods of curatorship, installation, and performance production and often requires a different kind of pragmatic expertise and production support. Art curators are learning from presenters, stage managers from gallery installers, set designers from digital artists, painters from social workers;

and vice versa. By looking closely at the forms, histories, supporting apparatuses, and reception of a variety of experiments, we see how our varied responses depend upon inherited assumptions about the nature of different art forms and the social function of artistic practice more generally. Medium-specificity thus appears in different guises across a wide variety of cross-medium experiments. It structures the perceptual apparatuses of different viewers who might disagree about what in fact they are seeing—whether it is intelligible or unintelligible, spectacular or restrained, alienating or interactive, referential or abstract, fast or slow. Medium-specificity can also have a kind of chiasmic quality as we increasingly realize that the disruption of one medium often requires a re-skilling in the techniques of another.

Social Works emerges within the field of performance studies, a recently consolidated interdisciplinary field that has confronted, with varying degrees of self-consciousness, differing investments in artistic disruption and disciplinary re-skilling. To address expanded art forms from the position of performance might seem to weight my project in particular directions, and, indeed, it does. In fact, I write with a keen awareness of the equivocal place of theatrical and performance legacies in visual art history, a precarity echoed in the barometers used to discern the intelligibility, accessibility, form, materiality, collectivity, activism, duration, and even artfulness in the analysis of socially engaged art. Theatricality, furthermore, has traditionally been a figure for medium un-specificity in visual art criticism, hence my interest in positioning social practice as a vehicle for generating some new conversations across visual and theatrical domains. I realize, however, that I cannot hope for new conversations without recounting a few of the old ones . . .

The question of theatricality in visual art seems to raise its head repeatedly, if differently, in various stages of art history.[5] The persistence of the question can be confusing if one's discipline happens to be theatre. The gap between the art historian's question and the theatre historian's confusion is due in many ways to different understandings of the referent in words such as theatre and theatricality. It can be quite unnerving for a theatre historian to learn that the traditional terms of their workaday world are the terms used to mark the disruption of visual art traditions, whether that disruption is celebrated as a liberation of the object or castigated as the end of art as we know it. Even amid the celebration of boundary-breaking in art practice, there remains an ambivalence about the use of that t-word "theatrical." Upon encountering experimental works that re-use the fundamental registers of theatre—duration, embodiment, spectacle, ensemble, text, sound, gesture, situated space, re-enactment of an elusive original—it sometimes

seems strange to find that "theatre" is still often the thing that such works actively seek not to be.[6]

We can continue to ask why "theatricality" is the perpetually avoided term and note the very long history of that prejudice in Western intellectual history from Plato through Rousseau to its twentieth-century instantiations in J. L. Austin, Theodor Adorno, and Michael Fried, and in some of the work that will appear in this book. Even an exhibit on collaborations between visual art and theatre as exciting as the one organized by Museu d'Art Contemporani in Barcelona needed to title the project "A Theater Without Theater" to make its ambivalence clear.[7] But we can also notice that anti-theatrical discourse is decidedly imprecise; indeed, it might be its imprecision and self-contradiction that makes it so resilient. Sometimes anti-theatrical discourse links theatre with the degradations of artifice, as they appeared variously in Plato's condemnation of its tertiary status, Austin's repudiation of its "*etiolated*" form, or even in naturalistic theatre's attempts to avoid its own artificiality.[8] Visual art has had a tougher time reconciling an anti-artifice discourse with its own enmeshment in a history of pictoriality, so its anti-theatrical discourse often invokes different, though still varied, terms. Sometimes theatre is about duration, an engagement with temporality that violates the juxtapositive simultaneity of visual art forms. Sometimes theatre is about referentiality or, worse, literality, a pursuit that compromises the goals of modernist abstraction. Sometimes theatre is about spectacle, a discourse that supports fragile delineations between a consumptive society of the spectacle and presumably anti-consumptive forms of image-making. Sometimes theatre is about situatedness and the spectatorial encounter, an extended spatiality that unsettles the circumscribed spatiality of the autonomous art form. Sometimes theatre is about mixture, an art of the in-between that violates modernism's "medium purity." Of course, we find many of these heterogeneous associations patched together in Michael Fried's "Art and Objecthood," the "badly written and pompous essay" that Patricia Falguières argues has earned "a critical reputation that it did not deserve."[9] Falguières's important critique notwithstanding, occasionally a poorly written polemic helps us become clearer about the poorly processed assumptions on which our presumably better criticism depends. Whatever one thinks of Fried's polemic, its terms and its interlocutors resurface at different points throughout this project. Readers will also find an engagement with other histories of aesthetic debate—around Constructivism, at the Frankfurt School, by the Situationists—in which theatrical and performative turns are alternately defined as social action or as social collusion, as aesthetically expansive or as aesthetically compromising.

Across the Social

My own take on how the registers of theatre and performance contribute to our understanding of socially engaged art will linger on the above complexities, but it will also depend upon an ability to focus on the contingencies of these forms. Indeed, it is such systems, contingencies, and coordinations that, for me, offer a certain kind of grounding in otherwise heterogeneous and free-floating discussions of art and politics. It will also mean using contingency not simply to lament the encumbrances of performance but also as the basis for a theory of the infrastructural politics of performance itself. Before turning the discussion in this more precise direction, it might be worth thinking about how substantively the question of contingency has structured contemporary social theory, a recognition that ultimately affects how we understand the social in socially engaged art.[10]

While the focus of this book is on late twentieth and early twenty-first-century art-making in Europe and the Americas, such contemporary work wrestles explicitly and implicitly with a longer twentieth century of critical debate and experiments in governance. Often recounted as an abstract tussle between capitalism and socialism, sometimes made more abstract as a tussle between Individualism and Collectivism or between Freud and Marx, this longer history recounts stories of philosophers and policy wonks, idealists and pragmatists, leaders and *lumpen* as they debated and systematized the micro and macro interdependencies of selves and others. Grand and small collectivizing experiments—from Bolshevism in the Soviet Union to the New Deal of the United States to the highly varied "welfare states" of Europe—all initiated and modified different kinds of structures for distributing resources, care, and maintenance across and within national sectors. Along the way, they encountered friction and resistance as ideal imaginings refused to go entirely to plan. The individuals within collectives turned out to have more desires than those that could be fulfilled by the noble goals of virtuous labor or the obligating systems of state tax codes. While the Russian revolution and a Euro-American economic depression of the 1930s had made the call for systemic interdependency look attractive, two world wars and a post-war, technologically fueled corporate boom offered different attractions. Meanwhile, the rise of a philosophical and psychological discourse of individual subjectivity recursively fueled and was fueled by the realization that there might be more complexity within the desiring machines of individuals than the governing machines of states had anticipated. Along this fitful and rocky ride, the social and affective barometers that citizens used to gauge qualities such as freedom and organization, care and

constraint, flexibility and burden, desire and obligation, autonomy and heteronomy changed and morphed for different occasions.

The United States has tended to tell its post-war social history in fairly triumphalist terms. That story includes members of the "Greatest Generation" fighting a second world war from which the United States emerged militarily and economically victorious. Funded by a GI education bill whose nationalized, dependency-making status is unevenly remembered in histories of individual triumph, a new managerial class set about creating a newly organized capitalist society in which to raise the children of a Baby Boom. Around the late sixties those Baby Boomers famously rebelled against what they understood to be the authoritarian, hierarchical habits of their parents and grandparents. While protest against the Vietnam War consolidated a movement to some degree, it was a movement in which civil rights, feminist, gay rights, and anti-institutional voices of all kinds gathered in alliances that were never easy. Living within the mechanisms of state welfare unevenly maintained in the countries of Europe, post-war European historians often recount a similar generational pivot round about 1968. There, as in North America and varieties of campuses and liberation movements in Chile, Argentina, Brazil, and more, an assemblage of counter-ideologies—anti-war discourse, sexual liberation discourse, mixtures of Marx, Mao, Foucault, Marcuse, and Freud—responded to an assemblage of institutions generalized as The Man—militaries, dictatorships, racist governments, campus presidents, parents. As numerous chronicles of what Kristin Ross calls "the afterlives" of 1968 have made clear, there was enormous heterogeneity within counter-movements of the 1960s and early 1970s within and across nations.[11] That heterogeneity is only fitfully remembered as contemporary citizens (and artists) invoke the era to mobilize social engagement now.

Often the invocation of the sixties is followed by an urgent and plaintive question: "What happened?" Where is activism now? Where is The Man? Where was the spirit of protest during the Thatcher-Reagan years? When The Wall fell? Or when Gen X irony gave way to a series of "post" reflections that seemed, to some, to make action impossible? There are of course numerous ways to answer those questions as well, but I find myself more attracted to ones that complicate decade-by-decade traversals between ends of a continuum. Rather, it seems important to notice places where the desires, values, and structures that we associate with different eras are inadvertently birthed and heterogeneously developed across periods whose distinctiveness we too easily assume. Along those lines, then, we might notice how the so-called rebellions of the sixties could be creatively absorbed with a few discursive and systemic adjustments.

The anti-authoritarian critique of the sixties could be directed not only at capitalist hierarchies or genocidal dictators but also at "bureaucratic" unions and state welfare systems, making the dismantling of social welfare look like the triumph of individual resistance. As French economic philosophers Luc Boltanski and Eve Chiapello argue, the "new spirit of capitalism" developing at this moment would claim to be uninterested in the old organization of managerial power, claiming to offer its workers new opportunities to create flexibly spontaneous lives in corporate structures whose former hierarchies were now lateralized in a rhizomatic network. Paradoxically, a newly spirited capitalism would present itself as the way to avoid becoming a "one dimensional man."[12] In such a context, Boltanski and Chiapello find an "aesthetic critique" absorbed by a flexible mode of capitalism; by differently channeling the ironic suspicions of aesthetic critique, "older" governmental or unionized operations were cast as anachronistic and burdensome structures that would only neutralize the "creativity" of self-empowered and networked citizens. This discourse of "flexibility" would, as Brian Holmes writes, become pervasive in all social sectors.[13] From work-at-home mothers to high-end freelancers to art market speculators, "flexibility" was the ultimate desideratum; by extension, a generalized "resistance to regulation" was a stamp of creative agency. In the process, the federated processes that organized public art or distributed food stamps or regulated bank loans could be cast as bureaucratic forms that constrained the "flexible self." This way of telling the story of "what happened" to the legacy of the sixties thus questions the logic that would simply lay blame on the eighties. Complicating the genealogical puzzle in a way that could continue ad infinitum, it asks instead how the eighties were enabled by what the Baby Booming sixties did to the legacy of the thirties.

Rather than vilifying or celebrating the espoused values of any particular generation, however, the analysis of art-making in the late twentieth and early twenty-first centuries might best be understood as a warning, reaction, compensation, and questioning of changing historical contexts that were developing very specific ambivalences toward concepts such as institution, system, or governance. To make art as the twentieth century wore on was to live in a context that was developing telling if not fully processed attachments to concepts that could occasionally be placed as their opposite—say, flexibility, resistance, or agency. In the presumably "post-socialist" era conveniently marked as "post-1989," phrases such as "the fall of communism" and "the end of the Welfare State" mobilized a variety of systemic changes that we have come to associate—again in terms fast and loose—with neoliberalism and

globalization. The systemic changes launched in post-national nations were and are uneven, but the discursive context they share is one that questions the historic role of the state in managing interdependent systems of human welfare, including those that regulated provisions for health care, education, social security, unemployment, disability, pensions, transportation, utilities, and dependent care. As these systems were increasingly read as "anachronistic" structures whose bureaucracy constrained human beings, policy-makers across the European Union and North America were encouraged to create societies of increased flexibility and more opportunities for individual life choices. In art worlds and other contexts of the critical humanities, lay discourses of individual choice and flexibility interacted unevenly with critical discourses that valued agency and resistance. Indeed, sometimes a discourse of flexibility and a discourse of critical resistance could work in unwitting mutual support. If institutions were not to be trusted, if regulation constrained, if bureaucracy was a thing to be avoided, and if disciplining systems of subjugation were everywhere, then a generalized critique of system pervaded not only neoliberal policy circles but also avant-garde artistic circles and critical intellectual ones where freedom was increasingly equated with systemic *in*dependence.

A variety of differently empowered social theorists and policy-makers have tried to come to terms with the concept of structure posed within discourses that opposed flexibility and constraint or others that re-labeled the same opposition "risk" and "care." The discourse of "welfare to work" circulated among national systems across the European Union, the United Kingdom, and Clinton's America—sites whose benefits and provisions differed from each other enormously. François Ewald, a French policy analyst and critical philosopher, welcomed the language of flexibility in a continental France whose public services were in his mind out of control—evoking his tangled roots as a trained Foucaultian-turned-insurance-entrepreneur to encourage skepticism toward state-based regulation. Meanwhile, Anthony Giddens had launched his book-a-year effort to remake social policy in Great Britain and the globe. The most widely circulated of those books, *The Third Way*, would try to loosen oppositions between terms such as flexibility and security (and the capitalist and socialist frames attached to them).[14] Giddens's project ensconced him within the advisory offices of Tony Blair, the UK prime minister blamed for the neoliberalization of the Labour Party or, depending upon your perspective, credited with reforms that made the Labour Party "New." Meanwhile, Giddens's sociological homologue in Germany, Ulrich Beck, achieved a different kind of critical renown in articulating the economic and sociological puzzles within the language

of "risk." His *The Risk Society* and subsequent books afterward underscored the degree to which the operations of flexibility necessarily invited the experience of risk, imagining social life and its choices as a gamble toward an unknown future. The process of "individualization" that accompanied risk-based social models increasingly encouraged citizens to "seek individual solutions to systemic problems."[15] The tricky thing was that the individuating freedoms of the risk society also masked the underlying threat of individual precarity.

Across the Social Arts

Debates among European and North American intellectuals about self and structure and changing socio-economic systems cannot be adequately represented by any summary that I could offer. Furthermore, *pace* Giddens, those with the most cachet in critical theory circles do not usually receive cabinet positions. But I use the brief snapshot above to give a general context of the domain in which we find a discourse of socially engaged art emerging, and, more particularly, a generalized anxiety or mistrust of "structure" that would propel and rattle the assumptions of such work. The international art world, specifically the kind of visual art world advanced in the gallery-collector-biennial-magazine system, has its own uniquely equivocal place in this context. In twentieth century aesthetic debate, to take an artistic stance on the social is to exercise the relative autonomy of the aesthetic domain, using that distance to defamiliarize normative categories and modes of perception and to ask impertinent and never fully intelligible questions of normative life. At the same time, parallel aesthetic movements have taken up this essentially critical stance by paradoxically questioning the conceptions of autonomy on which aesthetic critique seemed to depend. After Minimalism foregrounded the art object's spectatorial dependence, for instance, movements in institutional critique extended that sense of aesthetic dependence to include the economic and social infrastructures of the museum itself. But we can also look at such a gesture from another vantage point, one that might differently explain the reason that many now speak of institutional critique's "exhaustion," seek an "exit strategy," and examine its "after" life.[16] What if we consider, for instance, Boltanski and Chiapello's *The New Spirit of Capitalism* (cited on page 23) from the vantage point of de-autonomizing art movements? These authors argue that an essential feature of this new spirit is its decisive incorporation of what they called the "aesthetic critique" into socio-economic representation. The innovative ironies and wry distance associated with the aesthetic position now inform capitalism's self-marketing, offering

criticality as a consumptive pleasure, whether at Prada-funded receptions or in the marketing of edgy artist loft condominiums. From this perspective, then, institutional critical gestures of systemic exposure might themselves be a vehicle for criticality's market absorption. The irony of this use of irony has of course not been lost on many of its signature artists and their critics, before and since Benjamin Buchloh warned of the fate of an "aesthetics of administration."[17] Meanwhile, whether despite or because of aesthetic critiques of the social, the "market" in the art market has developed as a kind of ur-model of the de-regulated institution, one buoyed by a discourse of flexibility and appreciation to sustain a system of complex and unending speculation.

As much as some might worry about art's absorption by the market, however, just as many critics are worried by the history of art's absorption by the state. Whether in remembering the Stalinist purging of Constructivist Art from state-approved aesthetics or reviewing Theodor Adorno's criticisms of Brecht's didacticism, critics and artists remain concerned about the instrumentalization of the arts by pre-determined civic and state agendas. The histories of former Soviet-bloc and communist Asian countries that are most often read in the West are those that define aesthetic expression not as something buoyed by the generosity of public art funding but as brave acts of resistance against structural, state-imposed censorship. Within current and former European welfare states, histories vacillate between the proud recounting of magnanimous state-funded artistic initiatives and constrained confessions of the instrumentalized art that state arts programs produce. In the United Kingdom, Claire Bishop argued that artists were more corrupted by their collusion with the state, especially a current one informed by a discourse of diversity, than by their collusion with the art market.

> I think that these are the kind of projects we have to think about much more carefully and critically than work done within the relatively neutral and staged confines of a gallery space ... I think I am very critical of the instrumentalization of people with respect to long-term artistic projects engaging specific commun- ities with very particular economic or ethnic backgrounds, which receive prioritized government funding in order for culture to reflect policies of social inclusion through the artificial generation of an audience for a participatory work.[18]

While the history of Stalinist purges and contemporary ethnic identity politics seem to bear little relation to each other, the former can be invoked by critics of the latter to question the instrumentalized use of the arts in national image-making. For community artists for whom civic engagement

is a given—and for whom a "gallery space" is never "neutral"—Bishop's sense that socially engaged art actually invokes "community" to deflate debate and impose consensus is hard to fathom. However, when "government funding" of culture was recently re-prioritized in the UK to fund the national image-making of the London Olympics, some de-prioritized artists and art organizations felt the sting of a state culture discourse. In the United States, where the relatively small federal and state budgets earmarked for the arts make the concept of "prioritized government funding" somewhat laughable, the non-profit foundation system is felt both to sustain and constrain the field of art-making. Rosalind Deutsche's complex analysis of aesthetic infrastructures in *Evictions* tracks artistic imaginings within a wide network of civic claims and gentrifying speculation. In her US-based study of site specific and community art, *One Thing After Another*, Miwon Kwon recounts the processes by which artistic autonomy and heteronomous community agendas could some-times run into conflict. Both Alexander Alberro and Julia Bryan-Wilson find art workers of the Vietnam Era vacillating between an activism that would focus on public health care and housing for artists and one that would focus instead on rights of ownership in an appreciating art market.[19] Meanwhile, the funding that does remain available through foundation or public grants for US artists to work in schools, in prisons, in militaries, in hospitals, and in other under-funded state institutions provides both a welcome avenue of artistic support and the lurking anxiety that artists are being asked to pick up the pieces of US educational, health, and welfare systems that have been increasingly "rolled back." In such situa-tions, systemic support for the arts paradoxically can use the arts as a vehicle for training citizens to seek "individual solutions to systemic problems," to recall Ulrich Beck. Such artistic palliatives offer therapeutic rehabilitation, temporary pride, or imaginative escape in once-a-week artist visits that are not reciprocally empowered to re-imagine the political economic landscape of participants. As we work through these and other paradoxes around artistic privacy and publicity, private funding and public funding, it becomes clear that art-making as a supported and supporting apparatus is also in need of a third way—perhaps several third ways—to respond to art's heterogeneous mixed economies.

What, one may ask at this point, does this discussion of social art's mixed economies have to do with my earlier discussion of mixed media? At a fairly basic level, my interest in joining a discussion of cross-medium experimentation with that of social theory comes from a recognition that socially engaged art seems to require artists to develop skills in more than one medium. The sculpture becomes a public sculpture when knowledges of audience perception and motion are

tracked and re-imagined—i.e., when sculpture becomes self-consciously choreographic. The theatrical production becomes site-specific theatre when the extension of civic space unhinges the proscenium's boundaries—i.e., when theatre becomes self-consciously architectural. The photographic installation becomes interactive when mounted within a scene—i.e., when installation becomes a self-conscious act of set design. One can cite example after example where the "social" turn in art seems to depend upon a cross-medium turn as well. There is, however, something else that is conceptually intriguing in deciding to see social-engagement in medium-dependent terms. Most interestingly, such a conception challenges our understanding of what is properly within the aesthetic sphere and what is heteronomously located outside of it. Not only does it position social art as intermedial; that intermediality also re-calibrates inherited understandings of what is within and what is without the art event. Any clear division between an intrinsic *ergon* and extrinsic *parergon* unravels in the cross-medium encounter. Conversely, the unsettling of inside/outside divisions is helped along by cross-medium experimentation, especially when one medium's *parergon* turns out to be another medium's *ergon*. If a public art audience's gestures are choreographic, then the gestural realm is not simply a "contextual" effect of the art piece but interestingly integral to its interior operation. If a theatre extends its site-specific parameters, such a social engagement needs the expertise of an architectural imagination; theatre's social engagement may break with its own medium-specificity skill set, but it needs the architect's medium-specific skill set to complete the task. By capturing the medium-specific skills that enable social engagement, the "social" in these scenarios cannot be neatly located to the realm of art's "context." The social here does not exist on the perimeter of an aesthetic act, waiting to feel its effects. Nor is the de-autonomizing of the art object a de-aestheticization. Rather, the de-autonomizing of the artistic event is itself an artful gesture, more and less self-consciously creating an intermedial form that subtly challenges the lines that would demarcate where an art object ends and the world begins. It is to make art from, not despite, contingency.

There are particular reasons that I want to hold on to this perceptual sense of how cross-medium social art challenges inherited parameters for defining the within and the without of art. Most importantly, such a sense responds to a long-standing debate in twentieth and twenty-first century theory on autonomy and heteronomy, art's proper inside and its external outside. Such categorical oppositions are always in danger of being reified in social art discussions. As noted earlier, the problem then

with socially engaged art is that it would seem, nearly by definition, to be beholden to the "external rules" of the social. It is thus not properly aesthetic, that is, not capable of extracting itself from social claims long enough to take a properly critical or interrogative stance. What if, however, we can also notice the degree to which such externality treads upon the internal territory of another art form? What if, furthermore, the negotiation of an externalized governance can itself be conceived as part of an art project? What if such aesthetic negotiation defamiliarizes the social processes that might otherwise be defined as exterior, as milieu, or as instrumentalizing? Finally, what if we remember the contingency of any dividing line between autonomy and heteronomy, noticing the dependency of each on the definition of the other, watching as the division between these two terms morphs between projects and perspectives?

To historians familiar with a history of art-into-life experiments, such possibilities may no longer seem promising. For those who have witnessed all varieties of instrumentalized alienation—whether in a post-Brechtian theatre or an institutionally critical art gallery—these efforts have run their course. It will be my contention, however, that a different frame emerges in these discussions if we account for the artistic skills required to sustain the Life side of the supposed Art/Life binary. This is where my position within the field of performance studies shows its hand again, as I am probably more discontented than others when aesthetically organized acts of performance receive homogenizing and facile treatment as the "disruption" of "life" into art.[20] It is my contention that some socially engaged art can be distinguished from others by the degree to which they provoke reflection on the contingent systems that support the management of life. An interest in such acts of support coincides with the project of performance. Performance has often been placed in a supporting role to other arts, whether because its autonomy has been under question or—on the flip side—because it is the form to which other arts turn when they need a little heteronomous engagement. By emphasizing—rather than being embarrassed by—the infrastructural operations of performance, we might find a different way to join aesthetic engagement to the social sphere, mapping a shared interest in the confounding of insides and outsides, selves and structures. To emphasize the infrastructural politics of performance, however, is to join perform-ance's routinized discourse of disruption and de-materialization to one that also emphasizes sustenance, coordination, and re-materialization. To redirect along these lines is finally to remind ourselves that the Art/Life discourse has a different traction when we recast it as a meditation on the paradoxes of Art and its Support.

29

Support

> "Picture further the light from a fire burning higher up and at
> a distance behind them, and between the fire and the prisoners
> and above them a road along which a low wall has been built,
> as the exhibitors of puppet shows have partitions before the men
> themselves, above which they show the puppets."
> "All that I see," he said.
> "See also then, men carrying past the wall implements of all
> kinds that rise above the wall, and human images and shapes of
> animals as well, wrought in stone and woods an every material,
> some of these bearers presumably speaking and others silent."
> "A Strange image you speak of," he said, "and strange
> prisoners."
>
> Plato, *The Republic* 514b

Plato's very early reference to the theatrical run crew is a reminder of
the fundamental role of aesthetic support. It is also a reminder that such
support takes human form and extracts human costs, a fact trivialized
when such laboring bodies are cast as "rude mechanicals."[21] Performance
both activates and depends upon a relational system, a contingency that
makes it a prime venue for reflecting on the social and for exposing the
dependencies of convivial and expressive spheres. Because this issue of
"support" will be important throughout this book, let me share a few
historical associations that will resonate differently as my arguments
develop. From 1382, we find: "To bear, to hold up, to prop up; To
endure without opposition or resistance; to bear with, put up with,
tolerate." The words have a structural association that is literal, to "hold
up," and that suggests a more metaphorical association that is social—
"to bear with." The use of the word "prop" is particularly resonant for
me, as it anticipates the visual art term for pictorial support as well as
the theatrical term for the human object world. There is a temporal
commitment implied in this holding and this bearing, an "enduring"
that will be ongoing. Interestingly, this enduring is also tolerant and
resigned; in fact, a tolerating resignation might well be what it means
to offer enduring support. To support is to hold up "without opposition
or resistance," implying a kind of promise to bear however unbearable
the task becomes. By 1686, more definitions and associations start to
augment the social character of the supporting act, ongoing acts whose
descriptions use the gerund verb form. As the *OED* (*Oxford English
Dictionary*) chronicles, it is defined then as: "The action of keeping from
falling, exhaustion, or perishing, especially the supplying of a living thing

with what is necessary for subsistence; the maintenance of life [1686]."[22] The subtle difference between "holding up" and "keeping from falling" emphasizes the fragility and indeed gravitational vulnerability of the thing held, making clear what would happen if it was withdrawn. But now there is more sentient possibility in the thing propped up and, by extension, more metaphoric kinds of "falling"; it might "exhaust" or "perish," implying in turn the need for a range of supportive actions beyond those that compensate for the literal pull of gravity. Indeed, the propped object is now very possibly a "living thing," one whose subsistence depends upon a range of necessities that imply a range of actions—feeding, cleaning, watering, etc. There is then, ever so slightly, a formal expansion in what the support includes here, opening up from a stably static entity—one that quite often sustains from below—to a more dynamic, lateralized series of supporting actions. Support is not only "undermounted" but also imagined in motion and as laterally relational. That lateralized, dynamic expansion of supporting actions is necessary to sustain an entity that seems to be, for all intents and purposes, "living." Living beings, in fact, need their run crews.

Having reflected generally on the term's etymology, let us focus on some specific disciplinary trajectories with which a term like "support" interacts. The tendency, or not, to engage in the "avowal of support" is what interests me since the question of that avowal is at issue in long twentieth-century aesthetic discussions about the autonomy of the art object. Of course, the conventions of the nineteenth-century idealist aesthetic argued that art achieved its greatness to the degree that its representations transcended its material substrate, rising above its raw material and its social apparatus of production. This is one way of casting an early aesthetic opposition between "autonomy" and "heteronomy." Transcendent art achieved that state by appearing to exist independently from its material, that is, it seemed to exist autonomously from the conditions of its making. In many ways, the debates of twentieth-century aesthetics have revolved around whether, how, and to what extent an art form could have such status and/or achieve such an autonomous effect. For some, the achievement of transcendence was only sublimation —the perception of autonomy only the disavowal of the "external rules" that perpetually structured all social life, including the social life of aesthetics. This is to say, for some, the "disavowal of support" was the illusory trick needed to create the effect of an autonomous work of art. Early twentieth-century workers' movements re-imagined the social role of art in heteronomous terms, whether in the appropriation of vernacular forms, the institution of social realism as a progressive aesthetic, the Brechtian *Verfremdungseffekt*, or the Constructivist re-imagining of the

affinity between artistic labor and social labor. While we often remember these and other movements with a generalized vocabulary that celebrates art as socially-engaged, *Social Works* wants to remember the dimensions of this kind of work that induced infrastructural avowal, that is, that understood "heteronomy" as a socio-political but also as an aesthetic-formal openness to contingency, to experiments in not being privately self-governing. It thus considers aesthetic responses to what AbdouMaliq Simone has called "living infrastructures," the sentient run crews that sustain the social in our contemporary moment.[23]

Similar kinds of preoccupations around the art object's supporting structure have propelled other twentieth-century art experimentation. Marcel Duchamp famously entered to ask similar questions about the autonomy of the art object, installing everyday objects in the art museum to expose art as an effect heteronomously produced by the conventions of the museum. As I discuss at more length in a later chapter, the Situationist International sought to join a Duchampian legacy with a Brechtian one in re-imagining artfully the psychogeography of civic terrain. Temporally coincident but politically differentiated, the late fifties and sixties also saw the rise of modernist art criticism. A discourse that emerged around movements in Abstract Expressionist painting, its major critics re-activated a debate about the autonomy of art by emphasizing elements (such as the flatness of the canvas) that nineteenth-century critics might have defined as its substrate or *parergon*. It is at this juncture that a discourse of "medium specificity" emerges to isolate the terms of modernism. Powerful modernist art critic Clement Greenberg exemplified a position that found a new aesthetic autonomy for modernist painting in the degree to which it conducted its own inquiry into its medium-specific condition, which was to say, for Greenberg, its flatness:

> It quickly emerged that the unique and proper area of competence of each art coincided with all that was unique to the nature of its medium. . . . It was the stressing . . . of the ineluctable flatness of the support that remained most fundamental in the processes by which pictorial art criticized and defined itself under Modernism. Flatness, two-dimensionality, was the only condition painting shared with no other art, and so Modernist painting oriented itself to flatness as it did to nothing else.[24]

What is noteworthy about the original articulation of this oft-quoted passage is the equivalence it draws between the painting's "support" and

the painting's "medium." In later versions, Greenberg would tellingly amend his phrasing, substituting "the ineluctable flatness of the surface" where he had first referred to "the ineluctable flatness of the support." But by temporarily equating the painting's surface canvas with its "support," Greenberg opened the door to debate about whether the canvas's flatness exhausted "the limiting conditions" of the painting's supporting apparatus. What about the frame? The hooks and wires holding up the frame? The wall to which the hooks attached? The people who built the wall? And what about those people who entered the walled space to receive the painting? In many ways, Minimalist artists recognized the latent de-autonomizing potential in a medium-specific modernist art paradigm, pushing its principles to places unintended by its critics.[25] Greenberg and Michael Fried would famously trounce these moves, interpreting the tendency to "unflatten" the canvas as "anti-painting." "Shaped supports only prolong the agony," Michael Fried famously wrote. When Minimalist sculpture sought to redefine its supporting conditions from the undermounted pedestal to the spectatorial relation, Fried was similarly dismissive. Such "literalist works of art must somehow *confront* the beholder—they must, one might almost say be placed not just in his space but *in his way*."[26] The avowal of support felt terribly inconvenient.

Of course, the agony for Fried would continue with decades of new experimentation, spawning whole varieties of post-Minimalist art movements—from body art to institutional critique to site-specific art to social practice and relational aesthetics—that variously engaged ever-widening contexts, milieux, and supporting apparatuses. By 2005, W. J. T. Mitchell and legions of other critics would suggest that this expansion had fundamentally altered our ability to locate a stably autonomous art object.

> The medium is more than the material and *(pace* McLuhan) more than the message, more than simply the image plus the support—unless we understand the "support" to be a support system—the entire range of practices that make it possible for images to be embodied in the world as pictures—not just the canvas and the paint, in other words, but the stretcher and the studio, the gallery, the museum, the collector, and the dealer-critic system.[27]

This expanded sense of art's "support system" has also produced varieties of "social" engagements that challenged the opticentrism of the visual art event, incorporating the artist's body, inducing a spectator to

"interact," or asking all participants to engage in unorthodox relations of exchange and duration. Such work has changed visual art understandings of what constitutes the "material" of the art object as well. Indeed, international art darling Rirkrit Tiravanija regularly plays with this convention; the didactics for his gallery-installed cooking pieces include a reference to materials, but instead of writing "oil on canvas" or "wire on steel," he writes that his materials are "lots of people." In his much cited 1995 book *Relational Aesthetics,* Nicolas Bourriaud argued that, in such artistically relational experiments, "inter-subjectivity is the substrate" for the art event.[28] I take up readings of Bourriaud's work throughout *Social Works,* but it is worth noting now that his use of the word "substrate" placed this contemporary brand of experimentation in an ongoing conversation on the nature of the "support." It will be interesting then to see whether such relational activity can be interpreted as a revelation of interdependent support, even if the support has moved from the static undermounted place of the base to the lateralized dynamic of the living infrastructure. Of course, if we remember Plato's "prisoners" supporting the spectacle of the cave, we might want to question any analytic frame that would track a movement *from* supporting canvases and pedestals *to* the supporting actions of relational art; early theatre histories trouble such chronologies, reminding us that image production has depended upon lateralized supporting action from the get-go.

Having lingered on a discourse of support in aesthetic and visual arts trajectories, let us also try to integrate a discourse of support as it animates social theory. We could think about its relation to another keyword that has both aesthetic and social resonance, "the base," where, of course, Karl Marx theorized the material and economic structures that acted in a determining relation with the so-called superstructure. In reductive Marxist thinking, the inherited images and diagrams often used to describe the supporting relation of the base show a stacked relation, where base is lower and foundational, superstructure higher and illusory. While the base in this Marxist picture is, in art historical terms, "undermounted," all kinds of post-Marxist thinkers have tried to unsettle the base's metaphorically gravitational placement. Louis Althusser exposed the force and power of the supposedly illusory ideological sphere, producing a conversation between psychoanalysis and Marxism that developed a concept of interpellation to dramatize the simultaneity of psychic and structural self-installation. A later path-breaking intervention—indeed, the intervention that arguably launched the term "post-Marxist"—came from political philosophers Ernesto Laclau and Chantal Mouffe with the publication of *Hegemony and Socialist*

Strategy.[29] Resuscitating the thoughts penned by Antonio Gramsci in his *Prison Notebooks*, they argued that the concept of hegemony offered the most helpful tool in combating the orthodoxies of Leninist Marxism, showing the realm of the "psychic," the interior, and the "subject" to be more complexly dynamic than a theory of false consciousness had allowed.

Subsequently, the theoretical branches of the social sciences and the humanities worked to dismantle the oppositions between inner and outer, micro and macro, above and below, self and structure, base and superstructure—along with the tendency to locate one dimension as properly humanist and the other as socially scientific. Marxist geographers such as David Harvey, for example, have tried to foreground the dynamism of a material sphere in which scales ranging from the macro-international to the micro-corporeal mutually define each other. Indeed, fellow geographer Neil Smith suggested that the most interesting cultural and social projects are those that "jump scales," those that foreground the systemic interdependence of intimate and global spheres.[30] Meanwhile, from within the critical humanities, theoretical frames have sought to dismantle oppositions between inside and outside at every turn. Michel Foucault proposed that the concept of the individual in the individual self was in fact produced by the so-called exterior structures it would claim to oppose.[31] Judith Butler would take this insight to show the embeddedness of interiorized selves within a network of relational fields, making the social formation of both self and field a recursive and mutually dependent operation.[32] Across social and critical theory—including a much wider network of scholars who proceed from varied disciplinary and regional positions—a discourse of mutual dependence has arguably loosened conceptions of supporting apparatuses, conceiving them as neither exclusively "basic" nor exclusively exterior but rather as dynamic and relational in multidirectional planes of interaction. Jasbir Puar extended Deleuze and Guattari's language of "assemblage" to analyze the social "concatenation of disloyal and irreverent lines of flight—partial, transient, moment, and magical."[33] It is worth remarking that Allan Kaprow and fellow Happenings and Fluxus artists also used the language of "assemblage" to describe their own unsettlings of figure and ground, object and support, art and life. While the perpetual pursuit of autonomy continues to animate a theory of democracy as well as a critical concept of aesthetics, the bounded referents for autonomous personhood and autonomous art become less stable and more permeable in contemporary critical imagining.

Within this theoretical conversation, of course, it has not always been the case that the language of self-construction has used the language of

interdependence, or that the "external rules" of heteronomous expansion have been registered as "supporting." Rather, "rules" and "regulation" are often registered as invasion, as corruption, or as oppression, even when so many thinkers have argued so carefully that the unsettling of inside and outside means critiquing the insidious projections implied by such adjectives. It is hard to argue for an understanding of systemic complexity when so many are suspicious of "The System." At the same time, because thinkers ranging from Foucault to Butler have been so careful to argue that "power" is in fact "productive" or that "subjugation" and "subjectivity" depend upon each other, it seems important to bolster these complex models with a complex affective sphere. For me, such a necessary sphere is one where interdependence is not imagined in compromised terms or where a recognition of heteronomous personhood comes only after grudging acceptance. To avow the supporting acts that sustain and are sustained by social actors is to avow the relational systems on which any conception of freedom rests. It is to make a self from, not despite, contingency. The impulse to give conceptual and affective complexity to the supporting act brings us back, too, to systemic questions of governance glossed earlier; within the history of debates about first, second, and third ways, we also find the discourse of "dependency" dragging at the heels of social imagining. There, those policy wonks and pundits return at different stages to debate the "dependency" of certain groups on state welfare provisions, casting a certain model of citizenship within the pejorative language of addiction. As Nancy Fraser, Linda Gordon, Wendy Brown, Gwendolyn Mink, Mimi Abramovitz, Theda Skocpol, and others have argued, these discourses raise autonomous personhood as a self-governing ideal against the heteronomously contingent disabled citizen, undocumented migrant, or welfare mother.[34] Furthermore, these feminist critics argue that a discourse of dependency simultaneously allows certain citizens to imagine themselves as independent and "self-governing." The perception of autonomy is once again achieved through a kind of disavowal, a disavowal of the tax breaks, military pensions, public schools, wifely labor, housekeepers, off-shoring, and capitalist alienation that allows certain persons to believe themselves to be unfettered and individually responsible for their private success.

It is here where the radicality of projects that might be called post-Marxist or post-Foucauldian seem most in need of asserting themselves, complicating a social model that would cast interdependency as deformation or, conversely, as inconveniently "in the way" of the citizen-spectator. Psychically and socially, such a project will have to confront the Freudian dilemmas of "anaclitic love" on a wider social scale, what

Judith Butler elaborates as "the type of love that is characterized by the need for support or by the love of those who offer support."[35] The problem of this semi-conscious attachment to support is that "the Child" paradoxically is annoyed to discover "his" reliance upon it. In both art projects and social projects, receivers similarly use the language of inconvenience and constraint to manage the psychic scandal of being exposed to their own disavowed dependency. It is hard to ask someone to get off your back once you realize that she has your back.

Let me close with some final reflections on performance's relationship to support and a preview of the chapters to come. The fact of Bertolt Brecht's pivotal place in a history of theatrical experimentation offers one kind of anchor for joining questions of aesthetic infrastructures to social ones. But as the breadth of references above make clear, his genealogy cannot exhaust it. It appears certainly in dance contexts to describe the relation among moving bodies, altering the choreography of gendered hierarchies where male dancers "support" the gravitationally defiant ballerina to modern and post-modern dance forms where weight is distributed across figures who simultaneously support each other. Within the field of disability performance, questions of support have a particular philosophical resonance, especially when apparatuses such as prostheses, canes, and wheelchairs challenge the perceived autonomy not only of the disabled but of all temporarily abled humans. The prosthetic extensions of self that characterize both aesthetic and everyday performances of disability underscore the fragile contingency of the *parergon* in the management of autonomous subjectivity. The disability movement's activism around "independent living" in fact rests upon a complicated understanding of the "interdependent" living conditions that structure all social life.

In both lay and professional theatrical contexts, of course, one might think of a phrase like "supporting actor." A staple of acting award ceremonies, it is often interpreted as excellence in a smaller role. To take seriously its designation as supporting is to take seriously the structural location of certain roles in holding up the entire performance event; this is to emphasize a working ethic that most of us take from theatre, that "main" characters are never autonomous but interdependently supported by others, that "there are no small parts, only small actors," etc. Interestingly, however, the word "support" was connected much earlier to the theatre as a way of describing acting itself, that is, the relation between the actor who "supported" the character s/he played. "Support" referred to the act of "sustaining a character in a dramatic performance." A 1791 *Theatre Guardian* review, for instance, noted that "The characters were admirably supported." Support also referred to social

acting as much as theatrical, to the act of "maintaining a certain behavior of conduct." For example, a 1765 conduct manual asserted that: "The higher character a person supports, the more he should regard his minutest actions." Support thus gave terminology to the material and gestural apparatus of acting in general, and only recently became a term reserved for specific characters whose outlying but structurally necessary placement in a narrative demoted them to "supporting." What I like about this genealogy is that it seems to emphasize the actor and acting as material substrates; certainly most anyone in theatre knows that Rirkrit Tiravanija was not the first to notice that "material" could be "lots of people."

However, once we add the multiple associations attached to terms such as theatre and performance, it becomes exceedingly clear that one cannot consistently place performance on any particular "side" of a paradigm that would divide self and structure, inside from outside, literal from figural, individual from collective. Indeed, in some discussions of social theory, metaphors of performance emphasize its connotations of artificiality and playfulness to align it with a global capitalist ludism that has no time for the encumbrances of social claims. For some, the term performance is equal to the "spectacle" in *The Society of the Spectacle*, the realm of consumptive simulation lambasted by Guy Debord; for others, performance is aligned with Debord's psychogeographic interventions that he hoped would disrupt the consumptive secession of simulacra. The ambiguity of where to place performance on a continuum between culture industry and cultural resistance is only compounded by the number of ways individuals understand the medium. For readers of Peggy Phelan, performance's primary condition resides in its ephemerality; "performance's being," to quote an oft-quoted sentence, "becomes itself through disappearance."[36] Such a sensibility aligns with the visual art sensibility that positioned performance as a vehicle for "de-materializing" the art object. The socio-political claims made for ephemerality—that it resists capitalist commodification—of course now seem increasingly hard to maintain; indeed, such shape-shifting might actually enable rather than stall the flexibly de-referentialized spirit of new capitalist formations. But it seems to me that Phelan's provocative statement did not suggest that we disavow the labor required to create an experience of unraveled becoming. Indeed, we might find a slightly different emphasis by thinking about how her argument develops: "Performance honors the idea that a limited number of people in a specific time/space can have an experience of value which leaves no visible trace afterward."[37] It is here, in imagining what it takes to gather but to limit the people, what it means to secure a space and specify a time,

what it means to be one of the limited people who will make the effort to get to that space at that time, that we begin to acknowledge the material relations that support the de-materialized act. Ephemeral forms still need their stage managers and their run crews. Becoming unpresent does not mean that no one ever needs to show up.

Once we take this awareness out of the body art space and into less dyadic relational experiments, the infrastructures for sustaining performance's operation become even more complicated. *Social Works* will focus on case studies that show this range, focusing on places where questions of social contingency meet those of aesthetic contingency. Joining the artistic impulse to "expose the support" inherited from Duchamp and Minimalism in visual art and from Bertolt Brecht in theatre with the vexing question of the role of "support" in globalizing social welfare models, I consider social practices that provoke reflection on the supporting infrastructures of both aesthetic objects and living beings. Readers will see me most interested in social practices where the exposure of the aesthetic infrastructure that supports the aesthetic object coincides with the exposure of the social infrastructure that supports human societies. Chapter 2 takes a more in-depth look at contemporary debates on social practice and relational aesthetics in visual art circles, joining them to similarly termed but differently directed debates in theatre and performance studies. I then link the twists and turns of these discourses to two instances of social art practice that can be diametrically opposed: the antisocial reductions of international art star Santiago Sierra and the community art installations of Shannon Flattery's Touchable Stories. These cases become occasions for repurposing inherited aesthetic vocabularies and barometers for social effectiveness, most importantly recasting the autonomy/heteronomy opposition to give the domain of social relations a certain degree of formal attention.

After situating debates in contemporary art, experimental theatre, and aesthetic and social theory, the next two chapters recast recent histories that are often said to precede the "social turn" on contemporary art. Chapter 3 takes contemporary debates back to an earlier artistic moment in the sixties to find a feminist and class-based exploration of public infrastructures before terms such as institutional critique and social practice had been coined. Reconsidering the large body of "maintenance art" produced by Mierle Laderman Ukeles, I consider her fundamental interest in exposing systems of human and ecological support. Along the way, her case provides an opportunity to situate a wider network of feminist, Situationist, and experimental art movements that did not always agree upon the systemic goals of political art. In my longest chapter, "Staged Management," I look at three case studies to elaborate

the varied role of theatricality in "institutional critique." As the term given to post-Minimalist experiments that addressed the encumbrances of aesthetic institutions in upholding the Art category, a generational history of institutional critique has already been well elaborated, even if its connection to theatre has been less roundly embraced. Through the work of Allan Sekula, Andrea Fraser, and William Pope.L, I consider classed, gendered, and raced dimensions of institutional critique. More specifically, I explore their backstage and frontstage performances of labor, art, and social welfare, considering how the critical responses to these time-based works also dramatize the potentials and perils of cross-media reception.

Having plotted different kinds of connections between performance and the vocabularies of expanded visual art historiography, the next three chapters widen the scope on the infrastructural politics of performance. Chapter 5 looks at two theatre companies with a substantial profile in both international performance and visual art circles, Rimini Protokoll and The Builders Association. While I am interested in many projects, I focus most intently upon their explorations of the global call center industry. In *Call Cutta* and *Alladeen* respectively, each group represents the human workers who offer "tech support" in the field of new technology, expanding and dispersing the formal apparatus of the theatre to dramatize global citizenship's enmeshment in an expanded and dispersed labor politics. Chapter 6 is perhaps the most "artworld" oriented of all my chapters, focusing as it does on the work of the Scandinavian duo Michael Elmgreen and Ingar Dragset. As queer artists who have been identified with institutional critique and enjoy a high degree of art market success, their large-scale piece *The Welfare Show* provides an opportunity to consider how a critique of the welfare apparatus interacts with a twenty-first-century art economy. Their work critiques the constraints and norms of public institutionality even as it calls for the maintenance of such public operations. It also offers a moment for me to speculate on the degree to which a radical critique of liberal democratic forms can unwittingly collude with neoliberal arguments and affects, something made more apparent in 2008 when the art market felt the effects of a global economic free-fall. My final chapter focuses on another site of what Ruth Wilson Gilmore has called "infrastructural abandonment," that is, the naturally and socially produced destruction of Hurricane Katrina in the American city of New Orleans.[38] Because the effects of the hurricane on New Orleans have brought the consequences of "rolled back" state provision into high relief, a number of non-profit art and community groups have stepped in where the US Federal Emergency Management Agency did not.

Within this large network of social art practices, I focus on the provocative and occasionally improbable staging of visual artist Paul Chan and Classical Theatre of Harlem's *Waiting for Godot*. As an artist deeply invested in concepts of aesthetic autonomy even as he maintains a profile as a political activist, Chan's collaborative project brings our discussion back to twentieth-century debates around "commitment" in art. At the same time, it demonstrates how the systemic operations of theatrical production could respond to the formal preoccupations of social practice, re-skilling a network of curators, visual artists, actors, and community organizers along the way.

As should be clear by now, most of my cases focus on trained visual artists as they turn to performance to expand their practice and engage wider systems of social and aesthetic support. I chose these cases in part because this turn from the visual to the performative was the place where I had the most to learn; I also wanted to understand why visual artists engage performance in order to do a kind of systemic avowal. At the same time, cross-art turns happen in multiple directions, and so I will also be asking what performance scholars and artists can learn when we find performance's systems and processes re-defined, undone, or revised by visual artists. As someone whose previous projects included a book on social reform history (*Lines of Activity*) and on the formation of theatre studies (*Professing Performance*), certainly I have found my own assumptions undone and redefined. In some cases, I have had to investigate my own initial responses of bafflement, ambivalence, and even recoil as works challenged some of my basic assumptions about the goals of community engagement and the aesthetic skills of performance. At the same time, I know that my lens on experimental performance has changed radically after the privilege of writing from within the space of a challenge.

Some of my selected *social works* require the socio-temporal imagining of a production calendar; some require cross-art collaboration with agreements of projected commitment over time, creating a series of deadlines that anticipate more deadlines in anticipation of an eventual "designated time/space" of audience arrival. Some endurance forms will actively refuse such a progressive temporal model but, in doing so, will have different requirements for socio-temporal support. Ultimately, it is the simultaneity of such fragilities and encumbrances—what Alan Read might have had in mind when he referred to its processes of "re-association and re-assembly"—that makes performance such a fruitful place to think through the paradoxes of social engagement.[39] Like any coordination of human welfare, performance requires an encounter with some very difficult problems that are both formal and institutional. It

installs systems for managing duration and relationality whose consequences cannot be fully foreseen. It anticipates a future that cannot be known but on whose unfolding its identity depends. Performance promises to accommodate within limits collaborating groups of people who do not always know each other and commits to being inconvenienced by the claims that they bring. It endures the conflicts of these commitments of resources. As such, performance processes, like human welfare processes, create sites that know the paradox of such systems— that sustaining support can simultaneously be felt as constraining. Performance experimentation is, to some degree, the management of competing claims of inconvenience (it is often "in the way" of the person who makes it). At the same time, to work in performance is to remember, and then to forget and to remember again, that such inconvenience is the price paid for being supported. Because so many relational art practices and so many new social models debate their willingness to ride that paradox, it seems important to ask what we can learn by foregrounding performance as a series of supporting relations, relations that sustain entities that are, for all intents and purposes, living.

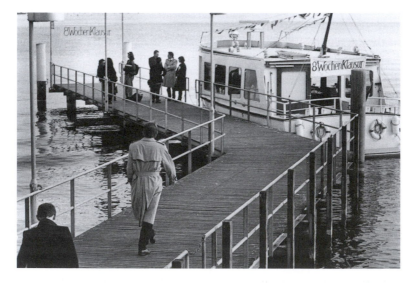

Figure 1.2 WochenKlausur, *Intervention to Aid Drug-Addicted Women* (1994), an eight-week intervention in collaboration with the Verein Shedhalle Zürich, Switzerland

Source: Courtesy of WochenKlausur.

2

QUALITY TIME
Social Practice Debates in Contemporary Art

> Touchable Stories began in 1996 with idea of using the talents
> of contemporary artists to help individual communities define
> their own voice and give it public expression.
>
> Shannon Flattery, Touchable
> Stories website[1]

> In my innermost heart I am a Minimalist with a guilt complex.
>
> Santiago Sierra[2]

By a certain metric, both Shannon Flattery and Santiago Sierra work in
the art of social practice. Both have created projects that broach issues
of immigration, labor, race, poverty, exile, and environmental degradation.
Both have created projects with large groups of people that require
significant infrastructural commitments from art, community, and civic
organizations. Both were trained in sculpture before "expanding" into
the arena of social practice. Soon, however, the parallels start to unravel,
as the structures and sensibilities that propel the works of each differ
enormously. Flattery's projects are created under the umbrella of
Touchable Stories, a Boston-based US non-profit that relies on donor
contributions, foundation grants, and under-funded civic commissioning
bodies. Santiago Sierra's projects are created under the umbrella of his
authorial name, one that receives artistic commissions, fees, and royalties
from an artworld network of biennial, public art commissioning, museum,
and gallery-collector systems. Whereas the language of community voice
appears ubiquitously in the descriptions of Touchable Stories, the concept
of "voice" is eclipsed in both the descriptions and practices of Santiago
Sierra. Whereas the language of Minimalism serves as a touchstone for
Sierra's formal expansions, it is never cited as a resource by Shannon
Flattery, who in fact expresses a degree of bafflement at such references.

Such eclipses and bafflements have their parallel in the critical discourses that surround Touchable Stories, Santiago Sierra, and the thousands of artists and art organizations who self-consciously engage "the social" in their work. For those who measure a work's success on its degree of community "self-definition," its efficacy is measured in its outreach strategies, its means for providing access, the representational demographics of its participants, and its identifiable social outcomes. Such critical barometers also worry about the mediating role of the artist, about whether an artistic vision enables or neutralizes community voices.[3] But other critical frameworks question the concept of artist-as-community-helpmate on different terms; indeed, for some, a critical barometer starts by questioning the concept of community on which such work relies. To what does a term like community refer? Does it pursue or enforce visions of harmony and consensus? Should a work seek to represent under-represented voices or provide a shared forum for all? Does the helpmate model obscure other goals of artistic work that might use the language of critique rather than the language of consensus?[4]

A related conflict emerges from quarters where questions of aesthetic form remain primary. In this domain, we find critics couching "the social" within a post-Minimalist trajectory of artistic innovation. This trajectory concerns itself with the precarious boundaries of the aesthetic object, questioning the logic that would divide the inside of the art object from the outside of the material, institutional, and social relations on which the art object relies. The turn to the social thus proceeds from a formal questioning of artistic form and its embedded support systems. In such a domain, heretofore exteriorized processes—the labor of installation, curating, and spectating—are themselves conceived as the material of an art event whose boundaries can be extended ad infinitum. New critical questions then respond to art projects that proceed from this trajectory. Is such a formal pursuit in fact a "guilty Minimalism"? If so, is it adequate to the task of social engagement? Do such social practices break institutional boundaries or set the scene for the recuperation of sociality by a service economy hungry for de-materialized encounters? If sociality is the new substrate of contemporary art, where, if anywhere, do questions about access, diversity, and representation fit into the equation?

In this chapter, I turn to these and other themes while placing different disciplinary debates around community art, relational aesthetics, and social practice into conversation with each other. I return later to the work of Touchable Stories and Santiago Sierra in order to consider how languages from different domains might provoke new reflections on the formal and social innovations of such experimentation.

Throughout, the chapter considers several other artists who have served as touchstones for debate around terms such as community, activism, public art, intervention, autonomy, heteronomy, relationality, and social antagonism. Along the way, I try to unsettle some of the binary frames that many use to judge both social efficacy and aesthetic legitimacy. I suggest that the "social turn" might be given more weight and traction when it provokes an awareness of our enmeshment in systems of support, be they systems of labor, immigration, urban planning, or environmental degradation.

Social Art and its Discontents

Published originally in France in 1998, *Relational Aesthetics* was curator Nicolas Bourriaud's rapid attempt to come to terms with a heterogeneous array of contemporary art practices. Many of his examples are taken from the exhibition Traffic, which he curated at the CAPC, the Bordeaux museum of contemporary art, in 1996. In brief, serial descriptions, Bourriaud gathered artists such as Christine Hill, Rirkrit Tiravanija, Liam Gillick, Dominique Gonzalez-Foerster, Vanessa Beecroft, Carsten Höller, Fareed Armaly, and Felix Gonzalez-Torres into his articulation of a shared relational practice in contemporary art. Resisting not only pictoriality but objecthood as such, relational aesthetics pushed Minimalist and time-based art to create aesthetic spheres of inter-subjective exchange. For Bourriaud, rather than paint, clay, or canvas, "intersubjectivity" is itself the "substrate" of the art event.[5] To exemplify his argument—and anticipate some of the critical response—let me offer one emblematic moment toward the beginning of the book. Bourriaud lingers a good deal on the work of Felix Gonzalez-Torres, an artist whom he sees as a central figure in the relational art movement. One of Gonzales-Torres's stack pieces appeared in Traffic, a form that the artist re-used in other commissions in which stacks of paper or stacks of candy appeared in piles on the gallery floor. This is how Bourriaud describes it:

> In Gonzalez-Torres' *Stacks* and piles of sweets, for example, the visitor was authorized to take away something from the piece (a sweet, a sheet of paper), but it would purely and simply disappear if every visitor exercised this right: the artist thus appealed to the visitor's sense of responsibility, and the visitor had to understand that this gesture was contributing to the break-up of the work. What position should be adopted when looking at a work that hands out its component parts while trying to hang on to its structure?[6]

This passage is notable because it is one of the only places in the book when Bourriaud uses the word "responsibility" positively, that is, as a term that enhances rather than dilutes the aesthetic impact of a work. Bourriaud here offers a window into the durational projections of this piece, for *Stacks* propels us to imagine our relation both to others in the gallery and to those whom we will never encounter. What, the piece provokes us to ask, is our relation to those who took a piece before us? What is our relation to those who will not have a piece to take away after us? Despite this meditation, however, most of Bourriaud's book questions the frame of responsibility in relational art. He admits that relational interactions would seem to invoke Emmanuel Levinas's ethics of the face, defined by Levinas as "the bond with others only made as responsibility."[7] But, Bourriaud asks instead, "don't ethics have a horizon other than this humanism which reduces inter-subjectivity to a kind of inter-servility?" Rather than a responsibly "servile" exchange, Bourriaud argues for a less obligating paradigm: "[p]roducing a form is to invent possible encounters; receiving a form is to create the conditions for an exchange, the way you return a service in a game of tennis."[8] If Levinas's ethical paradigm emphasizes a relationality with an Other that we do not choose, one to which we must respond and whose claims are not alterable by us, Bourriaud proposes a relationality that is perpetually revisable.

The tennis game analogy, like other moments throughout the book, seems to be drawn in a frictionless environment, unencumbered by the claims of responsibility. While Bourriaud makes an important intervention in the discourse on ethics in art practice, it is still hard to imagine that this playful exchange could occur without other responsible (or servile) parties. If sociality is a tennis game, do players call the lines themselves? Do they pick up their own tennis balls? Or are relational players in fact relying implicitly on a crew of ball-boys and umpires to keep the exchange both just and aloft? In fact, if we add an awareness of parallel support systems to our understanding of relational art, a different view comes forward. What if we remember another central component of the piece, which is that Gonzalez-Torres contractually specified that his pieces would be replenished by the exhibitors and collectors who presented and purchased them? The threat of the ephemeral—"it would purely and simply disappear"—is thus less an ontological reality than a potent effect sustained by a steady operation of support and maintenance. The resonance of this relational work thus lies in the fact that it both required and indexed a supporting system—one that was material, spatial, temporal, and too formally intriguing to dismiss as "servile."[9]

Visual art critic Claire Bishop's 2004 *October* essay "Antagonism and Relational Aesthetics" was an attempt to critique the perceived

weightlessness of Bourriaud's paradigms. In so doing, she set off a great deal of discussion in the experimental art world, not always to defend Bourriaud but to respond to the new paradigms she offered in the process. Bishop's continued reflection appeared subsequently in *Artforum*, along with a variety of explicit and implicit responses in that journal and others.[10] The concerns of this debate are symptomatic of the kind of discourse and confusion that often emerges when a discussion of politics and aesthetics is under way. Claire Bishop's *October* essay and her *Artforum* piece expressed themselves in slightly different terms, but together they created oppositions among different critical paradigms and art movements. Most generally, Bishop argued for what she called the "antagonist" possibilities of art practice. Antagonism is the term for a criticality and a resistance to intelligibility that is, in her view, both necessary for aesthetics and neutralized when art starts to tread into socially ameliorative territory. Art practices that seek to create a harmonious space of inter-subjective encounter—i.e., those that "feel good"—risk neutralizing the capacity of critical reflection. Furthermore, art practices that seek to correct social ills—i.e., those that "do good"— risk becoming overly instrumentalized, banalizing the formal complexities and interrogative possibilities of art under the homogenizing umbrella of a social goal. As her argument unfolded, certain artists—such as Rirkrit Tiravanija and Liam Gillick—ended up on the "bad," feel-good side of her critical equation; Tiravanija's renowned use of gallery space as a site for food preparation and festive circulation did not leave room for a critical antagonism. Meanwhile, the "do-gooding" impulses of other social practices in Liverpool, Los Angeles, San Sebastian, Rotterdam, and Istanbul were critiqued for their uncritical gestures of "responsibility." Bishop's concerns were leveled most heavily on Oda Projesi, a Turkish artist collective that moved into a three-room apartment in Istanbul and extended invitations to their neighbors, eventually sponsoring children's workshops, parades, potlucks, and other events that created a context for dialogue and exchange. At the same time, other artists such as Santiago Sierra, Thomas Hirschhorn, Francis Alÿs, and Alexsandra Mir ended up on the "good," antagonistic side of Bishop's critical equation. She reconsidered Thomas Hirschhorn's well-publicized contribution to Documenta XI in 2002, *Bataille Monument*, a piece that was sited in a local bar and on the lawn shared by two housing projects in Norstadt, a suburb kilometers away from the Documenta venue in Kassel. Defending against accusations that Hirschhorn appropriated a local space without gaining a sufficiently deep understanding of its politics, Bishop foregrounded the degree to which Hirschhorn's decisions and structures created a space of disorientation for Documenta spectators,

one that disallowed any notion of "community identity" to form and, in so doing, "re-admitted a degree of autonomy to art."[11]

In creating a critical barometer for making these determinations, Bishop invoked the work of Ernesto Laclau and Chantal Mouffe as well as that of Jacques Rancière. She cited Laclau and Mouffe's arguments on the necessity of antagonizing boundaries within and between large-scale and small-scale social sectors. She implicitly aligned the antagonistic gesture also with Rancière's language of "rupture" in his aesthetic and democratic theories of radical equality. Bishop thereby equated (post-) socialist theories of antagonism and rupture with the felt discomfort of a spectator's encounter with appropriately edgy art material.[12] By opposing antagonistic and non-antagonistic art, Bishop sought to foreground the extent to which "ethical judgments" and a "generalized set of moral precepts" govern the goals and analysis of such work in lieu of aesthetic criteria.[13] In her view, the social mission of social art over-determined its structure, creating a desire for functionality and efficacy that neutralized art's capacity to remain outside the instrumentalist prescriptions of the social. While Bishop's arguments were not exactly the same—sometimes Bishop did not like art that was feeling good and sometimes she did not like art that was doing good—together, the essays re-assembled a familiar lexicon for evaluating a committed art practice. Such a critical barometer measured an artwork's place among a number of polarizations: (1) social celebration versus social antagonism; (2) legibility versus illegibility; (3) radical functionality versus radical unfunctionality; and (4) artistic heteronomy versus artistic autonomy. The thrust of Bishop's "discontent" was that "the social turn" in art practice was in danger of emphasizing the first terms in this series of pairings over the critical, illegible, useless, and autonomous domains that art must necessarily inhabit in order to be itself. With references that are easily consumed and accessible, with social goals that aspire to effective social change, with collaborative turns that overly invest in a "Christian ideal of self sacrifice" to "renounce authorial presence" before the will of communities, Bishop drew some new lines in the sand in some old debates about aesthetics and politics.[14] "The best collaborative practices of the past ten years address this contradictory pull between autonomy and social intervention, and reflect on this antinomy both in the structure of the work *and* in the conditions of its reception."[15] Interestingly too, her criticisms also turned to a theatrical language to characterize such works' capitulations, whether in their mimicking of the "staged experiences" of a service economy, in relational art curators receiving undue credit for their "stage-managing," or in Liam Gillick's compromised "backdrops" and "scenario-thinking."[16]

For anyone with any allegiance to the Adornoian vision of aesthetic commitment sounded in Bishop's language of antimony, it is hard not to argue with some of her conclusions. Indeed, the fact that Bishop also advocated art practices that "attempt to think the aesthetic and the social/ political *together*, rather than subsuming both within the ethical" seems to dovetail with the kind of coincidence between the social and the aesthetic that scores of contemporary artists and critics perpetually seek.[17] At the same time, we might wonder about the terms by which such antimonies are formed. By what logic are artistic autonomy and social intervention made "contradictory" in the first place? Where have terms such as intelligibility and unintelligibility become polarized? Why is the other-directed work of social art cast as a capitulation to the "Christian ethic of the good soul" (a religious equation that is surely the fastest route to damnation in critical humanities circles)? Finally, what does it mean to reinvoke divisions between autonomy and heteronomy in a domain of practice that unsettles the discrete boundaries of the art event?

If we go back to those classic debates among Theodor Adorno, Georg Lukács, Bertolt Brecht, and Walter Benjamin, we are reminded both of the political stakes behind such terms as well as the variation in interpretation about what they might mean. Adorno roundly criticized Bertolt Brecht's "didacticism" and argued that the playwright's desire to be socially engaged had in fact blunted his efficacy.[18] Brecht's desire to be useful had produced an instrumentalization of aesthetics. Brecht's desire to be accessible had produced a legibility of plot and character that only "trivialized" politics into easy good and bad oppositions.[19] For Adorno, Brecht's entire "oeuvre" was a capitulation to the "crudely heteronomous demands" of the social that ultimately divested aesthetics of its reason for being. But it is also important to note that Adorno— and Brecht—were just as likely to encounter critics who argued the opposite. Contra Adorno, Georg Lukács—as well as a variety of leftist comrades—did not find Brecht's work "too intelligible"; rather they found it to be not intelligible *enough* to be of social use. Meanwhile, Walter Benjamin argued that Brecht was the ur-example of an aesthetic practice that was at once socially engaged and formally innovative, not simply an instrumentalization of aesthetics. This variation in interpretation notwithstanding, it is intriguing to consider the degree to which Bishop's concerns parallel Adorno's defense of autonomy. Adorno was concerned with how much the call for socially intelligible art rationalized intellectual closure:

Today the curmudgeons whom no bombs could demolish have allied themselves with the philistines who rage against the

alleged incomprehensibility of the new art. . . . This is why today autonomous rather than committed works of art should be encouraged in Germany. Committed works all too readily credit themselves with every noble value, and then manipulate them at their ease.[20]

For Adorno, aesthetic autonomy was important to preserve a space of criticality, a question mark amid the piety, righteousness, and neat dualisms of "committed" art. "Even in the most sublimated work of art there is a hidden 'it should be otherwise.'"[21] This willingness to occupy a place of refusal was for Adorno the most important goal of aesthetic practice. It meant questioning the social pull to "accommodate the world"—refusing social conventions of intelligibility and utility, however well-intentioned and morally just their causes seemed. While Adorno's legacy in modernist aesthetics has been qualified and even repudiated in the last half of the twentieth century, his language still echoes in a variety of critical circles. At the same time, it remains a question whether Adornoian criticality can be equated with Laclau and Mouffe's "antagonism," or whether both are equal to Rancièrean "rupture." (Meanwhile, all varieties of theatre scholars will wonder why these defamiliarizing terms cannot just as easily align with Brecht's *Verfremdungseffekt*.) It might not seem appropriate to ask artists and art critics to debate the finer points of twentieth and twenty-first century changes in social theory—even in a field such as social practice. But it does seem worth reviewing some of this literature in order both to understand why such philosophy provides a resource for artists and to plot our way out of certain stalemates produced by selective readings.

Ernesto Laclau and Chantal Mouffe first published *Hegemony and Socialist Strategy* in 1985 to reconsolidate a left politics. Their project was a response to the conservative economic and social developments that would underwrite neoliberalism; it was also one that integrated concepts drawn from psychoanalytic and critical theories of representation, discourse, and subjectivity to unsettle Marxist determinisms. The concept of "antagonism" was one that they carefully distinguished from other social theorizations such as "contradiction" or "opposition" to delineate a more fundamental space of epistemological contingency. For Laclau and Mouffe, the problem with "contradiction or opposition" was that such terms defined struggle as a clash between objective relations:

There is nothing antagonistic in a crash between two vehicles: it is a material fact obeying positive physical laws. To apply the same principle to this social terrain would be tantamount to

50

saying that what is antagonistic in class struggle is the physical act by which a policeman hits a worker militant, or the shouts of a group in Parliament which prevent a member of an opposing sector from speaking. "Opposition" is here a concept of the physical world which has been metaphorically extended to the social world.[22]

With a term such as antagonism, however, they sought to delineate not a relation among objective forces but instead the constitutive "limits to every objectivity":[23]

> Antagonism, far from being an objective relation, is a relation wherein the limits of every objectivity are shown . . . if, as we have demonstrated, the social only exists as a partial effort for constructing society—that is, an objective and closed system of differences—antagonism, as a witness of the impossibility of a final suture, is the "experience" of the limits of the social . . . Antagonisms . . . constitute the limits of society, the latter's impossibility of fully constituting itself.[24]

In contrast to the opposed relation of physical forces, antagonism exposed the precarity of socially defined roles:

> It is because a physical force *is* a physical force that another identical and countervailing force leads to rest; in contrast, it is because a peasant *cannot be* a peasant that an antagonism exists with the landowner expelling him from his land.[25]

While an analogy between the physical and social world would, for example, define the relation between "landowner" and "peasant" as an opposition, an antagonistic relation would focus on the fact of the peasant's non-identity with her assumed social role, dismantling the presumed objectivity and givenness of her position. If Laclau and Mouffe worked to integrate a discursive theory of representation into an analysis of society, their sense of the non-objectivity of relationally defined social sectors did not mean to discount the weight of their effects. Benveniste's reminder that relational definition does not mean airless relativism proved helpful:

> To say that values are "relative" means that they are relative to each other. Now, is that not precisely the proof of their necessity? . . . Everything is so necessary in it that modifications

of the whole and of the details reciprocally condition one another. The relativity of values is the best proof that they depend closely upon one another in the synchrony of a system which is always being threatened, always restored.[26]

As they wrote in the preface to the 2000 edition, Laclau and Mouffe viewed the subsequent "post-1989" responses from the left—declarations of the undoing of separations between the right and left, calls for "third ways" or "radical centers"—with a degree of dismay.[27] By revivifying Gramsci's concept of hegemony and complicating a notion of antagonism, they had hoped to give new life to democratic political articulation:

> We never thought, though, that discarding the Jacobin friend/ enemy model of politics as an adequate paradigm for democratic politics should lead to the adoption of the liberal one, which envisages democracy as simple competition among interests taking place in a neutral terrain—even if the accent is put on the "dialogic" dimension.[28]

A non-objective and partial model of society's constitution was not meant to discount the vital interdependence and "non-neutral" asymmetries of such processes—or to support a vision of a new, frictionless world of relational tennis games.

One can see why this conception of antagonism has a certain appeal to artistic sensibilities. This brand of social theory is notable not only because of its commitments to democracy and political articulation but also because of its conceptual and perceptual unhinging of the givenness of the social world. It finds a politics in an orientation that questions the ontological match between social roles and living beings as well as the ontological division between precariously differentiated social sectors. By a certain logic, then, the fundamental pursuit of contemporary conceptual art is in fact the disclosure of antagonistic relations. The terms of such a pursuit receive related if slightly different treatment in the hands of Jacques Rancière whose aesthetic and social theory shares interlocutors with Laclau and Mouffe—and is also ubiquitously invoked by contemporary art critics and artists. Rancière elaborates politicized perception as a radically equalizing incarnation of a genuine democracy. For Rancière, the experience of rupture occurs in moments of categorical crisis that no longer uphold social hierarchies, on the one hand, or aesthetic divisions, on the other. Pupil and student, peasant and land-owner, the philosopher and the poor, the governing and the governed,

all occupy the same lateral plane. In such a world, governing relations might be redistributed not by seniority, class, or education but by unanticipated exchanges in fields of mutual ignorance and knowledge, sometimes even by the "drawing of lots" that, Rancière reminds us, was the Athenian "democratic procedure by which a people of equals decides the distribution of places."[29] Rancière brings this same radically equalizing vision to an aesthetic domain, to argue not only for its perceptual potential but also for the necessity of questioning the categorical divisions and binary oppositions that govern an aesthetic "distribution of the sensible." A radically equalizing vision dismantles analytic polarities that divide activity from passivity, stasis from duration, use from contemplation, image from reality, artist from audience, object from surround, individual from community.[30] Indeed, in *The Emancipated Spectator* (*Le Spectateur émancipé*), previewed in an English translation in a 2007 issue of *Artforum*, Rancière uses the site of the theatre to argue against such polarizing distributions in a wider discourse on relational, interactive, and "open-ended" art. More precisely, he questions discourses that risk reinstating such distributions in the call to overcome them:

> Why not think, in this case too, that it is precisely the attempt at suppressing the distance that constitutes the distance itself? Why identify the fact of being seated motionless with inactivity, if not by the presupposition of a radical gap between activity and inactivity? Why identify "looking" with "passivity" if not by the presupposition that looking means looking at the image or the appearance of, that it means being separated from the reality that is always behind the image?[31]

The logic that calls for the overcoming of differentiation thus misrecognizes the fundamental equality that is already there, consigning theatrical and other relational art discourses to a state of "self-suppressing mediation."[32]

While it is perilous to imagine such rich and wide-ranging theory as frames "to be applied" by contemporary artists, we can still see why such thinking has been a provocative resource in the world of contemporary art and performance. Though the vocabulary and direction of the Laclau/Mouffe project differs from that of Rancière, their articulations chime with an art context that is grappling with the categorical legacies of medium specificity in the same moment that new relationships between aesthetics and politics are being tested. Paradoxically, though, we also find artists and critics invoking such social theory to create new

differentiations and exclusions about the direction of contemporary art. This seems odd for a social theory that critiques the impulse to differentiate. To return to its implications for social practice in art, the issue is whether an art critical invocation of antagonism operates with the kind of logic articulated in contemporary social theory. Bishop's exchanges with Bourriaud, Kester, Gillick, and others provide helpful places to consider such a question and to understand the difficulties of maintaining reliable barometers in such highly expanded fields. For instance, Bishop critiques Tiravanija for valuing "use over contemplation," but her other critiques of the role "festivity" in his projects suggest that utility is not their primary value.[33] Elsewhere, she critiques Liam Gillick for not offering "clear recipes" and "remaining abstract on the issue of articulating a specific position" but later defends "illegible" practices whose rigorous abstraction refuses to sacrifice itself to the "altar of social change."[34] The "cozy situation" of Tiravanija and Gillick's status as "perennial favorites of a few curators" provokes concern about the reach and limits of their work, whereas the "high visibility" of Sierra and Hirschhorn "on the blockbuster art circuit" apparently does not.[35] Finally, Bishop's mistrust of the "quality of these relationships" in "feel-good" projects does not stop her from criticizing the pursuit of quality relationships in "do-gooding" projects. She characterizes involvement in long-term community research as modeling "a Christian ideal of self-sacrifice," as being motivated by the "incapacitating restrictions of guilt," and as capitulating to "the predictable formulas of workshops, discussions, meals, film screenings, and walks."[36] Jeremy Deller's *The Battle of Orgreave*, which organized a large-scale community re-enactment of the 1984 miners' strike in Great Britain, is redeemed not because of Deller's research or knowledge of community history but because it was "utterly pointless."[37]

Several critics have accused Bishop of doing what, frankly, many critics do, that is, finding a way to celebrate the artwork that we happen to like. Whether supported by a language of antagonism or of Rancièrean rupture, Bishop's work can be read as a plea not to repeat the "self-suppressing mediations" of social art projects that seek to "overcome" their own aestheticism. At the same time, her important intervention can be diluted by the impulse to reinstate those hierarchies and divisions, to re-value "contemplation" *over* use, "unintelligibility" *over* intelligibility, objectification *over* durationality. In such an analytic quagmire, the goals of sustaining antinomies or of "thinking the social and the aesthetic together" slide all too easily into the re-valuing of a devalued side. In the process, some of the antagonistic aspirations of community art practice are sidelined as well; as Grant Kester argues in his own

frustrated comeback, they are equated with the "identity politics" of a "community arts tradition" that, for Bishop, occupies "the lowest circle of hell."[38] In the antimony between individual artist and social community, Bishop values "highly-authored" projects over a consensual collaboration, missing the chance to question formally the individuated author's social role.[39] Social practices might in fact provoke their most intriguing experiences of antagonism in their recognition that, like the peasant, an author "cannot be" an author. There are other telling conceptual trade-offs in the texts, including the degree to which Bishop's concern about community identification derives from her suspicion of "government" involvement in the arts. As anticipated in my introduction, she applauds projects that ensure "their remoteness from the socially engaged public art projects that have sprung up since the 1980s under the aegis of 'new genre public art'" and critiques those that collude with a New Labour "government [that] prioritizes social effect over considerations of artistic quality."[40] Importantly, Bishop notes that such projects can be "a cost-effective way of justifying public spending on the arts while diverting attention away from the structural causes of decreased social participation, which are political and economic (welfare, transport, education, healthcare, etc.)."[41] Intriguingly then, Bishop gestures to the importance of maintaining public infrastructures and critiques the burden placed on artists to do the work of maintenance. Such an importance critique underpins her desire to renew the value of aesthetic autonomy. Interestingly, though, she decides to find that autonomy in the "relatively neutral space of the gallery."[42] When asked directly whether it is worse to be instrumentalized by the state or by the market, she conceded, "I'm afraid I think it is the former."[43] Such comments show how an interest in antagonizing one social register ("the state") can leave others untouched ("the market"); recalling Laclau and Mouffe's dismayed reaction to misuses of their work, the economically fettered space of the gallery system ends up positioned as "neutral terrain." The historical compromises of British governance notwithstanding, Bishop's relative disdain for public funding processes and relative tolerance for the foibles of a private art market ring strangely in a text that allies itself with a book on "socialist strategy."

We do find more consistency from Bishop in the language she uses to describe the projects she favors. Most of the descriptive terms used—whether dramatizing Hirschhorn or Sierra, Phil Collins, Artur Zmijewski, or others—have a similar ring. They are "tougher, more disruptive"; they create "difficult—sometimes excruciating—situations"; they provoke "discomfort and frustration." They may appear "uncomfortable and exploitive"; they "sustain tension" and are sometimes "staggeringly

hard."[44] Importantly, such language counters the "feel-good" spin she finds in Bourriaud's relational paradigms as well as the do-gooding she finds in texts such as Grant Kester's *Conversation Pieces*, a book that she feels "seems perfectly content to allow that a socially collaborative art project could be deemed a success if it works on the level of social intervention even though it founders on the level of art."[45] But the combative language of disruption also re-animates quite familiar modernist, oppositional languages in both aesthetics and politics. Despite Bishop's own careful attention to the distinctions Laclau and Mouffe make between a physical concept of opposition (the "car crash model") and a social concept of antagonism, the routine celebration of the "tough" and "excruciating" risks forgetting these nuances. The "discomfort" between art and receiver becomes the force worthy of critical interest; if such an encounter does produce an antagonistic experience of "the limits of objectivity," that effect is sidelined by her language's oppositional fixation on whether it is "staggeringly hard." Such a concern seems to underwrite Liam Gillick's own response to Bishop's critique of his work, arguing that "Mouffe is not calling for more friction within some of the structures proposed within such a context, but is elaborating an argument against the kind of social structuring that would produce a recognizable art 'world' in the first place."[46] Gillick continues:

> The implication that Hirschhorn and Sierra upset more people than Tiravanija and I do does not mean that they are closer to Mouffe's notion of antagonism; rather, all four of us are, at best, engaged in an ongoing sequence of arguments in relation to one another and the broader culture that, when taken as a whole, is a limited yet effective demonstration of the potential of a new recognition of tensions within established models of social relations.[47]

Despite a call to re-embrace modernist unintelligibility, the focus on a hyperbolic toughness risks framing antagonism as a quite intelligible—and marketable—crash between two opposing forces. For Gillick, such a focus also enables "the right degree of verbal commodity exchange" to sustain the blockbuster artistic careers of Sierra and Hirschhorn:

> Regardless of the complex ideology behind the work, "Have you seen the blocked-up pavilion?," "Have you been to the Bataille bar?" or "Have you seen the tattooed and humiliated workers?" is far easier to share than, "Have you seen the thing

that was the backdrop for the writing of a book that exists only in parallel to the structure here yet attempts to decode the way ethical traces find form in the built world?"[48]

This kind of debate might be unique to a certain brand of artworld discourse, and yet it does find its echo in other discourses as well. Theatre and performance studies scholar Sonja Kuftinec has argued for the need to address "the image problem" of community theatre, paralleling Grant Kester's attempts to legitimate the theoretical ballast of public art's "conversation pieces."[49] Perhaps the specificity—even the peculiarity—of this artworld debate comes into higher relief by briefly comparing its contours to another debate on the limits and radicality of social art. Preceding Bishop's article by four years, Sara Brady published an analysis of Touchstone Theatre's adaptation of *Prometheus Bound* in the former steel town of Bethlehem, Pennsylvania, in the United States.[50] Entitled *Steelbound*, the production came about after a year of research and interviews with city inhabitants and former employees of Bethlehem Steel, which had closed its century-old plant in the late 1990s, leaving the inhabitants and economy of Bethlehem to founder. Appearing in *The Drama Review* in 2000, Brady's article tracked Touchstone members' processes of discussion and research, their town hall meetings and interviews, their collaboration with Cornerstone Theatre in the re-writing of the script, their outreach campaign in the audition process, rehearsals, performances, and feedback sessions along the way. Brady's conclusions were anticipated in the title of her text, "Welded to the Ladle: *Steelbound* and Non-Radicality in Community-based Theatre." What happens when we compare and contrast the terms by which this "non-radicality" was measured? Like Bishop's concerns about public funding, Brady suggested that "big-budget projects of late have operated less by the principles of the company and more by the demands of governmental funding agendas."[51] She also had a concern about other agendas. Touchstone went through a request process to receive permission to perform on the site of Bethlehem Steel's grounds; it also received permission from the Parks Commission to authorize their public congregation. Brady critiqued both this private and public collusion as an eclipse of a genuine grassroots project. "Hopes of the organically developed 'community art-making' that grassroots artists prioritize were clouded over by the reality of Bethlehem's actual centers of power."[52] She cited Baz Kershaw's analysis of Welfare State International's *Town Hall Tattoo* as a resource for lodging a critique of practices that include "very little radicality" when companies are "operating too close to the heart of local power to take any really significant ideological risks."[53]

While Brady lauded Touchstone's devotion "to school residencies, summer workshops, and local community-organization partners, bringing Touchstone company members off-site out of the theatre and into the neighborhood," she felt they needed to be more aware of the situatedness of their involvement.[54] Bethlehem's community voices were not transparently presented but were "community stories *as told to, as mediated by* a professional playwright"; she argued that community theatre projects had not come to terms with the impurity of this position.[55] Measuring the project's distance from a "Matrix Articulating the Principles of Grassroots Theatre" developed by the Community Arts Network in 1992, Brady concluded that *Steelbound* "falls short" in terms of its lack of comprehensive inclusion (she did not find a Latino member of the cast) and the rhetoric of "celebration," "closure," "moving on," and "hunger for healing" that seemed to motivate its dramaturgy.[56] For Brady, non-radicality was confirmed by the fact that *Steelbound* did not make a direct appeal for industry accountability or reparation; "never did the script ask the company to answer for the shut-downs, for the failure of the company to keep up with other mills in the U.S. and internationally."[57] *Steelbound* might have felt good but did not do good. Much like the heated response elicited by Bishop's *October* and *Artforum* interventions, Brady's essay prompted a storm of letters to the *The Drama Review*; the letters critiqued her vision and questioned the terms of her analysis.

Both Bishop and Brady thus argued that community art projects were insufficiently radical, but there the comparison ends and the contrast begins. Whereas Bishop worried about the sacrifice of authorial vision to the collaborative ethos, Brady worried that the mediating function of aesthetics was still too strong. For Brady, a document such as the "Matrix Articulating the Principles of Grassroots Theatre" was an ideal only partially reached; for Bishop, such a matrix—involving as it does "workshops," "meals," and no doubt quite a few "walks"—would certainly have been deemed "a predictable formula." For Brady, the lack of a directly legible appeal was non-radical; for Bishop, such illegibility was the place where radicality might have had a chance of residing. In analyzing the labor performance of Jeremy Deller, Bishop celebrated the fact that it was both "politically legible" and "utterly pointless;" for Brady, *Steelbound* was not pointed enough. What these critiques shared was a mistrust of "feel-good" collaboration—whether manifested in festive situations or in gestures of "healing." Neither seemed to feel that the experience of social antagonism was possible in a context that felt good. But they located the needed antidote in places diametrically opposed. For Bishop, a diluted form of consensus would be combated

by a re-commitment to autonomous aesthetic forms, unfettered by heteronomous social claims. For Brady, a diluted consensus would be combated by a deeper commitment to the social claims of a community, removing itself further from the specious autonomy of aesthetics.

Infrastructural Avowal in Two Acts

It can be argued that a certain kind of detached antagonism is perhaps less prevalent in a theatre context than in an artworld context, where critics more explicitly reckon with the legacies of Adorno's negative dialectics and with the inherited formalisms of modernist art criticism. By contrast, it can also be argued that a kind of activist antagonism is more prevalent in a theatre context where the collaborative necessity of its collective form seems more clearly aligned with the performative politics of protest and direct action. But it is important not to engage in another brand of medium-specific exceptionalism; a divide between ambiguous visual radicality and unambiguous theatrical radicality would only play back into the hands of those who equate theatricality with culinary spectacle or unsophisticated literalism. Many of the most renowned experimental theatre companies are just as skeptical of politically explicit calls for social change; The Wooster Group might be well matched to Bishop's critical paradigm, not only because of its artworld street credentials but also because of its refusal to announce its political allegiances.[58] Additionally, the ambiguous, dissonant juxtaposition of forms and themes found in much post-dramatic, post-Brechtian playwriting makes a point of resisting overt political intelligibility, which to many is in fact the point of Brecht's concepts of estrangement and defamiliarization. Theatre scholars such as Alan Read, Nicholas Ridout, and Joe Kelleher have recently argued that an instrumentalizing pull in "theatre for social change" can compromise the more complex social antagonisms that exist within the theatrical aesthetic.[59]

In order to concretize this conversation without falling back on a visual versus theatrical binary, let me return to the two artists who I said were "very different." Both incorporate the registers of performance in their work, and both began such incorporations as an extension of visual art practice. As noted earlier, Santiago Sierra, a Spanish-born artist currently based in Mexico City, has an international reputation in the contemporary art world. He has participated in annual festivals and biennials and received major commissions from a range of art organizations in both elite cosmopolitan cities and in more locally engaged galleries and museums in Latin and South America. Shannon Flattery is the founder and artistic director of Touchable Stories, a Boston-based community

arts group that creates multi-year, interactive, site-specific oral history installations in neighborhood community spaces. According to their curators, spectators, and reviewers, both artists address issues of social marginalization, especially around poverty, labor, immigration, exile, urbanization, and environmental injustice. However, to compare one artist who calls himself "a Minimalist with a guilt complex" to another who seeks to give marginal sectors of society the opportunity to "define their own voice" is to compare different artistic methods of social engagement. Sierra already occupies a favored place in Bishop's critical paradigm, one that would critique Touchable Stories in terms akin to those directed at Oda Projesi. Meanwhile, Touchable Stories would find a relatively secure place under "Grassroots Matrix" barometers, one that would judge Sierra's practices to be cynically colluding and transparently exploitative.

Rather than choosing between polarized critical and artistic allegiances, I would like to experiment with the language that we use to analyze them. My sense is that both of these forms of artistic work produce a consciousness of artistic heteronomy and social interdependence *together*, though the techniques by which they achieve such a coincidence differ. While Flattery's practice exemplifies an ethic of critical ethnography in its methods of extended collaboration and inter-media incorporation, Sierra's social engagements are in some ways "anti-social," exposing the reductive operations of social inequity by mimicking their forms. At the same time, both artists cultivate an awareness in spectators of their systemic relation to the social issues addressed and to the durational, spatial, and embodied structures in which that address occurs. Both artists have different ways of exposing the aesthetic infrastructures of the art object to highlight the social infrastructures on which sentient beings wittingly and unwittingly depend. I would also suggest that the experience of antagonism—as a recognition of the limits of the objective constitution of society—are possible in both domains. An analytic sense of such a possibility, however, can only emerge with a variable sense of its conditions, that is, with a willingness to release from the sense that a radically antagonistic art exists *either* in an extra-aesthetic space of community action *or* in an aesthetically protected space of ambiguous discomfort. As a first step, then, I would like to compare some of the forms and techniques we find in these works, considering in particular how a post-Minimalist formal language offers critical traction in reckoning with these expanded performances.

Santiago Sierra impertinently reworks Minimalist forms such as the cube, the line, and the parallelepiped, a reworking that often involves the incorporation of wage laborers. In his 2000 *Workers Who Cannot*

Be Paid, Remunerated to Remain Inside Cardboard Boxes, the exhibition space of Berlin's Kunst-Werke was scattered with vertically poised cardboard boxes just large enough to enclose Chechnyan refugees hired to remain inside. It was a structure repeated in similar projects in Havana, Guatemala City (see Figure 2.1) and other sites where the imagery of boxed people both metaphorized and literalized local refugee and labor politics. In a piece that seemed to comment on both the Minimalist form and on the desire to "do good," Sierra's *90 cm Bread Cube* (2003) was a solid bread cube baked in specific dimensions and offered as food in a shelter for homeless people in Mexico City. Documentation shows people gathered around to slice off parts of the cube onto paper plates, the geometry of the cube undone by the claims of its marginalized consumers. These and many other projects re-engage Minimalist geometry as well as the anxieties invoked by these experiments. *Workers Who Cannot Be Paid* recalled Tony Smith's *Die*, the large vertical block that was the object of Michael Fried notorious projection as a "silent presence of another person."[60] The inclusion of living bodies as material within these geometries thus literalizes Minimalism's threatening anthropomorphism. But the bodies also engage and push farther some of the fundamental perceptual challenges of Minimalism, something

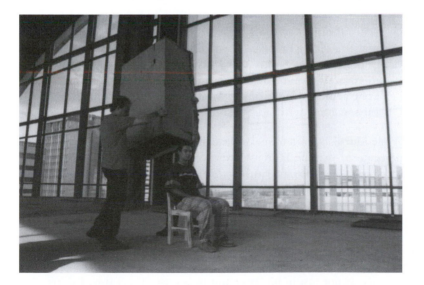

Figure 2.1 Santiago Sierra, *8 People Paid to Remain Inside Cardboard Boxes* (August 1999), G & T Building, Guatemala City, Guatemala

Source: Courtesy of Santiago Sierra.

made apparent when we look again at the early challenge of "Specific Objects." As noted by sculptors such as Donald Judd, Tony Smith, and Robert Morris, such a reductive sculptural vocabulary—one that rejected both figuration and abstraction to utilize specific geometrical forms and their serial repetition—exposed the conditions of viewing to the spectator who received them. As legions of critics have noted subsequently, Michael Fried's impulse to call such techniques "theatrical" had to do with his discomfort with such self-aware forms of spectatorship and with the durational experience they produced. For example,

> [l]iteralist sensibility is theatrical because, to begin with, it is concerned with the actual circumstances in which the beholder encounters literalist work . . . the experience of literalist art is of an object in a *situation*—one that, virtually by definition, *includes the beholder*.[61]

Fried then went on to quote sculptor Robert Morris's "Notes on Sculpture," to comment on the artist's desire to turn aesthetic experience into a self-consciously spatialized experience for the spectator:

> The better new work takes relationships out of the work and makes them a function of space, light, and the viewer's field of vision. The object is but one of the terms in the newer aesthetic. It is in some way more reflexive because one's awareness of oneself existing in the same space as the work is stronger than in previous work, with its many internal relationships. One is more aware than before that he himself is establishing relations as he apprehends the object from various positions and under varying conditions of light and spatial context.[62]

While Morris wanted to make clear the degree to which such situations de-centered the spectator—"I wish to emphasize that things are in a space with oneself, rather than . . . [that] one is in a space surrounded by things"—Fried refused to accept the importance of the distinction:

> Again, there is no clear or hard distinction between the two states of affairs: one is, after all, *always* surrounded by things. But the things that are literalist works of art must somehow *confront* the beholder—they must, one might always say be placed not just in his space but in his *way*. [. . .] It is, I think, worth remarking that "the entire situation" means exactly that: *all* of it—including it seems the beholder's *body* . . . Everything counts—not as part of the object, but as part of the situation

in which its objecthood is established and on which that objecthood at least partly depends.[63]

Neither Fried nor Morris used a language of antagonism in 1967, but we could say that both were coming to terms with the jostling of perceptual boundaries that such work provoked. What is striking is Fried's degree of discomfort with the externally derived claims of the "situation," claims that placed demands of an external order that could only be experienced as confrontation or inconvenience (*"in his way"*). The "everything" that "counts" saturated the viewing experience, provoking not only an awareness of a new medium—the *body* of the beholder—but also an awareness of the art object as "dependent." The interdependence of art and spectator, art object and situation, thus disallowed an experience of aesthetic autonomy; or, to use Mouffe and Laclau's language, it provoked an experience of the limits of its objective self-constitution. The revelation of the non-objective given-ness of both an artwork and a social subject came when their systemic inter-dependence was exposed.

If Minimalism sought to provoke an awareness of the supporting apparatus of the larger viewing situation, then Sierra seems to push both the aspirations and the anxieties that accompanied such a gesture. Consider, for instance, Sierra's reconsideration of the Minimalist desire to avow the force of gravity; indeed, Sierra's work can be placed in a genealogy with Minimalism's emphasis on sculpture over painting and the tendency in that movement to privilege artworks that oriented themselves toward the ground plane of the floor rather than the anti-gravitational plane of the wall. Orientation toward the floor—without a pedestal—was seen as an avowal of the art object's relationship to the natural external rule of gravity—opposing itself to painting's attempt to overcome gravity with hidden hooks and wires on a wall. In pieces such as *Object Measuring 600 × 57 × 52 cm Constructed to be Held Horizontally to a Wall* or *24 Blocks of Concrete Constantly Moved During a Day's Work by Paid Workers*, Sierra evokes the Minimalist impulse toward gravitational avowal as inherited from the large, heavy geometrical installations of Donald Judd, Sol LeWitt, Richard Serra, and others. However, Sierra's engagement with the social politics of gravity is different; indeed, by hiring workers to move such large, heavy Minimalist forms, Sierra exposes the anti-gravitational labor required to install a gravitational aesthetic. The Minimalist debate on material support must now reckon with its relationship to the asymmetrical supporting apparatus of physical labor. Here, the gravitational has a class basis, forcing an acknowledgement of the long classed history that governs the social management of physical weight. Gravity has always been readily avowed by the class historically hired to do the most heavy lifting. We can see

a similar relationship of re-use and revision when it comes to another Minimalist trope: seriality. As a term that exposes the steady operation of time and that uses repetition to question the myth of originality, the serial reproduction of similar forms appears throughout Sierra's work; once again, however, the "moved constantly" of such repetitions exposes seriality as enmeshed in the repetitive forms of labor that were never given the status of "original" in the first place.

Finding such Minimalist redefinition in the practice of Touchable Stories would require a reorientation and a willingness to look in different places for an engagement with gravity, seriality, futility, and the limits of the intelligible. It might begin with a form—the suspended collection of glass jars—that has become a recurrent motif in all Touchable Stories projects (see Figures 2.2 and 2.3). Jars hang at slightly different eye levels in a series; inside, viewers find miniature photographs of old buildings transferred to translucent paper, usually illuminated through the backlight of a nearby wall. While listening to stories of neighborhood spaces that have since been destroyed, visitors linger before the jars,

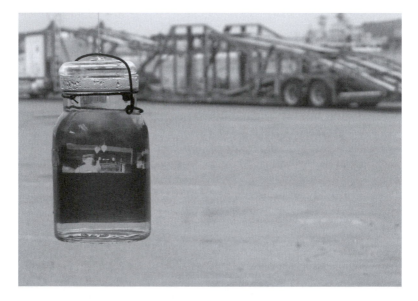

Figure 2.2 Touchable Stories, from *Richmond—An Introduction, November 2005–May 2007*, Touchable Stories in collaboration with The Arts Research Center at The University of California Berkeley and The City of Richmond

Source: Courtesy of Shannon Flattery and Touchable Stories.

Figure 2.3 Touchable Stories, *Fire Museum then and now*, detail, "History." Installation by artist/founding director Shannon Flattery. Two of approximately sixty paired jars contrasting images of the Fort Point Boston neighborhood from the early 1900s and the present day. Jars are filled with water; immersed Xeroxed acetates give the images a 3-D effect. Also used prominently in *Allston*

Source: Photo by Lolita Parker Jr., London Parker-McWhorter, and Anthony Feradino; historical photos courtesy of The Boston Wharf Co. Touchable Stories: Fort Point, 2001–2003.

holding them to identify the doorframes, signposts, and other features that tell them which disappeared building they are viewing. The installation functions at many levels. It evokes the rhythms of encounter found in a gallery or museum, calling forth the steady flow of people as they move from one image to the next in a row. However, the images are suspended from the ceiling, allowing circular movement around the image as one might encounter a sculpture. The anti-gravitational suspension from on high emphasizes the airspace underneath and allows for another kind of interaction—touch, the careful holding of the object itself. Meanwhile, that formal suspension sets off and is set off by the contents inside; the seeming weight and immobility of the building is

countered by the ease of its uprooting. A social history of uprooted urbanization is thus made palpable by an aesthetic form that lifts all too easily, presented in a glass jar that is both precious and easily broken. While this kind of seriality is surely a sentimental one, the cumulative effect creates a heightened spatial consciousness on several levels, allowing the boundaries of the art object to extend into the spectators' space—*in his way?*—while simultaneously provoking reflection upon the spectators' own infrastructural location in a longer urban history, a history on which that spectatorial location "depends." Such a relational encounter thus requires and indexes a wider systemic sphere; in the words of Neil Smith, it "jumps scales."[64]

Similar kinds of exercises in reorientation would be necessary to compare other elements in the work of Santiago Sierra and Touchable Stories. As another exercise, we could consider the experience of duration, as it came forward from Minimalist experiments and as it has been re-worked by Sierra. The durational consciousness produced by the Minimalist object was an effect disparaged in Michael Fried's essay and celebrated by Minimalist proponents. Whereas Fried condemned the "endlessness" of Minimalist sculpture, Robert Morris lauded durational experimentation to such a degree that he found himself turning to collaboration with time-based artists of performance and even adding another signature essay "Notes on Dance" to his critical writing. In this essay, Morris emphasized the structural nature of time. Duration was less something to be manipulated than a structure to be exposed; pauses were used not so much as "punctuations" but "to make duration itself palpable."[65] Santiago Sierra utilizes duration in a way that both extends Minimalist technique and calls its bluff. Consider, for instance, Santiago Sierra's 1999 piece *465 Paid People*, created for the Museo Rufino Tamayo in Mexico. Here, 465 people were hired to stand over the entire floor space of the museum's primary display area (five persons per square meter). As the crowd of people stood, expecting to receive an hourly minimum wage for their effort, spectators came to watch the still bodies who endured the ticking of time. The basic structure of the piece thus addresses the conventions by which labor is organized under the logic of "time and materials." In a structure where the only material is the hired worker's body, the notion of time as something bought comes more startlingly into view. But it also shows the degree to which the Minimalist interest in "time's palpability" has a class basis, paralleling the classed management of gravity. The piece exposed the degree to which time is already quite palpable to those who watch the clock for a living. Thus, the piece not only avowed duration as a structuring influence on the artwork but also exposed duration as

Figure 2.4 Touchable Stories, *Allston* (1997), "Map of Living Maze," Allston,
Massachusetts, USA

Source: Courtesy of Shannon Flattery and Touchable Stories.

itself governed by the "external rules" of the wage-system. Subsequent pieces such as *Eight People Paid to Remain Inside Cardboard Boxes* (Guatemala City, 1999) (Figure 2.1), *A Person Paid for 360 Continuous Working Hours* (New York, 2000), or *430 People Paid 30 Soles* (Lima, 2001) re-used a similar basic structure. Indeed, in Sierra's explicit use of hired labor as the foundation for his pieces, time emerges not only as a natural force that the artwork can no longer transcend (à la Minimalism) but also as a social force heteronomously dependent upon the asymmetries of capitalist economics. Duration is all the more palpable when it is exchanged for a wage.

The reduction—indeed, some would say, the replicated de-humanization—of Santiago Sierra's practice seems nearly the opposite of the kind of re-humanizing impulses at work in pieces by Touchable Stories. Whereas Sierra's pieces transform "collaboration" into a hiring relationship and make little mention of the histories of participants—and never their names—Touchable Stories conducts roughly eighteen months of research—meeting neighbors, attending civic meetings, holding community dinners, and collecting hundreds of hours of oral histories to serve as both the inspiration for an exhibit and as the aural medium in an installation. The process of living among the people they seek to represent supports the creation of large site-specific installations that are called "living mazes," sited in church basements, community centers, and former retail spaces donated for two years by individuals and groups living in the marginalized neighborhoods of Dorchester, Central Square, and Allston in Massachusetts, in Richmond, California, and in the city of Birmingham in Great Britain where they worked with Friction Arts (see Figures 2.2 and 2.4).[66] In each of its "living mazes," small groups move through interactive installations, listening to the voices of taped oral histories as they open drawers, turn knobs, pull curtains, and relax on pillows to hear stories of migration, relocation, gentrification, violence, and loss.

As different as this gesture is from the work of Sierra, we could say that "duration" is still an integral structure to the Touchable Stories practice. However, understanding its durational investments requires that we look in different places. Indeed, "time" is a word that repeatedly emerges in much Touchable Stories documentation, but here the emphasis is on the artists' and neighbors' willingness to spend the time to understand issues and worlds with more complexity. The durational commitment to shared time and space is in fact the underlying structure of the practice of Touchable Stories, a willingness to commit time—indeed, to commit, as Shannon Flattery does, to self-relocation in a new neighborhood space for years. This temporal commitment allows

Figure 2.5 Touchable Stories, *Irish Pub* (Spring 2009); Mary Taylor and friends from St. Eugenes with telephones from "Echoes from the Edge" exhibit; Birmingham, England

Source: Touchable Stories in collaboration with Friction Arts. Photo by Chris Keenan.

a pre-determined sense of the issues to change and seeks a provisional degree of community trust. As such, Touchable Stories shares in a "grassroots" ethic of participatory ethnography as so many of its practitioners have theorized it, committing to a degree of sensuous knowing over time. Of course, in this durational and spatial commitment, Bishop might only find "predictable formulas." Adorno too might well have found a capitulation to the "crudely heteronomous demands" of the social.[67] But it seems to me that the challenge here is to allow duration to have a different kind of aesthetic palpability. Even if Shannon Flattery's ethic of participation can be analogized to the practices of the ethnographer or social worker, it seems important to notice the specificity of her desire to do so under her self-identification as an artist. While her attempt to know others with more complexity and intimacy might read as an instrumentalization of the art process to some, we might also note the degree to which this form of participation is differently "endless" in a Touchable Stories project. Just as we might analyze the experimental, durational structures of the endurance performances of Marina Abramovic or Linda Montano, we might notice that the durational commitment to shared time-space is a *technique* of the social artist, that

it is a commitment made whose consequences are unforeseen and—by virtue of an implicit social contract—will redefine the work's process and structure. Moreover, such an experience of duration is part of a larger gesture of collaboration that is not only an "authorial self-sacrifice" but a more radical experiment in authorial release to the external claims of others, one that might be asking a conceptual question about how far the avowal of aesthetic heteronomy can be pursued. With this kind of frame, collaborative authorship is not simply a rejection of aesthetic form but its own kind of formal experiment.

Context Art's Contexts

Having lingered on the role of aesthetic frames in the analysis of social practice, let me conclude by turning back to the question of the role of social theory's frames in the analysis of extended art practice. If such a frame is preoccupied with the *limits* of social constitution, then we might find the thorniest puzzles when we examine contemporary art's processes of *extension*. The questions that continue to remain are twofold: (1) whether some explorations of society's limits are themselves foreclosed by a collusion with social processes, be they "community" or "bureaucratic," be they instrumentalized do-gooding or ameliorative feel-gooding; and, from the other direction, (2) whether some explorations of society's limits are themselves foreclosed by the protections of aesthetic categories and art market processes, be they elitist, speculative, hierarchical, or individuating. But in all of these domains, the puzzles that brew in the midst of the extensive gesture seem to be rich spaces of possibility, even when the language of consensus or healing describes it, even when a curator or blockbuster artist has stage-managed it.

Some of those puzzles come forward from the very particularity of the contexts in which they occur. Such a project not only would track the ways that Sierra's propositions vary in different national contexts but also would take the lead from Andrea Giunta and Alexander Alberro to show Sierra's relation to the complex historical use of human exhibition in avant-garde contexts throughout Mexico, Central, and South America.[68] Furthermore, Sierra's own discourse about his projects can be frustratingly self-exempting: "The problem is the existence of social conditions that allow me to make this work."[69] Social extension gets more interesting in moments when social conditions change, and his bluff is called. Consider the documentation of how social conditions changed during a minor strike at the Deitch gallery in New York. Deitch reported:

We were finally able to get the 18 required people to come and do this. Everyone was there for the opening, and they started in with them holding these beams against the wall, and then suddenly a number of the guys dropped the beams and there was this conference in the middle of the room, and this older, distinguished African American man is leading the discussion about "Why are we being paid to do this demeaning thing?" They thought it was beneath their dignity to be there as props in an artwork, and they walked off the job.[70]

At such a moment, the human materials positioned as support for the art object refused their undermounted position; using the time-based capacity for alternative action, they altered the social situation by walking out of it and, in so doing, questioned the givenness of "social conditions that allow [Sierra] to make his work" (see Figure 2.6).

More intriguing questions occur when we take seriously the processes of stage management necessary to support weighty relational acts. Such a project means questioning the tendency routinely to define systemic engagement as institutional capitulation. Take, for example, Sara Brady's

Figure 2.6 Santiago Sierra, *9 Forms of 100 × 100 × 600 cm Each, Constructed to Be Supported Perpendicular to a Wall* (June 2002), Deitch Projects, New York, USA

Source: Courtesy of Santiago Sierra.

concern about Touchstone's permits to create a site-specific production on the grounds of Bethlehem Steel, one she invoked within a larger concern that community art projects often "suck up" to sites of institutional power.[71] So too, Bishop expressed a similar sentiment when she critiqued Liam Gillick's non-antagonism, citing the fact that some of his conceptual work has led to new design systems for urban traffic or intercom systems for housing projects. She read such aspirations as directed toward "the middle ground . . . the compromise is what interests him most."[72] In both of these critiques, certain forms of civic collaboration make unpalatable alliances. But we might look again at these extensive processes not simply as degraded forms of stage-management but as opportunities to ask what comes forward when artists mimic and engage bureaucratic or institutional processes. For Gillick, it is exactly here that social practice has a chance of coinciding with the complex goals of social theory:

> Things get truly interesting when art goes beyond a reflection of the rejected choices of the dominant culture and attempts to address the actual processes that shape our contemporary environment. This is the true nature of Mouffe's plea for a more sophisticated understanding of the paradox of liberal democracy, which concerns the recognition of the antagonism suppressed within consensus-based models of social democracy, not merely a simple two-way relationship between the existing sociopolitical model and an enlightened demonstration of its failings.[73]

Gillick suggests here that the antagonistic potential of the aesthetic gesture might occur in a moment of institutional engagement. To recast Bishop's own phrases, they might "divert attention" *back to* "the structural causes of decreased social participation, which are political and economic (welfare, transport, education, health care, etc.)."[74] Such an orientation proposes that an aesthetic intervention in civic and state processes might be its own act of estrangement or redirection, not perhaps institutional opposition but something more like infrastructural antagonism. We could take this sensibility back to the question of institutional engagement in *Steelbound*, including the civic bureaucratic process that allowed the production its site permit. While impure in its alliances, a sense of infrastructural engagement might notice that families and former employees had not been allowed onto the plant's grounds since its opening, a prohibition that was over-ridden by the mounting of a permitted, site-specific performance. While instated within the hierarchical social mechanism of an approval process, the plant had to

rethink its policies, and the art process "enabled families to step on the ground where their loved ones had worked and in some cases died."[75] At such complicated moments of bureaucratic re-imagining, we find an embedded antagonism within the processes that shape our contemporary environment. I think too of Shannon Flattery's arduous process of negotiation to secure site approval in the 2007 project by Touchable Stories in Richmond, California. Creating an installation that addressed the inequities of gentrification in this California town, the project site was continually uprooted by the social force it tried to address. Landlords who had been in support of donating empty, unrented urban sites withdrew throughout the process, tempted by the speculative offers of prospective condominium developers. It took intervention at the level of the mayoral office to secure the time and space needed for a durational and environmental work. It was thus at once a collusion with a site of institutional power *and* an act that forced civic leaders to redefine civic renewal with something other than a market logic. Success in securing these sites no doubt "felt good" for both Touchstone and Touchable Stories, and no doubt the word "consensus" might have been used to describe their processes of deliberation. But it seems important to notice the provisional antagonism experienced by these collaborative gestures as well, one where the objective givenness of urban policies and gentrifying markets was challenged by an aesthetic suggestion that they "could be otherwise." To recall Fred Moten's discussion of the *parergon*, such heteronomous engagement is not simply a compromising encroachment from the outside but in fact revelatory of "the exteriority that interiority can't do without, the co-operator."[76]

Finally, having offered some sample readings of the work of artists who are legitimated and delegitimated by competing art critical discourses, it is simultaneously important to notice how "different" such readings could be. To emphasize this fact is not simply to withdraw into a generalized relativism as a critic but to foreground the different kinds of precedents and object histories that structure an encounter with a social practice. Such variation seems to affect and afflict practices that seek to think "aesthetics and politics together," and the classed tastes and sensibilities that surround community art installation and gallery art installation certainly structure the perception of formal innovation. Just as Bertolt Brecht became a figure who received contradictory forms of critique, so the work of both Touchable Stories and Santiago Sierra have both endured all varieties of response, ranging from every position on the poles to which I referred above: social celebration/social antagonism, radically unfunctional/radically functional, unintelligible/intelligible, autonomous/heteronomous. For some, the slicing up and doling out

of Sierra's *90 cm Bread Cube* was an attempt to be functional; for others, it was a parody of such a gesture. The contrast begs the question of how we might compare such a meal with the kind of "community dinners" Touchable Stories sponsors as part of its process. For some, the glass jar displays by Touchable Stories are overly explicit histories of a neighborhood. For others, however, the miniaturization and absent didactics do not convey *enough* information. Too intelligible? Too unintelligible? For some, Sierra is an advocate for the poor; for others, he is simply a cynic. For some, Touchable Stories instrumentalizes aesthetics in service of social progress; for others, its desire to maintain an aesthetic space over two years in a site that could be put to "real use" is further evidence of aesthetic futility. Such differences demonstrate the very different metrics and barometers critics and viewers bring to bear on social practice. But such differences might also be the occupational hazard of social practice as well. In this conjunction, there are numerous ways that the avowal of heteronomy can be both aesthetically precise and socially effective, and our awareness of some of them might not mean that we are fully able to see the antagonisms or presumed neutralities of all them. Such an approach, however, means deciding to believe that an awareness of interdependency can yield forms that are both aesthetically and socially innovative. And it means acknowledging the degree to which art worlds and social worlds are not autonomously "self-governing."

3

HIGH MAINTENANCE

The Sanitation Aesthetics of
Mierle Laderman Ukeles

> While feminism is a broader initiative encompassing all levels of cultural experience, its insights have become so central to our understanding of the world that it informs most modes of visual culture analysis at this point, whether its dependence is acknowledged or not.
>
> Amelia Jones[1]

> I loved it because it was very clear thinking; also because I felt that I was reordering every social relationship.
>
> Mierle Laderman Ukeles[2]

In the 2008 Pixar movie *WALL-E* we find the title character in a projected future overwhelmed by the effects of a few centuries of human garbage habits. WALL-E is a curiously low-tech robot assembly of belts, cranks, binoculars, and gears who trolls his way through a larger-than-life heap of human discard. He lives alone in a dump left by a world-wide and world-containing mega-box store, one whose incapacity to contain the unstoppable pile of refuse prompted Earth's remaining human inhabitants to evacuate into space. WALL-E moves endearingly and deliberately through the hills and valleys of garbage, picking up, sorting, shelving, and labeling the items he finds: dolls, videos, tools, containers. In so doing, he distinguishes and defines the indiscriminate piling system that has turned discrete objects into generalized garbage, transforming those items through re-use into new, careful, and discriminating categories. Indeed, in *WALL-E*, de-garbagification requires categorical re-discrimination, the willingness to decide that the homogenized object world that we call "garbage" deserves to be internally differentiated once again. Encountering WALL-E's tricked-out collector space brings to mind a storage room for theatrical properties. Those spaces too are filled

from floor to ceiling with shelf upon shelf of categorized items: vases, spectacles, lamps, picture frames, guns, canes, umbrellas, jewelry boxes, fans, ashtrays, etc. The list ranges on and on, inviting its visitors to choose among differently styled objects of different eras, a collection whose categories make the infinite extension of the object world both typical and newly specific.

In deciding to explore the subtle difference between categorized storage and uncategorized garbage, the Pixar creators of *WALL-E* struck upon one of several environmental principles of sanitation aesthetics as identified by artist Mierle Laderman Ukeles. For Ukeles, the process by which a valued thing becomes de-valued garbage is importantly a process of homogenization:

> To call something garbage means stripping the materials of their inherent characteristics. So that even though differences are obvious, hard becomes the same as soft, wet as dry, heavy as light, moldy old sour cream as a shoe, wet leaves as old barbells—they become the same things. The entire culture colludes in this un-naming.[3]

As the long-time official, unsalaried artist-in-residence of the New York Department of Sanitation and its commissioned percent for art artist with the world's largest landfill at Fresh Kills, Ukeles has developed several projects, events, performances, and installations around sanitation. After a series of small and mid-scale "maintenance" works in the late sixties and early seventies, Ukeles embarked upon what seemed to her a logical extension into the realm of public sanitation, creating projects from *Touch Sanitation*, in which she shook the hand of thousands of sanitation workers, to the reflective garbage truck of *Social Mirror*, to a variety of "ballets" orchestrated with street sweepers or landfill barges, to her recent work in transforming landfills into urban parks and sanitation exhibits. One of Ukeles's many ongoing project proposals develops a mode of sanitation art that seeks specifically to counter the garbagification of the object world and to force still earthly humans to construct a different relationship to material. In the proposals for *Public Offerings: Made By All, Redeemed By All*, she invites "one million 'Donor Citizens' to create or select something of personal value as public offerings" (see Figure 3.1). Rather than being treated as devalued waste, "these items will be bar-coded, recorded, inventoried, encased in glass, and maintained—to be visited and examined by other citizens over time."[4] Using the value-making structures of museum exhibition—or, one might add, the habits of care and categorization of a props mistress—Ukeles's

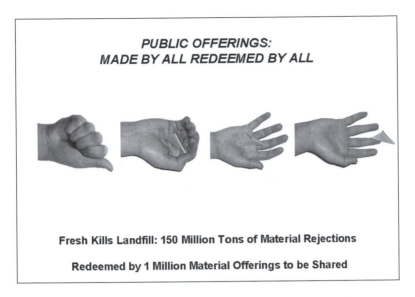

Figure 3.1 Mierle Laderman Ukeles, *Public Offerings: Offerings exchanged via network of citywide cultural transfer* from *Proposal for Fresh Kills* (1989–2006)

Source: Courtesy Ronald Feldman Fine Arts, New York.

project seeks to differentiate the undifferentiated. As someone who echoes Joseph Beuys to call "landfills" an unwitting form of "democratic social sculpture,"[5] Ukeles hopes to encourage an intentionality and care about the kind of new social sculptures we might make and remake anew.

This chapter uses the work of Mierle Laderman Ukeles to demonstrate earlier feminist and class-conscious innovations that preceded the conceptual gestures of "relational aesthetics." As a figure whose "Maintenance Manifesto" and body of work address the unrecognized labor of domesticity and sanitation, her solo and collaborative experiments with New York's Department of Sanitation demonstrate how the so-called inter-subjective substrates of relational art simultaneously interact with systemic substrates of material support. To foreground Ukeles in this way is to respond to George Baker's concerns about the blind spots feminist artists occupy in a discourse of relational aesthetics, or more pointedly, the feminist artists that Bourriaud "dismisses with a sneer."[6] This chapter revisits key debates in feminist art history as it relates to Situationist, Minimalist and Conceptual Art, investigating a major artist in light of others such as Mary Kelly, Suzanne Lacy, Martha Rosler, Lucinda Childs, and Alison Knowles. My goal is not only to "recover"

feminist work for a contemporary discourse on the relational but to ask why certain conceptual barometers prompt us to mistake their form for content, their systems for identity, their explorations of redistribution as pleas for recognition, their re-enactments of labor as essentialism. By positioning Ukeles's work as gestural and collaborative performance, this chapter also provides an opportunity to integrate the vocabularies of the ready-made from art history, the prop from theatre studies, and the transitional object from psychoanalysis. Ukeles is a key figure in any attempt to integrate an exploration of public welfare systems via the tools of Conceptual Art, and by extension, the link between this conjunction and the apparatus of performance. What this conjunction ends up emphasizing is not only registers of performance such as liveness, ephemerality, or display that have defined the field of performance studies but also the sense of performance as a provisional and fragile system, as coordination, and as a hyper-contextual form that is embedded in a network of coordination in space and over time. It is this sense of performance as a reciprocally sustaining infrastructure—one that needs to be supported in order recursively to support the show—that serves as its most fundamental link to a larger socio-political consciousness on the role of maintenance in sustaining human welfare. As part of that conjunction, Ukeles's work is guided by what many social theorists might deem an anachronistic belief in the role of public institutions in the management of the social. Her work is not only about engagement with materials, or engagement with people but about engagement with bureaucracies that she is less disposed to critique than many who are suspicious of the aesthetics of administration. I spend a portion of the chapter thinking about the prop's materiality and performative inter-action in Ukeles's feminist, classed, and pro-"public" explorations of maintenance. I then return to her recent work and recent proposals to investigate the conjunction of politics and aesthetics found in the concept of the Sanitation Artist, expanding Duchamp's notion of the reciprocal readymade to understand Ukeles's mutual estrangement of social and aesthetic systems.

Props

The *WALL-E* metaphor is partial, of course, but striking for what it might do in a popular imagination around the idea of garbage, recreating in many ways the forms of consciousness around the avowal of waste that Ukeles has developed in her long career as a self-named "maintenance artist." Since claiming such a position has historically meant enduring a few chortles and a few raised eyebrows—as well as the large systems and extended calendars of bureaucracies that continually delay her work's

arrival—the prospect of a Pixar-infused degree of public mobilization might be welcome, even if one might regret their imbrication in the mega-release systems of Disney film distribution. One of the many interesting things about both *WALL-E* and Ukeles's *Public Offerings* is the way that they echo, however obliquely, the strategy of the "readymade," that is, the effort to bring forth new interpretations of the object world and its institutions by re-contextualizing objects in an unexpected environment. As Duchamp's urinal forced a different attention not only on the urinal but also on the institution of the museum, the re-valuing of an object based on alternate principles of categorization—whether through WALL-E's stacks or Ukeles's bar codes—makes us look anew at the object world and its institutions. What do we make of institutions and dumping systems that allow us to decide that those objects are garbage in the first place? What do we make of art, theatrical, and ecological systems that tell us that they aren't?

Those allied with the institution of theatre know that the prop room was already re-using our material before an ecological movement told us to do it. The prop room retains and categorizes as many elements of the hand-held object world as possible, sometimes providing storage for other elements too small to store among the re-used furniture and flats of "the set." The relation between props and costumes constitutes another precarious place of discrimination, based in conceptual questions about relative proximity to the actor's body as well as pragmatic ones about what kind of maintenance each material form requires. The organizers of both costumes and props sustain the so-called "accessory," the smaller-scale forms that are often quite essential to the formation of a thing called "character." Provocatively, such questions about necessity and accessory recur continually when we consider the etymology of the prop. It is most conventionally used as a noun to refer figuratively to "a person or thing that is a major source of support or assistance; a provider of help or comfort; an upholder of some institution." Its use as a verb echoes such language as well as the language used to define the phenomenon of support more generally:

> To support or keep from falling by or as if by a prop; to keep in position with a prop, or with something used as a prop; to provide support or help, *esp.* to some weak or failing cause or institution; to sustain.

Its literal definition also has figurative resonance, however, in the discussion of the plastic arts and social theory:

> A stick, rod, pole, stake, or beam used as a temporary support or to keep something in position, *esp.* one not forming an

integral part of the thing supported; (in extended use) anything that serves to support something or keep it in place.

There is much resonance then in the equivocal status of the prop as a means of support that is simultaneously deemed "temporary" or as something other than "integral."[7] The language suggests a kind of expendability that is often given to the accessory or, to load up the anti-theatrical language, the ornament. But the accessory object can also be a vital helpmate, one that advances and supports the goals of a larger action. In many ways, the concept of the prop might be most resonant for a networked social world that does not always imagine itself in need of a base. The lateral relation among the props onstage—the hats and telephones and cutlery that cohere into realism or disperse into surrealism—support the show in ways that are simultaneously aesthetic and pragmatic. Props always have a look, and they have use. And when they are used, they in turn activate a richer aesthetic. How many actors have "found" their character when a props master found the right object for them to hold? How many actors have upbraided a running crew's "prop boy" when he failed to re-supply it? The world of props constitutes a theatrical re-animation of the object world on which the constitution of subjectivity rests. In this world, an object becomes a prop in the moment it animates and is animated by a self-in-formation. Andrew Sofer argues as much in *The Stage Life of Props*, showing that sets and costumes are both dynamizing of and dynamized by performer interaction.

> To paraphrase the British psychoanalyst D. W. Winnicott's famous remark about the baby, "there is no such thing as a prop"; wherever a prop exists, an actor-object interaction exists. Irrespective of its signifying function, a prop is something an object becomes, rather than something an object is.[8]

The prop is thus an object that needs gesture, which is to say, embodied action over time. Perhaps a few too many have been a little too quick to call the aesthetic meditation on this need "de-materialization." While the *OED* includes a definition of the prop that equates it with "accessory, an appurtenance," the prop may actually elicit an extra form of attachment precisely because of its non-integral temporariness. As such, the prop is a useful term for a social theory that wants to embrace the relationality and movement of networked exchange, even as it also knows the stasis and loss that comes when relational elements are removed. The prop's resonance comes in the ease of its withdrawal, its shelving, its losing—despite its vital importance for the constitution of selves and worlds. It is an object in a system that is at once material and psychic, pragmatic and semiotic. The vitality of the prop comes in the precarious realization that the object you hold is also one that holds you.

Such thinking reflects back on the larger stakes of "support" more generally. If the classic opposition in social theory has been between psychological and structural readings of society—an opposition that has attempted reconciliation from Frankfurt School joinings of psychoanalysis and Marxism through to varieties of post-Socialist writing in the work of Chantal Mouffe, Nancy Fraser, Judith Butler, Slavoj Žižek and more—then the notion of "support" or "infrastructure" would seem to emphasize the structuralist side of the equation. In so doing, it would seem to turn away from the psychoanalytic paradigms that have propelled certain strains of performance theory, especially the work of scholars such as Peggy Phelan, Ann Pellegrini, Gavin Butt, José Muñoz, and more. But by remembering the luminous attachments given to the object world, we also remember the role of both structural languages and psychoanalytic theorizing to avoid the re-entrenchment of an old opposition. Doing so means revising the inherited reductions that associated psychoanalysis with individuals and Marxism with collectives as well as those that use psychoanalysis as the way to attend to pleasure and Marxism as the way to attend to needs. Rather, psychoanalytic understanding of the role of material in the management of needs—quite often needs that the infant as well as the socialized citizen does not notice are being fulfilled—is where the point of connection lies for me. The casualty too of being a prop is that, *pace* that actor's intelligence, subjects may not realize the degree to which they rely on you.

Visual artists have of course tried to make sure that we do not take the object world for granted. The intervention of Marcel Duchamp's ready-made is perhaps the most oft-cited example of a gesture that questioned the social and psychic construction of the object world—and indeed, the division of social and psychic—through the placement of bathroom apparatuses inside a public exhibition. In what follows, I use Duchamp as a resource for thinking about Ukeles's re-animation of a degraded object world. But for her expansive sense of the connection between degraded material and larger social systems, other resources are necessary, too. My interest in joining theatrical and visual art histories has been emboldened and enlivened by the work of several visual art and performance scholars, but Tom McDonough's excavation of Situationist International (SI) and post-war French art has provided considerable ballast. There, McDonough suggests that a certain amount of theatrical history is necessary to understand the SI, particularly to understand how significantly the reception of Bertolt Brecht's estrangement techniques affected Guy Debord and Gil Wolman's conceptualization of *détournement*. He argues that "*détournement*" needs to be "redefined as a politico-aesthetic revision of interwar collage techniques, articulated under the twin receptions of Brecht and Lautréamont in these years."[9] McDonough quotes Debord and

Wolman's disquisition on the appropriation and replacing of given classical texts and images in new de-familiarizing contexts, quoting their response to Bertolt Brecht's interview in the *France Observateur* where the two activist artists decided that they found Brecht to be "much closer than Duchamp to the revolutionary result we are calling for."[10] While one might have wished that McDonough had also considered theatre historians' work on Brecht, his use of Frederic Jameson's *Brecht and Method* shows him alighting upon many of the Brechtian elements most intriguing in the history of political theatre:

> The effect of habituation is to make us believe in the eternity of the present, to strengthen us in the feeling that the things and events among which we live are somehow "natural" which is to say permanent . . . it is to make you aware that the objects and institutions you thought to be natural were really only historical: the result of change.[11]

McDonough reminds us via Jameson that both the SI and Brecht sought to defamiliarize the unreflectively normal through creative trans-contextualization. If we consider the prop as a means of temporary support—and as an object all too easily lifted and displaced—then Ukeles's work gives a more specific resonance to what such a trans-contextualization might mean.

Art After Parenting

While the SI and other allied artists reflected on their position in varied cultures of 1960s France, Mierle Laderman Ukeles was studying sculpture in New York and Colorado. Like many of this generation, she was influenced by the techniques and vocabulary of American Minimalism as it staged its related, if inconsistently politicized, response to the bourgeois art world. From the early sixties onward, Donald Judd, Robert Morris, Richard Serra, and other "founding fathers" appropriated industrialized idioms to create their specific objects. Tony Smith spoke of his famous New Jersey highway encounter in 1966; "I thought to myself, it ought to be clear that's the end of art. Most paintings look pretty pictorial after that," he said, much to the chagrin of painting's modernist art critics.[12] In 1967, Robert Smithson took his own drive on a New Jersey highway, too, struck before state construction signs that announced "your Highway Taxes 21 at Work," a form of address that Smithson read as a kind of "ruin in reverse" in which public infrastructures "don't *fall* into ruin *after* they are built but rather rise in to ruin before they are built."[13] Meanwhile, while debates on art's

suspect materiality raged, civil rights and campus movements combated untrustworthy governmental and educational institutions across the United States. The conventional telling of Ukeles's story most often begins with her *Washing Tracks* series (see Figure 3.2) and *Maintenance Manifesto* as they reckoned with her status as wife and mother. Before

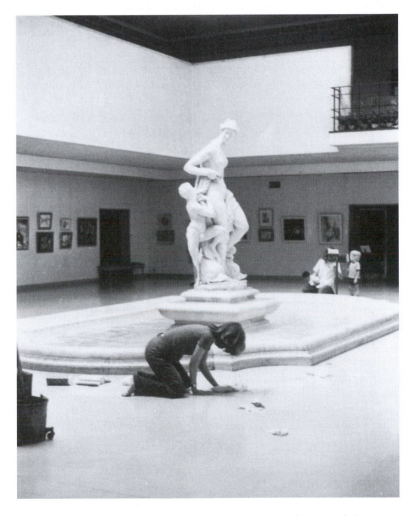

Figure 3.2 Mierle Laderman Ukeles, *Hartford Wash: Washing/Tracks/Mainten-ance: Inside* (July 22, 1973), part of Maintenance Art Performance Series, 1973

Source: Courtesy of Ronald Feldman Fine Arts, New York.

turning to those pieces, however, it is important to note that Ukeles's skeptical infrastructural imagination preceded the parental moment.

Earlier in the sixties as an art student, Ukeles was already making structures from found material. Gathering objects to "stuff" and "wrap," she created bulbous forms that we might now compare to those of Eva Hesse or Annette Massager. The wrapping preoccupations began with frames and moved to other structural apparatuses and resonant containers—"window frames, doors, bedsprings, baby furniture—bibs and playpens. My being drawn to the baby furniture really scared me. I was buying rags by the hundreds of pounds, then started buying stuffed animals."[14] She found herself trying out a social movement discourse of liberation to redefine her relationship to this increasingly scary material:

> In the summer of 1966, I got an idea that I could stuff these things with air—inflatable sculpture. I could make very big work and these things could be in the water, on the land, in the air: the central image was a giant piece that, when I was finished showing it, I would fold it up, put it in my back pocket, and I was free. I wouldn't have to take care of these works, schlep them around and worry about them.[15]

The inflatable was thus theoretically an embodiment of freedom, one that matched an immaterial form to a spirit that distrusted institutions and their extensive materiality:

> This was the sixties when materiality was suspect. There was something wrong with occupying space, something imperialistic about it. . . . Art, on the other hand was about utter freedom. Freedom was Art's only ally. Any connection to an institution was corrupting. . . . All this was aimed at work that would be free, unencumbered, and not imperialistic.[16]

The desire to create an unencumbered art form, however, turned out to produce new forms of encumbrance:

> I worked in heat-sealing factories in New York and Philadelphia, trying to make these inflatables, where they use di-electric radio frequency sealing. I didn't understand until later that I was still trying to hand-make my art even though I was completely dependent upon industrial processes. So there was a big glitch between concept and process. And they all leaked. They had horrible maintenance problems. I got deeply involved in valves,

chambers, openings, and closings. I was also dependent upon getting materials from companies that weren't used to working with artists, and they neglected to tell me basic things such as the vinyl cracks and seals break when the temperature drops below a certain degree.[17]

The quest for independent art forms had thus produced new forms of dependency, dependencies upon labor, expertise, and unexpectedly resistant material that re-encumbered the freedom-seeking artist. Having found herself enduring "so much trouble with the maintenance of the inflatables whose purpose was to be so free, unfettered," Ukeles found herself in a suspect relation to the liberatory goals that activated this pivotal decade.[18] The de-materialized art object turned out to require new hyper-materialized processes. Unlike other artists, however, Ukeles would go on to avow rather than to hide the materiality of unfettered art.

It was in the notoriously revolutionary year of 1968 that Ukeles found herself further marginalized by both political and art world definitions of "the revolutionary," marginalized most specifically because she had become a wife and mother. Despite a pregnancy that meant she "sort of became an inflatable [her]self,"[19] she boldly continued her art training:

> I remember when my pregnancy began to show. I came into my sculpture class and the instructor said, "Well, I guess you can't be an artist now." And I thought, "What are you talking about?" I wanted to be a mother . . . but I was in a panic that it meant I couldn't be an artist.[20]

After the birth of Yael, one of three children, she ended up in a predicament now so familiar in a reputedly post-feminist generation that it has become cliché. "I tried to be an artist half the time and a mommy the other half. But I was in my studio thinking about my kid and in the playground thinking about my work."[21] Finding herself saddled with the task of housework and childcare while simultaneously trying to maintain her definition as an artist, she decided to use her relative autonomy as an artist to make her own decision about what qualified as art. "If I'm the artist I get to say what's art. And I pick this."[22] She decided to name her daily chores of cleaning, sweeping, washing, changing diapers, cooking, and bed-changing "maintenance art."

The first section of what would eventually be published as "Manifesto for Maintenance Art 1969!" laid the central ideas on the table, opposing "two basic systems: Development and Maintenance," which were also

linked to two fundamental psychoanalytic drives, "The Death Instinct and the Life Instinct."[23] With the theories of Freud, Lacan, and eventually Winnicott circulating in both art worlds and parenting circles, Ukeles trenchantly linked the animating drive of political protest and of avant-garde art with the edgier subjective pleasures of the Death Instinct: "separation; individuality, Avant-Garde par excellence, to follow one's own path to death—do your own thing; dynamic change . . . new, change, progress, advance . . . flight or fleeing."[24] If radicality and revolution were indexed by the disruptive, differentiating aspirations of the Death Instinct, then intriguingly the "Life" instinct occupied a definitional zone of uncreativity, that is, the zone responsible for maintaining the creativity of others. Maintenance and the Life-sustaining Instincts were humdrum, repetitive, earnest, lacking an edge—and notably gendered and classed:

> unification, the eternal return, perpetuation, survival and operations . . . keep the dust off the pure individual creation; preserve the new, sustain the change; protect progress; defend and prolong the advance; renew the excitement; repeat the flight, show your work—show it again / keep the contemporary art museum groovy / keep the home fires burning.[25]

With the manifesto, however, and its accompanying three-part exhibition proposal "CARE," Ukeles sought to redefine the place of radicality, seeing it not in the assertion of autonomous personhood, change and disruption but in the habits of maintenance and care on which such assertions of autonomous personhood depended. If, as Saba Mahmood writes, feminism has itself been compelled by the desire to "conceptualize agency in terms of subversion," then Ukeles's earlier example shows the blindspot of those models of radicality as well.[26] As many women within political movements have found themselves asking, "after the revolution, who is going to pick up the garbage on Monday morning?"— the interrogative that, when posed, always turns its speaker into a "sourball."[27]

In portion 1.C. of the manifesto's outline, Ukeles launched into a litany that exceeded the outline's confines as well as the secure narrative voice of the "artist's statement." "Maintenance is a drag. It takes all the fucking time (lit.) / The mind boggles and chafes at the boredom / The culture confers lousy status on maintenance jobs= / minimum wages, housewives=no pay."[28] The manifesto continued in streamed monologue whose address and interior dialogue shifted voices and positions, vacillating between commands said by the maintenance worker

and commands said to her, commands said to herself and commands said to others, phrases that might be uttered, and phrases that might be found on a to-do list:

> clean your desk, wash the dishes, clean the floor, wash your clothes, wash your toes, change the baby's diaper, finish the report, correct the typos, mend the fence, keep the customer happy, throw out the stinking garbage, watch out don't put things in your nose, what shall I wear, I have no sox, pay your bills, don't litter, save string, wash your hair, change the sheets, go to the store, I'm out of perfume, say it again—he doesn't understand, seal it again—it leaks, go to work, this art is dusty, clear the table, call him again, flush the toilet, stay young.[29]

The experience of being a wife and mother who cleaned, and cooked, and engaged in the repetitive motions of household care positioned her in a new place in the art production apparatus, on the side of supporter and maintainer rather than on the side of the genius artist. The "seals" that continued to leak were not only those of an inflatable but also those of a precarious household. Meanwhile, the proposal reproduced a fractured and simultaneously collective interior monologue of mainten-ance workers, repurposing the super-egoic consternation endured by mothers ("change the baby's diaper"), of wives ("I have no sox"), of secretaries ("correct the typos"), and eventually sanitation workers ("throw out the stinking garbage").

Ukeles wrote the document in one day after having reflected for much longer on her position. She trained attention on the ceaseless, repetitive motions of household labor, not to argue her way out of doing it (as a certain class-unconscious liberal feminist position might have done) but to expose the pervasive necessity of such labor, even in both revolutionary and artistic contexts that would rather consider themselves free and independent of such needs. While the manifesto presented itself in outline form—with Roman numerals and letters organizing its presenta-tion—the text itself bubbled beneath this schematic categorization. It vacillated between isolated titles and qualifying verbiage, sometimes presented in phrases that seemed to call for bullet points, sometimes expressed in run-on sentences and questions that amplified in a highly personalized voice. Sometimes the text's interlocutor seemed to be a curator, sometimes a husband, sometimes a child, sometimes a friend, sometimes the writer herself. It has the character of a manifesto that has been pondered fitfully during afternoons at a park, in the midst of multitasking, or while rocking in the middle of the night. It in fact feels

like it was written in one day, or perhaps more precisely "a day" where writing could only occur during the precious hours stolen during a baby's nap.

The psychoanalytically rich account thus also sought company with a class-based critique of labor, joining both psychoanalytic and Marxist feminisms in a single gesture. As such, it enacted the structural subtext underpinning psychoanalytic accounts of infant identity formation, accounts that positioned mothers as the necessary structural "maintenance" of infant "development." Consider D. W. Winnicott's writings on maternal labor and the transitional object, collected and published under *Playing and Reality* two years after Ukeles's manifesto. There, and in several publications leading up to it, he argued for the necessity of the "good enough mother's" labor as a ready and consistently responsive adaptor to the infant's illusion of co-extensive reality, one that initially could not see a disconnect between himself and the world around him. Consigned to function as a stabilizer of an infant's primary narcissism, "good enough mothering" oriented itself toward the maintenance of the infant's illusion of reality. Importantly, a prop—a "transitional object"—was key in her ability to manage her role as the unconditional provider of undifferentiated continuity; the attachment object—the *doudou*—provided tenuous material support in the child's ongoing process of self-constitution. While eventually the mother's job would become one of "progressive disillusionment," successively withdrawing structures that maintained the illusion and exposing the otherness of that which was felt to be "self," the mother was doomed to occupy the equivocal position. She had to choose between the labor of maintaining primary illusion or being blamed for its withdrawal. In both cases, the task of maintenance was a thankless one, thankless in the first case because its recipient did not recognize its dependence and thankless in the second case because dependence was only recognized when support was perceived to be ungenerously withdrawn.

Parenting—and maintenance in general—was thus a formal problem in every sense of the word. It broached divisions between art and life; and more specifically it unsettled divisions between medium and support, precisely by showing how wide, varied, and unquestioned such forms of support could be. Maintenance is a structure that exposed the disavowed durational activity behind a static object as well as the materialist activity that supported "dematerialized" creativity, a realization that called the bluff of the art experimentation of the era. Perhaps remembering her leaky inflatables, Ukeles wrote: "Conceptual and Process Art especially claim pure development and change, yet employ almost purely maintenance processes."[30] Ukeles was not the first nor the last to find herself

in an equivocal position when it came to reconciling the claims of the "good enough mother" with those of the "good enough artist." Alison Knowles's *Child Piece* (1963) had placed a playing child before Fluxus eyes to ask where such a figure fitted in a discourse of experimental play and de-authorized intentionality. Knowles also might have learned that she was received a little differently when she offered to *Make a Salad* (1962) than when George Brecht offered to execute a *Recipe* (1963). A subtly gendered optic threatened to gender the "life" in the Art/Life exploration, and it appeared in numerous works by women that were occasionally received as "ungenerous." Allan Kaprow, Steve Paxton, and Robert Dunn's sweeping or vaccuming "tasks" changed when a female body executed them, such as in Lucinda Childs's *Vehicle* (9 Evenings 1966). After Jill Johnston's vacuum-ridden extravaganza in *Music Walk for Dancer* (1960), she received a scolding from John Cage for "not giving up [her] ego. He meant I suppose for not giving it up to him."[31] It was different for Ukeles to say that "Everything I say is Art is Art" than it was for Kaprow, or for Duchamp. Female artists' use of a conventional avant-garde lexicon threatened to expose the gendered asymmetry of "the Everyday."

As the 1970s wore on, artists such as Martha Rosler and Mary Kelly would explore the formal problem of parenthood and the general problem of society's illusory dependence upon disavowed labor. Martha Rosler's *Semiotics of the Kitchen* and *Domination of the Everyday* politicized "the everyday" of the avant-garde by exposing its dependence upon gendered and international scales. Mary Kelly's famous *Post-Partum Document* was a psychoanalytically rich exploration of female labor, one that had followed an equally urgent exploration of non-maternal maintenance work in curatorial and video projects such as *Women and Work* (1975) and *Nightcleaners* (1975). What distinguishes these works and other feminist art of the period, however, is not only a shared pursuit but also the shared frustrations of selective reception, reception that unevenly remembers their place in political and relational histories of art practice. That predicament recalls the fundamental equivocality of the "good enough mother" whose announcement of subjectivity is received as an unwelcome deflation of the reality in which the infant had wanted to believe. Perhaps such deflation prompts critics to receive these works, not as formal explorations, but as "ego" driven gestures that should be "given up." As Helen Molesworth writes, "Their omission was caused not by active suppression but rather a fundamental *misrecognition* of the terms and strategies they employed. The overtly domestic/maintenance content of such works was read as being equivalent to their meaning."[32] Or, in slightly adjusted phrasing, the

exploration of form was read as meaning; parenting and maintenance were formal problems that, when explored, turned up too much content. In many ways, Ukeles's work and that of other feminist artists of the period was an exercise in "progressive disillusionment" for an art world enamored of its own radical disruptions. As such, they endured the ambiguous position of every good enough mother blamed for selfishly puncturing the dream of an infant's radically boundless reality. If maintenance was necessary to the "Concept and Process Art" that undid the art/life binary, then its care-providers' announcement of their presence made them look like "sourballs" in the eyes of revolutionaries who thought they had done it all by themselves. Such maintenance workers were often rewarded not with acclaim for expanding the definitional complexity of expanded art (much less appreciation for having taken out the garbage) but instead with the individuating label of ego-driven feminism. Feminist artistic labor endured uncertain status as a force in the revolution and was often tagged as an index of a "special interest," "content-preoccupied" "identity politics" that thwarted it.[33]

After Jack Burnham agreed to publish a portion of the manifesto in *Artforum*, Lucy Lippard learned of Ukeles and assisted in organizing exhibitions around the manifesto. Ukeles's husband took photos of her doing her daily chores—dusting, mopping, cooking, rinsing a diaper in the toilet—and those photos circulated in a variety of exhibitions. The gesture was thus a photographed, documentary version of a readymade, emplacing photographs of everyday labor into a museum context that was not used to encountering them. Gratified by the success, Ukeles found herself uneasy about this instantiation of her artwork:

> I made Maintenance Series with several photos of me doing the laundry, dressing up the children to go out—and they're out for 10 minutes and they say "I want to go home" and then 45 minutes taking off all their clothes etc—but capturing every detail, which is so fabulous because it shows real life. Then I got jealous of my work. Here's my work traveling around this city, that city, that city, and I thought, "Hey! How about me!" So I started writing to the curators of these museums and asked, "Would you like me to come do a performance work while this show that I am in is there?" And they all said yes, because I wasn't asking for money. So that's when I did fifteen different performance works or more. Wherever the show went, I would also go and do a performance work. And then, you know, one thing led to another.[34]

Interestingly jealous of photographs that got to go out while she stayed cooped up in the house, Ukeles found her labor practices to be in yet another "supportive" position in relation to her artwork. The photographs relied on her labor to exist, but the photographs, not the labor, were conceived as the "art." Her "How about me?" came from an uncomfortable recognition that she was "sustaining change" and "renewing excitement" for the photographs and not for her artistic labor. Addressing the problem meant involving herself in another medium, one that some would call performance and that her critical supporter Lucy Lippard would famously characterize as "de-materialized art."

In fact, it is interesting to linger on the analytic frames both applied to and spawned by Ukeles's numerous mixed-media, task performances. How did this embodied and durational gesture of coming out to clean—and Ukeles not only cleaned but engaged in fifteen performances that showed her maintaining kinship networks, sustaining natural systems, and even removing snow—supplement the photographs and objects inside? As Miwon Kwon argues, Ukeles's performances were critical not only of household labor but also of the museum as an institution. Her repetitive gestures exposed the labor required to keep the walls of the gallery white and the phenomenological encounter with its stone steps clean. As Kwon argues, "She forced the menial domestic tasks usually associated with women—cleaning, washing, dusting, and tidying—to the level of aesthetic contemplation."[35] To make sense of these performances that have been called "contextual extensions of her work," Kwon invokes Lippard's vocabulary of de-materialization, a term that stayed in the art world and that resonates strongly with the theories of performance that emphasize the ephemerality of the form. Kwon's lengthy account speaks more generally to the role of embodiment and duration in the redefinition of site-specific practice:

> [T]he site of art begins to diverge from the literal space of art, and the physical condition of a specific location recedes as the primary element in the conception of a site . . . it is rather the *techniques* and *effects* of the art institution as they circumscribe and delimit the definition, production, presentation, and dissemination of art that becomes the sites of critical intervention. Concurrent with this move toward the dematerialization of the site is the simultaneous deaestheticization (that is, withdrawal of visual pleasure) and dematerialization of the art work. Going against the grain of institutional habits and desires, and continuing to resist the commodification of art in/for the marketplace, site-specific art adopts strategies that are either

aggressively antivisual—informational, textual, expositional, didactic—or immaterial altogether—gestures, events or performances bracketed by temporal boundaries. . . . In this context, the guarantee of a specific relationship between an art work and its site is not based on a physical permanence of that relationship (as demanded by Serra, for example) but rather on the recognition of its unfixed *impermanence*, to be experienced as an unrepeatable and fleeting situation.[36]

As we move here from a discrete notion of an art *work* to a process-based notion of the *work* it takes to make art, Ukeles used performance to expose the "conditions of production" for visual art. She focused the attention of the receiver away from the framed canvas or the Minimalist block in the center toward the institutional processes and material conditions required to maintain the walls and floors that support them. As someone trained as a sculptor and painter, Ukeles's turn to performance was an extrinsic expansion away from sculpture's intrinsic forms; the movements and motions of performance were very explicitly the vehicle for enabling Ukeles's "contextual turn." It seems quite significant that performance is understood here less as its own medium or text and more as a vehicle for exposing visual art's conditions of production and reception. This kind of framing also informs Kwon's invocation of Lippard's language of "de-materialization." In its link to post-Minimalist art movements, the language of de-materialization refers to an artistic interest in situations and processes, away from discrete objects.[37] Kwon's disquisition on the de-materialization of site also invokes the language of ephemerality and impermanence, reminding us of the art historical genealogies that support Peggy Phelan's theorizing of performance's ontological ephemerality.[38] At the same time, I think it is important to ask to whom Ukeles's crouching, squeezing, and scrubbing appears "de-materialized." By what logic are this "gesture" and its institutional critique "im-material?" When we remember Ukeles's experience of her inflatables—and her ongoing mistrust of immaterial forms that disavow the materialized labor they require—this language seems only partially helpful. Recall again how Ukeles's statement before her proposal for CARE underscored the materialist systems required to sustain de-materialized forms: "Conceptual and Process Art especially claim pure development and change, yet employ almost purely maintenance processes." This 1969 statement was in fact skeptical about the radical language of immateriality. Despite Ukeles's doubts, however, the vocabulary would stick in the parallel worlds of art and performance history, leading to a situation where the materialist systems

of de-materialized art are inconsistently avowed. The analytics of de-materialization could sideline the hypermateriality of a maintenance consciousness, one that was less preoccupied with watching the erosion of the world than with resupplying a world ceaselessly in need of repair.

Readymade Reciprocal Systems

Mierle Laderman Ukeles offered her manifesto during a time when varieties of happenings and other experiments had already sought to unsettle art/life boundaries. Paradoxically, she suggested that the death drive propelled the radical unsettling of art and life. The alternative radicality then of her decision to see household maintenance as art came not only from her interest in defining "life" artistically but more specifically, from an interest in defining life's supporting systems artistically. The art/life binary had here a differently politicized angle when enmeshed in an art/support binary. Calling her everyday maintenance work "art" highlighted the contours and intensity of household work as a never-ending, repetitive, and invisible endurance performance. In so doing, she also addressed a potential spectator whose own sense of personal freedom and creativity was, to quote Brecht and Jameson, "historical," that is, dependent upon invisible systems and labor that allowed certain persons to experience their freedoms and creativity as normal, natural, and unfettered by dependent claims. The transcontextualized move from the field of the household to the field of art sought to defamiliarize and thereby counter everyday assumptions of personal independence.

The concept of transcontextualization—and its link to the defamiliarizing impulses of Brechtian theatre—provides a segue to an alternate frame for thinking about Ukeles's work. To suggest a different way of joining visual art and performance history, let me return to the resources offered in Tom McDonough's study of Situationists International. I am thinking in particular of the kind of artistic works that, in McDonough's view, made good on Debord and Wolman's sense of Brecht's political and formal potential. In the joining of Duchamp and Brecht as legacies in a politically engaged art, McDonough chronicles how varieties of later artists within and beyond the SI made politicized use of a Duchampian "*blague*." McDonough specifically focuses on Duchamp's penciled notes for what he called "the reciprocal readymade" defined by example in the following proposition "(Use a Rembrandt as an Ironing Board)."[39] Throughout the sixties and early seventies, a variety of artists pushed Duchamp beyond himself by taking up this proposition. Consider McDonough's example of Christo's late 1960s *Mur Provisoire*,

constructed from stacked oil cans to block a Parisian street. In examining the discourse around the production and reception of this temporary form—this provisional prop—McDonough finds an emphasis not only on the act of declaring a barricade to be art (akin to the declaration that a urinal could be art, too) but also on constructing a work of art to be a barricade:[40]

> The *Mur Provisoire* adhered, in other words, to the logic of the reciprocal readymade, allowing Christo to illegally close a public street with a tall, improvised blockade whose antecedents obviously derived from the techniques of street fighting while simultaneously entitling his wife Jeanne-Claude to explain, when the police arrived and demanded it be dismantled, that "it's a work of art" and thereby to halt in their tracks.[41]

McDonough uses the formulation of the "reciprocal readymade" to unsettle some of the routinized frameworks that have interpreted the SI, those that "pitted, on the most simplistic level, 'art' against 'politics.'"[42] What McDonough says of the SI and allied artists might well be taken to other routinized debates on social practice.

> The question was not one of a neat choice between the free practice of the arts and pursuit of political aims; rather the debate was centered—to paraphrase Walter Benjamin—around the question of the function of a work within the cultural relations of production of its time.[43]

What is particularly interesting is how this kind of reciprocity—barricade as art and art as barricade—stages a conjunction of presumably different social sectors in the same formal gesture. It allowed those social and aesthetic sectors to experience the perils and the protections of the other simultaneously.

So what happens when we take the concept of the reciprocal readymade back to Ukeles's work? On the one hand, we could say that her earlier Maintenance photographs made use of a kind of documentary version of the readymade, suggesting that a mop, a sponge, a housewife, and her own household toilet could be art. The gesture turned everyday objects into defamiliarized and defamiliarizing props. At the same time, her performances also worked in the other direction, performing not only the notion that cleaning could be art but the fact that an artist and her artwork could clean. While Ukeles's decision to perform tasks at the museum was certainly "a contextual expansion of her work *from* home *to* museum, from individual to group,"[44] they were also gestures that

moved *from* museum *to* home, *from* group *to* individual. Her multiply-contextualized stooping, squeezing, washing, and rinsing questioned the logic that would define one direction as expansion and the other as retraction. Via the embodied, durational, and social registers of performance, the Washing series maintained that cleaning and art-making could occur simultaneously, a reciprocal encounter between art worlds and service worlds. Akin to using a Rembrandt as an ironing board, the Washing series used an artist as a cleaning person. In the process, one social sector—the household—and another social sector—the art world—moved back and forth in a temporary process of reciprocal redefinition.

The systemic antagonism lurking in these reciprocal encounters continues when we consider other portions of Ukeles's maintenance performances. Having defined her cleaning of a museum's exterior steps as "floor paintings," she moved inside the museum to clean its objects, dusting its existing displays and wiping its glass cases. Ukeles went a step further, however, in order to provoke a structural consciousness of the labor divisions in which such micro-gestures occurred. As a precursor and post-cursor to the creation of her "dust paintings," she initiated an explicit act of *Transfer* (see Figures 3.3 and 3.4). Helen Molesworth describes the systemic ritual:

> [I]n a ceremony staged for the camera, the janitor relinquished his rag and cleaning fluid to Ukeles, who then cleaned the case as a "Maintenance Artist" as opposed to a Maintenance person, making what she called a "dust painting." After the mummy case was cleaned she stamped both it and the cleaning rag with a rubber stamp certifying their new identities as "Maintenance Art Works." The stamped rag and the cleaning fluid were then offered to the museum conservator, in the same ceremonial manner; for the cleaned case, now a work of "Maintenance Art" could only be cleaned (or maintained) by the conservator.[45]

With this performance, Ukeles not only made labor visible but also made visible divisions of labor within the art institution. The custodian's role conventionally defined maintenance as cleaning; the conservator's role defined maintenance as preservation. Each form of maintenance also presumed distinctions between the intrinsic dimensions of the art object and its extraneous forms of support, with the former falling under the purview of the conservator and the latter under the purview of the janitor. Like other Minimalist and post-Minimalist experiments, Ukeles's gesture troubled and widened those boundaries, changing the glass vitrine from a supporting container into the medium of the art object. But Ukeles's gesture went farther than many of her contemporaries by incorporating

Figure 3.3 Mierle Laderman Ukeles, *Transfer: The Maintenance of the Art Object* (July 20, 1973), performance at the Wadsworth Atheneum, Hartford, Connecticut, USA

Source: Courtesy of Ronald Feldman Fine Arts, New York.

the people involved in this field of animate objects. With *Transfer*, receivers were encouraged to question the integrity of the art object, but also to reconsider the status of the labor that simultaneously needed and main-tained distinctions between art and its surround, between medium and support. Moreover, the conservator was subsequently required to engage with the materials of the custodian, paradoxically saddled with the task of preserving *Transfer*'s errant dustball and its fragile streak in the glass. In bringing the act of cleaning into the interior of the artwork, she questioned the institutional values that routinely demoted cleaning to the exterior, that is, to the extraneous, the *parergon*, and the inartistically expendable.

The precarity among divisions of labor took a different shape in another performance entitled *The Keeping of the Keys*. There, Ukeles proposed another act of transfer: this time she assumed responsibility for the keys to all of the museum's galleries, offices, and storage rooms. The enactment of the piece involved her walking through the galleries and administrative spaces, explicitly locking and unlocking different doors, naming this small but necessary act of security a form of art. What is perhaps most notable about this piece is the shocked reaction from the curators and administrators when their office doors were placed on display. All but one of the curators fled their offices just as she arrived, leaving their desks scattered with unfinished work. The administrative

Transfer : The Maintenance of the Art Object © 1973

Museum Maintenance Rule: only the conservator is empowered to touch the art object, handle it, clean it.

1. Selection of the Art Object in the Museum:

 Mummy (female figure) in glass case.

2. Activity : 3 people → same task → Museum → 3 powers

Activity	Person	Task	Result
	Maintenance Person	Clean the glass mummy case, (as usual).	A clean glass mummy case
	Mierle Laderman Ukeles, Maintenance Artist	Clean the glass mummy case: ("dust painting"). (Stamp glass case as Original Maintenance Art) (Maintenance Person can no longer touch it.)	A Maintenance Art Work
	Museum Conservator	Perform conservation condition examination: Art Work is "Dusty. Requires superficial cleaning.) Clean the glass mummy case	A clean Maintenance Art Work

Figure 3.4 Mierle Laderman Ukeles, *Diagram for Transfer: The Maintenance of the Art Object, Mummy-case Dust Painting* (1973), ink on paper, 11 × 8.5 inches

Source: Courtesy of Ronald Feldman Fine Arts, New York.

staff's spontaneous self-furloughing thus underscored the degree to which they had become habituated to a modicum of backstage privacy. Molesworth links this gesture and its reaction to long-held systemic attachments to divisions between private and public:

> The work stoppage that resulted from the systematic privileging of maintenance work over other forms of work is a vivid instance of Carole Pateman's argument that it is absolutely structural to patriarchy and capitalism that the labor of maintenance remain invisible. When made visible, the maintenance work that makes other work possible arrests and stymies the very labor it is designed to maintain.[46]

These workers thus found themselves inconvenienced and scandalized by an artistic gesture that exposed their own supporting system. As a "good enough artist" engaging the art institution in a process of disillusionment, Ukeles found herself treading in a field loaded with fragile psychic and structural identifications. The lack of cooperation of the curators also points up how enormously this curatorial stance has changed since the late sixties. Elmgreen and Dragset have redesigned the sightlines of curatorial offices; Rirkrit Tiravanija has relocated museum directors' desks to the center of a gallery; Andrea Fraser has critiqued edgy curatorial statements as an artwork. With a prescience less often recognized in the feminist artwork of her time, Mierle Laderman Ukeles asked art administrators to withstand a modest version of the kind of subjection any curator now expects to endure when a "relational" artist comes to town.

Such structurally and psychically loaded acts of transfer characterized much of Ukeles's work as the seventies wore on, a time that she remembers as a period of "clear thinking" in which she was "re-ordering every relationship."[47] The reciprocal redefinition in this transferring and re-ordering showed up structural inequities by introducing the anxious possibility of their equality and exchangeability. Not only could "mothers" be "artists" but conservators could be custodians, and curators could be art. Years later, we see that same sense of "reordering" when her work progressed into the field of public sanitation. Saying that public sanitation is merely "the domestic on an urban scale," Ukeles's turn from household maintenance to public maintenance was for her a logical extension.[48] In fact, the analytic utility of the reciprocal readymade comes into higher relief when we consider the story behind Ukeles's first project with the sanitation department. Intrigued by the custodial consciousness she found in her first maintenance pieces, she crafted more collaborations with service workers, including a performance in a

New York City skyscraper that involved a cast of 300 custodians in the building. David Bourdon was a critic who reviewed the piece with some degree of ambivalence. At one point, he made a tongue in cheek suggestion that alluded to the city's fiscal crisis in the 1970s. "If maintenance can be art, perhaps the Sanitation department could call its work performance and replace some of its lost manpower with a grant from the NEA."[49] Rather than being upset by the backhanded criticism, Ukeles was provoked by the suggestion.

> Reading this I thought, "the Sanitation Department, hmmm" and sent a copy of the review to the Commissioner of Sanitation. I got a call from the Commissioner's assistant asking if I would like to "make art with 10,000 people." "I'll be right over," I said.[50]

At this formative moment, Ukeles's work was notably propelled by the idea of a reciprocal collaboration between two social sectors, indexed by an agency such as the Sanitation department and another such as the National Endowment for the Arts. Her projects would put a beleaguered and under-funded public art system and a beleaguered and under-funded public sanitation system to mutual use. Parodically intervening in two "down-sized" social institutions, both systems were mutually estranged.

Touch Sanitation (1978) took eighteen months of fundraising and permission approval, and then another eleven months to execute. She went to "every single, garage, section, transfer station, landfill" to shake the hands of 8,500 sanitation workers in the five-borough system of New York City (see Figure 3.5). Upon saying, "Thank you for keeping New York City alive" to each one, she found herself in new conversations. Sanitation workers told her about their workdays and shared stories, about the "names . . . Terrible names" that people called them. Further research gave her the idea to coordinate a name-cleaning project in which sanitation workers listed the worst names that they had ever been called. Ukeles wrote them all on long panels of two-story glass windows, inviting 190 guests representing all sectors of society to wash the names off of seventy-five feet of glass. Sanitation workers were invited to watch their fellow citizens "cleanse the bad names": "They wiped them out."[51] Sanitation workers spoke often of the strange substitution citizens made between laborers and the object of their labor, "like I AM the garbage or the garbage is my fault."[52] More stories exposed sanitation's acts of transfer as well as the public's acts of transference: "It was so hot . . . One lady . . . We had loaded her garbage. We had sat down on this lady's stairs to rest; we were so tired. And she opened up her door and she said, 'Get away from here you smelly garbage men. I don't want you stinking up my porch.'"[53]

Figure 3.5 Mierle Laderman Ukeles, *Touch Sanitation* (1978–1980), "Handshake Ritual" with workers of New York, City Department of Sanitation

Source: Courtesy of Ronald Feldman Fine Arts, New York.

As her fieldwork with the sanitation department continued, Ukeles sought to counter the public's disavowed and aggressive relationship to their garbage and to the public employees who carried it. The mirror on the side of *Social Mirror*'s truck thematized the mirror stage of citizens who had yet to understand their co-extensiveness with a system of maintenance that supported their own cycles of consumption (see Figure 3.6). As Ukeles became increasingly knowledgeable about the specialized processes of the sanitation apparatus—its classed processes of environmental zoning as well as its labor processes for managing pick-up, delivery, compression, transfer, leeching, and landfill creation—more projects dramatized a large systemic apparatus. Interestingly, she began to use an explicit language of theatre and choreography. She set up the timing and sightlines for the viewing of a massive process of garbage transfer from dumps, across rivers, and onto landfills (e.g., *Transfer Station*). She conceived a variety of "ballets" in which sanitation apparatuses such as sweepers and barges "danced" (e.g., *Ballet Mechanique for Six Mechnical Sweepers*). Such gestures set up a stage for viewing the existent but otherwise under-noticed spectacles of sanitation.

In the summer of 1992, *Art Journal* devoted a few of what the publication called "Artists' Pages" to Mierle Laderman Ukeles, who used

the pages to excerpt prose from past projects and to speculate about new ones.[54] She opened with a reference to her 1969 "Manifesto for Maintenance Art!" Excerpting the exhibition proposal for *Care*, the text appeared as an intriguing linguistic artifact. Part pitch and part description, its detailed processes and movements had an anticipatory ring that, given their historical status, also appeared as documentations of an old dream. The Ukeles of 1992 chose to quote Part C, the "Earth Maintenance" portion of the proposed exhibition that seemed most pressingly to respond to an increasingly warming planet and its toxic environments.

> Every day, containers of the following kinds of refuse will be delivered to the museum: 1) the contents of one sanitation truck; 2) a container with polluted air; 3) a container of polluted Hudson River; 4) a container of ravaged land . . . each container will be serviced; purified, depolluted, rehabilitated, recycled, and conserved by various technical, and/or pseudo-technical, procedures either by myself or by scientists. These servicing procedures are repeated throughout the duration of the exhibition.[55]

Figure 3.6 Mierle Laderman Ukeles, *Social Mirror* (1983), mirror-covered sanitation truck

Source: Courtesy of Ronald Feldman Fine Arts, New York.

The 1992 reprint quoted the above and concluded with a new sentence. "Status: excerpts from manifesto published in *Artforum* (1971); museum exhibition *Care* as yet unrealized."[56] While *Social Mirror*, *Touch Sanitation*, *Hartford Wash*, and the *Ballets Mechaniques* are discrete works for which Ukeles is known, her *Art Journal* self-representation listed positions and pieces that operated on a different scale and as such remained in different states of realization.

> 1978–79 Received two NEA grants to plan this series [in Public Sanitation]. Soon after, projects blocked because new, tighter environmental regulations reclassified New York City landfills as inactive hazardous waste sites. . . . 1989–2000? Percent for Art Commission award by New York City department of Cultural Affairs to be the [DSNY] artist of the Fresh Kills Landfill . . . to work with design and engineering group that will create the site's end use. . . . 1990–93 . . . permanent work for Danehy Park . . . providing 20 percent more open space for the fifty different ethnic groups in Cambridge; 1983–95 Flow City, the first ever permanent public art environment planned as an organic part of an operating waste management facility.[57]

The text listed large-scale projects that indexed what Ukeles elsewhere described as the great goal of her work, something formally anticipated by the micro-gestures of *Care* and *Transfer* decades earlier:

> The design of garbage should become the great public design of our age. I am talking about the whole picture: recycling facilities, transfer stations, trucks, landfills, receptacles, water treatment plants, and rivers. There will be giant clocks and thermometers of our age that tell the time and health of the air, the earth, and the water. They will be utterly ambitious— our public cathedrals. For if we are to survive, they will be our symbols of survival.[58]

The lack of discretion or boundedness, temporally, spatially, and systemically in these pieces meant that Ukeles's role as an artist was blurred with that of the engineer, the policy advocate, the cultural administrator, the educator, and the curator, requiring an expansion of skill sets to engage an ever-expanding social field. It also meant that the Ukeles of 1992 was projecting into the future in what had to remain a guess about possible completion—1993 for Danehy Park, 1995 for Flow City, and 2000 with a "?" for the Fresh Kills project. That deadline would

only be extended further when, in the late fall of 2001, Fresh Kills was re-opened as a site to house the remains of the World Trade Center collapse, thereby making a former dump into a grim memorial. Working environmentally is often about maintaining a commitment to projects that are "as yet unrealized." The incomplete character of these propositions—another kind of "prop."—casts a different kind of politics on the "Process Artists" of past and contemporary generations where unrealization was a conceptually interesting puzzle. As compelling as are her realizations, therefore, a significant number of Ukeles's works are also poignant and urgent for their unrealization as well. Part of their animating structure lies in the fact that—like all maintenance—they endure the perpetual threat of being deferred.

4

STAGED MANAGEMENT
Theatricality and Institutional Critique

> Beyond its architectural determinations, the scenic space of art soon absorbed a whole set of economic and political implications that artists set about deploying in a veritable dramaturgy of unveiling. Institutional critique or "contextual" art derived from this virtually unlimited expansion. But for many years, some Puritan superego forbade us from recognizing its original theatricality.
>
> Patricia Falguières[1]

> If we want to surrender ourselves to this great passion for producing, what ought our representations of men's life together to look like?
>
> Bertolt Brecht[2]

Institutions elicit profound ambivalence. As a network of systems that both support and constrain human activity, institutions are honored and feared, thanked and criticized for their role in the constitution of selves and societies. In this chapter, I consider a selection of artists who have been interpreted at various stages of remove from the practice of "institutional critique," a movement that is often recounted as "preceding" the relational and social turn in contemporary art. More specifically, I would like to explore Patricia Falguières's provocative suggestion that this largely artworld practice partook of a fundamental theatricality. While presenting some of the goals of institutional critique to theatre, dance, and performance studies for whom this trajectory is less familiar, I simultaneously place theatrical discourses in dialogue with these paradigms in visual art criticism. By tracking artists' and curators' engagement with the question of "institutions," moreover, we also find a rich sense of the paradoxes involved in the management of social selves and social groups.

As noted in earlier chapters—and by Falguières—one of the most difficult issues in inter-media research is the long-time critical resistance to the term "theatre" in visual art discourse. For many, this suspicion is a legacy of Modernist art criticism and its preoccupation with medium specificity. For Clement Greenberg, painting's spatiality was non-durational and highly circumscribed by the essentially flat medium of the canvas—that "ineluctable flatness of the support that remained most fundamental in the processes by which pictorial art criticized and defined itself under Modernism."[3] Indeed, it was this critical preoccupation that underpinned Michael Fried's polemic against what he called "theatricality" in Minimalist art, a theatricality that he associated with medium impurity, cross-media mixing, literality, and a scandalizingly explicit audience relationship.[4] Fried's decision to align Minimalism's "literalism" with "theatricality" came from his sense of its concern with the "actual circumstances" of encounter, "*a situation*" that "*includes the beholder*," even "the *beholder's body*."[5] For Fried, "theatre" was the degraded term for an encroaching intermediality that needed to be avoided and evaded at all costs. At the same time, it was the extension of what constituted the "actual circumstances" of the art event that spawned a "dramaturgy of unveiling" that we now call "institutional critique," one that used a varied array of theatrical gestures to expose institutional structures.

To offer a varied sense of this expansive dramaturgy, I look most closely at three art practices—that of Allan Sekula, Andrea Fraser, and William Pope.L. These artists are all identified generally with the visual art world, but their critical practice makes use of different media. Together, they offer a chance to consider how theatricality might show up differently in relation to photography, in relation to the object world, in sites, in bodies, in speech, and in social exchange. The post-Brechtian scenic expansion of Sekula's photography, the use of acting technique in Fraser's site specificity, the deployment of abject gesture and community practice in Pope.L's interventions, all show artists grappling with the supports and constraints of institutional systems. They also show artists unsettling inherited conceptions of what constitutes the inside and the outside of art, of the institution, and of the social worlds. In different ways, these artists proceed to institutional critique by re-using theatrical convention. In different ways, I place their work in conversation with the theatrical figure most identified with the development of a socially critical theatre, that is, the discourse and practice of Bertolt Brecht. Indeed, T. J. Clark has suggested that a conversation between Clement Greenberg's sense of medium specificity and Bertolt Brecht's interest in "showing the medium" might reveal more kinship between the two than we might expect.[6] At the same time, we might also ask whether it was

in fact the theatrical *medium* that Brecht sought to expose, or the conditions of its *support*, a question that in turn begs other ones about how we can divide the two. In his call to show the seams or to let the lights show, Brecht's theatre developed a formal vocabulary for politicized theatre that has now become foundational in any twentieth-century theatre syllabus. As part of a complex theatrical *Verfremdungseffekt*, Brecht sought to provoke astonishment and critique by foregrounding the apparatus of the art and disrupting "culinary" theatre conventions through unexpected juxtaposition, cessation, non-cathartic durationality, and textual didactics. "An attitude," he wrote, "here is required of the spectator which roughly corresponds to the reader's habit of turning back to check a point."[7] Brecht's vocabulary both de-familiarizes and is de-familiarized by the practice of institutional critique we find in the work of Sekula, Fraser, and Pope.L. As theatrical deployments of institutional critique, they are all "staging management," redefining both curatorial and theatrical understandings of what it means to stage manage an art event along the way.

Allan Sekula's *Performance Under Working Conditions*

"Institutional critique" may have been coined by Benjamin Buchloh in 1989, or Andrea Fraser in 1985, or in the casual 1980s conversations of students in the Whitney Independent Study program.[8] Whatever its origin, institutional critique remains a catchall term for the disparate practices that extended Minimalism's heteronomous avowal of museum reception to address the museum's wider network of economic and institutional relationships. Now, with a history that includes "three generations" of practitioners and a future that remains unclear, its historicization follows a familiar litany.[9] That litany includes artists such as Daniel Buren, Hans Haacke, Michael Asher, Marcel Broodthaers, Dan Graham, Daniel Flavin, Lawrence Weiner, among others. Such a list of names—reproduced continually in edited collections on institutional critique, in Benjamin Buchloh's comprehensive chronicles, in asides in art journals, and in all varieties of artist statements—occasionally includes female artists such as Louise Lawler, Martha Rosler, Sherrie Levine, and Mierle Laderman Ukeles. Later, a so-called "third generation" of artists such as Andrea Fraser, Fred Wilson, Daniel Martinez, and Renée Green receive contextualization as figures who sharpened institutional critique's engagement with issues of gender and race. This heterogeneous list of practitioners were linked by the degree to which they pushed a Duchampian challenge—and, for Buchloh, a Constructivist challenge—to expose the institutional apparatus on which the category of art

depended. For Buren, such a challenge meant interrogating the de-contextualizing logic of the studio-museum relation. For Haacke, it meant displaying the museum as a real estate speculator. For Marcel Broodthaers or Michael Asher, institutional challenges came by mimicking the museum's institutional processes. Daniel Flavin and Lawrence Weiner, each in different ways, unsettled the object status of the artworks on which the art apparatus depended, turning to the fragile structures of lighting or text as alternatives. For Louise Lawler, institutional critique meant recontextualizing the central props of the museum within defamiliarizing didactics and conventions of display. These and a host of other practices created the "veritable dramaturgy of unveiling" to which Falguières refers. Indeed, one can go back through each of these practices and find that each institutionally critical gesture re-engaged one or more registers of theatricality. Art objects were placed within scenes. Visual artists made art objects into props and sometimes into scripts. Visual artists hung lights, cast actors, and engaged in ambiguous role-play themselves. Museum didactics started to sound like stage directions. The unveiling of the institutional apparatus seemed indeed to require varied forms of stage management. At the same time, those heterogeneous forms worked with different conceptions of what staging might mean.

When Sabine Breitwieser wrote her introduction to Allan Sekula's catalogue for the Generali Foundation, *Performance Under Working Conditions*, she noted that the exhibition's "retrospective look . . . was informed by a very specific focus: his interest in the theatrical, an aspect that the reception of his work in terms of issues related to documentary photography has pushed somewhat to the background."[10] She went on to recount his formation in a late sixties campus culture oriented in protest against the Vietnam War. Describing pieces such as a barbed wire installation that bore the title *Sculpture Commemorating the 102nd Anniversary of the University of California* or his 1999 *Waiting for Tear Gas [white globe to black]* on the World Trade Organization conference protests that year in Seattle, Breitwieser's account of the "performative element" in Allan Sekula's work sometimes follows a general argument that aligns performance with overt political activism. As such, it parallels varieties of other moves within scholarly recountings that return to "theatricality" or to "performance" as a means to politicize art practice. This analogical habit seems also to follow a generational arc as well, positing the late sixties as the apotheosis of an art-as-politics-in-performance. These kinds of moves in both performance studies and visual arts scholarship share in a certain narrative of performance's political history that also emphasizes certain hyperbolic effects. Theatricality comes back

into art when art needs to be loud, when it needs to disrupt, when it needs "Action!" Art leaves theatricality behind when it can afford to be subtle, critical, or ironic—that is, when a political landscape presumably calms long enough for art to be real art once more.

But a different performance sensibility also lurks within these narratives, one that locates performance's socio-political significance outside of the hyperbolic actions that are periodically lamented or celebrated as "over" with the aging of a Boomer generation. That alternate sphere lies in the performative labor required to stage those actions, the "word of mouth," the "planning meetings," and the mechanisms for distributing all varieties of media. The impulse to foreground performative labor is behind a phrase such as "working conditions" in Sekula's catalogue title, one roundaboutly theorized by Breitwieser throughout the catalogue. Breitwieser says that Sekula "makes the theatrical element dependent on a 'working condition,' the question of whether it can be meaningfully integrated"; she clarifies the meaning of this statement through a description of Sekula's own labor as an artist. "At this point, we should keep in mind that his photo sequences, which often cover long periods of time and many different geographical locations, demand great mobility of the artist."[11] The theatrical element thus seems to be tied to Sekula's commitment to "spend a lot of time" and to travel "for many days." Moreover, that labor refers both to an aesthetic practice and to the forms of labor that it documents. The artwork's "meaningful integration" of theatricality depends upon the working conditions of social engagement. The phrase "*performance under working conditions*" thus seems to be a provocative, even if somewhat tautological, way of isolating conditions of labor as documented and as implemented by the artist. Sekula documents theatricality's backstage labor of coordination as much as its more visible practices of extroverted display. The coordinating labor of performance advances the project of post-studio visual art practice by foregrounding working conditions; meanwhile, the art world's attention to the working conditions of itself and of society depend upon the theatrical knowledge that no act can ever be solo. Such a theatrical sensibility is one that recognizes our dependence as well as its own on the practice of the supporting act.

In looking back over the post-adolescent beginnings of Allan Sekula's artistic career, one finds an intriguingly compassionate curiosity in the midst of the resistant, masculinist ethos that we have come to associate with the late sixties. While still an art student at the University of California, San Diego, he took classes with art luminaries such as David Antin and post-Marxist political philosophers such as Herbert Marcuse. Influenced by the formal questions of aesthetic practice—both classical

and Fluxus-derived—as well as by campus activists who analyzed the industrial role of higher education, Sekula's early works explored the quotidian perils and paradoxes of the southern Californian environment in which he was raised. Fueled by the industrial technology boom in the Western United States, this was a California culture that mixed the high-stakes language of innovation with the hierarchical org-charts of capitalist managerial culture. It propelled the boom economies of an adventure state as well as the ever-sprawling suburbanization of California's landscape, marshalling all of its fecund human and natural resources. As the son of a middle-rung aerospace engineer inside a traditionally gendered family, Sekula observed the asymmetrical effects of California's systems from several vantage points: that of manual laborer, scientific engineer, impertinent artist, student in a pre-Prop 13 educational system, son, and brother. With *Box Car* (1971), for example, he photographed a California chemical plant where he had worked for extra money as a teenager, while traveling inside a moving freight train's boxcar (*Box Car*, 1971). In a gesture that inverted the historical role of locomotive motion in the history of the moving image, the photograph stopped time long enough to capture the factory site before its eventual closure. Moreover, his seat on the train simultaneously marked the role of train systems in a transport history that was already being usurped by California's state-funded superhighways. The next year, his *Untitled Slide Sequence* (1972) continued his interest in the depiction of industrial labor by making a different kind of nod to the history of film. Mimicking the sequenced early filming of the Lumière brothers, he trained his camera on California laborers exiting a factory. That same year, he consolidated his interest in the photographic isolation of action with *Meat Mass*, a project that started out as a performance in which he threw expensive pieces of meat onto a highway of oncoming cars. "There was a performative dimension to all of these actions, especially since all were predicated on trespassing and other misdemeanors," he has said of this early work. "But there was a way in which the observational and more strictly 'photographic' properties of the exercise had won out by the third effort. I was convinced that documentation was more interesting than the action itself."[12]

With his larger work of 1973, *Aerospace Folktales*, Sekula integrated both the eclectic Marxism and expanded art practice of his college training into what he called a "disassembled movie" that placed his recently fired father at the center (see Figure 4.1). Speaking of him in third person as "the engineer," the piece combined images of Lockheed Corporation, where his father had worked, and different snapshots of life in his childhood home. His parents' motions were photographically frozen as they passed between living rooms, kitchens, and bedrooms

wearing the iconic garb of the generation who gave birth to the Baby Boom: short-sleeved, white-collared shirts, house dresses, and thick, black-framed glasses. The piece also included soundtrack interviews of conversations with his parents as well as a commentary text that "constituted the self-implication of the artist."[13] In keeping with the disassembling of a movie, the images were blocked as unsutured frames documenting everyday actions, sometimes with accompanying text: "In the evening, the engineer would write letters and straighten the lamps. His wife would fix the dinner."[14] Other images linked the putterings of quotidian life in an economically imperiled home to wider systems of power. Lockheed's triumphant CEOs appeared as did Lockheed's triumphant self-marketing: "translating the discoveries of science into advanced products."[15] Those images were sequenced with photographic excerpts from "the engineer's" nightly reading on the human effects of nuclear weapons.[16] Along with images of his professional resumé—both a tool and an index of human objectification within professional management—the piece piped intimate interviews with his parents through the installation space. "You are more or less interested in knowing what some of the background was to the present economic condition, as far as aerospace work is concerned?" asks his father, euphemistically clarifying, "The layoffs and so forth?" Meanwhile, Sekula's mother's interview circulated through the space as well (represented visually in the catalogue underneath the voice of her husband) chronicling the engineer's "spells of being disturbed and upset."[17] This engineer/father occasionally spoke in the first person about his situation in an abstract organizational landscape, turning more protectively to second-person along the way: "Perhaps the major difficulty that I have encountered is being able to contact people who might have knowledge of positions which you could fill. Many times, you were sidetracked by receptionists, office personnel, clerical staff, and so forth."[18] Other times, his self-testimonial turns to the abstract third-person, often when the narration comes closest to self-introspection:

> There is a demoralizing reaction on the part of the individual experiencing unemployment. At first, he might feel very confident that he has something that will impress a potential employer. And as time goes on and when he is faced with refusal after refusal, he begins to doubt, then that doubt turns into what you might call discouragement.[19]

By combining text and image, but also offering text, image, and sound in unsutured layers and streams, the multi-media piece showed more

Figure 4.1 Allan Sekula, *Aerospace Folktales* (1973). Mixed Media: 1 of 51 B&W
photographs in twenty-three frames, three red canvas director's chairs,
six potted fan palms, three CD players, three speakers; three simul-
taneous, unsynchronized CD recordings 22.5 × 29 in × 73.7 cm

Source: Christopher Grimes Gallery, Santa Monica, California, USA.

dimensionality to a man who might have been cast as "one dimensional"
within Professor Marcuse's frame. Refusing to sentimentalize his parents
and, perhaps more poignantly for his era, refusing to cast them as victims
of total hegemonic absorption, the son's artwork resides in a place of
embedded critique, collapsing polarities that would separate the intimate
and the systemic at the same time. Key to this effect is Sekula's interest
in the "disassembly" of sound, text, and image, or what Bertolt Brecht
had earlier called a "radical separation of the elements" in epic theatre.[20]
Brecht's response to Wagner's notorious "fusing" of the arts in the
Gesamtkunstwerk parallels Sekula's response to the "suturing" of the arts
in the medium of film.[21] They both unhinged representational elements
in order to unhinge our sense of the simplicity or givenness of represented
reality. Avoiding the affects of melodramatic sympathy, on the one hand,
and of Oedipal rejection on the other, the unsutured film foregrounded
his father's reality as itself a complex and contingent assembly.

After leaving the University of California at San Diego, Sekula pursued
his photo practice while also working as a part-time employee in various
industries. His art continued to contemplate the effects of economic and

social institutions on the people charged with sustaining them. His *School as Factory* tracked the espoused principles and regulating architecture that joined the educational system to the hierarchies of industry for whom the school was training ground. His *Pictures of Salespeople* offered a micro-historical study of a rising service industry. The discourse of theatricality began to appear more and more as a metaphor for service labor, as if anticipating the discourse of "managed hearts" and "affective labor" that feminist sociologists such as Arlie Russell Hochschild and later theorists of globalization such as Michael Hardt and Antonio Negri would use to characterize a global service economy.[22] In a text and photo piece called *This Ain't China: A Photonovel*, Sekula describes his interest in exposing the institutional condition both of documentary and of the "theater" of labor in a semi-fictional restaurant (see Figure 4.2). "So the joke was that 'genuine' documentary required access to the plenitude of the world of capitalist property," says Sekula. "Without access to capitalist 'reality,' one was left with 'poor theater' to borrow Jerzy Grotowski's term. This is what I came to think of as 'performance under working conditions.'"[23] Like other artists such as Gordon Matta-Clark or Claes Oldenburg, *This Ain't China* used the ur-service site of "the

Figure 4.2 Allan Sekula, *This Ain't China: A Photonovel* (1974)

Source: Christopher Grimes Gallery, Santa Monica, California, USA.

112

restaurant" to demonstrate the material infrastructure of so-called immaterial labor. The fictional rather than actual restaurant freed him from the financial constraints of a "genuine" documentary.

Sekula's under-punctuated, italicized text both used and parodied the theatrical analogy in its focus on the restaurant owner as hierarchical director in relation to his subordinate actress-waitress. In other words, he used poor theatre's resources to critique a hierarchical and obfuscating brand of for-profit theatricality:

> *H told her that there was a one-to-one analogy between many aspects of the restaurant business and the theater business. In the theater you design a set which creates part of the atmosphere and mood an audience becomes involved in that set they identify and that's how they enjoy the production in the restaurant there is a set too it's the booths the way the walls are done the way the interior is done the front door the costumes the waitresses wear the whole atmosphere.... you have a script it's the menu and just like theater the same script lays every night yet no two shows go alike cause you're playing for a different clientele every night*
>
> *You have actors the actors are your waitresses. They are certainly not necessarily delighted to see everybody who walks in or eager to serve them or enjoy the role they're playing, but they are indeed playing a role and they've got lines . . . and you've got a backstage crew the people in the kitchen they are making the show click the stagehands the technical director the cook who runs the wheel who is in charge of the kitchen is just like a stage manager. He's got to watch his cues to get everybody out on time get all the food out on time. There's the same kind of "show must go on" atmosphere an urgency . . . the customer cannot be conscious of what is going on in the kitchen. . .it spoils his meal. As soon as a member of an audience is conscious of what's going on backstage it's taken his mind away from the show he's had to step out and look it ruins the show*
>
> *She decided that his insight lacked any sense of irony he took his metaphor too seriously . . . his logic was consistently that of the businessman . . . so this is what Brecht meant by culinary opera she thought.*[24]

Indeed, in that last fleeting reference to Brecht's culinary theatre, Sekula embeds a quite different theatrical logic into the piece; in marked contrast to the obfuscating theatrical goals of the restaurant owner,

This Ain't China is in fact an attempt to make a receiver conscious of the goings-on in a kitchen. The theatrical tools of *Verfremdungseffekt* seek to disrupt the theatricalized society of the spectacle. The process of worker sublimation is made visible in the announcement of the waitresses' emotional management.[25] The visibility of the backstage labor of food production does in fact threaten "to spoil" the enjoyment of the meal. The text is juxtaposed with Sekula's image of the food and his images of the cooks in action, transferring materials across counters, through slicers, into dishwashers. If the durational action of such labor is naturalized in the enactment of a service economy, then Sekula's photographs create a moment of critical cessation. By stopping the action (again à la Brecht), the service industry's naturalized backstages—whether architecturally framed in the kitchen, or psychically framed in the sublimated interiority of the actor-waitress—are made visible.

Meanwhile, of course, the restaurant "director" earnestly and relentlessly pursues his metaphor, invoking a hierarchical division of theatrical labor to naturalize a hierarchy of labor in his site of employment. As the piece continues, it is clear that he hopes to keep other theatrical models—co-operative, collective, didactic, or actionist—at bay.

> *A few of the cooks would rather play rock and roll than work. On the other hand a couple of his employees seemed to have a misguided ideological commitment that could only have been the result of a Vietnam-era college education in the liberal arts. These employees were willing to exploit the grievances of the others to foster an atmosphere of discord. He was quite willing to deal with his employees as individuals but not as a mob.*[26]

This Ain't China tracked a world of theatrically coordinated service, one where the relationship between production and consumption may be "alienated" but can never be time-delayed. In the process, a variety of theatrical models—culinary, poor, spectacular, and Brechtian—and a variety of social models—unionized, itinerant, capitalist, individuated, mobbed—were put in play. Even as Sekula provoked a critical stance on this service industry, the piece incorporated a degree of self-implication once again. Sekula himself was an artist with just such a liberal education who knew to quote Brecht and Grotowski. As such, the artist himself was embedded within the institutions he critiqued.

It was around *This Ain't China* and *School as Factory* that renowned art critic and scholar Benjamin Buchloh began to engage Allan Sekula's work, eventually bringing him into a wide-ranging conversation on the innovations and limits of institutional critique. With Sekula, perhaps more

than with some of the other artists canonized under "IC," Buchloh also had the chance to link late twentieth-century conceptual practice to the legacies of Constructivism, Productivism, and Soviet factography, that is, an expanded tradition of critical aesthetics that differed from the legacies charted from Duchamp or from Minimalism. To recover this early twentieth-century social art movement as a resource for interpreting late twentieth-century socially engaged art meant grappling with the legacies of a factographic aesthetic, one that found both a formal and social intelligence in the representational effects of everyday materials. Photography's link to the tradition of documentary made the connection between factographia and Sekula's photo-practice relatively clear.

> It is the work's 'factographic' approach—its insistence on the necessity to explore and clarify the construction and operation of representation within present day reality and to make that reality transparent rather than mystify it—which distinguishes the work of Allan Sekula from most contemporary aesthetic practice.[27]

More transhistorical resonances came from the fact that the photos and texts of *This Ain't China* were lodged in a gallery of images and suspended books—complete with chairs for spectators to linger—replicating the educational environments of the Constructivist reading rooms and kiosks as well. It is here too that Buchloh tracked Sekula's interest in sites of industrial labor whose practices were being made increasingly anachronistic by the forces of globalization. In *Freeway to China*, Sekula researched the trucking and shipping industry, fixating on the highways and transnational seaways that transported containers of consumable goods. In *Fish Story*, the long durations of time to which Breitwieser referred above become central to Sekula's exploration of performance under working conditions, especially when Sekula decided to create some new working conditions for himself. As he recounted later:

> As things stood at the outset of *Fish Story* in 1987, I was working entirely outside the gallery system—and continued to do so for eleven years ... This freedom from short-term exhibition or publication demands allowed me to consider a project that could extend over seven or eight years.[28]

This was the same time that Buchloh had started to make analogies between Sekula's practice and that of the Soviet artist and writer, Sergei Tretiakov. Indeed, part of Buchloh's theorization of institutional critique—and his concerns about the limits of some of its practitioners—seems to have come from his desire to find a Tretiakov for the late twentieth century, one that would:

take us back to the historical moment when photomontage, both in the Soviet Union and in Weimar Germany, is displaced by more systematic factographic models ... [that is] the principles of long term observation, work sequences at large, and complex social relations.[29]

It was in 1984 that Buchloh had made the analogy between Sekula's twenty-first-century photopractice and Tretiakov's 1931 reflections in "From the Photoseries to the Long-term Photographic Observation," the essay from which the language of the "long-term observation" of "complex social relations" had come. Tretiakov's extended practice of course had also supported another early philosopher's attempts to come to terms with socially engaged art; Tretiakov was Exhibit A in Walter Benjamin's "Author as Producer":

> Tretiakov distinguishes the operating from the informing writer. His mission is not to report but to struggle; not to play the spectator but to intervene actively. He defines this mission in the account he gives of his own activity ... When, in 1928, at the time of the total collectivization of agriculture, the slogan "Writers to the Kolhoz!" was proclaimed, Tretiakov went to the "Communist Lighthouse" commune and there, during two lengthy stays, set about the following tasks: calling mass meetings; collecting funds to pay for tractors; persuading independent peasants to enter the *kolhoz* [collective farm]; inspecting the reading rooms, creating wall newspapers and editing the *kolhoz* newspaper; reporting for Moscow newspapers; introducing radio and mobile movie houses, etc.[30]

For Buchloh, Sekula's engaged documentary practice positioned him as a kind of operating photographer, at least when it came to certain long-term projects.[31] This carefully coordinated attempt to explore "working conditions" charted a different kind of theatricality for expanded visual art practice. Rather than the hyperbolic protest gesture, Sekula's theatrical sensibility is interested in the coordinated systematicity of labor, one that has patience for the mundanity and *longue durée* of its process.

Whether all of Sekula's projects have had the same long-term character or the same relations of address with their audience, Sekula seems continually to expose the working conditions of photography in the same moment that he explores the working conditions of contemporary society. For Sekula—and for Brecht—the dramaturgical unveiling of the conditions of the art event simultaneously unveils the dramaturgy of

social process. Performance is both the thing unveiled and the means by which unveiling occurs. Echoing Benjamin's stance on Brecht and Tretiakov, the self-conscious awareness of the artist's location in a working process was just as important as his attitude to the politics of work itself. Benjamin famously asserted, "Rather than ask, 'What is the *attitude* of a work to the relations of production of its time?' I should like to ask, 'What is its *position* in them?'"[32] Sekula's work is an engagement with his own positionality but also with the relations of many labor positions within coordinating systems. In being thus engaged, the ethical and political consequences of those systemic arrangements, be they capitalist or unionized, hierarchical or collaborative, short or long term, become an urgent question. "Performance," moreover, is both a way of denoting the action of the working condition but also a means of de-mystifying the action of work itself. Interestingly, as a photographer for whom documentation of action became increasingly intriguing, such an attempt at de-mystification came in the photograph's ability not simply to provoke action but also to arrest it. Photography could freeze cooks, dockworkers, and shipping laborers in the *durée* of labor that was otherwise naturalized or rendered invisible. The laboring action thus acted as support for the photograph in the same moment that the photograph defamiliarized labor's naturalized unfolding. As such, this "epic" practice made a photographic analogy to the strike. Akin to this most venerated of labor's performance forms, the strike is one based not only in a hyperbolic brand of spectacular action but also in a confounding commitment to cessation. The resolution "not to act" is in fact central to its effects. The inaction of the strike is what shows the dependence of industry, of consumption, and of social worlds on the steady action of labor. Allan Sekula's photographs are to action what the strike is to labor—and what epic cessation was to theatre. All made critical interventions through the strategy of the stall.

Andrea Fraser and Institutionalized Acting

In the winter of 1989, a young, spectacled woman entered the lobby of Philadelphia's Museum of Art to act as a tour guide to a group of assembled visitors. Dressed in a houndstooth checked double-breasted suit "with a skirt just below the knee," her hair in a "small bun held in place with a black bow," the museum docent offered a welcoming "Good afternoon" to her guests and introduced herself as "Jane Castleton."[33] The tour would follow a course that was both typical and unusual, meandering through the public halls of the well-endowed museum but stopping at a variety of other places—drinking fountains, admissions desks,

cafeterias—to wax rhapsodically about the aesthetic qualities of operations that were heretofore ancillary to an aesthetic frame (see Figure 4.3).

Andrea Fraser's performance in *Museum Highlights* would place her firmly within the less than firm categorizations that defined "*Kontext Kunst*" (context art) in the late twentieth century and as one of what Alexander Alberro calls "third generation practitioners of institutional critique."[34] The text of *Museum Highlights* was published in the Summer 1991 issue of *October*. Subsequently, her re-performance of museum practice would continue in pieces such as *Welcome to the Wadsworth* and *May I Help You?* Her site-specific museum performances occurred at the same time that Guillermo Gomez-Peña and Coco Fusco would appear as *The Couple in the Cage* in various natural history museums. The fact that one form of museological critique would receive more critical traction in the discipline of performance studies and the other in the discipline of the visual arts shows up yet another dimension of art's institutionalized differentiation. In the 1990s, Fraser would take a break from explicit performance but continue to cultivate a critical practice as a kind of counter-curator in projects for the Berkeley Art Museum and the Generali Foundation, returning to a differently inflected use of self in performances

Figure 4.3 Andrea Fraser, *Museum Highlights: Gallery Talk* (1989), performed at the Philadelphia Museum of Art

Source: Courtesy of Andrea Fraser.

such as *Official Welcome,* her much debated *Untitled* (2004), and in *Projections* (2009). Throughout her career as a self-styled autodidact, she has maintained a highly regarded writing practice as well—her texts collected and edited by Alexander Alberro and published by MIT Press.

Andrea Fraser's work uses a variety of theatrical registers. Indeed, a significant portion of her work has included not only an ambiguous score or script, not only text as object, not only duration, not only embodiment, not only soundscape, but also that specific conjunction of text, sound, embodiment, durational action, and speech that conventionally defines "acting" in the theatre. "Good afternoon, uh, everyone? Good afternoon. My name is Jane Castleton . . ."[35] The opening lines of *Museum Highlights* present Jane's attempts to establish herself, mimicking the conventional welcoming gesture with a touch of insecurity. Fraser's text includes the "uh's" that show Jane re-gathering her poise, including a question mark after "everyone?" to show a bit of uncertainty as to the positioning of her addressee. Just as the performative mode momentarily struggles, however, that same mode will attempt to override all appearance of anxiety with newly firm declarations. "Good afternoon. I'm Jane Castleton, and I'd like to welcome all of you to the Philadelphia Museum of Art."[36] The performance gains both its force and vulnerability from its co-present situation in shared time. Jane begins her tour with an introduction to the West Entrance Hall, which includes "the Museum's brand-new combination information desk, admissions desk— I hope that all of you have paid your admission fee—and, uh, membership desk. If you're a Museum Member, of course you don't have to pay an admissions fee."[37] The performance text thus brings a docent's eye to an apparatus of museumship that, despite its necessity, usually goes unnoticed in the moment of its use. The text's non-grammatical hope for the payment "uh, membership desk" could be either a slip in Jane's self-presentation or the documentation of Fraser's slip in memorization. That slight question about the relation between actor and persona continues upon reading, and hearing, the next portion of a monologue. It quotes a document produced by the President and Director of the Philadelphia Museum of Art, only this time their words will be performed as Jane's spontaneous promotional banter.

> Membership, you know, "plays a vitally important role in the life of the Museum . . . Many Members indicate that they join the Museum because they perceive it to be an institution of the highest quality, one of the world's great repositories of civilization . . ."[38]

What sense can we make, not simply of a general turn to performance, but of Fraser's more specific turn to something like acting? Part of this

sense-making comes from recognizing that acting was already part of her repertoire of skills, something cultivated in high school theatre and put to use in her ten-year collaboration with the V-Girls. Including Martha Baer, Jessica Chalmers, Marianne Weems, and Erin Cramer, the V-Girls created a series of performances that mimicked the institutional conventions of academia, art criticism, and feminist consciousness-raising circles. In scripts that parodied the performance conventions of the "panel," the "roundtable," and the academic treatise, their work hovered between critique and identification, simultaneously idolizing and questioning the critical and institutional sites that elicited their desire and provoked their skepticism. Their titles included "The Question of Manet's *Olympia*: Poised and Skirted," and their oeuvre developed Lacanian analyses of *Heidi*. Their scripts developed a repartée that volleyed across panelists who endlessly quoted the quotations of each other. They offered asides that congratulated their own "formative" work or digressed temporarily into insecure hopes of being taken seriously. The performances of the V-Girls were enactments of institutional wannabes that simultaneously critiqued their own desires. In looking back at their work, we can thus find an instantiation of that insider/outsider position that institutional critique so often tries to inhabit. In the V-Girls, too, we see a turn to "acting" as a particular tool for inhabiting identificatory insides and skeptical outsides simultaneously. When the Jane of "Museum Highlights" said a line such as "I sincerely hope that I express my best qualities—as do we all, if I may say so. That's why we're here," her stylized longing echoed that of a V-Girl hoping for academic and aesthetic ratification.[39] The performance of such a line wears its heart on its institutional sleeve; its "acting out" is propelled by its "acting in" in which irony and earnestness collide. The torque and absorption might be better felt if the reader tries saying a line aloud herself, for such performed speech brings the classed aspirations of the institutional inhabitant tremulously proximate. In such speech, the full-throated expression of desire is felt in the same moment that it elicits doubt. It is in this sentient stylization of belief and distrust, aspiration and resistance, that "a new technique of acting" could theatricalize the practice of institutional critique.

The textual work of the V-Girls and Andrea Fraser's solo work greatly informed each other; and the "prim-suited-fresh-from-the-Sorbonne look" that C. Carr saw in the V-girls greatly informed the arch self-presentation of Fraser's early characters.[40] But if "acting" appears in *Museum Highlights* as a mechanism of institutional critique, it is also one that bears a strong relationship to a more specific technique of acting that tried to develop a critical function for the theatre. As already noted

120

above, Bertolt Brecht is the figure to whom theatre scholars turn for help in imagining such a function, one where the defamiliarization of the theatrical act simultaneously defamiliarizes the social acts of society. Coincident with the project of *Verfremdungseffekt*, Brecht and his fellow artists developed a "new technique of acting" that worked dialectically with the techniques of the epic theatre. His vocabulary produces an intriguing match with Fraser's practice. Like the epic actor, Fraser's stylized portrayal of Jane Castleton has "a definite *gest* of showing."[41] As a form of acting that "shows" more than "becomes" its character, that showing simultaneously partakes of the "historicized" mode that Brecht sought in his actors. "It is up to the actor to treat present-day events and modes of behaviour with the same detachment as the historian adopts with regard to those of the past." The goal of historicization is to estrange the naturalized habits of society—and we could say the naturalized habits of art institutions. "Characters and incidents from ordinary life, from our immediate surroundings, being familiar, strike us as more or less natural. Alienating them helps to make them seem remarkable to us."[42] Such characters are presented not as individual heroes with idiosyncratic foibles but as figures who exemplify and embody the contexts that produce them. In an attempt to de-autonomize individuated acting styles that produced individuated heroes, Brecht's actors were told to be narrators of their characters in the moment of their enactment. To perform as a Brechtian actor was to perform the context of one's character, emphasizing rather than smoothing over its contradictions. "These expressions of a *gest* are usually highly complicated and contradictory," he wrote, "and the actor must take care that in giving his image the necessary emphasis he does not lose anything, but emphasizes the entire complex."[43] This call to perform "the entire complex" thus offers a somewhat different theatrical precedent for what visual art historians now call "context art." Jane Castleton is, in many ways, epically realized, both in the quotation marks that appear in her text and the stylized citationality that seems to surround her self-presentation. At the same time, the placement of acting within a museum space un-used to such conventions is already a kind of de-familiarization. As Andrea/Jane moved across the museum, from the desk to its galleries, and through its apparatuses, the performance not only showed the seams of acting, but used gestic acting to show the seams of the art institution.

To place Fraser within a Brechtian frame is not only to posit influence (Fraser has read a great deal of Brecht throughout her career) but also to notice what comes forward when contemporary socio-political experimentation in one medium finds itself working in a tradition of socio-political experimentation in another medium. For Fraser, her

avowed influences were also other visual artists, the V-Girls, and the trenchant writings of Pierre Bourdieu on the "habitus" and "social field" of art. Indeed, much of Fraser's work can be seen as a performed enactment, sometimes literally, of texts such as *Distinction* and *Towards a Reflexive Sociology*. Interestingly, a link between Brecht and Fraser's brand of institutional critique comes forward in Pierre Bourdieu's take on her work, offered in prose that re-articulates the goals of *Verfremdungseffekt*:

> Fraser creates a genuine experimental situation: a provocation that challenges the existent itself, as when a museum's security apparatus is parodically described in the language of aesthetic analysis, or when the celebratory discourse surrounding the artwork is ironically evoked by a fake guided visit. . . . [S]he is able, like a sorcerer's apprentice, to trigger a social mechanism, a sort of *machine infernale* whose operation causes the hidden truth of social reality to reveal itself, exposing or calling up underlying power relationships and confronting human agents with an unblinking view of what they are doing.[44]

Notably, Bourdieu positions Fraser as an apprentice rather than as the sorcerer herself, showing what kind of angle of vision we gain by occupying the position of a supporting assistant who mediates between back and front stages. The motive of "causing a hidden truth to reveal itself" speaks to the Brechtian goal of "alienating the social gest underlying every incident" and indeed, the offer of "an unblinking view of what they are doing" shows naturalized acts in the process of being made remarkable.[45] As theatre scholar Elin Diamond elaborates:

> The gestic moment in a sense explains the play, but it also exceeds the play, opening it to the social and discursive ideologies that inform its production. Brecht says that the scene of the gestus "should be played as a piece of history."[46]

Diamond specifies further with the help of French theatre scholar Patrice Pavis: "Gestus makes visible (alienates) 'the class behind the individual, the critique behind the naïve object, the commentary behind the affirmation.' "[47]

Such a perspective offers an intriguing frame for reading some of the moves of Fraser's scripting techniques. If the docent is a key figure in the naïve affirmation of the art object, then a strategy of contradiction and transcontextualization makes explicit her ideological work. In front

of *The Birth of Venus* by Nicolas Poussin, the celebratory language of the *Introduction to the Philadelphia Museum of Art* gets a different hearing precisely because it is heard aloud in a public context: "Resplendently . . . amazingly flawless . . . sumptuous . . . This figure is among the finest and most beautiful creations . . . An image of exceptional rhythm and fluidity."[48] The excess of the description becomes hearable through *Verfremdungseffekt*, that is, when such textual material is placed in juxtaposition with an object it was not meant to describe. After performing rhapsodic quotations on Simon Vouet, Augustin Pajou, and Adam Weisweiler, Jane directs her tour's attention to a guard's stool in the corner of a gallery, saying: "In scale and complexity . . . the most ambitious undertaking . . . in the great European tradition . . . abundance and grace . . . free from time and change . . ."[49] Later, she will walk into a coat room and gesture toward a drinking foundation at the far end to quote: "'A work of astonishing economy and monumentality;' 'it boldly contrasts with the severe and highly stylized productions of this form . . . most ambitious and resolved.'"[50] The performance thus dynamizes the logic of the readymade. Whereas Duchamp called attention to the operation of the museum by putting a pedestal under the quotidian object, Fraser instead shows the art object's dependence upon performed action by redirecting the museological actions in the direction of the quotidian drinking fountain. Such moments show the exercise of transcontextualization at work, the relocation and juxtaposition of objects and texts that Brecht always hoped would de-naturalize their effects. Fraser's theatrical juxtaposition of unfamiliar object, text, and spoken style makes nonsense of these naturalized relations, mixing the large and the small, the familiar and unfamiliar in a kind of performed montage.

Andrea Fraser credits Pierre Bourdieu as an interlocutor who helped her not only to lodge a critique of the art institution but also to find her way into realizing that "the institution" could not be safely located outside of herself:

> *Distinction,* as a reproduction of Bourdieu's relational, reflexive sociology, also made it impossible for me to imagine symbolic domination as a force that exists somewhere out there, in particular, substantive, institutions or individuals or cultural forms or practices external to me as a social agent or as artist— however young and disempowered I may have felt.[51]

In her writing practice as a critic of institutional critique, this primary embeddedness is central to her historicization of its major artists. Her reading of Michael Asher is one of many examples: "What Asher thus

demonstrated is that the institution of art is not only 'institutionalized' in organizations like museum and objective in art objects. It is also internalized, embodied, and performed by people."[52] Fraser's definition of institutional critique argues for the simultaneity of identification and resistance; it is also one that posits an essentially recursive relationship between institutions and institutionalized selves:

> So if there is no outside for us, it is not because the institution is perfectly closed, or exists as an apparatus in a "totally administered society" or has grown all-encompassing in size and scope. It is because the institution is inside of us, and we can't get outside of ourselves.[53]

If her own primary embeddedness is key to Andrea Fraser's exploration of institutions, then it also might shed light on her decision to drop the Jane Castleton character for future performances. Henceforth, she decided to use her own name in self-presentation, thereby disallowing herself the modicum of personal safety that comes with playing a character in quotation marks. Indeed, the documentation of *Museum Highlights* also suggests that the character of "Jane" could have provided a safety net for the audience. Those on the tour watched as audiences amused and in the know. Those who were audience members to her excessive displays within a cafeteria watch with a degree of disgruntlement. Whether through the chortling smirk or the outraged rejection, both positions seem to bring with them a degree of dis-identifying protection, one that allows both performer and audience member to locate the institution outside. Henceforth, much of Fraser's future work would try to disallow a righteous critical position outside of institutional processes.

This is a moment to notice other discourses that Fraser has brought to bear on the institutional project, notably one that might trouble the certainty of a stable "truth" that Bourdieu saw coming from her work. Such troubling comes with the realization that the process of internalization is itself fraught and never fully legible to the subject who internalizes. Indeed, this is a moment to notice the role of psychoanalytic frames in the construction of Fraser's pieces, a brand of "psychoanalytic site-specificity" that joins the frames of both individuating and structural approaches to relational infrastructure. Fraser writes:

> Psychoanalysis largely determines my conception of those sites as sets of relations, although I think of those relations as social and economic as well as subjective. And psychoanalysis also

defines, largely what is for me both a practical and ethical imperative to work site-specifically.[54]

That statement is reproduced as the first excerpted text in her collected writings, one that follows a preface lamenting that the collection does not demonstrate the influence of Mary Kelly on her work as strongly as it does the influence of Haacke, Flavin, Buren, and other (male) artists. However, the feminist and psychoanalytic notion that institutional critique is simultaneously an exploration of subjectivity is keenly important for an artist who wanted to work within a tradition of "systemic procedures" "that Buchloh called administrative and Rosalind Krauss called obsessional."[55] The necessity of co-locating the structurally administrative and the psychically obsessional seems necessary for her brand of institutional critique—and indeed, further explicates the role of performance in both miming and intervening at the moment of interpellation. Looking contemporaneously at the wider conversation in social theory taking place in the 1990s, we find scholars updating Althusserian interpellation in various ways, whether through Anthony Giddens's theory of structuration, Pierre Bourdieu's plotting of habitus and field, Bruno Latour's actor-network theory, or the mutually constitutive relation between acts and social codes found in Judith Butler's productive repetitions. If the goal is, following Fraser's commentary on Michael Asher, to show how "institutionalization" is "internalized, embodied, and performed by people," then her new technique of acting alighted upon these fragile, recursive moments. Performance offered a medium for recognizing not only the insidedness of something that one would rather locate outside but also the role of repeat performance in the relational construction of persons and institutions. Within the intimacies and fleeting corporealities of a museum encounter, with its repeated gazes and repeated gestures, we find the embedded enactments of institutional reproduction. To turn to performance as an aesthetic form was thus to re-inhabit performance as a social form. It was to reveal the institution to be less an object than a process, less static than durational, less a sculpture than a drama. It was to re-enact the recursive, mutually productive formation of an institution in need of repetitive action on the part of social beings. The strategic re-performance of an institution revealed its apparently autonomous thingness to be dependent upon a heteronomous series of repeated actions.

Whether as Jane in *Museum Highlights* (1989), as other proxies that appeared in *May I Help You?* (1991), or as "Andrea" in both *Welcome to the Wadsworth* (1991) and later versions of *May I Help You?* (2005),

the use of a persona who performs her contextuality is also a technique that shows a psychic network of internalized relations to be fundamental to any notion of what context might mean. "Oh, I've known happiness, intense happiness, exquisite happiness, here in the museum, beside these tiles, or across the room from those or, or over here, between these two. It's nice to feel alive. I'd like to live like an art object," says Jane, enacting the degree to which the affiliation with an art institution can be seen in relation to a project of self-consolidation.[56] But here, and in later texts, there is also a degree of opacity as speakers lapse into non-sequiturs that betray gaps in a coherent identity project. In *Welcome to the Wadsworth*, Fraser announces herself as an invited artist to give a tour, and goes on to discuss the role of the Daughters of the American Revolution in its founding. Her uneasy implication in this infrastructural history comes forward when she says, "I'm a Daughter of the American Revolution. It's true. One of my ancestors was an aide to Lafayette."[57] Fraser's use of the 'I' pronoun becomes more complex as she performs identifications with the museum from a script patched from multiple citations: "I deserve peace and tranquility after a full day. I want a serene and simple, a secure and stable life. A better environment for children. The healthy and orderly life of a people with deeply rooted social and cultural traditions. . . ."[58] The complexity of this re-performance might come into view more when one imagines the kind of questioning that might go on when an audience member receives it. Are these her words? Or someone else's? Even if they are someone else's, does she really feel them, too? Do I feel them? Receivers tack between relative positions of safety and implication, especially when a monologue re-sounds the phrases and affects of an audience's own interior monologue, mimicking something that she might have felt: "I deserve peace and tranquility after a full day."

A widened brand of psychoanalytic site-specificity appears in the construction of Fraser's text for *May I Help You?* The script for this piece pulled from a variety of sources to replicate the identifications and disindentifications that accompany the experience of art. For *May I Help You?* artist Allan McCollum agreed to reinstall a selection of his monochrome *Plastic Surrogates* along three walls of a gallery (see Figure 4.4). Interestingly, McCollum described his original motivation for the *Plaster Surrogates* and the related *Surrogate Paintings* as a desire:

> to represent the way a painting "sits" in a system of objects . . .
> the goal was to make them function as props so that the gallery
> itself would become like a picture of a gallery by re-creating an
> art gallery as a stage set.[59]

In titling the piece with its interrogative question, "May I Help You?" Fraser isolated the interpellating speech act of the service–client relation. In a directorial choice that Martha Buskirk calls "performance by proxy,"[60] gallery worker-actors were instructed to deliver and re-deliver a 15-minute script culled from the archival voices of six different people representing six different social positions. Ranging from connoisseur to critic to a person who felt herself excluded from cultural institutions, the piece used this structure "not only to map a particular set of social positions, but also to perform the relations between them."[61] In the text, we would find a single body moving through various forms of comportment, vocal style, and mood. It showed the class identifications of one who experienced the museum's object relations within a history of familial object relations:

> When I go to a museum, like the Metropolitan, I feel right at home. This is how my mother hung her collections—but in a foyer, the dining room, the living room, the bed rooms, the guest rooms, the halls, in the bathrooms. . . . She had one of these in the bath.[62]

Figure 4.4 Andrea Fraser, *May I Help You?* (1991), in collaboration with Allan McCollum. First performed in February 1991 at the American Fine Arts Co., New York

Source: Courtesy of Andrea Fraser.

But other voices displayed anxiety:

> This is a fine piece of art, but it's not for me. I wouldn't know
> what to do with it. This kind of thing only means something
> to a particular type of person. Don't think I don't understand
> it. I understand it. I understand that it was *produced* to mystify
> me, that it was *produced* to exclude me.[63]

With these and other voices, no one in the prospective audience is fully exempt from implication.

By scripting in this way, Fraser created a relational structure that made institutional critique an interior as much as an exterior process. It was thus not so much a performance against the institution but a performance of institutional internalization, theoretically disallowing the spectator a position of secure disidentification from the institutional critique performed. The lack of complete legibility contributes to this effect. Jane wants to "be a work of art" at one moment; other lines are even more referentially ambiguous: "It's the top. It's a Waldorf Salad," says one interlocutor in *May I Help You?*[64] In such moments, Fraser's work does not present itself as stably secure in its understanding of the "hidden truth" of any infrastructural process. Rather, receivers' realization of "what in fact they are doing" is one that is likely to include moments of critical astonishment but also moments of critical opacity. As such, they constitute a form of psychoanalytic site-specificity that does not ever reach a securely counter-institutional conclusion.

Having chronicled the specificity of a form of acting in relation to institutional critique, it is worth noting that this particular brand of theatricality is somewhat unusual. Alexander Alberro comments upon how Fraser's monologues deviated from the work of some of her mentors—such as Louise Lawler—and offers a provocative reading of their non-cohesive effects along the way:

> But whereas Lawler usually makes herself invisible as an artist,
> Fraser's performances characteristically place her in a position
> of excess. Replicating the discourses of the museum, Fraser
> incorporates and inhabits the institutional role that she sets out
> to critique. Yet the intensity of her identification with the role
> produces a surplus of elements that in their extravagance dissolve
> the underlying ideological structure of that role and especially
> its function within the institution. The result is not unlike what
> Slavoj Žižek refers to in another content as a "radical de-
> identification," as the ideological elements that usually combine

to constitute a reality proliferate so excessively that they fail to be articulated and find themselves instead in an empty space, floating as unconnected series of gestures and phrases.[65]

The surplus of identification seems to come from a theatrical institutional critique that takes seriously the Heizenbergian role of the subject whose relation to the site can never be fully knowable to herself. As Fraser says, this is something any good analyst knows.

> Like psychoanalysis, as Freud put it, artistic interventions can only work effectively on relations made "actual and manifest" in a given situation ... And this is what makes institutional critique, like psychoanalysis, so profoundly difficult, because to intervene in relations in their enactment also always means *as you yourself participate in their enactment*, however self-consciously.[66]

It is perhaps the attempt to conduct this "difficult" work that prompts the language of excess and extravagance that we find in Alberro. It also prompts the more pejorative language that some critics have used in responding to Fraser's work, including a concern about her " 'late heroic' stance."[67] Such kinds of assessment seem to be the occupational hazard of having turned to performance in order to show an institution "performed by people." The decision to locate her "actual and manifest self" inside of her critique can be read as a narcissistic re-consolidation of artistic personhood rather than as a de-consolidation of institutional processes. That paradox seems to persist in the reception of arguably her most embedded of institutional art performances, *Untitled*. Here, Fraser sold a night of sexual encounter, a form of aesthetic enmeshment that easily flipped into the appearance of aesthetic aggrandizement to those who reviewed it.

Patricia Falguières has suggested that the performed speech of the actor might in fact be the most baffling register for visual artists and art critics:

> What the visual arts may have envied the theater was not its explosive outbursts of *furia* (a very old poetic concept)—art has always found vectors for its paroxysms. Rather, it was the fact that in theater speech declares space. Speech and not text: speech stripped of any ontological overview and returned to its condition as one sign amongst others that are set out in space on the stage.[68]

Andrea Fraser's mode of institutional critique is one that quite often incorporates theatrical speech, using its status as an index of personhood to dramatize the art institution's recursive construction of persons. Not every critic, however, would use the language of "envy" to describe the effects of being addressed by such speech and the effects of being located in its space. The puzzle for an institutionally critical theatre seems to reside in the middle of such expressions of envy and discomfort, longing and distaste. If a Brechtian frame is at all helpful in understanding Fraser's embedded form of institutional engagement, then it is one where the status of the speaking actor is subjected to new questions. Whereas Brecht argued that a critical consciousness would emerge when actors distanced themselves from their characters, Andrea Fraser's use of acting in a visual art space often feels all too proximate in its sentient and spoken re-enactments of institutional processes. While, by some accounts, the discourse and practice of institutional critique has exhausted its interrogation of arts management, the specificity of what it means to *stage* management is still under question.

William Pope.L's Good Works

At an exhibit at Yerba Buena Center for the Arts (YBCA) in the spring of 2007, William Pope.L's *Black Factory* "came to town." At the opening of "William Pope.L: The Black Factory and Other Good Works," YBCA's cavernous white spaces filled with people who moved through its galleries after securing a promotional Campari cocktail in the foyer. In its largest exhibiting space, *The Black Factory* had been disassembled and re-assembled both as an object display and as an interactive performance. *The Black Factory* was a traveling work, housed in a readymade truck that served simultaneously as the vehicle for the donation and distribution of "blackness." Real-time and on-line visitors to *The Black Factory* are asked to contribute objects that remind them of blackness (see Figure 4.5). Ranging from props that are the color black (e.g., sun glasses) to viscerally racist images (e.g., Step N Fetchit) to objects that invoke metonymically racist stereotypes (e.g., pink foam curlers), Pope.L's literalist gesture points up the metaphorizing politics of race more generally. *The Black Factory* made its way from town to town across the United States, stopping at various art organizations and community sites where it had been booked. Assistants managed the social interactions and inventories of the truck's contents. Often hired out of art school, these assistants/performers had rehearsed scripted scenarios developed with Pope.L, asking receivers why they assumed that the "Black Factory was about race" or asking them to narrate more specifically their sense

130

Figure 4.5 William Pope.L, Black Factory packed truck, from *The Black Factory* (2005), an interactive, mobile performance art installation. Large blue bag is igloo, red board dividing center of truck is igloo frame, red objects are steps, plastic tubs and cardboard boxes are packed along walls. Location: Lewiston, ME

Source: Photo by *BF* Crew.

Figure 4.6 William Pope.L, Black Factory street auction for local charity, from *The Black Factory* (2005), an interactive, mobile performance art installation, New York

Source: Photo by Lydia Grey.

of the social histories of the objects they donated or bought. Proceeds from the "selling" or parodic auctioning of the *BF*'s objects went to local community organizations selected in each city, a gesture that enacted and parodied an ethic of "good works" (see Figure 4.6).

To fit the extended social and material processes of *The Black Factory* within the walled structure of a gallery was something of an improbable task—if also something that visual art venues from the Tate Modern to Palais de Tokyo to the Guggenheim to nearly every biennial now regularly try to pull off. If some installations of relational work have had what Lynn Zelevansky calls a certain "lightness of touch and spirit" in their pleasant offers of ingestion and unencumbered conviviality, the relational practice of *The Black Factory* appeared relatively "heavy."[69] That heaviness could be found metaphorically in its racializing themes, though the trickster sensibility of the self-nominated "Friendliest Black Artist in America" might not have seemed serious enough for some. But what struck me upon entering the gallery space was the literal heaviness of materials scattered and suspended around the space. Fold-out tables—they could have been from a cafeteria or a YMCA—were distributed throughout the gallery and piled with objects: masks, black gloves, coffee beans, and "Free Angela" buttons mingled indiscreetly with penguin

figurines, Sun Ra CDs, canned food, and Aunt Jemima syrup bottles (see Figure 4.7). Under piles that confused categorical logic, each table was lined with textualized paper tablecloths that depicted the maps of different Black Factory cities: Jersey City, Rochester, Philadelphia. A routing to Cincinnati appeared beneath bundles of licorice, a black calculator, a *Lion King* poster, and bottles of sun tanning cream. A routing to St. Louis marked both a presenting venue and a local hotel, partially covered by piles of coal, vinyl records, a Confederate flag and stacks of *The Black Factory*'s signature rubber duckies. In St. Louis, *The Black Factory* map highlighted, too, the welfare offices of Places for People: "PfP is a non-profit agency offering a variety of support and rehabilitation services to adults with severe and persistent mental illness."[70] In Philadelphia, the maps highlighted a different helping organization: "Programs Employing People—PEP—is a private, non-profit agency

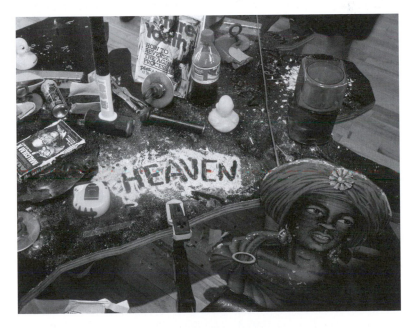

Figure 4.7 William Pope.L, Black Factory workshop table, from *The Black Factory* (2004), an interactive, mobile performance art installation. Pulverization workshop table with donated black objects, tools, *BF* products, and ground black beans with the word "heaven" written into them. The Interventionists: Art and the Social Sphere, MASS MoCA, North Adams, MA

Source: Photo by Arthur Evans.

that provides services to individuals with developmental and other disabilities."[71] In San Francisco, the welfare organization to whom *BF*'s proceeds were donated was another "private non-profit" called Helping Hand. As I lingered at each table of objects, I remember seeing Pope.L's assistant Lydia Grey talking to William and another *BF* worker on the side. "I'll fax you the rotation for getting to Amherst," she said. The language of rotation came up not only in Grey's coordinating conversation but also in the video documentation of *The Black Factory* projected in the space. There Pope.L characterized the *BF* as a "node in a series of rotations," re-purposing the language of network theory to track a process of assembly and disassembly in a linked series of acts that may or may not "do good." Even as the tables re-assembled and supported the display of the *BF*'s rotating objects, they also seemed overwhelmed by the load. Indeed, under the tables and on the sides of each wall, duffle bags were serially piled, filled with objects too numerous to fit onto the tables. More people entered and lingered somewhat bemused before the bags that seemed like they should have been removed from the exhibition space. The whole busy, preoccupied mood in the room conjured the feeling of a tech rehearsal; it combined a sense of anticipation with an awkward sense of lull. The aesthetics of blackness came forth as an aesthetics of the schlep.

If we follow his self-created chronology, William Pope.L has been making work since 1977 when he staged, at the age of 22, his first happening at Montclair State in New Jersey and formed a band called John Wayne.[72] Coming from a family that endured evictions, unemployment, alcoholism, and homelessness at various stages in his life, Pope.L mixed odd jobs with education, dropping out of the Pratt Institute when money was scarce, attending the Whitney Independent Study Program and Rutgers's Mason Gross School when money and loans were forthcoming. His practice has been a consistent mix of media and presentational display, ranging from painting-like text (*Vacationland*, 1991; *White Drawings*, 2000) to sculpture-like paintings (*Map of the World*, 2001), to performance-like installations (*How Much is That Nigger in the Window*, 1990, *Eating the Wall Street Journal*, 2000), to public billboards (*Distributing Martin*, 2001), to object-like endurance performances (*Eracism*, 1993, *The Black Body and Sport*, 1999, *The Great White Way*, 2002). He has received the Guggenheim, a Creative Capital grant, and famously had an NEA grant rescinded in the wake of the September 11th bombings of the World Trade Center. He is a central figure in ongoing discussions of black masculinity in art practice among a generation of critics and curators that includes (among others) Darby English, Huey Copeland, Renu Cappelli, Hamza Walker, Thelma

Golden, Mark Bessire, Nato Thompson, and René de Guzman, who curated the YBCA exhibit. Less remarked—and if remarked, less analyzed—is the fact that Pope.L taught playwrighting, avant-garde performance, and the performance of poetry in the Theatre and Rhetoric departments of Bates College for nearly two decades. Like many artists in the US, this academic affiliation has supported Pope.L's career artistically and provided health insurance along the way. In his largest retrospective catalogue, his final acknowledgements offer a "robust shout out to the Bates College Theatre Department," listing faculty members by name.[73]

Perhaps more than other African-American artists with whom he is aligned, Pope.L's practice dramatizes an anti-racist discourse of black disenfranchisement through the quotidian afflictions and quotidian bureaucracies within which that disenfranchisement is lived. His works invoke welfare offices and halfway houses, homeless shelters and battered women's shelters. His politics of blackness is often very clearly linked to a politics of class. In his attempt to create an aesthetics for what he calls a "subsistence imagination,"[74] the materials of his pieces revisit the food materials that filled his world of precarious consumption—hot dogs, Jell-O, white bread, mayonnaise, Pop Tarts, ketchup, and peanut butter. In *Map of the World*, hot dogs were nailed to a canvas. In *How Much is that Nigger in the Window*, he smeared mayonnaise over his body. Invoking but inverting the chocolate-smearing of Karen Finley's 1980s performances, he let the viscous whiteness of the mayonnaise fester on his skin into smelly translucence. The highly processed foods of the poor return in his artwork in various states of decay or, perhaps more disconcertingly, in improbable states of preservative-induced persistence. (De-materializing decomposition occurs more readily when the food is fresh.) In repurposing these condiments and snacks as materials, Pope.L extends the readymades of art's materials, but he also foregrounds the degree to which the food-on-the-side is re-centered as the main dish in the culinary practices of the disenfranchised. As Pope.L himself has written, "If God was a welfare mother he'd have to re-learn the lesson of doing something with nothing."[75] The root anxiety and material displacements of economic precarity are the ground from which his art emerges. "Have-not-ness permeates everything I do," he said at one point.[76] And at another point, he expressed the anxiety in a phrasing that was uncharacteristically straightforward. "I can't stand an empty cupboard. I think it's immoral. At bottom, I think it's scary and lonely."[77] Perhaps Pope.L's most famously truncated phrasing of the psychic and material effects of black disenfranchisement comes in his characterization of "Blackness as a lack worth of having." His wordplay joins a history

of painterly reflection on color, an economic discourse of precarity, and a psychic discourse of subjectivity into a single fulsome phrase. His self-nomination as "The Friendliest Black Artist in America" pushes the irony further. It is a persona that compensates for and works within the decidedly unfriendly mechanisms of America's racist welfare system, one where "friendliness" is a character attribute that stereotypically distinguishes the undeserving from the "deserving poor."

While Darby English acknowledges the importance of institutional critique as a frame for interpreting Pope.L's work, the discursive connections have been developed less clearly. This might have to do with the fact that Pope.L's practice cannot be neatly placed within the "from-Minimalism-to-institutional critique" progressions that chart the generational development of IC practice. Perhaps the most resonant connection to institutional critique is also one that brings forth the role of performance in its dramaturgy of unveiling. In 1978, before he had finished his MFA from Rutgers, Pope.L positioned himself on a Chelsea sidewalk in New York, just outside the Castelli and Sonnabend galleries. Seated yogi style on a yellow cloth, he arranged two bottles of Thunderbird, a can of Coca Cola, a bottle of Wild Irish Rose, eyeglasses, and a cup that could have been for drinking or for pan-handling. He surrounded himself and his assembly with a circle of strewn matches. *Thunderbird Immolation* joined the body of the black artist to the signature props of urban degradation. As Kristine Stiles chronicles, "Out of place in the center for the white international art trade, Pope.L represented himself as the quintessential crazy street person who is bad for business."[78] Pope.L never drank from any of the liquids, remaining still for as long as possible before security guards were called to have him removed. Stiles helpfully unearths the political economy behind the liquid that bore the title:

Gallo had created [Thunderbird] especially for inner city blacks whose habits of mixing large quantities of 40 proof port with sugar and lemon juice was the inspiration for its taste. Aimed to become the "Campbell Soup of the wine industry" Gallo sold some 2.5 million cases of Thunderbird in its first year of production. Ernest Gallo, who had capitalized on its extremely lucrative market, also delighted in telling the story of how he would drive through skid row neighborhoods, spot someone on the sidewalk, roll down his windows, and call out: "What's the word?" The immediate answer came back: "Thunderbird."[79]

In many ways, Pope.L's performance made use of the object-oriented, presence-based, strategies of experimental performance as developed by

Fluxus and other art movements in the decade preceding it. In this case, however, the quotidian props and tranquil poses of "experimentation in the everyday" were explicitly politicized without Pope.L needing to make any overt effort at theatrical contextualization. By positioning his highly marked presence within the gallery district, he not only reinhabited a stereotypical figure of black homelessness; he also provoked a question about the relation between such a figure and the art institutions just across the sidewalk:

> Superficially, Pope.L's action drew attention to a schism between diametrically opposed "types" of urban dwellers, particularly between poor black and the predominantly nonblack, relatively well-to-do traffickers in SoHo galleries dominated by the higher arts of painting and sculpture. As an artist who could claim membership in both groups, however, Pope.L was positioned to reconfigure the separation between these populations as a function of connection, even interdependence.[80]

If *Thunderbird Immolation* underscored the interdependent relation between art and art institutions, then that sense of inter-relationality only deepened and widened when Pope.L imagined inter-scalic connections between art and the institutions of welfare, housing, and public health with which he was all-too familiar. "In *Singing*, for example. the artist performed at a men's shelter on 3rd Street between 2nd and 3rd Avenue in New York close to where his family lived and where several family members probably were housed or participated in programs."[81] His aunt stayed at "the women's shelter nearby." Thinking about the context of this environment, Pope.L observed:

> Whereas the women's shelter was always quiet, the men's shelter was a real hangout. Every guy would sit on picnic tables in the courtyard and talk aloud and share information about where to get food, clothing, a drink . . . the men's shelter could be a raucous site. A site of laughter. A site of violence. *Singing* brought the show to the show, if you will. It was the overplaying of mirth against a backdrop of greed, need, and struggle.[82]

In *Singing* and in most of his subsequent work, the objects of Pope.L's embedded institutional critique are often institutional systems related to welfare, housing, and food. Once again, there is an "original theatricality" in the techniques used by Pope.L in his systemic exposures. Bringing the "show to the show" underscores a theatricality that is already present

in the social welfare processes, including a place such as the 3rd Street men's shelter.

In some ways, the goals of institutional critique are both met and challenged in Pope.L's continual thematization of his life as an artist in an environment that considered such a career choice an economic luxury for a black, working-class male. He suggested as much in his written contribution to *The Interventionists*, the catalogue edited by Nato Thompson who curated a large-scale exhibit on socially engaged art under the same name. There, in lieu of a traditional "artist statement" on *The Black Factory*, he decided to talk about everyday practices of survival: "during a mite chunk of the '80s, I made my way doing construction work, or what I liked to call construction work."[83] In a Minimalist art context that fetishized the authentic specificity of manual and industrial labor, the story of construction labor calls the bluff of the metaphor. Telling us that he found his first construction job from "an experimental theatre buddy," we are fleetingly reminded of how often such work—along with the restaurant industry—has supported the intermittent lives of artists (something made explicit in the Obie-award winning work of Marty Pottenger who, as another person who appears in Pope.L's acknowledgements, could have been the "buddy" in question). In Pope.L's elaboration, the flexibility that such work offered was countered by the new risks it brought in its wake:

> Started out as a laborer. Hauling things. In time, became a taper. I made the seams between things disappear . . . the name of the company I worked for—Merlin . . . I fell off the ladder and landed right on my knees like I was Mary or Joseph or one of the disciples. Yes, I was praying 'cause I knew I didn't have any insurance . . . Merlin treated its employees like its buildings. Each was expendable and individual. Each functioned as it own "company." They said this was to protect us so we would pay less tax. In fact, it was only in the best interest of Merlin because it meant they could avoid paying our health insurance, worker's compensation, etc. . . . It is difficult to succeed as an artist in our country today if you are not willing to look the other way—even if only for a little while.[84]

Pope.L's eventual decision to stop supporting himself through construction was a self-conscious attempt to strike a different balance of risk and flexibility—as well as a desire to stop being the one who made the seams disappear. He quit construction the same year that his mother quit drinking and went into rehab. The continual attempt to manage

personal and professional claims appears graphically in Pope.L's presentation of his "chronology," divided as it is between three categories "Life" "Work" and "Times." The word "Work" denotes art-making where exhibits, performances, and grant successes are listed; "Life," on the other hand, is a roomier category filled with personal relationships, family trials, odd jobs and day jobs. Life is thus a social and intimate space but also a place where labor is done for money, not for Work. Life both supports the making of Work and gets in the way of making it, too, an artist's counter-definition of what human resources managers call the Life/Work balance. While "Work" seems to continue at all times throughout his chronology, the category of Life is quite often qualified with only one word: "Nothing." That redefinition of a Work/Life balance was differently struck when Pope.L moved to Maine to teach theatre at Bates College. In addition to regular coursework, he directed university theatre such as Lorraine Hansberry's *A Raisin in the Sun* at Bates, a task that is categorized in the hum-drum category of Life. Interestingly, though, a production of contemporary playwright Suzan-Lori Parks's *The Death of the Last Black Man in the Whole Entire World* is one episode of Bates college theatre employment that makes it into the category of Work.[85]

While the specificity of ongoing theatrical employment is rarely emphasized in artworld accounts of Pope.L, the registers of performance have often been used to characterize a portion of his varied practice. "Using all elements that make up a performance (text or plan, actor, space, spectators, and the social circumstances)," writes English, "these works seek to collapse the context into the formal, thereby invalidating their separation in order to make what Pope.L calls 'fresh culture.' "[86] At the same time, his work does not always neatly fit within performance art's signature frames. When invited to participate in an exhibition and colloquium called "Live" at the Tate Modern, for example, William Pope.L's presence was most notable for its willed incoherence. Throughout the days of the colloquium and performance enactments, he spoke only in gibberish. As if refusing any logic that would have linked Liveness with authenticity, the illegibility of Pope.L's presence created questions in lieu of embodied certainties. His written contribution to the impressive catalogue of the "Live" exhibit partook of a kind of sense-making, albeit one that seemed to deviate from some of the catalogue's critical frames. Calling it "Sandwich Lecture #8," Pope.L's text did not focus on the apparent relational dynamics of body art but instead on the relational and political dynamics of food consumption. By offering a meandering account of the sandwich, Pope.L dodged "liveness" as a critical frame in order to provoke reflection on different ones; "I'm after

the mixed signal," he says.[87] In fact, the theorization of "liveness" became more pointed and politicized by the Sandwich Lecture's economic reference to hunger and sustenance, that is, to the process of staying alive.

If, as Andrea Fraser would have it, one of the developing conundra of institutional critique involves the attempt to join a complex theory of subjectivity to an equally complex critique of material environment, then food is a medium that makes this pivot and integration possible for Pope.L. Foodstuffs are medium-expanding materials that stretch and crumble, plop and splatter; they can be spread and sprinkled, sculpted and made vulnerable to processes of decay. But foodstuffs also lie at the center of poverty discourse; a recognition of the ineluctability of hunger might question the utility of siting food inside an art project. Food is also one of the few everyday materials that travel betwixt and between humans and their exterior world. A psychoanalytic history of oral fixations tells us that such bodily processes are central to subject formation. In its swallowing and its dispelling, food mediates between inside and outside, precariously defining while simultaneously violating the boundaries that divide self and world. The contingency of those boundaries thus comes to the fore when food exceeds its conventional placement as well as when food is withdrawn. "Lack of material is not Lack of immaterial," says Pope.L, as if responding to critiques of his practice. "Lack of form is not necessarily absence of structure."[88] By underscoring the psychic in the same moment that he underscores the economic contingencies of this "lack worth having," Pope.L constructs his own brand of "psychoanalytic site-specificity."

William Pope.L's inter-scalic practice expands the subjective micro-intimacies of the abject realm even as it tracks the subject's internalization of the macro-asymmetries of the economic realm. To suggest as much is also to follow Renu Cappelli's lead in joining Pope.L's practice to Neil Smith's discourse of "jumping scales."[89] At the unwieldy juncture where the corporeal scale mutually instantiates the urban scale, we find another series of Pope.L performances, namely the "crawls" that have received some of the most rich and baffled critical attention to date. The crawls are endurance performances that have taken several forms in cities ranging from Budapest to Berlin to Madrid to New York. In *Tompkins Square Crawl* and *The Great White Way*, he propelled himself on his hands and knees through block after New York City block. Sited within Manhattan environments noted for their fraught politics of gentrification, this durational site-specific performance attempted to provoke larger systemic conversations. Donning business suits in one and a Superman costume in the other that parodied the aspirations of a model minority,

Pope.L's endurance performances—and their documented responses—have been positioned as provocations in an ongoing debate on gentrification and homelessness in an urban environment. The block-by-block journeys ask a repeated question about the proper place of a black male body, both on a social ladder and in an urban dwelling. Once again, not-have-ness—in this case homelessness—is both biography and art material for Pope.L. "All my life, landlords had a great impact on the geographical fate of my family. My mother's motto was: when you move, you lose. And we moved a lot. . . . The idea that home and hearth could be something other than one thing after another, and that one thing after another might not just be a puddle, was a radical idea to me."[90] The serial repetition of limb after limb across the sidewalk replicates the seriality of eviction for the perpetually placeless, once again politicizing inherited aesthetic forms by transforming Donald Judd's "one thing after another" into an enforced diaspora. Darby English also reads into these crawls a provocation to interdependent imagining between those who are homeless and those who encounter them:

> [The] crawls offer the housed an invitation to suspend the social-institutional reproduction of the homeless as the dormant images of a lamentable condition, and to image a different, indeed integral kind of relationship with them, for we are all productive units in the same general economy.[91]

The crawls occupy a space shared by other artists such as Krzystof Wodiscko, Michael Rakowitz, or Cardboard Citizens whose traveling structures explore the "un-sited" condition of homelessness.

But what also intrigues me about the systemic provocations of Pope.L's crawls are the different ways we can account both for his techniques and their effects. When art historians and curators have read Pope.L in relation to a gallery practice, the durationality of the action comes to the fore. Performance scholar André Lepecki, on the other hand, measures Pope.L's distance from dance, calling his "crawls" and other street performances "parachoreographic." Pope.L is of particular use for Lepecki in a project that tracks the "exhaustion" of dance, that is, the ways in which certain choreographic practices have contested the hyper-kinetic fixation on movement that animates the dance medium. That kineticism usually lies at the basis of an analogy between dance and politics. Dance as action and motion serves as a metaphor for the actions and motions of political engagement. For Lepecki, a fixation on kinetic excess is a symptom of modernity, not a force against it—hence his interest in finding choreographic work that takes the tempo down, that

introduces a degree of cessation in a *mise-en-scène* where movement is normative. Whether or not Lepecki gives equal attention to the modernist preoccupations with "contemplation" that elevate static art forms in an equally entrenched modernist agenda, the notion that the medium of dance could be undone via the medium of something like sculpture offers a provocative lens. In the case of William Pope.L, in particular, the vocabulary for interpreting the street action is particularly resonant. Whereas Darby English, Nato Thompson, or Mark Bessire might call such "crawls" and street performances "actions" or "interventions," Lepecki focuses instead on the stalls and stutters of the gesture, theorizing their "stumble" and the "clumsy temporality" as blockages within a naturalized durationality.[92] This difference in emphasis evinces a difference in the medium-specific conventions with which critics gauge a work's innovation. When read para-optically, Pope.L acts; but when read para-choreographically, Pope.L stumbles.

In many ways, such unwieldy differences in media and perception also help us to understand the contingencies of creating, curating, and documenting a project such as *The Black Factory* that opened this section. As a project that combined in unorthodox ways the multiple dimensions of performance—"text or plan, actor, space, spectators, and the social circumstances"—as well as props, lights, image, and gesture, *The Black Factory* is a curatorial conundrum. To curate the relational medium of performance means using the object-oriented conventions of the museum to create structures for interactions whose outcomes one cannot always foresee. The fragility of this kind of exchange is something to which Pope.L alludes when he speaks of audience relations as he learned to appreciate them in the domains of theatre and music performance:

> I like audience. I like giving good audience. I like people. My appreciation comes more from my background in theater and rock bands than from being in the art world . . . I also respect and fear the audience. . . . I see my relation to the audience as a kind of dance in which I must be sensitive to the ebb and flow of the choreography. This choreography is collaboration. No one owns it. Its nature is mutually influencing. Bridges must be built and burnt viscerally.[93]

The paradox of creating this choreographic space that "no one owns," however, is that it still requires all varieties of material labor to come into being. That requirement was on show in the duffle bags of objects that documented "rotations" at YBCA. It was also apparent in other forms of project documentation of the friendliest black artist in his own

catalogue and in its appearance among the Interventionists at Mass-MOCA. The documentation of *The Black Factory* exists not only in photographs and video but also in projective and retrospective diagrams, blueprints, and floor plans that try to index movement, materiality, and inter-relationality. Diagrams and floor plans for *The Black Factory* as an exhibition site, as a social service, as a moving shelter appear on lined yellow paper, with measurements of walls made to scale and with keys created that distinguish graphics representing infrastructure (e.g., "Shelving,"), the placement of laboring bodies (e.g., "Worker"), and mechanisms for managing ocular display (e.g., "Curtain," "Closed Circuit Monitor," and "Camera").[94] More diagrams and lists also concern themselves with design construction and the environmental factors of human habitation; in one documentation of a to-do list for the construction of *The Black Factory*, Pope.L's notes include "Ventilation, Heat Building Codes?, Lighting, Shipping Containers (Build), Installing Manual (Photo), Paper Shredders, Clip Lights (Display Lights)."[95] Varieties of contingencies had to be plotted to anticipate the infrastructural requirements for a relational exchange. Such contingencies compounded in the organization of the tour, the "rotations" across cities and states that stopped at local community service agencies and experimental art organizations. By the time *The Black Factory* came to my hometown of San Francisco, Pope.L had decided it would be one of its last appearances. Even with Lydia Grey's help, he had developed "ulcers" and headaches from the overwhelming task of getting the project to move. The material encumbrances of the "good works" of *The Black Factory* had, like any endurance performance, exhausted the capacities of the performers who supported it.[96]

5

TECH SUPPORT

Labor in the Global Theatres of The Builders Association and Rimini Protokoll

Co-dependency, we know to our cost, does not necessarily mean mutual aid or agreement on much.

T. J. Clark[1]

Hi, I'm in Bangalore, (but I can't say so.)

Quote in *The New York Times*[2]

To join The Builders Association (TBA) and Rimini Protokoll is to engage the work of two artist groups that have figured prominently in contemporary discussions of post-dramatic theatre. This is to say that The Builders Association and Rimini Protokoll innovate within the theatrical frame even as they trouble it. It is also to say that, unlike some of the other socially engaged, cross-disciplinary artists addressed so far in this book, these are both groups whose aesthetic "measures its distance" from theatrical practice.[3] As such they also rely on professional theatrical networks to support their experimentation. While the specificities of their practice will unfold as I continue, TBA and Rimini Protokoll are productive interlocutors for a number of reasons. In similar and different ways, they challenge conventions of theatrical presentation while simultaneously re-connecting us with the fundamental elements and fundamental capacities of the medium. While they make use of the proscenium stage, they often use the techniques of other forms—site-specific installation, sculpture, architecture, and video—to expand or redistribute the effects of theatrical engagement. Additionally, they both respond in intriguing ways to the changing social landscape brought on by new technologies, whether by incorporating those technologies into the medium of enactment or by offering counter-spaces that anachronistically—and hence provocatively—return us to the low-tech space of

personal encounter. Finally, these are both international companies whose work thematizes and formalizes issues of internationalism. Both companies navigate the politics and logistics of being international touring artists in their modes of address and in the ways that they organize their labor. And, in moves that trouble distinctions between form and content, both companies also incorporate issues of international politics into the structure of their work, whether engaging post-national structures of feeling in a changing European Union or in plotting the economic asymmetries of northern and southern hemispheres in a globalizing world. Both The Builders Association and Rimini Protokoll explore the position of workers within globalizing networks driven by the affective labor of a service economy, asking what kinds of materials are still needed to motor this presumably "immaterial" sphere.

My goal here is to use The Builders Association and Rimini Protokoll as indexes in a larger conversation that considers the role of the theatrical medium in a so-called age of globalization. The work of these two companies—one based in North America, the other in Europe—can by no means capture all of the twists and turns in such a discussion. They do, however, offer an opportunity to think about globalization and theatre in relation to the central questions of this book, that is, to consider how twenty-first century humans imagine their relation to larger systems of support, labor, and human welfare. Often, a globalizing world of digital connection seems to have done away with terrestrial systems of labor and support. Rather than the under-mounted "base" of industrial labor imagined in vertical Marxist visions of social organization, humans are now connected electronically and even wirelessly in laterally networked relationships. With the "loose ties" of a network replacing hierarchical social systems, citizens are presumably freer to move; we can make connections and drop them; we can transfer money without ever seeing cash; we can initiate new collaborations without ever meeting our collaborators in real time. In such a changing context, theorists of globalization also speculate that our concepts of work have changed as well. The hyper-material labor of a Marxist base has also been replaced by the mobilization of what Hardt and Negri call "immaterial labor," whether taking shape in the exchange of information or in the "affective" offering of compassion, care, excitement, and hospitality—in Hardt and Negri's terms—"a feeling of ease, well-being, satisfaction, excitement, or passion"—in a growing service economy.[4] Overall, then, the digitally networked world of immaterial work presents itself as a kind of friction-less space, one where economic exchange seems to bypass the gravitational and referential pulls of economic power, one where labor seems no longer to leave any material trace of its enactment.

Importantly, such images of a friction-free world have been compli-
cated and qualified by those who think precisely about how they
actually work. Saskia Sassen argues that the global marketplace remains
"embedded" in the material infrastructures of cities and citizens who
animate them. "Emphasizing place in a complex global economy,"
she says, "is one way to address what I see as the need to destabilise the
accepted dominant narratives and explanations of globalisation."[5] For
Sassen, global exchange, no matter how electronically "diffused" and
"dispersed" will still always require its "territorial moment."[6] Similarly,
Hardt and Negri argue that a so-called immaterial sphere is still
dependent upon material labor whether or not we notice it.

> Immaterial labor almost always mixes with material forms of
> labor: health care workers, for example, perform affective,
> cognitive and linguistic tasks together with material ones, such
> as cleaning bedpans and changing bandages. The labor involved
> in all immaterial production, we should emphasize, remains
> material—it involves our bodies and brains as all labor does.
> What is immaterial is *its product.*[7]

For those who study theatre history or work in the theatrical field, this
kind of simultaneity has an intriguing ring. Indeed, long before we began
to speak of globalization, the laborers of the theatre could be found
engaging in all kinds of material production to create an immaterial product.
Mobilizing the resources of bodies, space, and the props of the object
world, theatre artists have been in the business of creating affective spaces
of "ease, well-being, satisfaction, excitement, or passion" that have left
little material trace. It is precisely because of this long-standing conjunction
—one where performance can stand in both for the encumbering and
embedded realm of material making as well as the ephemeral realm of
motion and affect—that theatre seems a prime place to investigate the
paradoxes of globalized connection. If an unfettered mediascape of
electronic connection currently predominates in our social imagining, then
the anachronistic materiality of theatre can be a reminder that such a world
still needs a human body to change its bandages. In The Builders
Association's and Rimini Protokoll's use of a contingent theatrical medium,
we find them illuminating the contingencies of this "living infrastructure."[8]

Even as I hope to find a kind of productive anachronism in theatrical
responses to contemporary global themes, it is also the case that con-
temporary theatres such as The Builders Association and Rimini Protokoll
have had to "modernize" their and our sense of what politically engaged
theatre might mean. In fact, explicitly political theatre has worked
throughout the twentieth century to emphasize the material apparatus

behind both aesthetic events and social subjects. For Bertolt Brecht and for generations of artists and critics who have interpreted him, political engagement came about in a context that announced theatre's formal dependence upon its material apparatus of production. As Brecht and his contemporaries puzzled over the exploitation of labor, the mystification of the commodity, and the equitable re-organization of society, he felt that such critical reflection could occur only in a theatre that had relinquished its own illusory tricks. The construction of society could be explored only in a theatrical environment that avowed and exposed its own processes of artistic construction. Today, artists and critics think regularly about what if anything a Brechtian theatre offers our contemporary moment. Put another way, we think continually about what "post-Brechtianism" means for a post-dramatic theatre, one where—as Hans-Thies Lehmann writes—the "post" never denotes complete rejection but always exists in productive tension with precedents and histories.

One way of framing the conditions of a globalizing post-Brechtian theatre might actually involve reckoning with changes in contemporary social discourse, perhaps asking to what degree post-Brechtianism can be analogized to a globalizing post-Marxism. What if, for example, we go back to the metaphors, truth values, and central assumptions of a certain kind of Marxist imagining. And then we think about their redefinition by generations of thinkers who sought to unsettle its determining vision, questioning the hierarchies that would give an authenticating finality to the "base" realm of labor and necessity, opposing it to the superstructural illusions of representation and ideology. For Ernesto Laclau and Chantal Mouffe—the thinkers whose work prompted the coining of the term "post-Marxist"—such a task meant rejecting any social model that would give structural primacy to any single dimension of a socio-psychic system. Indeed, even in Louis Althusser's attempts to offer Marxism a complex theory of psychonanalytic subjectivity, Laclau and Mouffe find him overly stabilizing the nature of the exchange by invoking a final "determination in the last instance by the economy." "If society has a last instance which determines its laws of motion," they worry about Althusser's paradigm, "then *the relations between the overdetermined instances and the last instance must be conceived in terms of simple, one-directional determination by the latter*" (their emphasis).[9] This "last instance," whether imagined temporally in terms of finality or spatially as an undermounted operation, thus short-circuits our ability to plot relational exchange and contradiction across multiple registers of the social. Laclau and Mouffe reject the notion that social formation is uni-directionally determined by a fixed realm of necessity or an immovable conception of "the base." They also use the concept of "hegemony" to complicate Marxist visions of an ideological,

super-structural realm of false consciousness, in order to dramatize the complex psychic enmeshment of selves within institutions that they seek to contest. Intriguingly, their language echoes that of an aesthetic discourse preoccupied too with unsettling divisions between art and apparatus, sculpture and base, foreground and background, inside and outside. Here are Laclau and Mouffe again:

> Here we arrive at a decisive point in our argument. The incomplete character of every totality necessarily leads us to abandon, as a terrain of analysis, the premise of "society" as a sutured and self-defined totality. "Society" is not a valid object of discourse. There is no single underlying principle fixing— and hence constituting—the whole field of differences. The irresoluble interiority/exteriority tension is the condition of any social practice: necessity only exists as a partial limitation of the field of contingency.[10]

While it could never be said that Brecht bought into a fixed vision of society's supporting apparatus, it can be said that his theatre labored under a determining vision of labor. Theatre's "exterior" processes backstage bore an analogy to the real, authenticating realm of necessity that theoretically was both hidden from and necessary to the operations of illusion. But if a post-Marxist vision is, in part, about antagonizing the values and reality effects given to certain "underlying principles," then a post-Brechtian theatre might also ask what it means to imagine material necessity—not as given, foundational, or determining "in the last instance" but as a "partial limitation on the field of contingency." A twenty-first century post-Brechtianism would also be skeptical of any theatre that imagined itself outside or uncorrupted by the social structures it tried to question.

Such an orientation qualifies and complicates the weight that any critic might give to either material or immaterial registers that we find in contemporary society—and that we find indexed in its contemporary theatre. Arguably, the structures of feeling that celebrate a friction-free digital world of immaterial connection need to be reminded of the material labor such a world requires. At the same time, a post-Brechtian theatre that takes seriously post-Marxist revisions will have to be careful of giving such material registers—whether imagined in bodies, in economies, in necessities, or in "territorial moments"—a structurally determining place. Such reflection is an important check on my own tendencies to give the material operations of support a certain kind of determining value. To engage in a post-Brechtian exposure of the

apparatus of support is, in fact, not simply to show "reality" behind "representation" but to find in that exposure evidence of their intimate and ever-shifting co-imbrication. The Builders Association and Rimini Protokoll provide an opportunity to think about the materiality of immaterial labor at the same moment that they animate the material sphere with the contingent dynamics of theatrical representation. The networked worlds they dramatize have by no means done away with the claims of necessity, but they are not uni-directionally determined by them either. The backstage of labor and technology is not the "exterior" real but in irresoluble tension with the interiority of the aesthetic event, an irresolution that is, to echo Laclau and Mouffe above, "the condition of any social practice." In the analog realm of theatrical analogy, we find stagings that show the limiting conditions of what we used to call the base.

The Builders Association

Seated in rows before a proscenium stage, it suddenly seems as if we are here to watch a video . . . or maybe a video game. A panoply of kaleidoscopic squares move in and around a video screen, forming grids that constantly change, their internal patterns lining up to form new symmetrical decorations. The images dance to the steady beat of techno-music, and more shapes zoom and unravel to form new arrangements of luminous, multi-colored eye candy. Columns of rectangles slide in from the side with the sound of a whoosh, changing pattern sequentially as if opening a series of doors. Large digitized squares descend from the sky and land with a synthesized plop on top of each other, eventually forming the blocked landscape of what seems to be a city street. As the techno beat continues, the iconography of LED advertising appears inside of the blocks that form stores, signs, and billboards; digitized buses and taxis pass through the screened proscenium. In their pixilated luster, the digitized screens of global consumer culture advertise international clothing chains, telecommunication conglomerates, and athletic equipment. Under the banner of Virgin Atlantic, a small grid of squares appears in rows that would be "thumbnail" if this was a computer screen; the rows form shelf after shelf of CDs for sale. The synthesized whooshes, plops, and kerchunks continue, mimicking the soundscape of a search on a high-end website. Suddenly, a mailbox, a phone booth, and a fire hydrant slide onto the set together; they get there—not by means of a gurney, a trap, a sliding stage, or a run crew, but as electronically mediated objects riding the transit systems of a video software program. Human characters begin to appear throughout this opening sequence,

though we realize that they are—like the fire hydrant—digitally rendered figures moving through the *mise-en-scène*. By the same means, a vendor's food cart drops from the sky with a synthesized crash.

One human character, however, walks onto the stage supported by the embodied medium of a live actor; in so doing, she also clears a three-dimensional set space in front of the video-screen's two-dimensionality. She is speaking into a cell phone headset in a not fully locatable cosmopolitan accent. "I love karaoke," she says to a friend on the wireless line. "It's like magic. You can be anything you want. You just have to find the right song." She goes on to confirm a rendezvous with her friend in Las Vegas at the newly refurbished "Aladdin Hotel" when she switches off to make another call. Her solicitous tone changes to a demanding one as she speaks with a car rental operator named "Monica." She bristles at what she decides is a slow and unclear response to her request for a rental reservation: "Don't you speak English?" she asks of the unseen Monica. "Where are you from?" She berates Monica— whom, we will learn later, is trying to avoid the lilting tones of a South Asian accent—blaming her for the fact that a car cannot be found quickly enough. "Well, this is obviously going to take longer than I thought. I'll have to call you back." She immediately takes another call from a friend in Hong Kong, speaking in Mandarin about their travel plans with Anglophone references to "Las Vegas" and "package deal" interspersed. And then another call comes in from a boyfriend. She tells him that she is in a "permanent state of jet lag," and then apologizes for being interrupted by the noise of a bus that has just stopped next to her. The digitized bus "leaves," and the conversation continues.

This opening scene from *Alladeen* represents in miniature the unfettered space of possibility afforded by global travel and global technologies. Its imagery and its soundscape mimics that of the web, the sense of "choice," "presence," "movement," "possibility" that Tara McPherson argues "structure a sense of causality . . . structuring a mobilized liveness which we come to feel we invoke and impact, in the instant, in the click, reload."[11] We seem to have complete freedom of movement in an uploadable world. If we have come to feel that this "volitional mobility"[12] is a condition of contemporary existence, this scene from *Alladeen* also suggests the fragile frictions of wires, cables, broadband, planes, cars, buses, and laborers on which that apparently friction-free world relies. The 2003 production of *Alladeen* was the seventh project created by the loose network of actors, designers, writers, and technical and assistant directors called The Builders Association, incorporated in 1994 by Marianne Weems, who has directed all of their productions. They named themselves while creating their first production

of Henrik Ibsen's *The Master Builder* (1993) in an illegal New York loft above what was then a dilapidated Chelsea food market. As the Builders Association has become one of the twenty-first century's most celebrated new media theatre companies, the anachronistic associations associated with the labor of "building" continue to animate their interventions into mediascapes where, it would seem, material labor is no longer required. Each of their eleven projects—from *Jump Cut/Faust* (1996) through *Extravaganza* (2001) and onto *Supervision* (2005)—is the result of two-year collaborations with company members and a variety of artists and designers, working through performance, video, architecture, sound, and text to integrate live performance and new media technologies. The Builders Association has worked in collaboration with media and architectural artists such as Diller + Scofidio, London's motiroti, and dbox, and they have created their innovative performance technologies with leading centers for new technologies, including the STEIM Foundation in Amsterdam and the National Center for Supercomputing Applications at the University of Illinois in Champaign-Urbana. They have received national and international awards and grants and presented at prestigious venues throughout North America, Asia, Australia, and Western and Eastern Europe.

The standard way of framing The Builders Association is as a company that combines "new media" and "theatrical" forms. Many forms of theatre use new media and screen technologies—including Disney musicals. The Builders' brand of new media theatre, however, more directly announces an interest in grappling with the effects of new technology by staging those new technologies themselves. "I'm not interested in the stage apart from the screen," says Weems. "We all spend a good portion of our day in front of one whether it's a computer, TV, or movie and this affects the way we see the world."[13] The Builders' work thus walks a line walked by many late twentieth-century artists who find themselves enmeshed within the social and technological forces they simultaneously critique. On the face of it, these two different domains—"new media" and "theatre"—also index a difference between "new" and "old" aesthetic domains. In both media and theatre criticism, these new/old connotations appear as some proponents celebrate the technological reinvention of the theatrical *mise-en-scène* while others lambaste the cheap techno-thrills of new media. New technologies are, of course, rarely cheap in the economic sense; indeed, criticism of new media art often derives from its supposed collusion with multi-billion capitalist industries that count on the new in new media to sustain the illusion of "growth" in economic growth. Of course, whether one is a researcher, theatre-maker, a citizen who mourns "the way we were" or

one who welcomes "the way we live now," the reification of the new in new media forgets the dependence of newness on relational contexts that define it as such. This, to exemplify the argument, is not a new point. It is a point made now repeatedly in collections and colloquia that address issues of media and technology in our culture, sometimes fighting the facile connotations of newness, other times surrendering to a collective, ill-defined sense that we all basically know "new" when we see it. It is a point made by Wendy Hui Kyong Chun in her introduction to *New Media, Old Media: A History and Theory Reader* when she echoes Slavoj Žižek's essay "Did Someone Say Totalitarianism?" with a question of her own "Did Somebody Say New Media?" Both words serve, says Chun:

> as an ideological antioxidant, taming free radicals in order to help the social body maintain its politico-ideological good health. . . . Although new media is clearly different from totalitarianism, it too can function as a stopgap. The moment one accepts new media, one is firmly located within a technological progressivism that thrives on obsolescence and that prevents active thinking about technology-knowledge-power.[14]

Invoking Descartes' early speculations on "the passionate state of wonder or surprise" that underpins the perception of the new, Chun laments uses of the term that seeks to "dispel surprise or to create it *before* an actual encounter."[15] The label of the new thus too often forecloses the possibility of wonder, domesticating the *most recent* as much as it constructs the obsolescence of the less so. The new is not a surprise so much as it is a brand.

Such a state of affairs threatens both to excite and to foreclose an analysis of The Builders Association. TBA's association with "new" technology, for instance, threatens to elide their relationship to a variety of "older" media histories. Artistic Director Marianne Weems's seven-year turn as the dramaturg for The Wooster Group—and producer of Ron Vawter' *Roy Cohn/Jack Smith* (1994)—is better known in late twentieth-century theatrical histories of influence. Less emphasized and just as significant, however, is Weems's eight-year turn as a member of the V-Girls, a feminist critical art group that was aligned with the origin stories of "institutional critique" in visual art history. This is one of many moments when the history of this "new media" company turns out to be joined to the media histories of the visual arts. Another cross-arts confluence comes when we recognize the significance of architectural

Figure 5.1 The Builders Association, *Master Builder* set (1994). Directed by Marianne Weems. Set design by John Cleater

Source: Photo courtesy of Marianne Weems and The Builders Association.

discourse and practice in their work. TBA's preoccupation with the doing and undoing of space has remained consistent whether one looks at their very first project—which located Ibsen's *The Master Builder* (1994) in a Gordon Matta-Clark-inspired set (see Figure 5.1)—their fifth—with Diller + Scofidio's digitally rendered stage in *Jet Lag* (1998)—or their eleventh—with the distributed windows of a digitally network space in *Continuous City* (2007). The tendency to homogenize these and other artistic genealogies under the rubric of "new media" can both obscure influences and rob us of a certain critical traction. In the last decade, dozens of reviews have celebrated them as "the future of theatre," an appeal to futurity whose calibrations of old and new made TBA artists extremely uncomfortable. Interestingly, reviews that are negative about their work criticize them in almost exactly the same terms, lamenting their collusion with a "future" of new technology that leaves the tradition of theatre behind. Alisa Solomon summarizes such a pro-theatrical, anti-technology discourse:

> Live performance is dying, lamenters have been saying for a century at least. Strangled by the more alluring glitz of ever

153

expanding technology. First it was radio, then the motion picture, then TV, and now the "digital age" that have been blamed for mesmerizing audiences and drawing them away from the finer forms of the drama, thus depriving spectators of the communal, even mystical, powers of theatrical presence. In this alarmed discourse, technology is always the enemy of the theater, an all-consuming colonizer of the superior art form.[16]

What the anti-technological impulses do not incorporate, of course, is theatre's long history of technological incorporation and cross-medium redefinition. Theatre and technology have always been in a constant state of mutual transformation, whether one imagines that cross-media relation in bodily systems for blocking a scene, in mechanical systems for transforming a scene, or in incandescent systems for lighting it.

In *Alladeen*, those bodily, mechanical, and incandescent systems re-appeared in new form, under the glowing lights of an LED billboard connected wirelessly to the fluorescent-lit space of a call center operation in Bangalore. After the opening scene of the multi-tasking global citizen on her cell phone, the stage switches to a Call Center company in Bangalore where "Monica" and her colleagues are being trained. Weems, working in collaboration with Keith Khan and Ali Zaidi of the UK-based arts group motiroti, traveled to Bangalore to conduct interviews with trainers and trainees at several call center operations, including 24/7 Customer.com whose "multi-channel, outsourced solutions deliver twice the quality of other alternatives at a lower cost."[17] In video-taped interviews, a trainer spoke directly into the camera about her attempts to "hire people without any mother tongue influences. . . . [I]f there are any dialectical or mother tongue influences, we do our best to neutralize it [*sic*]." The scene then switches to documentation of a vocal training session in Bangalore that is simultaneously re-enacted by actors on the stage. A white US-accented male trainer stands next to a trainee who is trying to pronounce US capitals; in the video and onstage, the trainer and trainer-actor stop the student and student-actor as they refine syllables and consonants for "Santa Fe, New Mexico . . . Santa Fe . . . Albany, New York, Albany, New York . . . try this: Albany . . . Albany, New York." As they move down the list in US geography, the trainer and trainer-actor both tell the student not to rush, and offer encouragement by saying there was "great energy . . . a lot of juices there . . . a lot of juice."

As with so much of their work, *Alladeen* shows TBA using the tropes of acting ("great energy")—and the long-standing anxieties about the Real that acting provokes—to trouble conventional assumptions about the reality effects of performance. With the live actors taking on the

personae of those who take on a persona juxtaposed with the video-taped documentations of laborers who also take on a persona when they do their job, *Alladeen*'s mediascaped stage offers a distributed network whose "original" performance is projected and deflected. Later, we will see documentation of interviews with the operators themselves, describing the difficulty of "getting the accent come what may" as well as their training in Western—more often American—popular culture. The stage shows re-enactments of more video documentation—of training sessions on the rules of "baseball" and the love lives of television celebrities. In restaging the performance training of the service industry, the piece thus also re-stages the unequal ground on which this circuit of mimicry occurs, one where cross-cultural training in pronunciation and popular culture occurs in one direction. This space of cosmopolitan mimicry occurs in an asymmetrical zone that compels certain performances, de-localizing the Indian site of the call center in order to address a global citizen who wants to hear the language and accent tones of the highly local site of the United States. The goal of the fictional call center represented onstage, like the nonfictional 24/7 Customer.com documented in video, is to create a system of tech support whose service is not interrupted by the jarring tones of an Other local context—and the accompanying psychic awareness of global dependency that would come if a privileged caller decided to ask "where are you from?"

In many ways, *Alladeen* represented a new take on The Builders Association's longstanding interest in the position of labor—labor as process, labor as enactment, labor as expression, labor as task, labor as supporting apparatus, labor as an "underlying principle" that could be differently distributed through theatrical processes and mediascapes. For example, the 1993 decision to place *Master Builder* inside the "splitting" house of Gordon Matta-Clark was in part an attempt to explore the affect of building through a process of un-building, that is, through an "anarchitectural" theatre. Matta-Clark's durational and anarchitectural pieces famously "split" or "cut" into architectural spaces in ways that opened up different perspectives on rooms, re-calibrating the perceived boundaries between and within them. In the "Splitting" of an abandoned New Jersey house at "322 Humphrey Street" (1974), Matta-Clark cut the structure in half, passing "through all/structural surfaces" and "beveling down/forty lineal feet/of cinder blocks/to set half the building on its foundations."[18] Weems's and *Master Builder*'s "set designer," architect John Cleater, pored over photographic documentation of the event that showed just how much the split equalized spatial elements that are usually differentiated. The cutting released a one-inch blade of light through drywall, a window frame, a door, a floorboard, and a

supporting wall, showing that they were all equally vulnerable. The light created new quadrants within single rooms and, in turn, opened previously bounded rooms so that they were now visible to each other. Meanwhile, the pervasive sense of vulnerability and the unorthodox blade of light seemed to obliterate structural hierarchies and categories that would separate frame from window, floor from ceiling, door from wall, inside from outside. The foundational role of the foundation was unhinged by a blade of light that noticed no difference between cinder block and plaster molding. It was this sense of un-building that Weems hoped to cultivate in a reconstructed adaptation of Ibsen, where the steady unhinging of a home coincided with the play's expressed longings for kinship and meaningful work. John Cleater designed a set whose "rooms" were precariously separated by walls that would be dismantled over the duration of the production. Master carpenter Joel Cichowski built the set. And, as if to further complicate the categorical division that would have placed master carpentry in the exterior backstage, Weems decided to place this builder in front of it. Every production of *Master Builder* would begin with a monologue from Joel, who presented each tool on his workbench with a no-nonsense description of the creative capacities of each. Anticipating the testimonies of the call center operators, it was the first time that the presentation of a laboring life challenged the theatrical frame and, with that gesture, the inside/outside boundaries of their theatrical space.

If both society and the theatre are dependent upon the labor of builders, then *Alladeen* offered an expanded exploration of who those builders were in the twenty-first century. The global management of labor was one of the central themes of *Alladeen*, especially at a time when a rise in "information" and "affective labor" drives the development of service economies. When beginning research in 2001 for a piece that would explore the employment practices of the call center industry, citizens and audiences were only just beginning to recognize the role of off-shore labor in a global economy, including call service industries where companies found that they could cheaply hire an educated Indian work force to field calls for technical support, international travel, catalogue shopping, and other forms of telephonic personal service. The article that first triggered the idea for *Alladeen* appeared in the *The New York Times* on March 21, 2001. "Hi, I'm in Bangalore," the title read, "(but I can't say so.)"[19] The text dramatized acts of international mimicry that supported global transaction:

> Ms. Suman's fluent English and broad vowels would pass muster in the stands at Wrigley Field. In case her callers ask personal

questions, Ms. Suman has conjured up a fictional American life, with parents Bob and Ann, brother Mark, and a made-up business degree from the university of Illinois. "We watch a lot of 'Friends' and 'Ally McBeal' to learn the right phrases."[20]

As the article went on to describe the rise of the "offshore" customer service industry, it quoted successful company founders who happily proclaimed: "India is on its way to being the back office for the world." Weems collected more articles about the offshoring of the service industries whose titles—such as, "Can I Help You?"—could have been a service art piece by fellow V-Girl Andrea Fraser. Exploring how jobs migrated from the US to India, articles discussed how a 24-hour industry allowed regions across the world to take advantage of their difference from the US time zones.

In creating a piece about the call center industry, TBA thus sought to de-mystify a form of labor that at the time went largely unregistered by the consumers who depended upon it. Performance turned out to be fundamental to the mystification process within these service industries— and fundamental to TBA's act of de-mystification as well. As TBA and motiroti artists learned in interviews, performance-based techniques of vocal training and rehearsal trained service workers to neutralize their biographical locality, creating a seamless service context whose human territorial specificity went unregistered by its clients. Builder actors thus set about researching what it "felt" like to be trying to make others "feel good." They began to make lists of typical scenarios of economic and emotion management where customers try to "get help for an inexplicably complex problem" or "seek the wrong product" or "try to get something for free." They then made lists of "What the operators do (response strategies): try to help, try to make the customer happy, placate, falsely compliment, end the call, deflect, bring caller back to the business of the call, offer alternative solutions, offer bargain discounts . . ."[21] From there, TBA actors created improvisations and scenarios of affective labor, casting themselves as individuals responsible for maintaining "emotions of ease, hospitality, excitement, and frustration."[22] For *Alladeen* to show call center training systems was thus to reveal the affective process by which the mystification of service occurred. It was to use the hyperbolic capacities of theatrical performance to show up the unregistered capacities of everyday performance, exposing the new "base" supporting global citizenship or, more precisely, the lateralized, mimetic, and dynamic set of social interactions that sustain global personhood.

TBA had already begun a longer conversation on the precarious place of humans within technological systems that purported to collapse global

temporalities. In part, these discussions came about in response to their own experiences as artists on an international presenting circuit. After *Master Builder*, their shows *Imperial Motel/Faust* (1996) and *Jump Cut/Faust* (1997–1998) received attention and support from artistic directors and theatre festivals outside of their native United States. Hence, the maintenance of the company and of their lives as artists depended upon a willingness to move from theatre festival to arts festival, across European, Asian, and North American cities. "We were in airports all the time," remembers Weems.[23] Company members tried to maintain their energy as performers while being in a constant state of jet lag themselves. The corporeal effects of international travel were thus something that they regularly felt in their own lives as what performer Moe Angelos humorously called "migrant cultural workers."[24] This theme would receive specific attention in their production of *Jet Lag* with Diller + Scofidio in 1998. Inspired by Paul Virilio's philosophizing on "speed" in contemporary culture, the company dramatized one of Virilio's signature examples where a real-life grandmother, Sarah Krasnoff, traveled back and forth across the Atlantic dozens of times with her grandson, reportedly dying of jet lag. The story was paired with that of Donald Crowhurst, a man who created false documentation of himself valiantly crossing the sea in a sailboat. Joining two stories of unproductive motion and unrestful stasis, *Jet Lag* used but also resisted the normative time-based conventions of theatre to ask audiences what it meant to travel, at what speed, and at what cost. It was another project in which Weems found herself working with architects to create a set design. Collaborating with renowned conceptual architects Diller + Scofidio, the theatrical process of rehearsal and the architectural process of the *charrette* mutually transformed each other. Digital architecture's rendering systems were themselves projected as the story's backdrop, creating images of airplane seating and airport lobbies that simulated three dimensions while actors moved beside and within them. Here was another chiasmic revision of the time-space conventions of visual architecture and of theatre. The theatrical bodies dynamized the flatness of architectural rendering while, conversely, the CAD-ification of the *mise-en-scène* seemed to render the theatre space static. In so doing, it exemplified what Hans-Thies Lehmann calls a "post-dramatic" turn away from normative "action" and toward "states," or the creation of an encounter that approached the condition of viewing a "static painting" that simultaneously wanted to move.[25]

Interestingly, this kind of aesthetic reflection on movement and stasis had its parallel in the social theory on globalization that Weems began reading in preparation for *Alladeen*. Consider, for instance, a

passage she underlined in an interview with Pico Iyer, the author of
The Global Soul:

> I begin deliberately with those dizzying surfaces and
> passageways—movement, an inundation of data, which I think
> reflects how the world is today—and you have to fight your
> way through it to get to the stillness and the settledness and
> the space that begins to open up in those last two chapters.
> The first chapters make you almost jet-lagged, there's so much
> information that you can't tell right from left, east from west.
> In part, the book is about the passage from speed to slowness
> and surface to depth. To me, that's the big challenge in the
> global era. The need for stillness, for seceding from that world,
> is greater than ever.[26]

As a former dramaturg with The Wooster Group, the formal concerns
around non-narrative stasis in post-dramatic theatre were quite familiar
to Weems. After *Jet Lag* and with *Alladeen*, Weems began to find that
such formal questions could be joined to social content, especially in a
globalizing landscape that was confounding perceptions of speed and
slowness, proximity and distance. Like *Jet Leg*, *Alladeen* was thus another
attempt to expose the mundane territory and vulnerable bodies at the
center of a world that promised friction-free connection and high-
velocity travel.

After presenting scrims and screens that documented training
programs with their simultaneous re-enactment onstage, *Alladeen*
continued by showing a call center in action (see Figure 5.2). Projected
screens were raised, not to reveal another digitally lush panel but instead
to reveal a cast of actor-laborers, working in real-time and shared space
to sustain the illusion of a frictionless technological world. They navigated
calls whose scripts would have sounded all too familiar to audience
members who had recently booked a flight or made a call to tech
support. The actor-laborers quite literally appeared as this production's
"base," undermounted below a screen of extended communication
that showed global maps and tracked time zones, and provided updates
on US news. Here, laborers struggled to keep the Mother tongue
at bay and to engage clients with their new abridged knowledge of
American popular culture. In making reservations, operators spelled out
names: "H as in Harry Potter, J as in J-Lo . . ." One operator with the
fictive name "Rachel" attempted to be geographically responsive when
talking to a client located in San Jose—"Oh chilly today, sir?" but, the
attempts at hyper-familiarity could also risk a misfire. "Terrible about

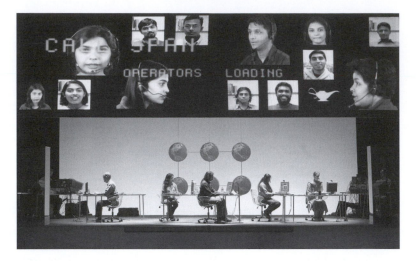

Figure 5.2 The Builders Association, *Alladeen* set (1999–2007), The Builders
Association and motiroti, directed by Marianne Weems, conceived
by Keith Khan, Marianne Weems, and Ali Zaidi

Source: Courtesy of Marianne Weems and The Builders Association.

that elephant," she continued, reading about an animal rights case from
a live West Coast newsfeed as she worked. "What?" asked the caller.
"The elephant who was abused," she anxiously responded, "oh . . . oh
perhaps you did not read about it yet," she said, embarrassed by her
overloaded knowledge of geo-trivia. As the scene proceeds, Monica
receives a call from someone attempting to fly to Boston and then back
to "Philly"; "Fiji?" Monica tries to confirm. Phoebe receives a disoriented
call from someone trying to drive from Los Angeles to Las Vegas; she
frantically tries to offer cartographical advice, "follow this street the 15
in Los Angeles, and you take it all the way, you are going to hit this
desert, now you can't miss it, because there is nothing there." As she
speaks, more screens with maps, translations, and popular references
appear and move across the stage space. The screens promise cross-global
informational exchange; meanwhile, a transnational workforce rushes to
keep up with the promise. The stagescape is a constantly changing
composition of images, sounds, and embodied actors whose actions seem
to trigger each other in a percolating network of screens, speech, and
gesture, re-positioning referents for the real and the illusory, the client
and the customer, the remote and the proximate.

So what, finally, do we make of a cross-arts form that incorporates
new media technology in the space of the theatre? As noted above, the

mix of theatrical screenscapes is often celebrated and critiqued in the same terms—terms that welcome or worry about the transformation of the theatrical realm by new technologies. Some reviews have accused The Builders Association of reification, of producing an eye candy that distracts from the social message. In response to *Alladeen*, for instance, Jennifer Parker-Starbuck worried that "the humour and gorgeous visual production mask an underlying critique of what it means to live as the workers or how it feels . . . to serve, American interests."[27] For her:

> the gloss of the production, in effect, reperforms the central act of capitalism, the forced erasure of visible labor in the production of the commodity. While the playbill lists all of those involved in the production . . . the technological wizardry stands out not for the human production of it, but for its own slickness as commodifiable/commodied theatre.[28]

The work of a non-profit theatre seeking to expose the human labor behind the production of service commodities can thus be read by some as re-performing "the central act of capitalism." The possibility of this kind of reading is of course ironic, given the aspirations of the performance, but might also be the occupational hazard of any post-Brechtian theatre that performs our enmeshment within the technologies it exposes. It is telling then that, in the same review that Parker-Starbuck expressed this concern, she also voiced a recognition of her own embeddedness:

> During much of the piece, I thought back to many of the recent calls I had received—did I perceive an Indian accent? How many times did a caller try to relate to the weather in New York, or say something about the sightseeing possibilities? Later I learned that many other audience members were processing similar thoughts!

What seems interesting about this moment is that it provoked in Parker-Starbuck, and apparently in other audience members, a momentary self-consciousness of their systemic interdependency in the midst of an apparently independent interaction—receiving a phone call. It was a moment when the apparent autonomy of global technology was revealed, however momentarily, to be fettered by a system of global dependency.

Some of the concerns about TBA's theatrical re-use of technology are coming from those of us in theatre who see the inclusion of the wireless phone, the broadband network, and the digital screen as a flattening of

the theatre, a way of rendering theatre a frictionless pool of visual pleasure. But what if we invert the gesture and decide also to see these hybrid pieces as a means of fettering the spaces of the wireless, broadband, and the digital image with the frictions of performance? *Alladeen* is not only a digital intervention in the space of theatre, but, just as interestingly, a theatrical intervention in the space of the digital. Consider, for instance, Margo Jefferson's sense of the set of *Alladeen* as "like a giant computer that supplies verbal information and visual distraction."[29] As a giant computer with a "set" underneath, the naturalized world of computers, digital images, and web searches are fitfully stalled by the social labor required to "support" the goings-on of the screen. If McPherson is right in suggesting that our contemporary experience of the web screen is that of "volitional mobility," then the contingent lives and terrestrial specificity of a call center shows the precarity of our sense of volition and our sense of movement.[30] Staging technology here has visual, temporal, and social dimensions, de-familiarizing the visual, temporal, and social habituations that go unregistered in the course of depending upon it. Staging technology means experiencing it at a different temporality than the temporality to which we have become habituated when the technology (usually) works. It means seeing the technology within a larger systemic dependency that is usually foreclosed and disavowed in the moment of its use.

Finally, it seems significant that The Builders Association takes on the questions of global technology in a theatrical space, one whose genealogies are located in time-space contingencies that are not simply pre-digital but arguably pre-industrial. This is to say that they juxtapose an apparently unfettered, though occasionally pixilated world of electronic connection, with the highly fettered space of the theatre, a space where the actor onstage was obligated to show up at a certain time. It is also a space where audience members could not upload their attendance; they had to plan with foresight to buy a ticket, get the right train or to find a parking place in order to be there. To think about digital connection in performance is to juxtapose the apparently non-contingent world of the digital with the avowedly contingent dimensions of performance, all to expose the supporting actions that produce the experience of seamlessness. As it turns out, the digital world cannot do without the analog any more than the immaterial economies can do without the materiality of servicing bodies. There is then a juxtaposition between the apparent autonomy of globalizing technology and the inconvenient heteronomy of the theatre. This might be a more precise way of framing the conjunction between certain forms of performance and certain forms of technology; "new media theatre" might be most

interesting for its juxtaposition of the apparently unencumbered next to the avowedly encumbered, a combination that is not always captured when we use the language of live/mediated or real/electronic to characterize the conjunction of performance and technology. This juxtaposition of what Marianne Weems calls "New Media for Old Theatre" seems to be a particularly intriguing match between media form and social issues. *Alladeen* shows the bodily and sonic cultural training required to sustain a call center in Bangalore. Its scenes juxtapose the travel plans of the most entitled global citizens with the occupational obstacles of those who are less so. Its stage images juxtapose the screens and sounds of global connection with the bodies of workers whose headphones support digital connection. Through this particular conjunction of performance and technology, *Alladeen* asks us to ask ourselves to what extent inconvenience can ever be "offshored."

Rimini Protokoll

In the fall of 2008, I entered the large atrium-topped space of Paris's Centquatre with my mom and kids. Still then only partially rehabbed, this cavernous former market greets visitors with an expanse of square footage where stalls might once have stood. Now, its public planes and sequestered storage sites house a variety of large studio and exhibit spaces where experimental videos are installed, where twenty-first century social sculptures provoke, and where France's hottest experimental directors conduct laboratory rehearsals for their upcoming productions. We dropped in on a video installation that was already running, letting it end and then staying so that we could see the beginning we had missed. We explored an exhibit of plants and dirt somewhat ambiguously displayed in the middle of the structure, and we played with a *maquette* of Centquatre installed low on the ground to accommodate the reach of a child.

The delivery system of such experimental art was one that still made use of a traditional form of museological encounter; that is, as long as we arrived between the hours of 10h and 18h, we could drop in at any time, encumbered only by the fact that other people might have decided to drop in as well, perhaps blocking a view temporarily or taking all the seats on the benches. While moving through these pieces, however, I was conscious that my mother and I each needed to be vigilant about parallel time/space contingencies, for in fact each of us had an "appointment" to see another work of art in a sequestered space of Centquatre. We metro-ed up to the 19th arrondissement to experience the Paris iteration of Rimini Protokoll's *Call Cutta in a Box*; posted

signs indicated that we were to go to the back of the building and find our way through a glassed-off entrance to the administrative wing of Centquatre. My appointment was at 16h30; my mother's at 17h. We each took turns playing with my children while the other went in. The one-to-one form would allow us both to experience a piece of theatre on the same day—if not at the same time, in the same space—without having to arrange for a babysitter.

When it was my turn, I went up the stairs to what seemed to be the offices of Centquatre curators, entering a small space whose lighting, white paint, desk, lamp, phone, chair, plant, and singular window could have supported the labor of most any type of white-collar worker. A phone rang, and I answered it. A woman on the other end of the line began talking to me in a chatty, friendly voice. She said that she was located in a call center in India and was also sitting next to French-speaking colleagues who would be selected to talk to most of the Centquatre's visitors. She told me about her country, its geography, and its cuisine. She told me what flavors of tea she liked best and managed—remotely, which is to say magically—to turn on a pot of hot water so that I could make a cup for myself. She told me about the powders, spices, and flours she used in her cooking, and about caste structures and social structures. Even though she was a call-center operator, she told me, she still had a maid at home. At different points, she asked more about me—which is to say she asked more of me. She asked what kind of animal I would like to be (and psychoanalyzed my answer). She asked me to sing her a song, asked me to draw a picture of what I thought she might look like. As I drew my picture (with as little exoticization as possible), and as I offered asides here and there about the inequities of the call center industry, I found myself trying not to get *caught* by this performance. She then asked me to lift the plant on the side of my desk, again magically knowing from afar each prop in my intensely localized space. Moving the plant opened a camera into video chat on my office's computer. I waved to my interlocutor and she waved to me, showing me the lineup of Formica desks and computer screens in the call center space. Her colleagues waved too, lit up by fluorescent lights in a part of the world where night had already come.

For Rimini Protokoll, *Call Cutta in a Box* is a form of "global theatre," and it is indeed a global expansion of certain theatrical fundamentals even as it is simultaneously a retraction of others (see Figure 5.3). Contrasting a call center industry that seeks to maximize efficiency with the highly inefficient relation of a "theatre for one," *Call Cutta in a Box* personalized an anonymous global exchange while, at the same time, showing the process of personalization to be ridden with

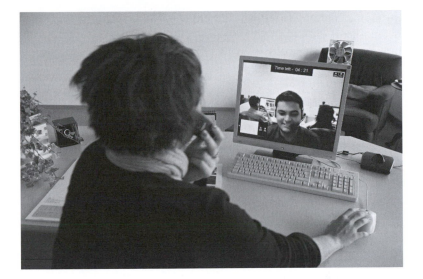

Figure 5.3 Rimini Protokoll, *Call Cutta in a Box* (2008–2010), directed by Helgard Haug, Stefan Kaegi and Daniel Wetzel, simultaneous premiere on February 4, 2008 at the Willy-Brandt-Haus in Berlin, at the Schauspielhaus Zurich, and at the National Theater in Mannheim. Pictured: Alexandra Lauck in the Willy-Brandt-Haus in Berlin

Source: Photo by Barbara Braun.

cliché and stereotype. Like many of their collaborations—with hospice residents, air crash victims, politicians, or truck drivers—this piece is a "real world" engagement, this time with the personal lives and asymmetrical relations of a globalized call center industry. As discussed in relation to *Alladeen* above, interaction with a call center worker on the other side of the world is often a regular dimension of white-collar work as it unfolds in white office cubes. This performance reproduced that relation, but this time with its direction powered by someone other than the client. Instead of talking about my computer problems or arranging a flight for me, we talked about personal and cultural topics that are usually evacuated from a call-center script. Though we know that operators are usually encouraged not to mention anything about their geographical location at all, the Rimini Protokoll performer relocalized the friction-less global conversation. I found out later that my mother's interaction with a different call center actor followed a similar template, though in her case, the biographical conversation seemed to go farther as my mom learned that her interlocutor had a graduate degree in English literature; when on video chat, she showed

my mother a photo of her two-year old son. Her interlocutor also asked my mother if she had any regrets in her life; my mom said that she did not. Because the casualty of many post-colonial global art experiments is that those who "know to go" are also "in the know," it seemed that she—who did not know what to expect—had the more interesting experience; indeed, my mother let herself get caught. She un-self-consciously talked with her interlocutor about how well she could understand her accent. And the next day, my mother found herself thinking a bit more about the question of regrets; she spoke of an episode from thirty years ago that she would have handled differently. She had never told me this before. For an intense moment, a call center's act of self-localization provoked us to re-localize ourselves. As a kind of alternate interpellation, it was both co-present and delayed, an uncannily personalized impersonal exchange.

Rimini Protokoll is the name given to and by its three founding artists—Helgard Haug, Stefan Kaegi, and Daniel Wetzel—who met each other as students of Applied Theatre Science at Giessen University in Germany. Founded by Andrzej Wirth and Heiner Müller as an artistic laboratory within a Germany university setting, Giessen's version of "applied" theatre-making was notably experimental, evading the industry-based and commercially driven versions of practical theatre-making found in many Anglo-Saxon theatre departments. It is no wonder that former Giessen professor and scholar Hans-Thies Lehmann cites his years at Giessen as formative for the development of his study of post-dramatic theatre, and no wonder that Rimini Protokoll is prominently featured there as exemplary of a new post-dramatic generation. Haug, Kaegi, and Wetzel have collaborated together, in pairs, and separately to conceive a variety of both commissioned and touring projects throughout Germany, Switzerland, France, Greece, Belgium, Poland, India, Brazil, Argentina, and elsewhere. While the themes and presenting mechanisms vary, their work is distinguished by their techniques for incorporating "real people" within the structure of a piece. Situated within a wider practice of Theater der Zeit, Rimini Protokoll artists create pieces based on the lives and desires of found individuals, coordinating pieces that feature the extraordinary contours of their ordinary lives. *Airport Kids* gathered children of diplomats, refugees, and other traveling youngsters whose nomadic existence prompted stories of abandonment and unexpected connection. *Karl Marx: Das Kapital, Erster Band* assembles a cast of committed readers of Karl Marx to present their interpretations, often finding new cast members and hence offering new scripts in each European city to which it has toured. *Mnemopark* created a large media theatre piece based on the preoccupations of model train

builders, tracking through videos and stories performed by them in real time of their delicate and nearly obsessional creations of diminutive worlds and systems. In these and other pieces, Rimini Protokoll artists call their non-professional performers "experts" or "specialists," figures whose unique angle on the world makes the label "amateur" inappropriate for these actors.[31] *Wallenstein* was a rare instance where a work was based on an existent dramatic play, but this mounting of Schiller's text incorporated German politicians as performing experts who shared stories of their trials and foibles.

Rimini Protokoll has been booked at international theatre festivals where it is framed as "documentary theatre," a designation with a wide set of connotations in contexts of political theatre. Thomas Irmer places it within a longer history of documentary theatre in Germany that makes clear the different stakes and methods of the contemporary scene in which it works. He argues that there are three periods of documentary theatre in Germany, beginning with Piscator's innovations around the new documentary capabilities of film in the 1920s and changing in the era of the 1960s with the revolutionary goals and epistemological certainties of Peter Weiss. For Weiss and others mobilized against the mendacious legacies of Nazism, the value of documentary theatre lied in its will to truth:

> The documentary theatre [was] only possible if it exists as an organized political working collective that has studied sociology and is capable of scientific analysis based on a large archive. [. . .] The documentary theatre stands for the alternative that reality, however inscrutable it may make itself appear to be, can be explained in every detail.[32]

For Irmer, the 1990s had brought auteur-directors' projects that were often more skeptical about documentary appeals to the "real." Instead, they were "critical of historical or sociological knowledge-making, exploring history as an open project that could not be known through accepted principles and ideas."[33] If a 1968 context was secure in using the truth telling capacities of documentary—and equally secure in isolating its enemies in history and in political institutions—contemporary documentary theatre has become less clear about the truth referents in documentary. It is equally unsettled about whether corrupting forces of power can be safely located in a past history or in alien institutions external to the theatrical act itself. Here is Irmer at length:

> Documentary theatre in its present incarnation in Germany exists in new forms and attracts a younger audience that may

have studied Weiss's manifesto with both admiration and reservation. . . . New German documentary theatre explores the phenomena of the present through an elaborate understanding of media culture, the theory of deconstruction, and forms of theatre that are not primarily based on text. There is also a new perspective on what can be a valuable document for the theatre—be it something that has not had historical assessment because it is too contemporary and/or has only just come to light through the artist's own research. Source material might be from either primary or secondary nonfictional sources; new German documentary theatre tends not to distinguish between these different types of material.[34]

This kind of theatrically specific history of recalibration thus parallels other art and intellectual contexts that began to grapple with the epistemological, political, and historiographical assumptions of social engagement. Much as Andrea Fraser and other practitioners of institutional critique found themselves—also in the nineties—unable to locate institutional power exterior to their own subjectivity, post-Brechtian theatrical groups such as Rimini Protokoll began to grapple with art's imbrication *within* rather than valiant separation *from* the social formations they critiqued. Moreover, the very concept of "reality" in the "nonfictional" form became, not so much a tool with which to counter "the inscrutable" appearances of a mendacious society, but itself the subject of contemplation. Indeed, Stefan Kaegi uses the language of contemplation to distinguish their work from "Peter Weiss" and the era of "1968" which felt itself to be clear about the truth-effects of its "message."[35] The language of "reality" certainly appears throughout responses to Rimini Protokoll's oeuvre, where critics and audience members refer to the real people, real trucks, and real sites in which they work. But such a discourse will also express a sense of uncanniness in the stylized conventions within which that reality is framed, making ambiguous the line that would divide reality and fiction.[36] In that space of ambiguity, audiences do not so much watch as watch themselves watching; they do not so much interpret as watch themselves interpreting. Situated within the embedded goals of critique, the unsettling of reality and fiction in contemporary documentary theatre provokes new knowledges but also invites reflection upon the conventions of knowing itself.

Even a revised language of reality and fiction, however, does not seem fully adequate to tracking the perceptual, material, and socio-political implications of Rimini Protokoll's work. It might be for that reason that they have often turned to other languages as well. In addition to the

language of "experts" or "real people," Rimini Protokoll artists are just as likely to refer to their performers as "theatrical readymades": "people who . . . are the experts on perspectives on reality come to serve as suppliers of materials and as actors"; these nonactors "are Ready-Made presenters for the stage."[37] Such language places these human materials in art genealogies other than those of documentary theatre. Within the Duchampian logic of the readymade, the quotidian object is placed within the frames and supports of the aesthetic institution in order to call attention to the institutional act of aestheticization, the process by which the quotidian object becomes aestheticized. To characterize human narrators as readymades is thus to name their role in the exposure of a system that makes them ordinary and, simultaneously, to use aesthetic conventions to re-fabricate a sense of their potential luminosity. "What draws us away from actors is the fact that they would never bring us across such stories," says Kaegi.[38] At the same time, as much as the concept of the readymade was meant to engage the exhibiting conventions of visual art, there is a way that the deployment of this language re-aligns Rimini Protokoll with those visual art conventions as well. The readymade participates in a discourse of objectification, asking how theatre might be made object-like to provoke alternate modes of viewing these people who are "suppliers of material." When Kaegi distinguished Rimini Protokoll from the documentary practices of the sixties above, the language of "contemplation" showed up as a shift that was not only political but formal, announcing his interest in the juxtapositive encounter with the visual:

> "Documentary theater" was a term that was used by Peter Weiss and also Peter Handke in a very different way. In the 1970s, they truly wanted to use social studies/sociology [*les études sociales*] to convey a message, I think. This is not the idea behind Mnemopark. I think that we could use the time of two hours in a theater as a form of contemplation that shares more with the contemplation of a painting. There is quite a bit of realism in all of that, but what it really means, I cannot answer in a few sentences. I think you have to come and watch for two hours.[39]

As we saw with The Builders Association's screened *mise-en-scènes* above, the statement echoes the language Hans-Thies Lehmann uses for characterizing the innovations of post-dramatic theatre:

> the new definitive "state" of the congealed pictoral work, in which the eye of the viewer wanting to access the picture has

to become aware of and reconstruct its dynamics and processes.
. . . It is no coincidence that many practitioners of postdramatic
theatre started out in the visual arts.[40]

In post-dramatic theatre's miming of the experience of painting, the
medium of theatre is being revised not only by the intrusion of a
documentary function but also by re-staging the static, pictorial
techniques of an "all-at-once" encounter.

The casting—on both theatrical and sculptural senses—of real people
as theatrical readymades has implications then for what we understand
to be the material of experimental performance. Rimini Protokoll's
"experts" can be placed within the frame that Claire Bishop offers for
interpreting "people art." "By real people I mean people who are not
the artist, the artist's friends or other artists: in other words, participants
from outside an artistic context who are chosen by the artists to represent
a particular socio-economic demographic, ethnicity, or gender."[41] In
creating a vocabulary for what are usually gallery-based uses of real people
in "live installations," "constructed situations," or what Bishop also calls
"delegated performance," the typifying use of real people in an exhibition
setting has historically provoked uncomfortably political and—sometimes
together—uncomfortably material encounters for receivers. In a visual
art context whose readymades are usually static objects, the casting of
real people as material has a discomfiting sentience. The medium-specific
contours of sculpture as a static form are challenged by the encounter
with material that moves and breathes. On the other hand, in the theatres
within which Rimini Protokoll presents, the deployment of sentient beings
is to some degree naturalized by the casting of actors in a theatrical play.
So here the question for the theatrical medium has less to do with the
sentience of the material than with the rejection of the framing
conventions by which that sentience is typically managed. Casting real
people to play themselves threatens to unhinge the work's status as a
play. Indeed, a struggle among jurors who eventually granted Rimini
Protokoll the Dramatiker Des Jahres prize for *Karl Marx* exemplified
this threat, for the "jury hotly debated whether actors could legitimately
perform the text without it losing its authenticity—in other words, whether
the piece was capable of being performed like a regular drama."[42] The
casting of real people provoked a question about what does and does
not constitute the proper materiality of the theatre. Interestingly, that
concern rested upon a desire to maintain theatre's surrogated processes.
Such a sensibility wants to uphold the notion that the substitutability of
actors is key to theatre's medium-specificity; interestingly, the substi-
tutability of human material is what seems to guarantee theatrical purity.

The socio-political provocations of Rimini Protokoll's work subtly interact with these questions of medium and material. All of their projects address larger scale issues around nationalism (*Deutschland*), finance (*Annual Shareholders Meeting*), mass media (*Breaking News*), politics (*Wallenstein*), globalization (*Airport Kids, Call Cutta in a Box*), and more. Their projects also result from intense processes of site-specific research. At the same time, the material that is turned up does not so much reveal the truth about a site as it does complicate what we thought we understood about it, giving us strange and often quirky resources with which to compose questions that may or may not be fully answerable. The stage of *Mnemopark* was taken up entirely by a large train set placed onto a landscaped replica of Switzerland, "complete with snow-covered mountains, lush green valleys, farms with plastic cows and chickens, and pretty little chalets; and of course train tracks, stations, trestles, tunnels, bridges and whistles."[43] With a *mise-en-scène* that replicated life without being life-sized, the piece broached issues of nationalist desire as audiences watched the construction of an idealized world. The narrator offered facts and figures that mimicked a kind of documentary research, telling audiences the size of Switzerland and the population of its people and its farm animals. Audiences also learned of the large state subsidies that go into preserving the green pastures of an agricultural landscape that is no longer profitable on its own, suggesting that the rural image of Switzerland now is based upon a nostalgic image of its national past. If a generalized critique of nationalist nostalgia can be found in such statistics, however, the audience's relationship to the act of idyllic presentation was complicated by the presence of the five "real" model train builders themselves. These retired *bricoleurs*—mostly in their eighties—told stories about their hobbies (one has had a train since he was seven), their personal trials (another speaks of doing the laundry since his wife died), and their obsessions with the laying of tracks, the creation of landscapes and the desire to assemble "*un monde a moi.*"[44] These experts are thus both figures of our nostalgia and agents of their own. As much as one might be inclined to critique nostalgia as well as the politics of aestheticized purity in the creation of these mini-worlds, the expressive complexity of these raconteurs produced a more complicated relationship. Nostalgia is not completely rejectable when watching and listening to figures for whom the imagining of miniatures and the creation of worlds is simultaneously an act of self-consolidation. The presence of "real people" in *Mnemopark* acts not so much as an authentication of reality but as a provocation to think about the complexity of reality's fabrication. The impulse to critique an outdated vision of idealized landscapes—for those who go and are "in the know"—

is put on pause as layers of images and affects accumulate in our two hours of contemplation.

If theatrical reception approached the condition of painterly viewing in several of their proscenium-staged pieces, a piece called *Call Cutta* obviously experimented differently with a theatrical delivery system. That experimentation had everything to do with the delivery systems in which the "real people" of the call center industry find themselves working. When the piece premiered in Berlin, it had a different structure from the one I encountered in my visit to Centquatre. In Berlin, the piece began when receivers were given a specialized cell phone and began a walking tour of the city with guidance from the person on the other end of the line. Like the *Alladeen* scene in which a call center operator attempts to give directions in a locale halfway around the world, *Call Cutta*'s mobile phone structure accentuated the uncanniness of global proxemics. Indian call center operators told cell phone walkers to turn to the left or the right, to linger before a key monument, and then to linger outside of an abandoned lot. Along the way, the operators told them about the histories of the spaces they were encountering, occasionally fielding questions and offering information about the Indian cities in which they lived and worked as well. For critic and site-specific receiver Susan Foster, *Call Cutta* in Berlin asked new questions about global connection by finding an alternate way to use the everyday technology of the cell phone:

> How might cellphone technology and the transnational space it constructs be recast so as to provide a non-disembodied period of contact between performer and audience member? How could contact with a cellphone voice not render all experience equivalent? How could a performance be staged on a variegated terrain, dense with memories and associations in some areas, and more sparse in others? Could performer and audience member learn to depend on one another and to solicit candid responses from each other in order to explore mutually the locality of our shared experience? What kind of score could we devise to reaffirm and even enhance public protocols of comportment through which individuals rely on and sustain one another?[45]

This first iteration of *Call Cutta* was thus a specific brand of media theatre, one that expanded the social field of cell phone comportment and its highly individuating behaviors. If cell phone performance typically enables mobility by focusing the user's attention inward, *Call Cutta* in

Berlin altered such movement by turning her attention outward. Rather than remaining a homogenized pathway of a chatting cell phone user, the city became a specific site with a local history and a global resonance. If, as we saw in *Alladeen*, call center communication typically represses the specific location of a call center interlocutor in order to satisfy the needs of a (usually) Western consumer, *Call Cutta*'s performance made cross-world localities palpable, simultaneously inviting users to see their own city through the eyes of someone else from across the globe.

In moving the *Call Cutta* proposition to other cities, the structure changed along with title. Calling it *Call Cutta in a Box*, the supporting apparatus for the piece moved from mobile phones and city streets to land lines and administrative offices such as the one I entered in Paris. With each movement to different artistic sites in different cities— Johannesburg, New York, Amsterdam, Seoul, Helsinki, Brussels, Dublin, and many more—a team of researchers gathered information about the city's history and about the local environment in which the art organization was located. At Centquatre, for instance, I was told that the site of this urban arts centre had once been a place reserved for civic funerals. The attempt was thus to reproduce the goals of site-specificity for each locale while simultaneously accommodating the demands of the international tour. For each site, teams of call centre operators are hired by the hour to support each one-on-one theatre "appointment." Some were already working as call centre operators; others responded to job advertisements because they were "interested in talking to Europeans."[46] Instead of training the operators in the cheery scripts of economic exchange, however, Rimini Protokoll artists trained their actor-laborers with alternate templates that encouraged them "to talk openly and listen."[47] The operators learned how to finesse introductory inquiries about each receiver's home, family, language, education as well as to step into more unorthodox interpersonal territory as operators disclosed more personal information and asked questions that might have felt strange ("Will you draw a picture of me?") or invasive ("Do you have any regrets in your life?"). Rimini Protokoll's alternate scripts thus literalized the "personal" in personal service. Whereas the affective labor of call centre service typically manages interpersonal exchange by avoiding interpersonal disclosure, these templates encouraged intimate exchange from both sides of the globe.

Rimini Protokoll has continued its innovative re-use of the theatrical medium to place everyday "experts" in intriguing relations with global audiences. In *Cargo Sofia-X*, for instance, theatre's delivery system changed once again, this time taking shape inside the container box of a transnational trucking company. The idea for this project came about

after extensive documentary research on the movement of commodities and services in a changing European Union (EU). As transnational exchange is encouraged over a greater territory, EU policies facilitated the movement of labor and the movement of goods, so that Western European citizens found themselves in increased contact with Eastern European and Baltic immigrants who were hired as custodians, as dock workers, in construction, as truck drivers, and in other manual and industrial sectors. Trade within the EU also facilitated—and depended upon—new companies formed to ship goods across borders. By creating a piece with "expert" Bulgarian truckers, Rimini Protokoll artists wished to explore these "nomads of cargo transport [who] no longer have tents and not yet Internet, but they work and live on less than 6 mobile square meters in front of their 40-ton freight."[48] Thus, global consumption (of the kind indexed in the LED advertisements of a piece such as *Alladeen*) requires the transport services of shipping and trucking, a travel across national territories that cannot always match the velocities promised by an online catalogue. Such services require barges, ships, rails, airplanes, trucks, and storage systems whose materiality moves at a slower pace

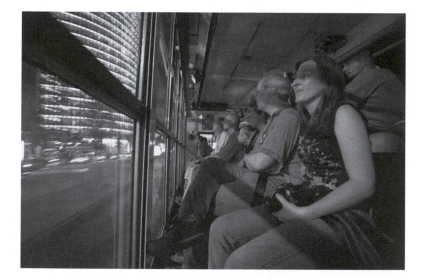

Figure 5.4 Rimini Protokoll, *Cargo Sofia Berlin* (June 2006), Bulgarian truck drivers Ventzislav Borissov, Svetoslav Michev, and others ride in a 12-year-old converted truck through West Berlin. Directed by Stefan Kaegi

Source: Photo by David Baltzer, bildbuehne.de.

and lives in an encumbered terrestrial space. "The customers only order when they need the goods," writes Rimini Protokoll, and hence "the motorway has become the biggest storehouse of Europe."[49]

Cargo Sofia-X placed its audience within the confines of this EU delivery system. Making an appointment to be one of the forty-five receivers, audiences were welcomed by two Bulgarian truck drivers— Nedyalko Nedyalkov and Vento Borisov for many of the performances —and then entered a truck that had been outfitted with seats and whose side panel was replaced by a window/screen system that raised and lowered on cue. After everyone took a seat, the truck was closed, the motor started, and the contained theatre—"A live spatial model [whose] freight is its potential"—began to move. Audiences submitted to being cargo for two hours. One critic and site-specific receiver, Sara Brady, offered a particularly candid chronicle of her initially discomfiting experience when *Cargo Sofia-X* came to Dublin. She found herself suddenly "nauseous" at being locked in, an exacerbation of theatre's typically confined viewing system:

> The truck is now moving; I'm looking for an escape latch and wondering whether they are going slow enough for me to survive the jump, when suddenly the two truck drivers' faces appear, in triplicate, in front of us. Projected along the lateral side of the truck is live feed from the cab. The (real) truck drivers wear microphone earpieces so we can hear them tell us, via our translator, that we are in Sofia, Bulgaria, ready to start our journey to Dublin.[50]

The screen alternated between projections of a geography that crossed Europe and projections of the drivers inside the cab. In real time as they drove, the drivers told listeners of their life on the road, about what it is like to stop at motorways, about how expensive it is to eat at McDonald's, and about how much they miss their wives. The screen also showed a documentary of SOMAT, the trucking company for whom they work and whose corruption is chronicled in detail. Like *Call Cutta*, then, *Cargo Sofia-X* shares the personal experiences of laboring lives in confessions and testimonies, while simultaneously exposing their—and our—place within a larger system of consumption and travel. Like the "box" of *Call Cutta*, *Cargo Sofia*'s container box is adapted to each city in which the piece is housed. The route from Sofia to Dublin might be displayed for one piece, but the route from Sofia to Avignon will be projected in another iteration, and on and on at each host city— Barcelona, Bordeaux, Marseille, etc. While watching highways stretching

out before them, Dublin audience members could feel the rumble of cobblestones underneath them, juxtaposing the paved international with the old-world local. Site-specific research showed up in other ways, however, for at particular junctures the video screen rose again to reveal a window looking out on a local landscape selected to interact with the political themes of the piece. Brady recorded an uncanny feeling of replaced theatricality as the screen arose to create a window frame around Dublin's dockyards:

> A man stops the truck. He is in clear view as he approaches the cab; then he disappears. The truck starts moving again deeper into the port; I only realize the man who stopped us has boarded the truck when I begin to hear his voice through my earphones. He introduces himself: he works at the port. He explains the difference between freezer containers and chemical containers; how every container has a unique number; how much weight the massive cranes can hold. In front of us a crane reaches for a container like a mechanical arm in an arcade game. With seemingly little effort the crane grabs one of the rectangular steel boxes and moves it to another stack of containers. The cargo ferry docked nearby, however, dwarves the scale of the crane and containers.[51]

Presenting a scene that could have been a documentary photograph from Sekula's *Performance Under Working Conditions*, the highly orchestrated piece encouraged a different viewing relationship to a laboring site that is seen (and passed) every day. "It is all about drawing attention to other aspects of reality," say Rimini Protokoll artists in an interview with Patrice Blaser, "by suddenly discovering something that has always been there, but remained unnoticed in everyday life, and is made visible only now, with the help of that special gaze that one has when one observes in an art-context."[52] But this dose of the "real" is a political as much as perceptual provocation. In creating pieces about the reality of labor in a globalizing world, that special gaze simultaneously provoked the audience's sense of the connection between their lives and the realities of others. One critic elaborates, using the infrastructural language of support, "the audience came up against the scaffolding of their comfortable quality of life to an intimate degree that no book, magazine report or even film documentary can offer. The show puts so-called reality to shame as voyeuristic extravagance."[53]

In many ways, we could say that *Call Cutta in a Box* and *Cargo Sofia*— as well as other Rimini Protokoll projects—re-activate a form that

precedes both post-dramatic theatre and post-Minimalist art: the funhouse. The funhouse has historically installed moving spectators within an interactive landscape, placing triggers and cueing surprises that altered the environment as receivers walked, sat, and touched elements around them. The thrill of the funhouse comes in the precarity of receivers' sense of control of the environment they activate, its ability to propel them between curiosity and fear, risk and safety as they explore its alternate reality and seek strategies of escape. In reviving the structure of the funhouse for a globalizing world, Rimini Protokoll uses its strategies of startling heteronomy to re-introduce a sense of the "external rules" that structure autonomous personhood. In an environment of corporatized labor, the world is not exactly your oyster when the props of white-collar existence—the computer, the phone, the personalized tea caddy, and the entire contents of every drawer—are part of a *mise-en-scène* whose unfolding is controlled from without. Meanwhile, the material goods displayed daily before a cosmopolitan citizen consumer are fettered by the stories and claustrophobic containers of the truck drivers who brought them there. In both scenarios, receivers submit to an environment that simultaneously makes them want to escape. The spectatorial relations use but exaggerate those of the theatre in which timed entrapment is something of a convention. Such a contemporary funhouse also uses but exaggerates the spectatorial relations of a post-Minimalist visual sphere, a space of personified entrapment in which Michael Fried famously found himself "being distanced or crowded, by the silent presence of another *person*."[54] Here, the person waiting for you is not only a sculptural block who announces your perceptual imbrication but an international laborer on whom you find yourself startlingly dependent.

What is also interesting about Rimini Protokoll's model of working is the way its production process actually interacts with—and sometimes mimics—the processes, delivery systems, and affects of a global service economy. These so-called immaterial experiences of site-specific theatre still need a certain kind of technical labor in order to exist. Technical directors follow *Call Cutta* to set up mechanisms to activate the funhouse. Other technical directors and researchers follow *Cargo Sofia-X* around the globe to redefine its propositions for each site:

> "We've brought it to about 14 cities," says Jörg Karrenbauer, who has spent a year making the piece work in urban areas such as Basel, Vienna, Berlin, Warsaw, Avignon, Belgrade, Sofia and Riga. Karrenbauer goes to each city ahead of time to size it up for performance, marking out areas on which to focus. He also

consults Google Earth for further information. "Because it can show such minute detail, we can locate things such as truck containers, industrial areas, places where trucks can park."[55]

Additionally, as noted in the *Call Cutta* scenario, each creation of a cast also engages in a brand of rehearsal that draws from the lexicon and the techniques of emotion management central to the service economy. One "expert," Sven Otto, a local politician who appeared in *Wallenstein*, marveled at Haug, Kaegi, and Wetzel's ability to mobilize their "real people" in each of their pieces:

> To take these people and unify them, to form a whole, is a huge accomplishment. It has a lot to do with the personalities of Helgard and Daniel, who are able to turn on the sweet-talk or be real slave drivers if they have to. They have very finely tuned antennae. This is something they share with all successful people in our service economy. Having an instinctive feel for psychology is becoming increasingly important.[56]

Finally, and quite interestingly, the project-based model of theatre-making developed by the three Rimini Protokoll directors allows its simultaneous circulation across the globe. At any point on the calendar, one can find six to ten productions "touring"; that is, their propositions circulate thanks to helpful technical directors who transport expert actors or find new experts in each site. Here, perhaps, we find a different labor politics in the practice of casting "real people" in mobile sites, for Rimini Protokoll artists are not obligated to cast repertory actors or to hire designers or builders for a traditional set. While a few projects fly complete casts around the world, many re-assemble casts in different sites; it is not a traditional production that tours, but a concept . . . along with technical directors who find new suppliers of material. The "delegation" of performance thus creates an internationalized distribution model that mimics, thematizes, and travels within the pathways of EU distribution.

Through the work of The Builders Association, Rimini Protokoll, and any number of experimental groups that I have not been able to consider, we become differently aware of newer distributions of the sensible in a technologically networked age. Such an awareness also provokes reflection on theatre's self-redefinition within it. This is a world that structures our perceptions of speed, space, and proximity, our impulses to plan or not to, our understandings of what constitutes delay. We perceive certain conditions of human accessibility via cell phones or the

Internet, and, as a result, we also experience ourselves as exceptionally vulnerable to being found. These technological redistributions also affect how we experience the real-time, shared space of performance that we might have called "conversation" in a social frame or "theatre" in an aesthetic one. Rather than imagining such realms as *old* antidotes to *new* technologized forms of interaction, we might instead examine how the social codes and corporeal conventions of those realms have changed together with technologies themselves. Changes in our perceptions of speed, proximity, materiality, and sociality become sensible when we recognize that a co-present rendezvous occurs not by planning a meeting but by counting on the consistency of cell phone contact to find each other. Such changes become sensible when we examine the conventions of private disclosure between face-to-face conversation, iChatting, IM-ing, e-mail writing, letter writing, GPS-linked tweeting and "Facebook-friending" to find that no particular medium has a lock on the authenticity of human connection. Such changes also become sensible when we find certain forms of interaction or creation unable to match the speed and voluntarism to which we have become habituated in digital or wireless realms, jostling us inside inconvenient domains where access is not assured with a point and a click and where resolution, if it does arrive, happens after what now feels like a lag. Having to find a plug, having to wait for a bus, having to take one's turn are all medium-specific experiences that continue to occur, but our sensibilities for enduring them are attached to new barometers for gauging freedom and burden, speed and delay, the convenient and the inconvenient. Finally, such changes in perceptions of speed, proximity, materiality, and sociality might also become sensible when we examine the felt structures that propel us toward newness and next-ness here at the beginning of the twenty-first century, the projective impulses toward the next window or link where information is sought, the speculative impulses toward investments whose offline referents are unclear, the consumptive impulses that are sustained when next-ness is strategically deferred. Such an orientation cannot support a paradigm that pits "live" theatre against mediated interaction or "actual" theatre against virtual space. Rather, the artistic practices that call themselves theatre or performance exist in a world where technologies and the global imaginings that attend them have affected the sensible apprehension of our world. Theatre that does *not* call itself "new media" is as affected by these technologies as theatre that does.

To ask about the role of theatre in a world changed by new technologies is to ask about the role of a form distinguished by the co-present state of its participants, one where "sender and receiver age

together."[57] To ask about its role is also to consider the labor required to sustain a space of shared durationality. Both Rimini Protokoll and The Builders Association experience the labor contingencies of being "migrant cultural workers" in numerous ways. As US and EU experimental companies, they sustain their work in the decidedly mixed economies and post-socialist societies that support an international art circuit. To speak of a globalizing, technologically responsive theatre is to speak, then, not only of its *mise-en-scène* or even its artistic technologies but also of the movement of theatrical processes within social organizations with varying commitments to local and international audiences and with varying commitments to supporting apparatuses and infrastructures that sustain the arts as a form of labor. The sustained life of companies such as TBA, Rimini Protokoll, and others is thus dependent not only on their ability to interface with the apparatus of whatever appears "new" in new media but also on their ability to present themselves within an international arts world that values a theatre from elsewhere. As such, their artistic livelihoods also mean grappling with a political economy of international arts programming, which is to say contending with the serial form of collectively coordinated contract labor that is "the international tour." For the small three-person collective of Rimini Protokoll directors, such tours are coordinated with a mix of "real people" and technical staff; for TBA, it means coordination with actors and designers who seek repeatable artistic experiences with each other, but for whom such repetition is not secure. The economy of the "tour" depends upon particular distributions that value the new, the limited run, and the temporary contract; the "tour" is thus a place where the nomadic sensibilities of flexible citizenship meet the economic precarities of flexible citizenship. In such a space, mobility is not always "volitional." It is a model of theatre-making that cannot count on the value of home-grown theatre sustained by a community over time—i.e., the repertory model of theatre. For that reason, the politics and human costs of making a life within structures that put that life on tour have been increasingly thematized in the work of both companies. The politics of "globalization"—in both its cultural and economic associations—are addressed theatrically in their *mise-en-scène* in part because of how globalization is lived as an itinerant artist on a limited contract.

If the feeling of volitional mobility characterizes the digital world, then theatre's anachronistic territoriality might be the most interesting thing about the medium right now. It is in such a space that the immaterial experiences of information, affect, volition, excitement, and service show their dependence upon the materiality of humans, spaces, and objects. Whether imagined in cargo, in technologies, or in bodies, the friction

and gravitational contingence of social formation makes itself felt. Post-Brechtian theatre means making theatre that "shows its seams" in a context where the technological fabrication of seams has changed enormously. It also means being skeptical of our ability to imagine resistance or critique as something that exists purely outside the social institutions and culture industries that constitute our lives. By re-calibrating our relation to the technologies we use and to the personal interactions on which we depend, however, experimental forms can make new use of old theatre, placing a frame around and a stage underneath the "tech" that supports us.

6

WELFARE MELANCHOLIA
The Public Works of Michael Elmgreen and Ingar Dragset

> This month, the duo—a fixture on the art biennale circuit—brings its trademark combination of social commentary and extreme theatre to the Power Plant with the Welfare Show.
>
> *Toronto Life* on Michael Elmgreen and
> Ingar Dragset[1]

> Whereas classical liberalism articulated a distinction, and at times even a tension, among the criteria for individual moral, associational, and economic actions . . . neoliberalism normatively constructs and interpellates individuals as entrepreneurial actors in every sphere of life.
>
> Wendy Brown[2]

In October of 2008, kicking off the opening week of the Frieze festival in London, Michael Elmgreen and Ingar Dragset opened their installation *Too Late* at the Victoria Miro gallery. While Frieze lost the most prominent headline coverage to angst-ridden articles on the United Kingdom's financial crisis, the festival put its best foot forward. Its directors coordinated with prominent galleries and caterers to distract attention from stories of a bedraggled Gordon Brown attending to the effects of a de-regulated Anglo-Saxon economy. The opening week of *Too Late* also coincided with a one night showing of "a play" by Elmgreen and Dragset called *Drama Queens* at the Old Vic, as well as with a special publication insert in the journal *Art Review* authored and formatted by the duo.

Poised as usual between criticizing an institutional world and announcing their absorption by it, Elmgreen and Dragset's network of pieces re-used the conventions of the artworld genres in which they were sited. Victoria Miro publicized *Too Late* as an installation that provided

"a mental image of a party that's already over: lights still blinking and disco ball sadly spinning, but there's no-one on the dance floor and the last round has been served a long time ago."[3] *Art Review* was pleased to offer the duo's meditation in print amid gallery publicity and other advertisements for luxury goods. Elmgreen and Dragset's ambiguous engagement with the gallery-collector-magazine system of aesthetic administration extended somewhat non-traditionally by incorporating a traditional theatre.[4] The Old Vic—currently headed by celebrity actor Kevin Spacey—promoted *Drama Queens* as a fundraiser for the theatre's creativity fund. All three pieces—one could say, presciently—offered occasions for pondering the speculative foibles of an art market at a time of market *malaise*.

The work of Michael Elmgreen and Ingar Dragset continues this book's larger discussion of cross-media experiments. This chapter also advances a conversation that wants to link cross-media systems to questions of social and political systems more generally. I am particularly interested in how performance—in its temporal, spatial, and, here, spectacular senses—have propelled this duo's critique of institutions that are dependent upon both capitalist and socialist principles of organization and (de) regulation. In art projects that provoke reflection on the freedoms and constraints of various institutional spheres and the immediate and projective fantasies of various social models, we find again an engagement with the encumbrances of theatricality as a spatially extended, time-based medium and group mechanism for art-making. While the "extreme theatre" that one critic used to characterize Elmgreen and Dragset is in no way equal to the actions taken by Brown's "entrepreneurial actors," we might find that both domains expose institutionality as dependent upon the repetition of actions that it simultaneously determines. Whether the systems interrogated are liberal or neoliberal, it is to these operations of recursive theatricality that both artists and intellectuals direct their respective institutional critiques. As artists whose work is "post-1989" and, now, post-2008, Elmgreen and Dragset address both the exhaustion of socialist imagining but also the anxieties embedded in capitalist fantasy. Throughout, I consider how their ambivalent media respond to artworld and global contexts that grapple with changing definitions of the social. Within that project, I am keenly interested in the ambivalences that come forward when "institutional critique" is directed at public institutions.

What follows is an introduction to their work and its relation to late twentieth-century discourses on power, structure, and institution. I then move to a lengthier analysis of one, large-scale piece—*The Welfare Show*—considering how its forms and its reception bespeak the paradoxes

of institutional transition between liberal and neoliberal models of social organization. I conclude by returning to their work in a 2008 context reeling from the effects of neoliberalism's entrepreneurial actions. Throughout the experiments of Elmgreen and Dragset, we see the possibilities and perils of launching a socio-economic intervention from within—very much *within*—an artworld space. Elmgreen and Dragset's mixed-media work resides, after all, in a decidedly mixed economy.

Structuring Powerlessness

Born in Denmark and Norway respectively, Elmgreen and Dragset have worked together since the mid-1990s. Initially co-creating performances and then moving into ever larger sculptures and installations, their work now enjoys artworld cachet. At the same time, they consistently engage issues of social space by developing formal vocabularies that extend and redefine the concept of institutional critique. Chronicles of their early biographies usually make reference to their personal heritage as Nordic queers. Though the artists do not have formal art degrees, Elmgreen spent some years writing poetry, and Dragset studied the Lecoq tradition in theatre school. Elmgreen had odd jobs as an interior decorator and also worked occasionally in a home for the elderly. Dragset worked as a theatre instructor for children and mentally handicapped youth, as well as in hospitals as a nurse's aid. Less emphasized—though we will learn about it later—is the fact that they received unemployment benefits and educational subsidies along the way from a Scandinavian welfare state. When asked about the roots of their collaboration, performance emerges as a kind of personal and professional glue between them. Dragset helped Elmgreen knit some "abstract pets" for one of his art installations, small items that "the art audience could hug and nurse and feel confident with."[5] But "in Stockholm nobody feels relaxed at openings, so we had to show the audience how to feel confident and how to use these knitted pets, and then everybody thought it was a performance—so it became our first performance . . . by coincidence."[6] The coincidental turn to performance thus took form as demonstration, a primary interaction to induce future ones. Elmgreen and Dragset's sense of performance was rooted in an interest in the structuring potential of the object world:

> Almost any cultural object is performative. If you take the coffee pot, it's waiting for us to make coffee in it. If you have a chair, it's waiting for you to sit on it. . . . So I don't see the objects that we're doing totally apart from the performances we're doing. It is all part of the same system.[7]

Despite this systemic sense of the relation between the static object world and the durational gestic one, they found that the gestic one began to predominate in curatorial representations of them: "we were always curated to be the funny guys in the corner."[8] Moreover, the gestic associations of performance interacted with sexual identification to fix them inside queer stereotypes, stereotypes that had propelled and constrained the careers of many queer-identified performing artists in the nineties.[9] Feeling that they "were becoming too much of a gay icon . . . we opened up our own artistic expression . . . to include all kinds of material, historical and cultural."[10] The "all kinds of material" meant developing a stronger relationship with the traditional materials of visual art but using them to explore the material structuration of powerful public spaces. In theatrical terms, it was a shift from the auto-gestic body to other parts of the "same system," that is, the exploration and design of alternate props and alternate sets. It was at this point that they also decided to move from Northern to Continental Europe, specifically to Berlin, to reorient their careers.

In *Powerless Structures* in 1997, they launched the first of several related spatial interventions, creations where overt autobiographical indexes were now placed at a remove. Announcing that the title "is derived from our misreading of Foucault,"[11] they roundaboutly joined a larger conversation on questions of institutional relations, invoking inherited social frames for pitting and pitching selves and structures in opposition to each other:

> [Foucault] speaks about how the structures themselves can impose no power—only the way we deal with them . . . any structure could in fact at any point be altered or interchanged with a new set of structures. . . . These nomadic tendencies have certainly had an impact on our work and on our ideas of a more flexible public infrastructure.[12]

In characterizing the goal of their interventions, "flexibility" often came forward as their word of choice. "New museums and McDonald's are the most standardized forms in the world now . . . the problem with them is that they are not flexible."[13] Indeed, "inflexibility" was the worst thing that they could say about a social space. Whether it was a social welfare operation, a store, a museum, or—following the Foucauldian analogy—a prison, increased flexibility was the goal of aesthetic intervention.

Even if Elmgreen and Dragset had turned away from the biographical inflections of performance art, an interest in agential resistance within

structures still very much animated their theatrical replacements of the object world. As their earlier emphasis on performative subjectivity gave way to a performativity of space, they engaged a different kind of sculptural theatricality linked to the Minimalist gesture. Their 1997 piece sited at the Louisiana Museum of Contemporary Art in Denmark installed a diving board through one of the museum's panoramic windows, one perched with Hockneyesque ebullience inside (and outside) a museum that is itself perched high on the edge of a cliff overlooking the North Sea. In 1998, they found themselves in Reykjavik, Iceland, this time offering *Dug Down Gallery/Powerless Structures, Fig.45* in which they embedded a white cube gallery structure into the ground in front of Reykjavik Art Museum, a gesture that altered the traditional spectatorial relation to a gallery. The gallery's display, by virtue of its dug-down infrastructure, was no longer at eye level, or, rather, eye level had a new relation to "the ground" in senses both pictorial and terrestrial. Other pieces, such as *Powerless Structures, Fig. 111* at Portikus in Frankfurt, Germany in 2001, altered the perceptual apparatus of the gallery by refiguring the space, this time by arching the hall's floor and skylight by over a meter, creating an elastic wave within the once austere and rational white cube of the gallery. As with many associated with institutional critique, alterations of "white cube systems" propelled their work, whether that white cube was the undoing of a gallery space as above or the undoing of a sculptural object. In their 2002 *Suspended Space*, they stacked a gallery's walled partitions at odd angles, rendering precarious the "ineluctable flatness" of the art object's support through the uncertain suspension of the "theatrical flat."[14] In their 2002 *Powerless Structures, Fig. 187* at Klosterfelde in Berlin, both the gallery and sculptural conventions were undone by a cubed packing crate, suspended in the process of crashing through the gallery ceiling.

If in Foucault's *History of Sexuality*, they had decided to learn that "all structures can be altered or mutated. . . the patterns could be different. It was just a question of imagination,"[15] then Foucault's status as a queer precursor was part of that mix:

> We both grew up being fags from the suburbs, which kind of teaches you not to take too much for granted . . . So you start to wonder if things really are as they have been shaped through tradition and conventions, or if they inhabit the possibility of developing into something else, something more open.[16]

That openness or unrecognized flexibility was thus also something that had a sexual politics, one that launched "a gay infiltration of Minimalism's

famously macho aesthetics."[17] Elmgreen and Dragset cite the influence of Felix Gonzales-Torres as a model for such an infiltration.[18] In *Cruising Pavilion/Powerless Structures, Fig. 55 1998*, queer politics joined with Minimalist aesthetics in a relational and spatial expansion sited outside of an art institutional space.[19] In offering what critic and curator Daniel Birnbaum called "a visually spare gay cruising area—to accommodate all kinds of encounters and transactions," Elmgreen and Dragset thus politicized the referent for "the relational" in an emerging discourse of relational art.[20] For Birnbaum, writing in 2002, this late generation expansion of institutional critique was notable as well for the pleasures it elicited: "their spaces and installations are always visually seductive, like splendid stage sets or an exquisite display in a high-end boutique."[21] In fact, the appeals and perils of the exquisite would be a continued theme. Elmgreen and Dragset went on to critique the boutiquification of the art market while cheekily remaining on its display shelves with pieces such as *Prada Opening Soon* (2001) in New York City or their 2005 *Prada Marfa* boutique installed on a Texas highway near the de- and oddly re-gentrifying space of Judd country.

Thus, even if the *Powerless Structures* series has been billed as a move away from performance in one sense—the one that frames artistic bodies as festive or as "lite" spectacles in the gallery corner—we can also see their work engaging performance in other senses, in the durational, spatial, and collective production of differently relational systems. Elmgreen and Dragset's coordination of the object world was activated by a performance sensibility:

> Most of the works that we've done are attempts to make dead material come alive. . . . In live acts like these, it is like our personal presence is only to keep the material moving. . . . In the performances we are taking part in a process that is going on with the material.[22]

Their theatricality sometimes shows up in the spectatorial relations of their work or in its durational approach to space. Sometimes, we find it in their stage sets, their props, their flats, and in the hired bodies that they install in their scenes. But in their incarnation and revision of the legacy of institutional critique, we find that the artistic avowal of social, institutional, material, and economic processes simultaneously requires a cross-medium encounter in spatial, durational, gestic, and group forms. Recalling Patricia Falguières's insight cited in Chapter 4, the "virtually unlimited expansion" of this mixed-media scene exemplifies her recognition of the kind of "dramaturgy" that institutional critique's

gesture of "unveiling" required. The avowal of a systemic apparatus in art practice simultaneously partakes here of an "original theatricality."[23]

Staging Welfare

To launch an art career in Western Europe in the mid-1990s, especially a career that invoked the art discourse of institutional critique, was to live in a context that was developing very specific ambivalences toward concepts such as "institution," "system," and "governance." It was also to live in a context that was developing very specific if not fully processed attachments to concepts that could occasionally be placed as their opposite—say, "flexibility," "resistance," and "agency." As recounted in my introduction, post-1989, "post-national" nations shared a discursive context that questioned the historic role of the state in managing interdependent systems of human welfare, including those that regulated provisions for health care, social security, unemployment, disability, pensions, transportation, utilities, dependent care, and more. If such state forms were seen as "anachronistic" structures whose bureaucracy constrained human beings, then a certain strain of institutionally critical art practice could reinforce this critique of state institutions. If resistance was lauded over regulation, if agency was measured by its ability to circumvent state structures, then a generalized critique of system pervaded not only neoliberal policy circles but also avant-garde artistic circles where freedom was increasingly equated with systemic *in*dependence. Arguably then, a number of people were misreading Foucault.

At the time that Michael Elmgreen and Ingar Dragset began making *Powerless Structures*, social theorists were coming to terms with the concept of structure posed within discourses that opposed flexibility and constraint or others that re-labeled the same opposition as "risk" and "security." Whether expressed in Anthony Giddens's discussion of the third way or in Ulrich Beck's elaboration of the risk society, new calibrations for balancing the precarities of market "freedom" with the constraints of state-based "protection" were under way. Within the domain of the critical humanities and political theory, Wendy Brown would try to clarify the discursive field in which terms such as "liberal," "neoliberal," "welfare state," "capitalism," "left," and "right" were bandied about. For Brown, it was crucial to remember that a tradition of liberal democracy differed notably from a neoliberal configuration in which all actions are figured as those of a "*homo economicus*" propelled by the exhaustive logic of "market rationality."[24] Liberalism, by contrast, was based in conceptions of rights-based equality and freedoms, a partial

upholding of non-market morality that underwrote the formation of welfare states—if not exactly the emancipation of labor that some leftists hoped for under socialism. "Put simply," says Brown:

> liberal democracy has provided over the past two centuries a modest ethical gap between economy and polity. Even as liberal democracy converges with many capitalist values . . . the formal distinction it establishes between moral and political principles on the one hand and the economic order on the other has also served to insulate citizens against the ghastliness of life exhaustively ordered by the market and measured by market values.[25]

For Brown, then, the ironic question now is how to formulate a left social vision in an environment where even liberalism's compromises —its modest ethical gaps—have been eroded. As the language of entrepreneurial speculation saturates everyday life, it also rationalizes the dismantling of a liberal welfare state, paradoxically robbing leftists of the object whose inadequacies had been a site of critique. Such a compromised object had in fact defined what it meant to lodge left critique, a gesture that found in liberalism's capitulations evidence of "its hypocrisy and ideological trickery but also . . . its institutional and rhetorical embedding of bourgeois, white, masculinist, and heterosexual superordination at the heart of humanism."[26] But what happens when even this emptied humanism is no longer valued? How could one continue to call for the public radicalization of social structures when neoliberal mechanisms had already undone them? What to do when even a paternally limited humanism could not fight an empowered *Homo Economicus*? Brown used the language of "melancholia" to characterize left critical ambivalence—a state that needed to reckon with the "psychic/social/intellectual implications for leftists of losing a vexed object of attachment."[27] While classically, melancholia refers to a subject's refusal to release from a lost love object, leftists were now losing an object that they had loved to hate, a distasteful object made more complicated by the fact that it was also an object of attachment. For all its trickery and inadequacy, liberal humanism is also an object that leftists—again to quote Brown—"cannot not want."

It seems crucial to remember that "institutional critique" emerged during this period of systemic skepticism and systemic confusion. It is equally important to remember the generalized mistrust of "structure" that would welcome a series such as *Powerless Structures*—even if mistrust might also give over to new anxieties when those structures were gone.

To look at these late twentieth-century debates from the vantage point of the twenty-first century is to ask new questions: What does one do when a critical language of flexible resistance becomes appropriated by a discourse of flexible markets? What does one do when a mistrust of social regulation paradoxically supports a project of economic deregulation? Critics and artists might find themselves in an oddly melancholic position, retaining a vexed attachment to a liberal foe who—in its gamely moral codes, gentlemanly hierarchies, and do-gooding compromises—suddenly seems like a decoy to distract from neoliberalism's rise.

Michael Elmgreen and Ingar Dragset moved to Berlin in part to give themselves new challenges and new opportunities as artists in an international city that combined relatively low rent with relatively high artistic energy. To make such a move was also to leave a Scandinavian social system, the generous, rigorously organized states that are invoked in professional and lay contexts as examples of successful welfare societies. In many ways, "Scandinavia" is the mythic signified of a supportive state structure, perpetually referenced within the European Union as a high tax/high service model that may not last, and invoked by varieties of North American and especially US artists whenever they wish that their lives were better. For Elmgreen and Dragset, however, Scandinavia's reputed system of care was not necessarily worth the constraints it created; moving to Berlin was in part about finding a less normative environment. "It was quite a relief when we first arrived here from the hyper-organized Scandinavian society, where anyone thinks that the world is about to go under if the bus is five minutes late."[28] The exchange of a Scandinavian system for a Continental one, the German model's mix of economic capitalism within a well-funded social state, thus provided the ground for their investigation of structures and their interest in flexible architectures in the broadest sense of the term. Socially, they were equally concerned with the normative dimensions of citizenship built in to certain aspects of the welfare system. The heterosexism of family provision was one example. When laws passed allowing Scandinavian homosexuals to adopt children, they created a piece called *Human Rights, Funky Hair* in which they adopted a nine-year-old boy for a day, dyeing their own hair red and yellow and his orange:

> Most rights are given only to obtain further government control with certain groups that don't fit into the dominant cultural system. It is wrong to claim that we have obtained any gay rights. What we have been given is a set of diminished

heterosexual rights to enter the institution of marriage, and even that is not comprehensive at all. We have been given the opportunity to be second-rate citizens with second-rate citizens' rights instead of being what we always were—outcasts.[29]

By putting such a frame on their post-1989 performance piece, we thus find Elmgreen and Dragset engaging in a version of what Wendy Brown identifies as a queer "left" critique of liberalism, criticizing "its hypocrisy and ideological trickery but also . . . its institutional and rhetorical embedding of bourgeois, white, masculinist, and heterosexual super-ordination at the heart of humanism."[30] *Human Rights/Funky Hair* (1996) read same-sex rights not as a benevolent welfare privilege but as a second-rate liberal system of social and sexual subjugation.

Elmgreen and Dragset's large-scale installation *The Welfare Show* began in the Bergen Kunsthall in Norway, the same year that their homage to/critique of Prada opened in Texas. The project brought together a variety of media in a multi-roomed installation that dramatized "the administered society." It showed their interest in moving from institutional critique's signature investigation of art institutions to the wider critique of "forms of bureaucracy associated with institutional systems extending beyond the white cube, the welfare system included."[31] The installation toured during a year when debates about a "European social model" circulated throughout the European Union. Fighting off what were billed as anachronistic remnants of the welfare state—especially those upheld by Chirac in France—Tony Blair would make his famous address to the EU parliament in the summer of 2006. While fending off characterizations of "Ango-Saxon" social models as proponents of neoliberal free-market deregulation, Blair argued that there was a false dichotomy between an "Economic Europe" and a "Social Europe," simultaneously suggesting that the promoters of Social Europe needed to change:

> If Europe defaulted to Euro scepticism, or if European nations faced with this immense challenge, decide to huddle together, hoping we can avoid globalisation, shrink away from confronting the changes around us, take refuge in the present policies of Europe as if by constantly repeating them, we would by the very act of repetition make them more relevant, then we risk failure. Failure on a grand, strategic, scale.[32]

As escapees from a Nordic welfare model to a Continental model in Berlin, Elmgreen and Dragset's piece was a timely engagement with a

complex issue. At the same time, the travels and travails of this project also exemplify a wider network of symptoms as artists, intellectuals, and citizens attempt to launch a critique of social structure in our contemporary moment. In 2005 and 2006, *The Welfare Show* toured from Norway to the BAWAG Foundation in Vienna to the Serpentine Gallery in London to the Power Plant in the not-quite-so Anglo-Saxon site of Canada. (It avoided the United States, whose non-universal health care and racialized castigation of welfare "dependency" made even a gentle "third way" debate on public social models nearly inconceivable.) As the show altered and responded to the contradicting associations attached to the word "welfare" within each site, it exposed some unintended ironies in the critique of bureaucracy. It fitfully slid between an effort to render the welfare structure "powerless" and an impulse to lament the fact that it already was.

The title of *The Welfare Show* had multiple resonances. At a first level, it placed the spectacularity of "the show" next to a presumably unspectacular form, "welfare," promising to place a stage underneath quotidian systems that are used but not seen. It also invoked the genre of the talk show, a televisual form that promised debate and engagement while offering pre-packaged banter and controlled catharsis.[33] In the mechanized land of the experience economy, the "show" is also the word attached to the extravaganzas of product display, usually located in conference centers, office parks, and corporate campuses where purveyors and buyers gather to share wares, ensconced in surrounding hotels with roughly the same shampoo samples and mini-bars. That latter association provocatively mixed with other associations around welfare in the binder-cum-catalogue that accompanied the exhibition. An array of sociological texts were gathered alphabetically in a distressed charcoal gray binder that could be a corporate catalogue or could be a social worker's casebook. With an old-fashioned and nearly non-functional clip and ring-system, one could almost turn the heavily card-stocked pages from A (Adoption, Age, Architecture, Army, Art) through to B (Bureaucracy) and on down the alphabet where E included Economy, Education, Ein Euro Job, Environment, Ethics, and Exclusion, where K only equals Kindergarten, and where P included Patriotism, Pension, Police, Postmodernism, and Poverty. W included not only Wealth and Work, but also a self-referential *The Welfare Show*. The binder ended with Zoo as the only entry under the letter Z.[34] For Peter Osborne, the catalogue both defined and undermined the "'pan-European' aspirations" of the project, "as if intellectual seriousness (which includes 'politics' of course) is something of an embarrassment (at best, a hostage to fortune) that needs to be presented under the covers of history, under the cover of pastiche."[35]

Visitors to *The Welfare Show* entered the space and could choose to go either right or left. This apparent sense of choice was soon forestalled by the antiseptic hollowness in every direction. *Social Mobility* was an anonymous institutional space with a less then accessible stairwell perched high above the floor, leading to a mythic doorway labeled "Administration." The piece could have symbolized a defunct welfare state that was no longer needed or a de-funded welfare state that was needed back. *Birthday*, a resuscitated older piece, placed on view an empty wheelchair with a single balloon attached to it. In keeping with a critical stance on liberalism's pieties, the artists hoped to comment on the degree to which disability rights discourse "infantilized" the disabled. *Modern Moses* consisted of a reproduction of a cash machine with a mannequin baby lying in a portable crib underneath, juxtaposing the flexible convenience of 24-hour banking next to the inflexible weight of 24-hour parenting. In *Interstage*, visitors saw a hospital corridor, encumbered with waiting gurneys and, in one case, a mannequin waiting for medical attention that would never arrive. *Go Go Go*—a retitled echo of their guiding light Felix Gonzales-Torres's piece—reproduced a pole dancer's pole with the trappings of a cleaning person assembled around it, juxtaposing an index of sexual labor (and pleasure) with that of custodial labor (and displeasure). In another portion of the installation, *Uncollected, 2005*, a lone bag orbited round and round a circular baggage claim, never to stop circulating, never to be picked up.

Throughout, Elmgreen and Dragset made different decisions about the spectatorial dynamics of each piece. Several pieces, such as *Social Mobility* or the comfortable chairs of a television studio beneath a neon sign saying *The Welfare Show*, were placed as bicameral spectacles before a viewer who was not allowed to enter but had to view from without. "Throughout our practice we have worked with what you could call denials," Elmgreen and Dragset have said, "installations which at first appear as if they were meant to be interactive but in fact don't allow any kind of direct participation by the spectator."[36] The sense of withdrawn invitation appeared in other portions of the exhibit. The potential interactivity of the cash machine in *Modern Moses* was forestalled by a similarly roped-off spectatorial dynamic. Some, however, were spaces to be entered, though environmental entrance did not necessarily mean relationality. In *It's the Small Things in Life That Really Matter, Blah, Blah, Blah, 2005*, spectators were invited to enter a reproduced waiting room, with chairs, a forlorn indoor plant, and a blinking number sign that never changed from zero; there they were asked to think about the number of places they had found themselves waiting. The pieces also varied in the indexical references to the human, ranging from the

metonymic index of the baggage or empty wheelchair to the representational mimesis of a mannequin. Probably the most discussed element of the piece was one whose indexical methods most explicitly invite the language of performance; in *Reg(u)arding the Guards*, Elmgreen and Dragset hired unemployed citizens (re-using strategies of "delegated performance" that appear in social practice ranging from Ann Carlson to Santiago Sierra to Francis Alÿs to Tino Sehgal and more), this time to wear guard uniforms and sit in chairs spaced evenly around a single gallery room.[37]

The opening of *The Welfare Show* in Norway was an oddly complicated form of homecoming. It came at a moment when Nordic governments were gradually developing different interpretations of a "third way," specifically "welfare for work" or "flexi-security" programs with varying degrees of benefits and varying degrees of perceived success. Elmgreen and Dragset reportedly tried to maintain an attitude of agnosticism toward these policies at the opening: "obliqueness is key: Dragset emphasized the pair's disavowal of didacticism to several inquiring visitors (his parents among them)."[38] Elsewhere, however, they indulged in the role of artist-as-policy-wonk to make clear their discontent with welfare principles—and with the fact that welfare-for-work had made its way to Germany:

> The piece developed partly from our own experiences with the welfare system in Scandinavia in the 90s. The Danes were the first to send people out in all kinds of ridiculous jobs in order for them to receive full unemployment money. Some of these jobs were absolutely meaningless and others were sort of hidden cultural subvention; a lot of cultural institutions took on staff from the unemployment office, but didn't have to pay for them themselves . . . This idea of working for your social welfare has later been widely exported—most recently in Germany, where they have created so called 1E-jobs. Most research shows that these initiatives do nothing to get rid of actual unemployment but in some cases cover up statistics and real problems. Everyone knows that it is impossible to keep up the economical models of today and at the same time believe in full employment, but somehow we are not meant to fully realise this. The absurdity of politics forms the rationale of this piece.[39]

In Norway, a small crowd at the opening included a delegation from the Office for Contemporary Art; "not keen on receiving the guards' undivided attention, everyone exited almost as quickly as they entered."[40]

But as a national event funded by an oil-rich nation seeking to develop its global cultural status, everyone in attendance had to be a good sport. At receptions and dinners—coinciding with the 100th anniversary of Norway's autonomy from Sweden—groups "chatted amiably about relative levels of Finnish and Norwegian melancholy, cultural isolation, and private sponsorship of public art."[41] The day after the opening "the Crown Prince and Princess were down the block to cut a red ribbon and inaugurate *The Welfare Show*. Word came back that prison food—literally—was served to the Royals at the officials-only lunch." [42]

A general sense of good, if somewhat bemused, humor circulated at the conference hosted by the Office for Contemporary Art Norway, one that invited art historians, economic scholars, and Norwegian politicians to engage in conversation, a gathering of such different perspectives that it seemed nearly every interlocutory offer was destined to misfire. There were the inevitable lay expressions of confusion endemic to policy-meets-art conversations. "But can't you explain it to a complete amateur?" inquired trade specialist and former Norwegian Minister of Labor Victor Norman of *The Welfare Show*. "Are you thinking of communicating with anyone?"[43] But within the awkward conventions of the post-show panel, the stumblings traversed and revealed intriguing questions. There were tussles between welfare researchers and politicians of different political parties: Victor Norman, a proponent of liberal democracy, offered his definition of welfare solidarity as "collective egotism if you like, or perhaps even selfishness."[44] In response, Norwegian sociologist Thomas Hylland Eriksen, critical of liberal democracy, pressed him further: "Exclusion is probably the main social problem that we are going to have in relation to trust, to solidarity, to support for the welfare system and so on."[45] Meanwhile, art theorists offered their own contextualization of *The Welfare Show* within histories of community art and social practice. When Peter Osborne worried that Claire Bishop was not sufficiently critical of the "megalomaniacal" instrumentalized use of "human beings within these installations," Bishop argued that panelists should be worrying more about art within state-based structures of instrumentalization that receive "prioritized government funding" rather than art staged in "the relatively neutral or staged confines of a gallery space."[46] For her, then, the constraints of government funding systems were clearly more worrisome than the "neutral" autonomy offered by gallery systems. The conversation became differently heated when Norman began to discuss the pragmatics of incarnating welfare ideals. When his ideal of "collective egotism" met questions of monetary distribution, he found himself concretizing social welfare's "mutual contract" by proposing certain casting policies and

fixed social arrangements. "What if we simply paid the people on disability pensions to drink their coffee and talk to people in homes for the elderly instead of doing it in the shopping centre? Then they would be doing a job." And it was with such an experiment in social arrangements—a policy wonk's relational aesthetics—that Dragset and Elmgreen began to bristle. Said Elmgreen:

> I think I consider the morality of participating in the work force very differently than you do. I was on social welfare for several years in order to put myself together as an artist. Because I never entered a heavily subsidized and very expensive art academy, my education was very cheap for the state of Denmark. What I am trying to say is that there are people who refuse to work and use their time in a productive way.[47]

Having alighted upon the puzzle of how to support aesthetic flexibility within a system of public security, the transcript records show a significant "Pause."[48] Marta Kuzma, the director of the Office for Contemporary Art Norway and the panel chair, stepped in politely to request a change of subject.

If targeting the constraining apparatus of a system of care was the genesis of the piece for a Norwegian context, things seemed to change, adapt, and compensate when moved to London and then to Toronto, where national debates on social welfare, pensions, labor, disability, and health care mixed strangely with an international art scene. It was in this move that Elmgreen, Dragset, and their curators could be found altering verbiage around the piece, now mixing a concern for public institutions in the midst of critiquing their constraints. It was in these contradictory and self-antagonizing responses surrounding the piece that we can see *The Welfare Show* as a symptom of a certain kind of melancholic position—one that shows, in Brown's words, the "psychic/social/ intellectual implications for leftists of losing a vexed object of attachment."[49] The welfare melancholic remains attached to an object, a system, a bureaucracy, and a support structure whose inadequacies he loves to hate. The ambivalence that surrounded the tour of *The Welfare Show* bespeaks a larger ambivalence as artists, intellectuals, and citizens announce their suspicions of the last vestiges of liberal democracy in the same moment that neoliberal models paradoxically help that critique along.

The lead up to the show in London included a high degree of wisecracking as critics anticipated that "this could probably rank with snuggling up on a sofa with the latest copy of *Understanding your Tax*

Code."[50] A Toronto critic would, by extension, worry that this "sounds pretty dull . . . About as exciting as *Newsnight* on a slow day"[51] Perhaps such Anglo-Saxon suspicion of bureaucratic reflection prompted Elmgreen and Dragset to sound the tones of a different kind of policy wonk than they had in Norway:

> It's scary how the term Public has become such a "dirty" word—something that makes people yawn and which is associated with dull and ugly spaces and heavy bureaucracy. Public should remind us of solidarity and acceptance but instead the neo-liberal economy has managed to give the terms such a bad reputation that most citizens today just think in terms of saving tax money and seem to be okay with the ongoing process of privatization . . . The control mechanisms of the welfare state—a construction built upon uniformity and regulations— have been its big failure. However these mechanisms don't disappear with the public responsibility just being handed over to private companies and initiatives. The structures of control remain the same since uniformity generates the lowest costs and biggest profit. This kind of fear blocks any progress. In the show we have tried to create a feeling of being trapped into a grey- and-white loop where you as an audience have very few possibilities of choice—a feeling of total powerlessness.[52]

Elmgreen and Dragset here thematized the turn to market rationality in the management of heretofore non-economic domains of life. They seemed to suggest that the solution to liberalism's public faults could not be neoliberalism's private speculation. What was interesting then was how this adjustment of discourse and goal—one that was now concerned over the loss of a liberal public institution, not only its limitations and encroachment—interacted with the perception of powerlessness induced by the antiseptic installation. Elmgreen and Dragset clearly hoped that a critique of "uniformity" was transferable between liberal democratic/ welfare states and neoliberal/capitalist systems, where the first was uniformity "with regulations" and the second was uniformity for the "biggest profit." What this adjusted concern about the rise of the neo- liberal economy did not quite track was how important the critique of uniformity is to enabling processes of privatization, one whose equivocations on "public responsibility" are rationalized by "flexibly" offering a way out of "uniformity" with more "possibilities of choice." In such a moment, Elmgreen and Dragset's celebration of "flexibility" within public infrastructures could ironically undermine the ethos of public

care; the representation of public welfare as antiseptically bureaucratic could indirectly support the fantasy of pleasurable privatization, one where social services could be purchased and consumed "by choice."

Elmgreen and Dragset managed changes in context by making changes to the pieces themselves, trying for a kind of touring-site specificity. In Toronto, they "altered signage on the Power Plant's iconic smokestack to read 'The Powerless,' suggesting that even the glossiest of public institutions is vulnerable."[53] In Norway, the mysterious door in *Social Mobility* had been labeled "Administration" and in London was changed to an exit/evacuation sign (see Figure 6.1). Moving from the oil-funded welfare models of Norway to a London that, in 2005, had just endured the Tube bombings, that door presumably invoked differently loaded associations of safety and security. The shift, however, from a welfare-based sense of security to a military one changed the resonance of the crumbling stairwell. Other critics wished that there had been more physical changes, noting that the "new face of Canadian institutionalism" was no longer an antiseptic space but a mimicry of "suburban house interiors of the 1980s: light oak plastic laminate, peach paint, and floral accents have been deemed more inviting than white walls, and polished

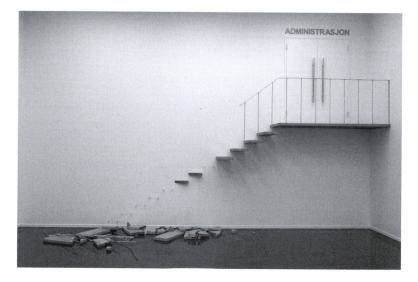

Figure 6.1 Michael Elmgreen and Ingar Dragset, *Social Mobility Fig. 1 (Administration)* Aluminum, wood, styrofoam, iron, concrete, pro-file lettering; first installation: 430 × 700 × 200 cm then: variable. Exhibited at The Welfare Show, Bergen Kunsthall, Norway 2005

Source: Courtesy of Galleri Nicholai Wallner. Photo by Thor Brødreskift.

steel, but in their overuse they have come to represent the new fact of institutionalism."[54] For this critic, the medical *mise-en-scène* might have been sharpened by replicating the homey relational style in which administrative care is currently offered.

More often, site-specific heterogeneity could be found in tracking shifts in reception more than shifts in the installation. To track such shifts is certainly not to offer a comprehensive picture of all possible responses to *The Welfare Show*, but it is to address Lynn Zelevansky's recognition that "the beholder" of contemporary art is never a single monolithic receiver.[55] Indeed, the variation in *The Welfare Show*'s reception exposes the structural ambivalences of the piece, ambivalences that bespeak larger ones as citizens reckon with social models that oppose freedom and constraint, desire and obligation, care and inconvenience. With melancholic equivocation, its reception shows this piece both reinforcing extant suspicions of welfare administration and simultaneously provoking its well-intentioned defense. Consider, for instance, one critic's response to *It's the Small Things in Life That Really Matter, Blah, Blah, Blah, 2005*:

> The work could allude to waiting lists for socialized heath care or be interpreted as social security or other public office. It is a generalized but potent comment on how much time we waste . . . Ask not for whom the queue waits: we are all diminished as we shuffle forward in a post office queue or hold for a response from a call centre.[56]

Such a response shows the piece eliciting the inchoate grumblings of anti-systemic individualization, one that sees the public systems as themselves oppressive. The sentiment does not know where exactly to pitch the blame, indulging the inconvenienced laments of "a flexible self" that wants care to come speedily, personally, and without the time-delaying "shuffle" of "bureaucracy." Such a response leaves unquestioned who exactly is "diminished"—the client wanting a response or the post office worker or call centre operator who maintains the system's operations? Exactly that question was posed by a Toronto journalist who worried that "The installation portion of *The Welfare Show* doesn't give justice to the extent to which those who staff and fund the system are themselves afflicted with burnout." Touring with her eleven-year-old, a largely un-ironic engagement with *The Welfare Show*'s catalogue provided the antidote, especially the C entries that included "Canada Pension Plan": "It highlights the arbitrariness of the actuarial models that are the basis of government and corporate finance of social and health care systems," she wrote, "and, by implication, reveals the fragility of these systems."[57] For this receiver, the catalogue was not pastiche.

Many responses were anti-rhapsodes to the feeling of powerlessness induced by entry into the environment. For one critic, certain mannequined aspects of the exhibit were overloaded with social concern. Criticizing *Modern Moses* and *Interstage*—"the commentary is far too literal and so the freedom the duo usually grant the beholder to roam is usurped"—he turned Elmgreen and Dragset's own discourse of flexibility back on them: "The most judicious of their works graft broader social concerns onto a critique of the gallery by way of presenting a thoroughly flexible scenario."[58] For Adrian Searle, however, the inflexibility was key to its unpleasant success:

> This is horrible. This is grim. These are the circles of hell or, if not, then a purgatory where the soul might die of indifference . . . a world of accumulated blank hours, of institutional anonymity, of boredom, trepidation, impotence and seething inner rage . . . part airport, part hospital, part day centre, part art gallery. They're all delivering a service and we are all customers now. Am I supposed to tell you, on a scale of one to 10, how satisfied I am?[59]

While for some, the expression of "horror" was an index of success, for others it indicated the failure of the piece. Probably no response exceeded the expression of disappointment more than that of another blog critic who came to find herself arguing against the whole principle of *The Welfare Show* as an art exhibit in the first place.[60] With critique after critique of each portion of the exhibit, she also showed her political stripes:

> [A]lthough *The Welfare Show* is free at the point of delivery, it really is absolutely free, in the sense that I was not being asked, or rather forced, to convey a large portion of my earnings to it in order to keep in action something I neither want for myself nor wish to impose upon others.[61]

She concluded her review urging her readers to consult the conservative and libertarian writers whose criticisms of the welfare state she found much more trenchant. Her response thus highlighted the ambivalent predicament of the piece. Its critical edge depended upon its ability to target liberal receivers for whom the compromised but still necessary goals of public welfare were a given. Receivers for whom those values were not a given could find their positions oddly reinforced.

The portion of the exhibit that provoked the most urgent and varied response was also the one that most explicitly deployed the techniques

of theatricality. In *Reg(u)arding the Guards*, Elmgreen and Dragset used the strategy of hiring unemployed citizens, this time to wear guard uniforms and sit in chairs spaced evenly around a single gallery room (see Figure 6.2). The curatorial staff in each venue found participants through advertisements at unemployment centers, and the cast size changed with availability. In Norway, twelve guards appeared from a rotating cast of thirty-six, whereas in London the cast was reduced to seven. Notably, the racial composition of the cast changed as well; a largely white group of men and women occupied the gallery in Bergen (Norway). A cast of mostly men of color occupied the Serpentine in London, and its photographic documentation now serves most often as an index of the piece as a whole. This use of "real people" in a "constructed situation" thus bore a more obvious relationship to the discourse of performance and to that of social practice in its deployment of persons and relations of exchange as the substrate of the art event. The Scandinavian—and Continental—context of the 1 Euro job might have prompted both the change in cast size as well as the different ways that the cast was received. The "meaningless" 1 Euro job was less resonant for receivers who lived in British or North American contexts, where

Figure 6.2 Michael Elmgreen and Ingar Dragset, *Reg(u)arding the Guards* (2005). Live installation, dimensions variable. Exhibited at The Welfare Show, Bergen Kunsthall, Norway 2005; Serpentine Gallery, London 2006; The Power Plant, Toronto 2006; "Surprise, Surprise," ICA, London 2006

Source: Courtesy of Serpentine Gallery. Photo by Thor Brødreskift.

even that provision was harder to find.[62] As a reduced, anti-relational relational exhibit, *Reg(u)arding the Guards* also varied in the brand of interaction it elicited. As noted above, Norwegian art professionals ran out of the room as soon as they walked in, but others lingered longer. The critic above who valued interpretive flexibility found it in this room, in part because the guards themselves were socially engaged: "occasionally plucking up the courage to make a pithy comment to an unsuspecting passerby. Their presence is intimidating but it is funny too."[63] For the "horrified" Adrian Searle, however, there was nothing humorous to be found in the depressing non-presence of the security guards: "they just sat there looking into space, like I didn't exist. Like they didn't exist either."[64]

At the conference sponsored by the Office for Contemporary Art Norway, Claire Bishop—the Anglo-Saxon critic most famous for her critiques of the social practice form—focused most intently on this portion of the exhibit:

> In Elmgreen and Dragset's installation the guards are themselves the focus of the observation. We watch them, watching us, watching them: guarding and regarding each other. This surfeit of care—there are more guards than necessary for an empty gallery—might lead us to consider, in the overall context of the exhibition, the excess concern of a welfare state. But this reading is strained and certainly not implicit in the work, which seems instead to focus on the intersubjective dynamic of our encounter.[65]

As should be expected from Bishop, this is a very helpful account of the relations of exchange made possible by this ambiguous situation of *The Welfare Show*. At the same time, it seems strange that the question of the piece's relation to welfare is so easily side-stepped. How could a reading of welfare be "strained" in a piece titled *The Welfare Show*? Is there a concern that finding such a reading might compromise the piece with an undemanding literality? If, as she noted above, government funding priorities are themselves more intrusive than market ones, do the resonances of "welfare" have to be kept at bay to preserve the art's legitimacy? If welfare is read as a "surfeit of care" and a site of "excessive concern," its heteronomous encroachment threatens to unsettle the gallery's "neutral" autonomy. In hiring unemployed people, this was a de facto engagement with people of "different economic and ethnic backgrounds," but for Bishop, its aesthetic integrity depended upon its ability to transcend such references.

Finally, in the ambivalences of its presentation and the ambivalences of its reception, *The Welfare Show* mimicked the flurry of irreconcilable principles and affects that afflict contemporary discourse on social structure. From a certain angle, it cultivated the radical agenda of a critical left, emboldened by a reading (or mis-reading) of Foucault, one that mistrusted the bureaucratized legacies of Old Left social structures. Given the easy slippage, however, from anti-bureaucratic skepticism to neoliberal individualism, the piece and the verbiage surrounding it seemed to teeter around this critical agenda. The pieces, the publicity, the interviews, and the accompanying texts all clustered as back-formations around each other, shuttling between critiques of welfare's instrumentalization and the dangers of not having a welfare system at all. The denizens of *Reg(u)arding the Guards* seemed to crystallize the conundrum in their sentient sculpturality, one that threatened to join the complex dyadic, interpersonal interactions of gazing and being gazed upon to larger systemic questions about power and powerlessness in the spatially encumbered, temporally ambiguous, interpersonally contingent experiment that might be called social welfare. As Mierle Laderman Ukeles's *Transfer* proposed three decades earlier, museum guards inhabit that paradoxical place in a system of care, both charged with protecting and experienced as constraining viewer spectatorship. They also are cast as functionaries in a system of surveillance but are themselves relatively weak as agents within it—powerless structures indeed. Finally, these performers were all unemployed, that is, they were individuals who might receive some form of public allocation. Whether or not they would or should seemed to be the systemic question to be asked in this unnerving personal exchange. As they stared, mumbled, shifted, or—in several notable cases—ran out to the toilet, the intimacies of intersubjective encounter both structured and were structured by the cumbersome claims of systemic reflection. But finally, and curiously, the ambivalence of the piece is also present in what we do not find, that is, we do not find sustained reference to the racialized composition of the unemployed in statements about this portion of the piece or in its reception. Perhaps a certain degree of racial privilege underpins a critique of welfare's normativity. Its provisions are more easily dispensed with when one is not in need of its resources, even if one once relied on them "in order to put [one]self together as an artist." Elmgreen and Dragset did include "Racism" as a term in the catalogue, excerpting from Allan Pred's *Even in Sweden* as a reminder of the prejudices and blindspots of apparently harmonious societies.[66] But if, as Hylland Eriksen had said, "exclusion" is the greatest threat to the dream of welfare solidarity, then it was curious that *The Welfare Show* itself did not reckon with the racial asymmetries

of different welfare models. As the racially marked photos from Serpentine Gallery circulate internationally, that asymmetry is reinforced, all the more so for going by without remark.

Too Late

The ambivalent contexts and effects of *The Welfare Show* provide more complex frames for returning to the 2008 pieces that opened this essay. Coinciding with the October opening of the Frieze Festival, *Too Late* and *Drama Queens* addressed an anxious milieu (see Figures 6.3 and 6.4). In October of 2008, British and international newspapers all around the world could speak of nothing but "the financial crisis" afflicting the investment banks and financial institutions run by the same social class that normally buys the art world's art. One art blogger wondered whether any artist would

seize the moment by creating something or a situation that provokes global artistic thought on a par with the original Frieze

Figure 6.3 Michael Elmgreen and Ingar Dragset, *Too Late—(Un)Lucky Strike* (2008). Installation: sofa, disco ball, 2 glass tables. Dimensions 80 × 360 × 367 cm, 31.52 × 141.84 × 144.6 inches. Exhibited at "Too Late," Victoria Miro, London 2008.

Source: Courtesy of Victoria Miro Gallery. Photo by Cameron McNee.

Figure 6.4 Michael Elmgreen and Ingar Dragset, *Drama Queens* (2008),
performance-for-sculptures with text by Tim Etchells, artistic director
of the Forced Entertainment theatre group. Exhibited at Skulpturen
Projekte Münster 2007; Städtische Bühnen (Play) + Landesmuseum
Münster (Video); Theater Basel, Art Basel 2008; Old Vic, London
2008.

Source: Courtesy of Michael Elmgreen and Ingar Dragset. Photo by Roman Mensing.

exhibition curated by Damien Hirst twenty years ago that was
actually facilitated by the capricious nature of the art market
and the economy at that time.[67]

London newspapers and blogs began to trot out twenty-five-year-old copies
of the notorious Labour Manifesto. That manifesto was, at the time of
the first Frieze exhibit, understood to be the "longest suicide note in
history," but its 1983 platform for economic regulation and social pensions
now sounded kind of good after all to those feeling the effects of having
refused them. The caprices of the 2008 economy were of a different nature
or, depending upon one's perspective, made visible the darker side of a
capricious system that trades in a de-referentialized brand of speculation.
Whether imagined as a system that exchanges art objects or one that
exchanges credit swaps, however, there is usually a moment when the
referent rears. With Société Générale's scandal being tried and the collapse
of Iceland's economy just around the corner, this was one of them. Various
members of the art world prepared to "expect the worst."[68]

If "performance" was something that Elmgreen and Dragset felt that they had to give up in order to be taken seriously as gay male artists, then the creation of *Drama Queens* marked a different kind of return to the form. Like other recent commissions for theatres, this performance piece was wholly different from their knitting pieces; it took place in a theatre rather than a gallery and by virtue of that location, labeled itself a "play" rather than "performance art." In a literalization of Michael Fried's castigation of Minimalist sculpture, *Drama Queens* turned "the silent presence of another person" into a noisy, populated stage. Elmgreen and Dragset hired Tim Etchells, director of the British experimental theatre company Forced Entertainment, to write a script that embodied as characters seven iconic art works: Giacometti's *Walking Man*, Hans Arp's *Cloud Shepherd*, Barbara Hepworth's *Elegy III*, Sol LeWitt's *Four Cubes*, Ulrich Rükriem's *Untitled (Granite)*, Jeff Koons's unstoppable *Rabbit*, and Andy Warhol's *Brillo Box*. The text alternated between group dialogue and caricatured soliloquies that repeated art critical statements as the internalized monologue of a sculpture. Says Koons's Rabbit, "They said I was nothing, an empty gesture, a superficial if kind of clever decoration. Others said that I embodied a devastating critique of the economy of the superficial."[69] The show was oddly advertised as "a play *by* Elmgreen and Dragset" with text by Tim Etchells. I say oddly from the perspective of a theatre producer who might assume a production of a play to be "written" by Tim Etchells, perhaps "directed" by Elmgreen and Dragset; as such, the collaboration reproduced visual art conventions of authorship in lieu of theatre's distributed conventions of artistic crediting.

The piece, which had been performed earlier in Münster as well as other sites, was a fundraiser for the Old Vic. In joining celebrity actors (Jeremy Irons, Kevin Spacey, Joseph Fiennes) to celebrity art markets, the hope was that theatre could cash in on some of the art market's residual revenues—before realizing that an economic crash would make the gesture "too late." The night's event made use of another artworld convention—the auction. Celebrity artists, curators, critics, and collectors gathered in the audience to laugh at the play's inside jokes—whose references they knew better than any standard theatre subscriber—adjourning afterward to watch the auctioning of an Elmgreen and Dragset sculpture to benefit the Old Vic. In what might be a sign of the limits of mixing, but probably of the financial crisis more generally, the sculpture failed to meet its £35,000 target. As the auctioneer's gavel pounded to give one buyer the piece for £25,000 instead, Tracy Emin—the British female artist famous for self-exposure and her own imbrication in other fundraising scandals—arose to promise a suite of drawings that

commemorated the evening. The artist Chantal Joffe bid £10,000 for them, thus making sure that the Old Vic had met its financial goals through an artist-to-artist to artist-to-theatre network of economic reciprocity. Elmgreen and Dragset also created a "limited edition" signed print on the occasion of the Old Vic's *Drama Queens* event. . . . *And The Moon Shines On, 2008* shows silhouettes of Walking Man and Rabbit enclosed inside the circle of a white moon and the square of a black background. It could be purchased through Victoria Miro.

As if itself a commentary on the Sunday night performance at The Old Vic and the struggles of its auction, *Too Late* opened the next day a few Tube rides away at the Victoria Miro Gallery. Offering the "mental image of a party that is already over," *Too Late* had an acute resonance when sited in London at a high-rolling, star-studded art fair.

The anxiety about the cessation of a financial circuit coincided not only with anxiety about the support of art-making but also with anxiety about the maintenance of a party circuit. *Too Late* was poised to give visitors a space to linger in the dregs of excess. With a disco ball spinning, and spilled glasses scattered, the space wallowed in its own hangover. The effect was another version of the form of "denial" at which Elmgreen and Dragset's un-relational aesthetic excels, replicating a space that dreams for a certain sociality while refusing to offer it, making highly marked social spaces exceedingly lonely. *Too Late* was both an enactment of durational art and its plasticization, a reference to time on the clock and to the metaphysical question about whether past gambles could be undone. *Too Late* thus positioned the party atmosphere of the "art fair" as itself the new object of institutional critique. At Frieze and other artworld sites, the institutional enmeshment of the artist does not occur at a board meeting as often as it does a party; art institutional power exerts itself over cocktail napkins as much as over contracts. The party scene of *Too Late*'s artistic *mise-en-scène* thus troubled the relational turn in art. Here, a relational aesthetic was not so much a counter to hierarchical institutional power, or even a benign escape from it. The convivial relation is in fact the very site of artworld authority, where speculative interpersonal exchange energetically propels the next speculative market exchange. With *Too Late*, Elmgreen and Dragset held up a mirror to the hierarchical conviviality of the art world; a lonely but inaccessible "VIP area upstairs" played music, "but only as a distant sound like a teaser from a place to which we (as ordinary guests) are denied access."[70]

While unclear whether *Drama Queens* or *Too Late* counted as the signature work that responded to the market precarities of London in 2008, they stood in kinship and as counterpoint to the twenty-year-old interventions of Damien Hirst, producing an art context that mirrored,

however misshapenly, all kinds of anxiety-ridden reflection about whether past mistakes were coming home to roost, whether something could be done, whether it was in fact too late. In tracking Elmgreen and Dragset's work, from knitted pits to *Powerless Structures,* from the immanent critique of liberalism in *The Welfare Show* to the immanent critique of neoliberalism in *Too Late,* we do not find definitive visions of new social utopias. What we do find is an ongoing meditation—sometimes playful, sometimes horrific—on the perils and possibilities of systemic imagining. Symptomatic of the neoliberal identifications pervasive in the period in which their art work has flourished, the years between *The Welfare Show* and *Too Late* both avow, forget, and then avow again the social, and sociable, embeddedness of the artists themselves.

In preparation for a project that would take similar shape in León, Spain, after Frieze, their *Art Review* text recorded—in journal-cum-blog tones:

> The coach is full of men who didn't get any sleep last night. They've all been making art . . . Just a few leftovers from a real party, a couple of balloons, a few bottles, a broken chair, scattered flyers on the ground. Nothing spectacular, but everything, every little scrap, will be cast in bronze, and painted in realistic colours. A day after that lasts for ever.[71]

Such a project thus began as a highly embodied multi-subjective exchange, even if it ended in a petrified sociality. While the text interspersed plenty of diatribes against "middle class" values and the "bourgeois" families from which these artists escaped, there was enough indulgence in narratives about the cosmopolitan lives of hotel-hopping artists at Prada weddings for the reader to notice the political and economic impurity of Elmgreen and Dragset's personal "escape." "We feel pure joy, and then a moment's panic: how long can this last? This has been strangely familiar feeling, actually, over recent years." This vaguely precarious feeling, underlying dread amid the celebration of riches, continued to bubble, anticipating a burst ". . . And the sales! . . . the last decade has seen no downturn in the art market, in spite of all other economic sectors behaving like rollercoasters. How long is this party gonna last?!" This space of subsidized revelry was fixed and fetishized, both by the affect of dread and by the bronzification process itself. In such statements, couched as readymade diary entries for a wider reading public, Elmgreen and Dragset displayed their enmeshment within the speculative life of a *homo economicus-cum artist.* Implicitly, they also revealed the neoliberal economic identifications on which their

previous critiques of liberalism's "powerless structures" had depended. No doubt it was not the first time that a radical critic of liberalism turned out to have its own neoliberal investments. Intriguingly, the allure of a seemingly unfettered construction of self—whether it was resisting bureaucracy, schmoozing at a party, or selling a piece of art—seemed to be accompanied by a certain kind of dread. The pleasures of escaping the constraints of one supporting apparatus were still dependent upon the precarity of another. Indeed, Elmgreen and Dragset's most consistent contribution might be their recognition of the precarity of the individuated biography to which they and we are pleasurably tied.

To be tied to such pleasures, however, is also to be tied to new ambivalences, risks, and precarities. Sited at Frieze at a moment when biographies were reportedly breaking down with repossessed homes and bankrupt banks, the transformation of July's sociality into October's petrification created a piece that, at the very least, achieved the modest but important goal of responding to its moment. Perhaps it was because of 2008's renewed interest in Scandinavian liberalism that Elmgreen and Dragset agreed to another (parodic) homecoming, accepting Daniel Birnbaum's invitation to curate both the Danish and Nordic pavilions at the Venice Biennial. Linking the two "houses," they staged an oblique narrative of a dysfunctional family who lived next door to a gay male wealthy collector, one whose body floated face down in his pool. And it was perhaps that same set of interests that prompted them to put a different title on the "after-party" that they made for MUSAC in León. Advertising itself as another reflection on the "problems we face when a voracious public sphere encroaches on the private," its title was actually far more ambivalent: they called it *Trying to Remember What We Once Wanted to Forget*. As if hoping that it was *not* in fact "too late" to remake the "voracious public sphere" that they had wanted to forget, Elmgreen and Dragset's reflections on selves and structures continued with the unabashed intensity of a welfare critic's melancholia.

7

UNFEDERATED THEATRE
Paul Chan Waiting in New Orleans

His whole oeuvre is a Sisyphean labor to reconcile his highly cultivated and subtle taste with the crudely heteronomous demands which he desperately imposed on himself.

Theodor W. Adorno
on Bertolt Brecht[1]

I am allergic to working with people.

Paul Chan[2]

In 1937, the Federal Theatre Project housed within the Worker Progress Administration of Franklin Roosevelt's New Deal government presented one of its most venerated newspaper theatre productions, *Power*, at several US sites such as Seattle, New York, Chicago, Portland, and San Francisco. In the opening image of a New York production on the importance of public utility regulation, two electricians and a stage manager took the stage when a voice on a loudspeaker said, "This is the switchboard of the Ritz theatre. Through this board flows the electric power that amplifies my voice, the power that ventilates the theatre, and the power that lights this show." The stage manager picked up a fat cable on the stage and, looking out at the audience, declared, "It all comes through here."

In November of 2007, hundreds of New Orleans residents and community activists, along with an array of New York-based art critics, producers, and curators, walked past street blockades in the Lower Ninth Ward to find a place on temporary risers to watch a site-specific production of *Waiting for Godot* (see Figure 7.1). The playing space was illuminated by lights installed behind them, powered by a portable generator. Beckett's Gogo, Didi, Pozzo, and Lucky ambled in and out of an illuminated playing space sited on a neighborhood block

Figure 7.1 Paul Chan, *Waiting for Godot in New Orleans* (2007): Audience
Source: Photo by Tuyen Nguyen.

of abandoned houses and occupied FEMA (Federal Emergency Management Agency) trailers. At one point in the production, Didi turned to his fellow actors and the assembled crowd to call out, "At this place, at this moment in time, all mankind is us. Let us make the most of it. While we have a chance, let us do something, before it is too late."

In many ways, these two examples make an improbable pairing. Separated by seventy years, the first is a federally funded and federally organized theatre project engineered by hundreds of collaborators on federal relief. The second is a project organized by a high-end artist in the mixed-economy of an under-funded world of public art and an under-funded world of public relief. I am interested, however, in using the Federal Theatre Project as a starting point for reflection on Paul Chan's *Waiting for Godot in New Orleans* by virtue of the fact that they both use theatrical forms to support what I have been calling an infrastructural aesthetic. Paul Chan's work continues an exploration of socially engaged, cross-disciplinary performance projects in which social goals and aesthetic forms have a kind of structural coincidence. As we have seen in other projects, the effect of this coincidence is often to make the public and material contingencies of everyday existence sensible to those who might otherwise experience themselves "privately" as non-contingent, as auton-

omous, as unfettered. Performance turns up as a vehicle for exposing the non-autonomy of persons and the interdependencies of worlds, a task that was important to many global citizens before the risky interdependencies of our so-called "neoliberal" financial structures were exposed. To the extent that such models of risk were also based in a conception of subjectivity that equated "freedom" with "freedom from regulation," this seems an opportune moment to take a breath, perhaps to reconsider the public dependencies and structural contingencies on which a different definition of "freedom" might rest. By exploring *Waiting for Godot in New Orleans* in a tenuous legacy with the WPA (Works Progress Administration) as well as with other visual art and community performance legacies, I continue to ask what socially engaged performance means in our contemporary moment, one where the hope of finding a single power source is no longer entertained. Indeed, it is at this point that the very different aesthetic choices of these projects come into high relief. The 1930s play had an emboldening certainty about its ability to locate power where it was most corrupt, an action that simultaneously sought to channel the literal and metaphoric energy of public power. In post-Katrina New Orleans in 2007—under George Bush, Jr. and post-Foucault—the reliability of any interpretation of power and its public was under question, making Didi's plaintive call "to do something" both urgent and belated, temporarily galvanizing and also a little bit quaint.

To speak of the social role of the arts also brings forward a variety of ambiguities and puzzles that have emboldened and plagued socially engaged art debates throughout the twentieth and twenty-first centuries. To imagine a conversation here across the fields of aesthetics and civic infrastructure is also to recall the myriad conversations that have occurred—and not always gone well—between civic planners and artists who are not sure that they want to be part of a civic plan. To imagine an infrastructural aesthetic is not only to take a community stance on the arts but also to take an aesthetic stance on community engagement; it asks what the aesthetic frame does to and with the idea of community and what the aesthetic process does to and with social processes. As in other projects analyzed thus far, such a pursuit means contending with some new versions of old questions that have afflicted the discourse of twentieth and twenty-first century aesthetics, tacking around one model that sees art as a vehicle for the consolidation of community and another that would seek to resist such consolidation at every turn.[3] My goal is to offer a different tack around the instrumentalizing risks of "community engagement" by focusing on the formal and material attributes of socially engaged art, joining conceptual questions about the contingency of the

art event to conceptual questions about the contingency of social interdependency. When I think about a performance of *Power* in the 1930s, for example, I find myself trying to give a kind of formal attention to elements of its social history. In the Seattle production of *Power*, the publicly owned City Lights company donated extra spotlights for the production. When that same public utility company allowed the production to use their lampposts ubiquitously installed throughout the city to advertise the production, an infrastructural consciousness happened in two directions, making this oft-unregistered public instrument into a signifier while simultaneously extending the signifying reach of the play into civic space. Indeed, coinciding as both instrument and signifier, support and sign, the signifying posts prompted recognition of the wider system in which taken-for-granted elements such as light and energy are embedded. Such coincidences of social function and aesthetic gesture exemplify the spontaneous Constructivism at work in the Federal Theatre Project. It is also an example of social goals and aesthetic forms having a structural coincidence, exposing the contingency of the social in the same moment that the contingency of the art object is exposed as well.

It is easier to speak of social interdependency in times of natural disaster and at times of economic depression. It is also in such times that an infrastructural aesthetic finds a readier audience. But if Ulrich Beck is correct in his assessment of the risk society, such audiences retreat when memories of collective need fade and opportunities for individual gain rise. For the most part, a pervasive "individualization" has encouraged humans to fabricate what Beck calls "do-it-yourself biographies, elective biographies, risk biographies"[4] that encourage people to pursue individual solutions to systemic problems. "The crucial difference is that modern guidelines actually compel the self-organization and self-thematization of people's biographies."[5] Michel Feher goes one step further in a *Public Culture* essay by noticing how much such do-it-yourself biographies are cast within the language of investment and speculation.[6] For both Beck and Feher, risk is taken on by individuals in the hopes that "appreciation" accrues; the precarities and shortfalls of such do-it-yourself biographies are in turn born by individuals as well: "your own life—your own failure."[7] Interestingly, for both Beck and Feher, the solution to this mix of contradicting neoliberal systems is not precisely to call for a "return" to "collective" models but rather to find different ways of mobilizing the individualizing effects of the neoliberal condition. They thus join but attempt to modify discourses of "the third way" that, after Anthony Giddens, have wanted to bypass the socialist/ capitalist polarities. Here is Feher at length:

In terms of discursive strategy, neoliberalism can boast two major successes: its promoters have made it legitimate to want to care for oneself while presenting themselves as the champions of personal responsibility (insofar as their policies identify self-appreciation with self-reliance). Their leftist opponents, by contrast, are accused of making people feel unduly guilty (by implying that the desire to value oneself is mere egoism) and, at the same time, of fostering complacency and irresponsibility (by allowing people to rely on social benefits rather than on personal effort and by making self-appreciating citizens pay for those who have squandered their human capital). Thus it may be that for the Left, challenging neoliberal modes of self-appreciation, rather than rejecting the framework of the neoliberal condition, is not only a sound tactical move. More decisively, it may also be a way of warding off its current melancholy by means of reentering the domain of the enviable and desirable—of raising, from its own perspective, the question of what constitutes an appreciable life.[8]

For anyone reckoning with our contemporary assemblages of old and new socio-economic models, it seems important to learn to address subjects hailed by prevailing neoliberal systems of self-appreciation. Moreover, as someone who comes from theatre and the arts where the actor's reputed narcissism exists in tension with theatre's reputed social collectivity, I am interested in thinking about what Feher's challenge could mean for a contemporary art world that is motored by speculation and investment. How does it square with our understanding of the political economies in which art-making occurs? Does socially engaged art require a return to collectivized models of art patronage? Or is there a way to deploy the art world's neoliberal processes of market appreciation for a different kind of end? After all, to many theatre historians and art historians more generally, the fusion of art and politics found under the umbrella of the Works Progress Administration—or other sites ranging from Soviet Constructivism to CETA (Comprehensive Employment and Training Act 1973) service learning—now seem like instrumentalized propaganda. In the words of Adorno cited in my epigraph, they compromise the "pristine" autonomy of art with what he elsewhere calls their "Sisyphean" "heteronomous demands." Indeed, the certainty with which WTA murals, plays, easel painting, and photography assert the importance of public involvement in matters of housing, food, education, health, utilities, and transport reads to many now, not only as "left" on the political spectrum, but as anachronistic

and theoretically naïve in its lack of irony. Meanwhile, contemporary artists and art critics have made new attempts at social and aesthetic integration—routes that seek to avoid some of the encumbering hazards of state-based aesthetics. The Duchampian legacy of the readymade is touted and questioned as a resource for exposing institutional operations. Minimalist incorporations of spectatorship point to and withdraw the possibility of social engagement. Developments in "institutional critique" or "relational aesthetics" have proposed challenges that have been unevenly re-absorbed by the service economies of a high-end art market.

It is in fact these artistic movements—often glossed in art histories that recount movements—"*from* Minimalism *to* relational aesthetics"—that most occupy the art worlds, journals, and galleries in which Paul Chan is located. Indeed, precisely because Chan has such cachet within today's high-art systems, his community engagement in post-Katrina New Orleans is a particularly interesting puzzle. Tim Griffin, the editor of *Artforum*, lauds Paul Chan's engagement in New Orleans as one of the best projects of the year, arguing that an anxiety-ridden distrust of social practice within the gallery system means that "many artists are seeking venues beyond the conventional circuitry of the art world . . . to obtain a renewed sense of relevance."[9] Why, this chapter wants to ask, did leaving artworld circuitry mean entering a theatrical circuit? What does it mean that a visual artist's engagement with the social simultaneously involved an engagement with the theatrical? And how, furthermore, does that social, cross-medium engagement offer an opportunity to consider the relay between the conventionalized "autonomy" of the solo visual artist and the conventionalized "heteronomy" of the collectively theatrical? There is a question in all of this about how we will re-calibrate relations of autonomy and heteronomy, freedom and security, in the next phase of our social life; for me, that question will also affect how we calibrate relations of autonomy and heteronomy in visual art and theatrical practice. Paul Chan's *Waiting for Godot in New Orleans* seems an opportune moment to think these two domains together.

Scenes

Under a certain principle of artistic crediting, the idea for Beckett in New Orleans belonged to New York-based artist, Paul Chan; his project's complete title was *Waiting for Godot in New Orleans: a play in two acts, a project in three parts*, a titling that mixed the sensibility of modernist drama with that of task performance. Born in Hong Kong and raised primarily in Omaha, Nebraska, he has been trained and employed by

various art schools, including Bard and the School of the Art Institute in Chicago. Chan's art works are owned by wealthy private collectors— Dakis Joannou, David Teiger—and are held in the permanent collections of the Museum of Modern Art, the Whitney Museum, the Walker Art Center, among others.[10] He has had group and solo exhibitions at the MoMA, the New Museum, the Carpenter Center, the Serpentine Gallery in London, and more. Chan also has what he defines as a separate life as an activist, working with anti-war and anti-globalization movements, including groups such as Chicago's Voices in the Wilderness. Much of his visual art work makes use of a "low tech form of digital rendering"[11] reinventing earlier bit-mapped shapes of video games with what one critic calls a "formal bravura" that deploys an "almost Matissean dissociation of his dazzling color and supple line."[12] At times, he wryly re-uses the degraded popular digital imagery found on marketing websites as the basis for his aesthetics. In repurposing the Flash ad form, he notes that "Brecht had it right (this was one of the few times) when he said one should start with the bad new things, not the good old things."[13] Such a re-use of bad new things also seems to drive his decision to re-use Microsoft Windows screen graphics in one piece or the tone range of a Mac Powerbook to create the soundscape of another or to re-use law enforcement software to render images for his 2000 piece *Let Us Now Praise Famous Leftists*.[14] His works draw from an array of sources, creating juxtapositions of apparently unlike references to find shared preoccupations of form and content. *Happiness (finally) after 35,000 years of civilization*, for instance, combined the differently utopian images of outsider artist Henry Darger with those of Charles Fourier. Produced in a limited edition of six, this piece solidified the interest of the Greene Naftali gallery, which now represents him. Greene Naftali sold all of them, including one to David Teiger who in turn donated it to the MoMA.

While Chan is known for his continual insistence on the separation between his aesthetic and political life, a varied array of politically inflected works suggests that this declared separation is less a description of reality than a symptom of an animating tension. In 2004, his creation of a map-cum-handbook-cum-artist book called *The People's Guide to the Republican National Convention* prompted a surprise studio visit from plainclothes government detectives.[15] Other socially preoccupied works include *Now Promise Now Threat*, a single-channel video, conceptual documentary that used his Nebraska birthplace as a starting point for thinking through the unexpected lines of connection across religion and politics within so-called "Red State America." A single-channel video *Re: The_Operation* was an activist piece against the war in Afghanistan,

filled with bloodied images of Bush administration officials. In parallel with his anti-war activism, he entered Iraq to protest economic sanctions and document Iraqi life, an action for which he was charged in federal court and defended by Bill Quigley, an experience emblematized in a video piece *Baghdad in No Particular Order*.

Chan attributes much of his desire to become an artist to an early fascination with Samuel Beckett. He recalls his high school days in Omaha, Nebraska when he saw three short Beckett plays performed by a new theatre company in his town:

> I didn't even pretend to understand it. I probably still don't understand it. But the combination of the cadence and the rhythms of the words coming at you, and the space and the lighting—it encompassed a nether world that I had never imagined and couldn't imagine anyone imagining. I was just gone.[16]

Much of his work has since made use of a Beckettian landscape, as if he has been in a long-term process of developing a digital set design for *Waiting for Godot*. *My Birds . . . Trash . . . the Future* (2004) re-arranged and placed in motion Beckett's signature elements—bicycles, birds, wires, telephone poles, eyeglasses, and other small objects that are only partially referential—walking the line Beckett routinely walked in his unstable, non-biographical use of objects conventionally used to stabilize characters biography. *My Birds . . .* also includes an abandoned iPod and Biggie Smalls references to expand the list of partially referential associations for the twenty-first century. All five editions of *My Birds . . .* have been placed by Greene Naftali in major collections.

Most recently, Chan has moved away from making what he and other critics have called "window pieces"—that is, projections held within a frame—though the preoccupation with Beckett remains. His *The 7 Lights* projects are created with so-called "windowless light," an organization of lighting that calls attention to the naturalized deployment of light in the gallery by theatrically de-naturalizing its effects. I mean the theatrical term in the theatrical sense, not only visual art sense, for the pieces are designed versions of lighting templates akin to those that carve light in a theatrical scene. Projected silhouettes of Beckettian detritus appear angled across a mostly darkened gallery space, laying themselves over the spectators that pass in and around it, themselves watched by the others who serve as spectators until they themselves pass as well. As someone who has a skeptic's fascination with Christianity, his work—again like Beckett—makes unorthodox references to biblical

creation tales and to the Christian concept of Rapture. In titling his works, notably *The 7 ~~Lights~~* but others as well, certain words are graphically crossed out. As he has told several critics, the cross-outs graphically isolate his fundamental interest in juxtaposing light and shadow, or—as he defines it—light and "light struck out."[17] The conceit echoes biblical creation myths: On the first day, God made a lighting plot. Indeed, the lighting designer's *métier*, one whose artistry is typically subordinated in the theatre to the writerly or directorially defined vision of the theatrical event, is here isolated and itself the subject of contemplation. Fortified by the lingering spectatorial habits of the gallery space and by singularizing signatures of the visual arts market, Chan's creative manipulation of lighting is given an individuated recognition that it rarely receives in theatre's collectivizing habits of artistic crediting. That convention of individuated recognition would find itself challenged but also alternatively deployed in a site-specific production of a Beckett play in New Orleans, reminding us of the tradition of windowless lighting in the theatre. In this case, *Waiting for Godot in New Orleans* would eschew the halogen lighting of a gallery as well as the gels hung from a theatre building's ceiling, moving outside to manipulate oversized theatrical spotlights . . . precariously plugged into a temporary power generator.

Katrina's Aesthetics

The aftermath of the unnatural natural disaster of Hurricane Katrina was another moment, like the Great Depression, when groups of Americans had the impulse to recognize themselves as infrastructurally contingent beings. As varieties of voices called out for FEMA, as George Bush helicoptered in to engage in a bit of what *The Nation* dubbed "FDR drag," Americans asked themselves whether their tax dollars were being put to work—or whether war spending as well as more recent tax reductions meant that no domestic tax work could be expected.[18] The media spectacle of the predominantly lower-class and African-American populations who huddled in Superdomes or perched on rooftops watching the dead bodies of their neighbors float by, exposed the racial asymmetry of federally based networks of infrastructural support and, in the words of Ruth Wilson Gilmore, "infrastructural abandonment."[19]

As many historians of the 1930s have shown, that distributive inequity was systemic to the New Deal and exacerbated exponentially during its late twentieth-century neoliberal dismantling. Meanwhile, the displaced Latino populations did not even receive the dubious distinction of being part of that media spectacle.

As implied earlier, Chan's work is not so much a representation of reality as it is an exploration of the odd, disconcerting moments when "reality" mimics the impossible scales and irreconcilable juxtapositions of art, whether in the glorious colors of a post-nuclear sky or the ashen layer that seemed to transform the detritus of 9/11 into sculpture. When Paul Chan accepted an invitation to speak at Tulane University in 2006, he found the landscape of post-Katrina New Orleans to be troublingly resonant. Its serial stacks of ruined furniture, its infinitely meandering streams of evacuating cars, its surreal substitution of water for ground in the "ground plane" of the landscape—all provoked an uncanny inversion; we are not so much struck by the accuracy of the representation of reality as we are shocked by the unreality of the real. Such a shock seems to have been at the origin of *Waiting for Godot in New Orleans.* As recounted at the New Orleans Community Bookstore store, in *The New Yorker*, for *The Drama Review*, and in many other sites, the idea for the project began when Chan was given a bus tour of New Orleans with Common Ground volunteers. What he saw was a landscape of "wholesale contradictions."

> Some neighborhoods, like the one around Tulane, seemed virtually untouched by Katrina. But in the Lower Ninth Ward and parts of Gentilly, the barren landscape brooded in silence. The streets were empty. There was still debris in lots where houses once stood. I didn't hear a single bird.[20]

His description conveys the uncanny sense of an improbable environment, as if reality was missing a soundtrack:

> The streets were still. . . . Friends said the city now looks like the backdrop for a bleak science fiction movie. Waiting for a ride to pick me up after visiting with some Common Ground volunteers . . . I realized it didn't look like movie set, but the stage for a play I have seen many times. It was unmistakable. The empty road. The bare tree leaning precariously to one side.[21]

Describing what he (and André Bazin) called the "hallucination"[22] that was the reality of the tour, Chan found himself using a formal language to make sense of it: "there was a terrible symmetry between the reality of New Orleans post-Katrina and the essence of this play."[23] This symmetry would undergird the central proposition of the work.

To decide to stage *Waiting for Godot in New Orleans* was to place oneself, unwittingly or not, in a larger context of social and aesthetic engagement. Long before Katrina, New Orleans has been the site of renowned community art practice and what a variety of scholars, artists,

and focus group coordinators call "theatre for social change," a network that compensates for the un-federated nature of theatre-making in the US now. New Orleans has a historic role in joining theatre to the civil rights movement, notably in the Free Southern Theatre co-founded by Black Power and SNCC (Student Nonviolent Coordinating Committee) activists such as Tom Dent and John O'Neal in the sixties to offer theatre to Southern, rural, mixed-race audiences who did not have it. Later, after O'Neal founded Junebug Productions, the social uses of the theatrical medium continued in projects for communities of all ages and races. The Crossroads Project of New Orleans has similarly oriented the arts toward community building, using not only theatre but also the socially extended processes of other art forms in murals, puppetry, and installation to forge community, a process instrumentalized under their signature CRAFT process (Contact, Research, Action, Feedback, Teaching). After Hurricane Katrina, Crossroads and Junebug adapted their techniques to the new situation, using the techniques of story-gathering familiar to many a community art practitioner. Junebug organized what community theatre activists call "story circles," using the voices of victims and government officials, the elderly and the young, and representatives of different racial and economic groups to devise multi-vocal performances. Similarly, groups such as the NOLA Project under the direction of Andrew Larimer, the HOME projected co-founded by Jan Cohen-Cruz, Willie Birch, and Ron Bechet, and O'Neal's Free Southern Theatre Institute have been imagined as a multi-institutional collaborations between university, social, and artistic organizations both to tell individual stories and to install sustainable, cross-sector relationships over time. From this angle of community arts activism, then, there is a certain improbability in the idea of presenting *Waiting for Godot* in New Orleans.[24] The project in many ways violates the processes of social interaction tested and developed in a network like this, offering less opportunity for the "voices of the community" to receive aesthetic representation as is the goal of so much community art programming. Indeed, the radical eclipse of social context in Beckett seems to make his work an inopportune resource for community art engagement.

At the same time, there is of course another parallel tradition of Beckettian production that has always existed in tension with Beckett's own contextless dramaturgical desires. Famously, Beckett's push for a highly de-contextualized dramaturgy is key to his aesthetic; in fact, it guaranteed his status as a modernist playwright precisely because he steered so clear of the messy antimodernist dimensions of the theatrical form. Subsequently, any and all efforts to contextualize—or to reinsert a degree of theatre's referentiality—were famously met with indifference

and often activist refusal by Samuel Beckett himself. Beckettian production history is replete with such controversial, artistic deviations. Estelle Parsons was denied a request to perform *Waiting for Godot* with women; with grudging agreement from Beckett, Herbert Blau directed it in San Quentin prison; Joanne Akalitis placed an overt "homelessness" frame on *Endgame*'s characters to the public consternation of Beckett and Beckett purists; Susan Sontag created a production of *Waiting for Godot* in Sarajevo (1993), notably after the playwright had died. Indeed, Beckett often seems to be the figure to whom modernist artists and intellectuals re-attach when they find themselves wanting to do some social good. Perhaps the most significant intertext for Chan's project, however, was one unknown to Chan himself. In the mid-sixties, Free Southern Theatre had itself staged *Waiting for Godot* in New Orleans, knowing then that the racialized and Southern context would create its own resonance with the play. O'Neal staged the mixed-race production of *Waiting for Godot*, reminding Richard Schechner in a 1963 interview for the *Tulane Drama Review* that his constituency "knew a lot about waiting."[25] While this theatrical genealogy was not fully apparent to Chan himself upon embarking, he found himself encountering it along the way, sifting his present plans' relationship to past inventions. When asked about this connection in several artist interviews, including a civic panel attended by John O'Neal, Chan has repeated a citation from Adam Phillips: "the longing for the new is a reminder of what is worth renewing."[26] As a "new" high-end artist in a speculative art world, it is intriguing to imagine his practice as a renewal of theatre's "older" invented wheels.

In fact, Chan's own critical barometer is tuned to a quite different formal orientation, one that places aesthetics and politics back into animating, and sometimes conflicting, tension. When asked what role political activism plays in his work, he answered:

> It plays the enemy . . . My political commitments—whether it's with Iraqi humanitarian groups, unions, or anti-globalization media cells—become the field that the work works against. . . . [Politics'] orthodoxy seduces you in a kind of myopic hope that is hard to resist . . . [Art] Work then becomes a way to "traverse the fantasy" of politics—like a splash of cold water, or a whipping.[27]

As a well-read aficionado of aesthetic and social theory, he asserts the need to keep the goals of art and the goals of politics from being conflated:

Collective social power needs the language of politics, which means, among other things, that people need to consolidate identities, to provide answers . . . to make things happen. Whereas my art is nothing if not the dispersion of power . . . And so, in a way, the political project and the art project are sometimes in opposition.[28]

In his paraphrasing of Adorno, he amplifies:

Old man Adorno wrote that just as art cannot be, and never was, a language of pure feeling, nor a language of the affirmation of the soul, neither is it for art to pursue the results of ordinary knowledge as, for instance, in the form of social documentaries, which function as down payments on empirical research yet to be done.[29]

In so channeling "Old man Adorno" for the Gen X generation, Chan's stance is wary of the documentary impulses of much "theatre for social change" and keeps its distance from the affirmative impulses of "the story circle."

Indeed, from a curatorial axis grounded in twentieth-century debates of aesthetic theory and less attuned to the contextualization of theatre history, to take up Samuel Beckett was to return to classic discussions about the role of autonomy and commitment in art practice. Samuel Beckett's suspicious relation to the encumbrances of theatre created a push and pull that underpinned his signature forms—static representations of duration, de-humanized representations of character, and a-social dialogue. That relation and those forms would also be the reasons that Adorno loved Beckett so much. Indeed, Beckett served as Adorno's exhibit A in lauding what he felt to be the importance of "uncommitted" art in a post-Second World War context. "Beckett's works . . . these enjoy what is today the only humanly respective fame: everyone shudders at them, and yet no one can persuade himself that these eccentric plays and novels are not about what everyone knows but no one will admit."[30] In a context that had seen the worst social uses of aesthetics under Fascism as well as under Soviet Stalinism, where the Constructivist experimentation sited above would be discredited and many of its central proponents (including Meyerhold) exiled or executed, Adorno felt that the twentieth century had endured the dark side of a political art righteously sure of its moral certainty. He argued for the preservation of a consistent illegibility in art practice to retain the interrogative stance toward the social rather than risk its absorption by it. "The notion of a

'message' in art, even when politically radical, already contains an accommodation to the world: the stance of the lecturer conceals a clandestine entente with the listeners, who could only be truly rescued from illusions by refusal of it."[31] Famously, Adorno's primary offending example was neither a Nazi collaborator nor a Stalinist social realist but Bertolt Brecht, a figure with whom all varieties of post-dramatic theatre and "theatre for social change" are in constant dialogue. For Adorno, however, Brecht was an inspired artist who had lost his way with his "committed" accommodations to the world.

Adorno is an avowed influence on Paul Chan, and, indeed, one can hear Adornian tones in his twenty-first-century meditation on the role of art's "articulate speechlessness" and on the need to differentiate an activist consciousness that concentrates power from an artistic consciousness that disperses it. At the same time, we can see his work equally engaged in a post-Adornian social and aesthetic theory that has taken up the formal arguments of modernist aesthetics in new terms. The notion of a "terrible symmetry" between Godot and Katrina matches the Rancièrian preoccupations of much of Chan's oeuvre. In a special *Artforum* issue on Jacques Rancière, Chan offered a reading of Czechoslovakia in 1968 when the Soviet reaction to reform efforts came in tanks and troops during what would become known as Prague Spring. Chan is taken with the fact that Prague citizens reacted to Soviet invasion by painting over all of the street signs, thereby confusing and disorienting the invasion; he reads this as an exemplary Rancièreian event, one where citizens seize a moment of liberty by leveling the field on which an enactment of inequality relied. Searching for ways to verify the radicality of the equality premise at the base of a Rancièreian recuperation of democracy, Chan gets close to joining an aesthetic discourse with a social one, though it will be one that resides not in traditional empirical measures of "efficacy" but in a certain equalizing of form:

(In my practice anyway), both the visible and invisible materials used to make work are all equidistant from becoming either form or content in the process of making . . . That is to say, the place to verify the practice of equality in the pursuit of a form of freedom (which seems to me like a pleasing if wonky definition of art) might well be a confrontation with a force of order that divides and partitions the ghostly whole back into measured forms of understanding and consumption. If the work is indeed a work, it will resist this partition at every turn and claim for itself the autonomy that can come only from the

practice of imagining the presence of this now not-so-secret equality in every line, shape, color, and sound.[32]

The pursuit here in New Orleans then was to foreground a "terrible symmetry" between Katrina and Godot to the point of exploiting the radically equalizing function of art, one that would fearlessly push symmetrical analogy to the point of equalizing the lines, shapes, colors, and sounds of the so-called "text" with the lines, shapes, colors and sounds of the so-called "context." Chan wrote in his artist's statement on *Waiting for Godot*: "In New Orleans in 2008, Godot is legion and it is not difficult to recognize the city through the play. Here the burden of the new is to realize the play through the city."[33] To site Godot in New Orleans was thus not simply to set Godot in New Orleans, but to allow Godot and New Orleans—along with their forms and contents, their backgrounds and foregrounds—to be perceived on the same interpretive plane. It was not so much the entry of life into art as it was an invitation to enlarge the circumference of an aesthetic imagination, to relocate infinitely the line that would conventionally divide art from the nearly unlivable life of the Lower Ninth Ward. To site Godot in New Orleans was to see what new angles on New Orleans could come from the realization that Godot was already there.

The Symmetry of Heteronomous Demands

Chan's practice is not one that invokes CRAFT; nor in general is it one that would seek the consolidating relief of an acronym. Indeed, his work seems to ask whether there is a peculiar productivity in placing a sensibility that considers itself "allergic to people" next to a political sensibility that is energetically social. This peculiar productivity is in many ways key to understanding his favorite playwright. At the same time, we find in the production process of *Waiting for Godot in New Orleans* all varieties of "heteronomous" engagement in the midst of an aesthetic project of radical symmetry. How do we grapple with this apparent antinomy? Is it possible to imagine socially engaged art sites as also in search of a "third way," between the autonomy of art and the heteronomy of its demands? Or perhaps, recalling the pursuits of Beck and Feher cited above, it is more accurate to remember that there are a variety of "third ways," practices that mobilize autonomous and heteronomous zones to respond adequately to the mixed economies, mixed ambitions, and mixed appreciations of both art and social repair.

As recounted in numerous versions of the tale, the process of putting together this project was multifarious, with decisions made that might

have been regretted later, with varieties of thoughts about what was playing cart to whose horse. Chan had read background work on post-Katrina New Orleans in a number of places, notably in the critical writings of his lawyer Bill Quigley. He called Anne Pasternak, director of Creative Time, to pitch the idea of *Waiting for Godot in New Orleans*. Pasternak committed Creative Time to the project, and Nato Thompson became the curator of the project, an assignment that both extended and challenged the curator's traditional job description. Thompson himself is already known for having met the challenge of curatorial redefinition required of socially engaged art practice. Previously employed at MASS-MoCA (Massachusetts Museum of Contemporary Art), Thompson is perhaps most renowned for his ambitious exhibition and catalogue, *The Interventionists*. As someone with a background in political organizing, Thompson also came equipped with skill sets that exceed the traditional skill sets of curatorship and hence are transferable to the kind of human mobilization and project management necessary for pieces whose social engagement require durations, embodiments, temporalities, group interaction, and pre- and post-production processes that exceed traditional museumship. That said, to be a curator of expanded art practice is also still to walk a difficult, not always fully processed, line between being responsive to the espoused social context in which the project occurs and being responsive to the artistic "freedom" of the commissioned artist, that is, between coordinating the material and immaterial labor required of a project and honoring the artistic desires rationalized by the single-author entitlements that romantically and economically propel the visual art profession. The process of social and site-specific engagement spurs an unyielding set of unanticipated contingencies that in turn prompt unanticipated requests. This new kind of durational and spatial management means that to curate socially engaged art is to occupy a perpetual state of "change-order," one where judgments are made daily about who will absorb the unexpected. After the success of *The Interventionists*, this tension came into unpleasantly high relief with the notorious MASS-MoCA scandal surrounding Christophe Büchel, one where the level of material intervention required by an artist who claimed the "freedom" to "change the order" exceeded the labor and fiscal capacities of the museum.

With the move to Creative Time and to Paul Chan's project, Thompson found himself testing the degree to which curatorship has become a kind of stage management, a mobilization of bodies in space over time. For Thompson, a curator was "kind of like a therapist between the artist and production, the pragmatics, permits, social organizing."[34] While that mobilization was something that Thompson

knew aesthetically and politically, the specificities of theatre's forms of mobilization were new. "I was trying to figure out my role. I can't do theatre but I can do the social organizing."[35] Chan too knew that his fascination with Beckett did not equip him to direct the play that he wanted to see realized. His first thought then was to contact Classical Theatre of Harlem who had recently produced its own production of *Waiting for Godot* set in New Orleans. Directed by Christopher McElroen and starring equity actors, including Juilliard-trained Wendell Pierce (of late recognizable to audiences as Detective William "Bunk" Moreland from the HBO television show *The Wire*), Chan and Thompson convinced Classical Theatre of Harlem to remount the production for the project. It was in the process of working through contractually, logistically, and aesthetically what such a remount meant that the occupational habits of the theatre world and the art world had their first confrontation. In fact, says Thompson, "It took us a while to realize that we were doing theatre."[36]

"Siting" a play in New Orleans turned out to be different from "setting" a play in New Orleans. Actors who had perched atop set designer Troy Hourie's stylized sunken roof in the theatre had to learn entirely new blocking in order to fill the highly expanded playing space of the Lower Ninth Ward. The contractual negotiations of collaborators also provoked new realizations about what it meant to "do theatre." "We drew the contracts up. I'm all for collaboration, but I've learned pretty early that clarifying credit and contracts are pretty important."[37] There, the visual art habits that attributed artistic credit to a site-specific artist's proposition confronted the theatrical art habits that distributed different kinds of artistic credit along a varied division of labor. "It started off as 'Paul Chan' but then Classical Theatre probably thought that it was theirs. And the actors probably also think that they are the artists."[38] To Creative Time and Paul Chan, the existent production of *Waiting for Godot* was one component of a "project in three parts." To Classical Theatre of Harlem (CTH), the piece was one that they had produced and whose rights to present Creative Time and Paul Chan needed to secure. To bring these projects together legally was to join a professional art world that would position CTH's *Waiting for Godot* as "material" for Paul Chan with a professional theatrical world that would position *Waiting for Godot in New Orleans* as a stop on CTH's national tour. In the process, a different vocabulary for crediting concept, idea, production, and presentation had to be invented. Along the way, other habits of property and crediting were discussed. As a response to the non-durability of ephemeral art practice, artists and their galleries control the terms of documentation, confining limited editions of photographs that can be

sold as art commodities. That professional practice ran up against theatre's professional practices; for instance, Wendell Pierce's status as a professional equity actor places him in royalty control of the use of his image; it thus made ownership of documentation—of his performance inside whose play inside whose concept—professionally ambiguous.

In addition to the "heteronomous demands" that came from a collaboration with Classical Theatre of Harlem, Chan, Thompson, and other Creative Time members engaged in nine months of social engagement with a variety of community sites in New Orleans—nine months that Chan describes as another dimension of the art piece, one of "three parts" that revolved around this play in "two acts." While ostensibly deviating from the aesthetics of heteronomous political art, there was an element of this work not unlike the CRAFT methods of a Crossroads Project and generally characteristic of community art practice. Chan began to introduce himself to a variety of civic and artistic leaders in the Lower Ninth Ward, Gentilly, and other sites, working to get feedback on the how-tos of making his proposition work. It is here that we find Chan's self-described allergy to people countered by an other-directed practice, the heteronomous demands as component parts of an autonomous artistic act.

Following the motifs of what James Clifford has called "ethnographic allegory"[39] in the fieldwork process, one of this project's central "fable[s] of rapport" comes around the tale of Robert Lynn Green who eventually became what Thompson called and what community art activists know they often need when they enter a new community: the "ambassador for the project." Like many communities across the United States that find themselves the object and not always the subject of community projects, Green also expressed concern about the number of other art or do-gooder projects that had come and gone in his neighborhood, leaving nothing of lasting value behind. Another activist, Robert Lewis, expressed the same concern in no uncertain terms. Chan recalls seeing a tree outside casting a shadow over Lewis's office where they were talking; it was at that point that Chan proposed the idea of a monetary matching program, a "shadow fund" that would follow the project to assist participating community organizations: the public schools, community centers, and book shops that Yates McKee has called "New Orleans' NGOs."[40] Calling it a "shadow fund" underscored, for those in sync with Chan's sensibility, the sense that such a fund was conceptually important and an interior medium of the project, no more incidental or a matter of "background" politics than "light struck out" was in any of his projection pieces. "It's a start,"[41] Green reportedly said back. Such a financially linked, non-profit structure or economic benefit

is often the measure by which some determine the efficacy of committed art as well as the appreciating benefits of civic "investment" in the arts. What was different perhaps was to conceive such a "real-world" effect, which would ultimately distribute $55,000 to community organizations, as simultaneously conceptual and formal in character.

Chan solicited more people for advice and assistance and began to understand the network of public schools and community organizations that would need to be involved and would need to benefit from *Waiting for Godot in New Orleans*. "Greta Gladney, an organizer who runs a local farmer's market . . . thought that the schools should be involved. Ron Bechet, an artist and professor at Xavier University, thought the same thing."[42] At this point, a different kind of language begins emerging in the articulation of the project, one that might pursue a radical symmetry between text and context but that does so in a way that simultaneously creates new points of contact across the spaces traversed. Chan began to speak about the three-part project as "a series of causes and effects that would bind the artists, the people in New Orleans, and the city together in a relationship that would make each responsible for the other,"[43] re-using a potentially anachronistic term to make "responsibility" formally innovative. Moreover, such points of contact are not only provisionally relational but also imagined as both foundationally and providentially interdependent. Chan began to make Excel lists of people on whom he began to rely, with phone numbers and locations. He created drop maps to plot the relations of exchange that existed between the project and eventually nine public schools and eight community centers in the area. As a means of offering the skills he had as an artist and thinker, Chan decided to teach two classes for free, using it as a way both to disseminate the kind of ambivalent social art discourse he had himself developed as well as to share professional tips with emerging art students.

Chan also worked to develop a discursive practice around the project. He kept a running list of keywords:

> Burner, Ghost, Time, Profit/Prophet, Net, Gross, Talk, Alien, Success, Intentions, Organizing, Collectivity, Archive, Fronts, Necessity, Prohibitions, Streets, Overhead, Enemies, Haters, Paperwork, Nature, Pedagogy, Gov'ment, Realignments, Ignorance, 'Shut Up', Non-profits, Flatness (after Bob), Loss, Magical Names, Parabasis (after Agamben), Periphery, (Sideways work), Abandonment.[44]

"Via Negativa!" and "Anabasis" run vertically up the list. He created a packet on Samuel Beckett for teachers, with selected biographies, reviews,

and excerpted scholarly essays.[45] He also listed the participants of important productions, including premieres in different countries, and those of Mike Nichols and Susan Sontag—not yet knowing to list the artists of Free Southern Theatre.

In these and other processes that would follow, we see Chan using familiar bureaucratic processes: questionnaires, maps, org charts, road signs. But he also introduces a degree of enigma within them, invoking as well as unsettling the language of belonging and service as if resuscitating modernist art antimonies into a different kind of co-existence. In another component of what Chan described as his DIY (Do It Yourself) residency, Chan initiated door-to-door interviews that both replicated and deviated from the questionnaires of a FEMA case worker; in a heuristic, conceptually resonant framing, he asked neighbors "what they were waiting for." Vickie Belle started by answering that, she was "Waiting on my insurance company to give me more than a nominal amount of money; living in a damaged home because of unfair treatment by the insurance company,"[46] eventually isolating her response into shorter sentences such as "Waiting for my residence to be fixed." Later, she went from a narrative of "Waiting for political people to help, to do something to bring people back"[47] to the efficiently phrased, "Waiting for people to come back." Indeed, the documentation of those conversations shows a certain eloquence when neighbors' speech did not stay within the conceptualist confines of the interview and a different kind of eloquence when it did. Sylvester Desponza's speech was awash in contingency, qualification and analysis: "Waiting for the politicians to either get out of office or do what they are supposed to do. There has not been enough action in the last 2 years to inspire me to come back and to start all over."[48] The qualification and contingency was as necessary as was the untrammeled articulation he eventually found: "Waiting for a plan."[49]

By August of 2007, three months before the performances were presented, Chan had created a document that was itself an index of the "three parts" of the project (see Figure 7.2). Employing but also challenging the graphic of the "org chart," it showed the three parts of the project—DIY Residency "Time," Godot "play," Shadow fund "language"—in a triangulated configuration around a space dubbed "Empty Origin of All Gravity." Around this triangle, following a key whose shapes distinguished different organizations, a spider network of elementary and high schools, universities, city hall officials, cultural/arts organizations, grass roots community centers, and "media" radiated out from the project, connected by bold or dashed lines depending upon the directness or indirectness of the relationship. The chart played with

229

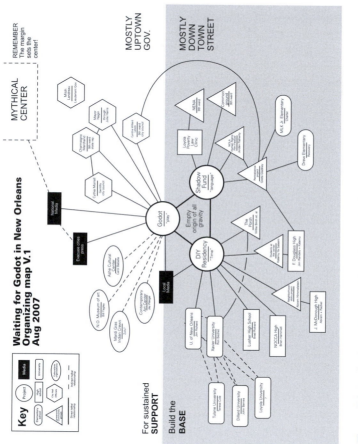

Figure 7.2 Paul Chan, *Waiting for Godot in New Orleans* (2007): Organizing map v.1, created by Paul Chan

Source: Courtesy of Paul Chan.

conventions of graphic representation in several ways. Though the chart had the character of a map with a bird's eye view, it simultaneously positioned the viewer in front of an apparently under mounted structure, positioning some organizations in a lower, shadowed position of "mostly downtown street" that constituted "the base" from those higher in a lighter portion of the paper who, as "mostly uptown gov.," represented the "Support." Notably, "Godot the play" straddled the light Support layer and the dark Base layer, as did "Local Media." Meanwhile, though the "empty origin" was centered on the paper, the linguistic representation of the "Mythical Center" was placed to the side and up high, its equivocal status emphasized by a side note that read "REMEMBER the margin sets the center." Thus, as a representation of the heteronomous nature of this three-part project, the organizing graph invoked the conventions of empirical representation as well as the discursive conventions of social organizing. It also approached the interactive graphics of community art. At the same time, the partial opacity and promiscuous mixing of referents and graphics of Chan's diagram refused complete legibility. The gesture toward empiricism was simultaneously troubled by a language that did not fully coincide with referential conventions. In a systemic adaptation of the logic of the reciprocal ready-made, the aesthetic sector and the civic sector were mutually estranged. As much as it charted the heteronomous demands and heteronomous reach of the project, the graph also resisted full incorporation into the documentary structure or the affirmative structure of a morally secure mission.

As often as the project incorporated social outreach into the social dimensions of theatre-making, the project also worked in the reverse direction by introducing an enigmatic aesthetic discourse into the space of the empirically overwhelmed. In the months preceding the production, Chan created numerous signs that replicated the enigmatic stage directions from Beckett's play, as if welcoming the neighborhood space of New Orleans into a *mise-en-scène* that had already been waiting side by side (see Figure 7.3).

The Ninth Ward, Gentilly, and other neighborhood contexts regularly saw pieces of paper with alerting signs stapled to doors, junk piles, fences, and telephone poles; the prose, however, was quite different, warning them of imminent demolition. In an echo of the radically equalizing signs painted over in Prague in 1968 (and an unwitting echo of the infrastructurally expansive signposts of the Federal Theatre's *Power*), Chan's performative signage enlarged the aesthetic perimeter of *Waiting for Godot in New Orleans*. De-naturalizing the secure referentiality of public condemnation, they simultaneously invited the never-completely

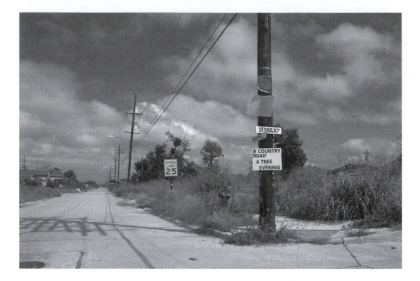

Figure 7.3 Paul Chan, *Waiting for Godot in New Orleans* (2007): A country road sign, Paul Chan and Creative Time

Source: Photo by Paul Chan.

legible invitation to think about whether the signifiers of New Orleans could have different referents.

Though Chan had focused initially on the Lower Ninth Ward as an index of the worst devastation experienced by New Orleans, the exclusive focus on this single site seemed inadequate. After conversing with a number of New Orleans residents, activists, and scholars, Chan and his collaborators decided to work toward a production at a second site in Gentilly. The move from one to two sites was both an attempt at expanding spatial coverage and itself an example of that gesture's impossibility. The initial "drawings of the playing space" created for *Waiting for Godot in New Orleans* in May of 2007 mimicked and deviated from both gallery-based and theatre-based models of infra-structural planning. The play spaces were imagined to situate viewers in relation both to an enacted play and to an expanded vista of post-flood neighborhood space, with FEMA trailers, deserted streets, a nearby breached levee, and an oil-digging apparatus all in view so that set and site could merge. Eventually, Chan would drop the "FEMA-like trailers" initially depicted when he realized that the existent site meant that he did not have to "dress the set."[50] Chan himself combined the labor of the plastic artist with those of the prop master and Master Carpenter by

deciding to create certain components of the object world himself. He constructed a cart, a bike, and a "tree" of found materials, molding a junk metal coat rack, and other scrap into characteristically composed and representationally charged assemblages of debris. The creation of this expanded field for this site-specific performance required permit processes and temporary street blockages. Risers were brought in to stabilize viewer spectatorship in a relatively traditional bicameral theatrical relation; a second line band was scheduled to lead audiences between their seats and a gathering space where they would find portable toilets as well as local information tables and food tables with gumbo for pre- and post-show discussion and celebration. A rented power generator behind the audience powered large "Movie lights" that were centered on the playing space. More spotlights were directed "upstage" from a central playing space. Another dressing trailer was located upstage right from the playing space, troubling any clear sense of whether the dressing trailer was in fact "upstage" or part of "the wings." Indeed, the troubling of the division between playing space, wing space, and neighborhood space seemed central to the perceptual imagining of the production, a perceptual alteration that went farther with the realization not only that the wings and the play space were joined but also that together they ran

Figure 7.4 Paul Chan, *Waiting for Godot in New Orleans* (2007): Performance
Source: Photo by Tuyen Nguyen.

233

over and past any traditional line that would divide them both from the neighborhood. From the wings of the neighborhood, "the boy" was to be transported on a bus, one that invoked the tourist buses that had brought well-intentioned tourist visitors such as Chan to these neighborhoods in the first place.

Although 600 chairs were provided by Creative Time, 1,000 people still had to be turned away the first night; other reports said it would be 2,000 total (Sisyphus indeed). The bus could not actually get through the audience. They ended up doing a third performance in the Ninth Ward. With two in Gentilly, that totaled five performances in all. Not a one-off, but not a run either. Reviewers commented on the uncanniness of the play's lines in the New Orleans context. Said Holland Cotter of the line: "and we'll be alone once more, in the midst of nothingness" "he really was in the middle of nothingness, or what looked like it."[51] And a certain kind of radical symmetry can be felt in the commentary of some of the participants. For Pierce too, the organization of this form of Group Art exceeded theatre's naturalized conventions of performing a play:

> There were times when I felt I wasn't in a play. To be surrounded by the people of that community, in the middle of the Ninth Ward, where many have died, and it's two and a half years after and still looking like that and you're saying, "At this place, at this moment in time, all mankind is us. Let us make the most of it. While we have a chance let us do something, before it's too late." Those lines just ring and ring.[52]

For Classical Theatre of Harlem director Christopher McElroen, the image created was memorable. After the curtain call, he remarked "[the cast] kind of melted into the darkness, walking slowly back toward the broken levee. It was one of the most powerful moments I've ever experienced."[53] Chan's theatrically sited windowless lighting pushed the envelope of site specificity. It is a reminder of what one critic said of *My birds . . .*, Chan's earlier Beckettian digital *mise-en-scène*: "Pictorial space then, seems to extend infinitely toward a horizon in both directions, fictively obliterating its physical container and, in the process, our view of ourselves."[54] To some extent, a similar adjustment in the perceived location of horizon seemed to occur in the spectacle. As actors of Godot melted into the darkness with the help of rented, power-generated lights, they prompted a continual spectatorial readjustment between the wings and the play, between the play and the neighborhood, between the neighborhood and the levee that could no longer be perceived as exterior to it. By confusing

Godot's form with Katrina's content and Katrina's form with Godot's content, asking a question of whether the levee was in the foreground or background, and proposing that this infrastructural prop might also be a theatrical prop, the production hovered temporarily in a radically symmetrical space, undividing the partitioned world of set and site back into a "ghostly whole." The project leveled the perspectives that would divide background from foreground, inside and outside, or, as the case may be, artistic inside from social outside. In Paul Chan's *Waiting for Godot in New Orleans*, a temporarily symmetrical gesture of environmental theatre was not only about incorporating the real into the art but also about extending the interrogative and even utopic headspace of aesthetics onto a plane without perimeter.

The trick in all of this, it seems to me, is to track the fact that *Waiting for Godot in New Orleans* could pursue this radically formal project at the same moment that it addressed demands that, by a certain logic, were heteronomous to it. To do so is also to ask how we understand the autonomy/heteronomy dialectic in a world where a discourse of flexible selfhood has triumphed over one that would regulate the distribution of a cultural life as well as of social goods. Recalling one point on Chan's triangle, this might mean excavating what is meant by the DIY residency, where "time" appeared as its modifier. The Do-It-Yourself phrase recalls the television shows, cable channels, and magazines that encourage the privatized preoccupation of home décor and home fix-it strategies, almost always of homes that are owned. The DIY discourse is a discourse of creativity, but it is one channeled for individual ends and one that ultimately makes—through its discourse of self-help—the individual responsible. Hence, it is also one that finds its way into sociologist Ulrich Beck's elaboration of what he has called the "risk society" and its attendant processes of "individualization." "The do-it-yourself biography is always a risk biography, inside a tightrope biography state of permanent (partly overt, partly concealed) endangerment. The façade of prosperity, consumption, glitter can often mask the nearby precipice."[55] For Chan to invoke the DIY discourse in an arena of social devastation is to attempt to channel this singularizing discourse into a scenario that is publicly shared, where the boundaries that divide my house from yours erupted with the realization that sewers and telephone lines are the "ground" of interdependency. At the same time, it is also to ask an impertinent question about the discourse of do-it-yourself, humorously parodying its ethos by joining it to the unhumorous issues of security and protection. Is the flexible self of the do-it-yourself putterer in fact adequate to the fix-it project of New Orleans? And what is one to do when "flexibility" is exactly what one does *not* want in a levee?

I think it is also worth remembering that Chan used the word "time" as the qualifier to DIY node on the triangle. For Nato Thompson, this word also came up to challenge Chan's own self-described allergy to people. "He is not allergic. He is a great community organizer. I mean the guy spends the time."[56] As such, he is also aligned with dispersed contemporary movements in local and digital activism that have tried to reinvent the DIY discourse for the non-hierarchical coordination of provisional collectivity. As the above recounting of curators, CTH artists, scholars, activists, residents, and other "ambassadors" attests, Chan definitely did not do this project by himself. At the same time, the DIY discourse shows that it was also not a project that could rely on historically collectivized forms of public care, whether from an NEA or a FEMA, an FTP (Federal Theatre Project) or a CETA or a WPA. As Chan said to me of the DIY label: "Myself and Creative Time had to build the infrastructure for my time there."[57] The "you" in Do-It-Yourself paradoxically had a vast individuated population, mobilizing the social organizing "network" to consolidate around beleaguered public institutions (such as schools) and un-federated bookshops and "Porches" that had become nodes for different kinds of shared activity. Not a project that chose between private or public sponsorship or made its case for either capitalism or socialism, *Waiting for Godot in New Orleans* mobilized within an economy that remains decidedly mixed. Within such an economy, a professional art world's resilient conventions of individuating authorial genius meant that the name "Paul Chan" could be mobilized in the service of wider points of connection while simultaneously inviting unexpected forms of alienation as artists and activists worked out the details of possession. It seems to me, then, that the project is inadequately understood within conventional oppositions of autonomy and heteronomy, i.e., it was not an autonomous project compromised by heteronomy or a heteronomous project compromised by autonomous pursuits. Instead, it was one that showed a cultivated ability to move through different sites where the lines relationally dividing one from the other constantly change.

In such a landscape, the offer of "time" is one with multiple resonances. On the one hand, it has medium-specific resonances with the form of art to which Chan turned, that is, to the classically durational/temporal dimensions of "drama." On the other hand, it also has wider resonances to the durational activity of planning, rehearsal, conversation, repetition, and more planning that go into social collaboration. "Time ended up being the biggest currency," says Nato Thompson, "even more than the shadow fund."[58] It probably cannot be overestimated how much the commitment of time provides the

material substrate on which the possibility of relational performance depends—the chain "of causes and effects" that Chan sought from this project and from which a different form of "responsibility" for others could emerge. It also cannot be overestimated how improbable such a commitment could be in an environment that values work when its hours are "flexible." That is, if life is currently organized by an appropriated aesthetic discourse, one that channels the apparent entitlements and less lauded precarious intermittencies of artistic labor to celebrate worker flexibility, the idea of temporal commitment is a decidedly unfashionable throwback. To decide to make "time" a currency, then, was also to emphasize a different kind of durationality in performance, one that fixates less on the ephemerality of its relations and more on the resiliency of its relational structures.

Finally, Paul Chan's theatre was unfederated in that it was supported by agencies and organizations that can no longer claim to be federally entitled; many of them are agencies whose mission is to counter the forms of anti-social federalism that led to Katrina's unnatural natural disaster. But it is also un-federated in that it seems, on the face of it, to refuse the documentary and political impulses of the factographic newspaper theatre that animated the Federal Theatre Project. And yet, like any neologism that contains a word it counters, the federal theatre legacy nevertheless remains a struck-out shadow in an un-federated project, one that finds itself reproducing the Constructivist inflected, other-directed forms of socially engaged art in info tables that might be kiosks, in community dinners that might be collective repasts, in book donations that might be reading rooms, in open rehearsals that were after-school programs, in discussions where stories were told (maybe even in a circle). It was lit not by a public utility per se but by a power-generator rented by Creative Time and other resources that supported the project.

Paul Chan's theatre was also implicitly funded by the remaining individuated structures of the speculative art market in which Paul Chan sells. Limited edition documentation of *Waiting for Godot in New Orleans* was available for sale at Greene Naftali; the cart (and "tree") made by *plasticien*/Master Carpenter Paul Chan was sold as sculpture. The history of twentieth-century aesthetics and the history of twentieth-century social theory have co-existed in a fraught, mutually galvanizing relation, one that casts as antinomies relations between private and public, between autonomous art and committed art, between capitalism and socialism, between social expression and social instrumentalization. As artistic sectors and social sectors seek different kinds of "third ways" in the twenty-first century, Paul Chan's work suggests that such searches might occur together, valuing a redistribution of resources in the same

moment that it values a redistribution of perception. Interestingly, that coordination was not a refusal of the neoliberal condition that many see undergirding Katrina but a re-coordination of its signature structures for a different kind of public end. In this process, labels vacillated as entities moved between visual and theatrical fields and between art fields and social ones, recalibrating distinctions between documentation and commodity, between prop and sculpture, between set and site, between artist and material, between director and site-specific artist, between curator and stage manager, between popular and conceptual artist. As visual art expanded unwittingly into theatre, as theatre found itself alternatively sited and its component parts reorganized, these ambiguously mixed media addressed an ambiguously mixed economy. Meanwhile, the project of infrastructural imagining at work in New Orleans continues on all fronts, stalling and lurching forward in daily testaments to the highly underrated work of Sisyphus.

EPILOGUE
Dependent Care

The performer is a single child, two or three years old. One or both parents may be present to assist him/her with a pail of water or a banana, etc. When a child leaves the stage, the performance is over.

Alison Knowles, *Child Art Piece*
(1962)[1]

Like all publics, a counterpublic comes into being through an address to indefinite strangers.

Michael Warner, *Publics and Counterpublics*[2]

In the 1962 Fluxus Festival in Stockholm, Sweden (and then again in Dusseldorf in 1963), Alison Knowles premiered a work entitled *Child Art Piece*. Like other works of the period—assemblages, events, happenings, task and instruction pieces—the text associated with the piece functioned both as direction of how to do it and as documentation of how it had been done.

Several decades after Baudelaire recorded the effects of the turtle walk in Parisian parks, Fluxus artists conducted their own investigations into the category of the everyday. Pieces ranged in scale; they were sited on streets and in lofts as often as they were sited in festivals and theatres; some took shape in boxes, some on walls, many with bodies re-enacting familiar everyday behaviors—pouring from a pitcher, lighting a match, cutting hair, making a salad, eating a sandwich. Together, Fluxus gestures underscored the extraordinary structures of ordinary activity. *Child Art Piece* extended the Fluxus imaginary to a figure who is by turns object and subject. This child was one whose actions moved between the willful and the involuntary; this child was also a figure whose theatrical

exploration required the supporting apparatus of a parent. When queried about the text's inclusion of parents, Knowles elaborated succinctly: "Parent was needed to get the child onstage and help with play. Stage is a fearful place!"[3]

In a 1964 Fluxus Concert in New York's Carnegie Recital Hall, Knowles arranged another *Variation on Child Art Piece*. The instruction there read only: "Exit in a new suit." When queried, Knowles elaborated, again succinctly. "Child (Ennis Patterson) came dressed in the new suit I had purchased for him. What I did was . . . walk him down the aisle under a spot light . . . child did not go onstage in variation."[4] The child's movements onstage were restricted in this new variation in part because the first had caught the attention of the Society for the Prevention of Cruelty to Children who "forbad the performance of *Child Art Piece* in its original form."[5] Said Knowles, "Carnegie checked pieces and said 'too young.' . . . There was a policeman present but the performance proceeded uninterrupted." This new *Child Art Piece* thus found itself embedded in "a whole system," one whose contours it both submitted to and defamiliarized at once. The presence of the policeman made the variation possible, but the execution of the variation also asked a question about why the officer had to be present in the first place. Was this piece an act of exploration or an act of exploitation? Was the officer there as protection or as disciplinarian? And what assumptions about care, dependence, and surveillance undergirded the answers to any of the above?

To some, a book on interdependent performance would not be complete without a reference to children. To others, exactly that reference would undermine a book's political edge. Children are to some extent the ultimate figure of interdependence. But for that reason, the perception of their social vulnerability can be appropriated for all kinds of political ends, ranging from the sentimental to the curious to the outraged. Children have both prompted and stumped the arguments behind criminal, labor, and welfare laws for centuries; varied legislation has constructed them as "minors," as "juvenile," and as "dependents." Children are cast as prelapsarian savages by some and as pre-social savants by others. They endure the projections of some adults who are nostalgic for their presence and the projections of others who are annoyed by it. Children are also humans who do some bold projecting of their own; the transferred memories of parent-child discord can be a psychic motor for social movements of all kinds. Hence, long before and long since Alison Knowles created *Child Art Piece*, children have been recurring fixtures in varieties of popular and conceptual performance. From the nineteenth-century vaudeville house to the twenty-first-century

art house, the child is riveting because of her potential to destroy the aesthetic frame; in her phenomenological presence and her social unpredictability, she is a walking threat to the divide between art and life. That heightened potential for catastrophe in turns makes any controlled execution on her part all the more striking; there is a particular kind of incredulity that comes when a child hits her mark.

Similar challenges to perception come not only when the child is in the art piece but also when the child encounters the art of adults. Bracken Hendricks recalled a Fluxus childhood that constantly integrated art and the everyday, making for a very different relationship to say, Dick Higgins's and George Brecht's "Drip Music." "The pitcher that's used to pour off the ladder is also the pitcher at home that's used to serve orange juice in the morning." Fluxdaughter Hannah Higgins chimed in, "We need the pitcher again, oh, then what are we gonna move the orange juice into because there's a performance tonight? Questions like that came up over and over again."[6] Arguably, most children of artists experience their parents' art in the mode of Fluxus, an approach to the gallery or theatre or cinema or poetry reading that encounters its front-stages and backstages with the leveling intelligence of one who is not primed to respect those boundaries. The children of artists play in the rows of seats while their parents rehearse or leave found objects in favorite corners of their parents' studio. They come to pre-show and post-show receptions, collecting handfuls of appetizers that will serve as that night's dinner. They take naps in lighting booths and brush their teeth in public restrooms. They make friends with the stage managers, curators, or tech crews that support their parents' events. They remake the art space into their living space with each urge to play, each stomach grumble, each declaration of boredom, each laugh in the place where one least suspected it. Children make art into a Fluxus event even when the art does not want to be one—and they call the bluff of those that do.

The volatility of children—combined with their capacity to cultivate both extreme sentiment and extreme annoyance—makes them intriguing to more varieties of experimental performance and contemporary art. The Castellucci family of Teatro Societas Raffaello has run the gamut of child-based performance, from those that extend the enrichment goals of youth theatre to avant-garde experiments that test the capacity to endure a spectacle of vulnerability.[7] In one of their most scandalizing performances, Romeo Castellucci left a new baby onstage alone in a blanket crying for minutes that seemed an eternity to some spectators. The performance thus withdrew the adult supporting apparatus of Knowles's *Child Art Piece* in an act of enforced autonomy. (The stage is indeed a scary place.) If Societas Raffaello provoked reflection on

human interdependence by subjecting a baby and its audience to an endurance performance that they did not choose, other artists have used child vulnerability and child virtuosity as themes, as forms, and as catalysts. Contemporary Belgian theatres—notably Victoria in Ghent—have developed something of a specialty in commissioning new works with children whose target audiences are adults. In Josse De Pauw's *Übung* and Tim Etchells's *That Night Follows Day*, children are not only the content dramatized but the medium by which it is explored. Rimini Protokoll's *Airport Kids*, and other pieces where children are cast as "experts," push that group's goal of presenting real world narrative in opposing directions at once. On the one hand, such performing children exude the kind of naturalized authenticity that make audiences feel that they are in the midst of the real. On the other, the odd attraction of the child performer comes from her ability to overcome the chaos of childhood with precocious performances of virtuosic poise. That same doubleness animates Tino Sehgal's use of children in his gallery-based "situations." In *This Progress*, first constructed at the ICA (Institute of Contemporary Art) in London and later remounted in the large rotunda and stairwells of the Guggenheim, children greeted incoming museum goers by asking them to meditate on the nature of progress. These young people sustained a conversation as they led their guests through the museum, handing them off to a young adult who picked up where the conversation left off. Having begun a conversation on progress with a child figure saddled with the burden of being its "origin," Sehgal's visitors were greeted by ever older interlocutors who passed them on in a conversational relay. Sehgal and his curators hold elaborate auditions to find children able to navigate the complex goals of the performance, at once to present themselves as children and to overcome childishness as the execution of the artist's concept requires. At the same time, his works blur the line between the art presented by the museum and the outreach programs traditionally offered by the museum on the side. Participation in a Sehgal work is not entirely unfamiliar to children habituated to after-school programs, interactive art rooms, educational outreach centers, and other enrichment initiatives structured to support juvenile activity at a museum. *This Success or This Failure* (2007) blurred the lines between grown-up art and childhood play even more; dozens of London children were asked simply to play for hours in the gallery of the ICA, periodically asking onlookers whether they considered Sehgal's work (and theirs) a "success" or a "failure." (Sehgal forbids any and all documentation of his scenarios while simultaneously commanding unapologetically high fees for his work, as if bent on proving that ephemerality cannot in fact resist commodification.)

Even when not the featured subject or the central material, children have appeared in various guises throughout this book, moving into the background and the foreground with different projects. Children can be found running around the Istanbul apartment of Oda Projesi's room project. They sit perched on a parent's hip during community dinners with Touchable Stories in Boston or community dinners with Paul Chan in New Orleans. The arrival of children prompted Mierle Laderman Ukeles to question the pursuit of unfettered freedom in radical art projects, and children kept her company when she washed the steps of the museum. From the Southern California boyhood recalled by Allan Sekula to the Harlem boyhood recalled by William Pope.L, the psychic and material complexity of childhood continues to animate the work of adults. And ambivalence about what it means to be a child and who gets to raise one propelled *Human Rights/Funky Hair* by Michael Elmgreen and Ingar Dragset.

The ambivalence of Elmgreen and Dragset's work echoes that of other queer-identified artists and critics who have lodged potent critiques of the sentimental "culture of the child" and of the hetero-normative parenting apparatus that goes along with it. In works such as Michael Warner's *The Trouble with Normal*, Lauren Berlant's edited collection on *Compassion*, and Lee Edelman's *No Future*, critics worry about the degree to which conservative and liberal pundits exploit the dependence of the child to normalize heterosexual, nuclear family models. For some, gay rights movements for same-sex parenting only further reinforce normalizing models. For Edelman, these initiatives are accommodations to the principle of heterosexual bonding, missing the opportunity to lodge a more radical critique of the familial social order and its fixation on the "futurity" of the Child. "Sinthomosexuality" is Edelman's neologism for a force, figure, and affect that rejects the compulsion to project relationality into a future or onto an act, both of which suffer from our impossible attempts to create political projects beyond a perpetual present. The Child in all her imputed innocence and always deferred future is the vehicle for the instantiation of a regressive and conservative politics. Edelman argues that by embracing the sinthomosexual death drive, the rejection of the future and the rejection of the cathecting pulls of the Child can go hand in hand, thereby allowing "queerness" to exercise its radically nihilist potential. Queer critics of color have struck a different note in this debate around the Child's normativity, appreciating the significance of a queer critique of the Child while simultaneously suggesting that inequities of race and class make it hard to rationalize a complete disinvestment in kinship and the support of intergenerational bonds. José Esteban Muñoz said as much

in response to Michael Warner in the nineties,[8] and he found himself saying it again to Lee Edelman after the century turned. To the latter's anti-futurian social theory against the child, Muñoz countered with the utopic hope of glimpsing a "'not-yet' where queer youths of color actually get to grow up."[9] He and others such as Roderick Ferguson and Jasbir Puar note that the anti-social turn in queer theory often comes from white ("Anglo-skeptical") critics for whom a dalliance with libertarian go-it-aloneness perhaps feels like less of a risk.[10] Meanwhile, Susan Fraiman and Judith Halberstam take issue in different ways with the latent anti-feminism of an anti-child discourse that sees reproduction only as a force of normalization and not as an asymmetrical and gendered system of labor.[11]

In thinking then about the historic and contemporary role of children in performance, qualified by a queer theoretical discourse on the child's performativity, it was both odd and interesting to watch my friend and colleague Joe Goode reset his piece *Deeply There: Stories of a Neighborhood*. It was odd because *Deeply There* was a 1990s piece about AIDS, sex, death, hope, and kinship, and I was watching in 2006. This is to say that I was watching Goode bring back a piece after ten years of historical shift and reflection in the discourse surrounding AIDS, sex, death, hope, and kinship. Indeed, the timing of the remounted production coincided with many of the above polemics, essays, and special collections that worried and wondered about the status of queer theory, about where we were "after" its urgent emergence and bloom in the nineties.[12]

Goode is an innovative dance-theatre choreographer, specializing in the precise coordination of text, song, and movement. In *Deeply There*, Goode and his company members worked together to create a piece that, in being about AIDS, sex, death, hope and kinship, is also "about" a gay man named Frank whose partner Ben is dying. Ben's bed is sometimes onstage, as are the variety of raced and gendered "neighbors" who find themselves or desire themselves to be involved in the ritual of Ben's death. An overly caring gay male friend clucks around the living room, trying to keep Frank company even though Frank insists that he wants to be alone. A son from Ben's previous relationship lends his adolescent presence. Members of a family of origin (including Ben's homophobic bio-sister) assert their right to care as a familial entitlement, temporarily destabilizing the rights of Ben's active neighborhood of support. As the piece continues, bio and non-bio kin are required to stitch themselves into a new, precariously coordinated ensemble. A lesbian best friend, "Stalwart Becky," knows she is playing a stereotype in the history of AIDS care-giving when she "handles" everything for Ben and Frank, from food drop-offs to pesky relatives to Frank's own

gloomy psyche. Meanwhile, as a "granola eating PC single parent," she brings along her young son who both offers a welcome distraction and, frustratingly, also requires more and different forms of care and attention. Indeed, before we know anything about their history, *Deeply There* opens with Frank and Becky's son moving together in an arrangement of text and choreography that redefines the "pas de deux."[13]

Lights come up on Joe Goode as Frank alone in a chair, until a little boy pops up behind him. The audience collectively reacts with an "aaawww," as the limbs of the pint-sized dancer embrace him. "Where's Ben?" asks the boy, curling his legs up Frank's back and around his shoulders. "I don't know," says Frank, yielding to the boy as he climbs but keeping his own hands down to his sides. "Where's Ben?" the boy asks again. This time he launches himself off of Frank's body and into the air. Before he lands face first on the floor, Frank raises his arms to catch him. He firmly plants the child down on his feet with a frustrated repetition of the phrase. "I . . . don't . . . know." But the boy stands up again and places his foot on Frank's lap once more. "Where's Ben?" the child will not give up his questioning, or his climbing. This time Frank holds out an arm to support the climb, returning him more softly to the floor and giving a more specific answer. "Ben's sleeping," Frank says. The boy steps across and counters. "Ben's always sleeping." The sequence continues; Frank resists and relents as the child continues to use Frank's body as a sentient jungle gym. "Where's your mom?" Frank finally asks a question of his own. "I don't know," says the boy with a comeback. Eventually, the two of them cease their conversation as music begins; responding to the music's invitation to collaboration, they begin a series of paired moves that exchange placement, position, and weight. Frank supports the boy until he balances on his own, and then lifts him so that he flies through the air. When landing, the child pulls Frank to the ground with him; then the boy stands and pulls Frank up to his feet. Sometimes Frank cradles the child, and sometimes Frank lets the child go. By the end of the sequence, Frank asks the child whether he has ever been to the bayous of Louisiana. Smiling, Frank recalls it as a place where "you can lay in the mud and the moss just grows over your face." Lifting and bending, he adds, "And nobody . . . cares about . . . anything." He continues, "nobody. . . has to do . . . anything . . . except watch the grass grow out of their toes."

Throughout the 1980s and 1990s, Goode worked to challenge normalized relations of support and suspension in choreography, placing female dancers as support to suspended male dancers. Here and elsewhere, Goode actively pursues new configurations of what he calls "dependent forms," that is, moments when the dancers' ability to stay

upright depends upon the shared support that they give and receive to each other. In *Deeply There*, Goode translates this exploration of gendered ability to the realm of generational relations. As Frank and the boy move between playful exchange and annoyed response, Frank's body alternates between dominant and subordinate positions. Meanwhile, their bodies stay linked even when they chase and retreat, alighting at successive moments in an improbably dependent alignment where an adult body and a child body work together to keep each other from falling. The choreography thus troubles and even inverts generational conventions. Whereas those normalized conventions would allocate supporting gestures to the adult, re-instantiating the difference between caring adult and cared-for child, *Deeply There* questions the division between the independently grown and dependently young. Weight is literally and metaphorically distributed between a small body and a larger one. At other moments, the so-called adult lets go of the so-called child who swings with his own momentum and balances despite not being carefully held; it is not entirely clear who needs who in those moments. Audiences might wonder whether the adult will drop the child. But audiences might also wonder whether the performance of support needs always to assume certain conventional forms of safety, reliability, and stalwart maturity in order for trust to be sustained.

The dialogue throughout the sequence vacillates between the buoyancy and burdens of child dependence. This child is both a welcome refreshment and an annoying pain, one who repeats the same question over and over but one who reminds the adult of being carefree, one who is insensitive to illness ("Ben's always sleeping") but also one who reminds the adult of the squish of grass in his toes. The child is both a welcome distraction and a figure who demands new kinds of care and attention. What a pleasure, what a pain. As such, the sequence is a reminder not only of the normalization of childhood but also of the labor of other-directedness as well. *Deeply There* supplements a critique of the normativity of adult-child relations with a perspective that also notices the bodily, logistical, and psychic labor of sustaining relationality. Moreover, to place this child sequence in a piece about AIDS, sex, and death is also to cross a number of erotic and political taboos that remain as entrenched in the early twenty-first century as they did in the late twentieth century, those that would keep children away from gay communities, those that would disallow non-parental adult-child intimacy, those that would keep children away from sex and death. In the normative nuclear world that divides "those who have children" from "those who don't," Frank would be someone who does not; "where's your mom?" he asks, grumpily returning to a nuclear model to save

himself from the encumbrances of queer kinship. And yet the sequence seems to dismantle the logic that would allow Frank to define this child as "not mine." The life decision not to be a parent is not the same as not having children in one's life.

As there was in *Child Art Piece* and as there is in nearly every piece of art with children, *Deeply There*'s child performance risks obfuscating sentimentality. The "aaawww" that comes reflexively from the audience is evidence enough that the affect of the child onstage is over-determined, set in advance before he arrives. It seems important to think, though, about how this reaction and many other affective responses to dependence co-exist within larger systems. Here and elsewhere, interdependent choreography invokes but can also challenge the conventional gestures of care-giving. This shift seems particularly important to a queer imagining of social work, for the impulse to re-invent the choreography of care has always been so central to queer theory as many of us have understood its promise and possibility.[14] "Queer culture," writes Michael Warner and Lauren Berlant, "has learned not only how to sexualize these and other relations but also how to use them as a context for witnessing intense and personal affect while elaborating a public world of belonging and transformation."[15] These models support a notion of queerness (and public-ness) not only as radical non-attachment but also as promiscuous attachment, foregrounding especially forms of attachment that bypass or exceed biological ties. Furthermore, *Deeply There*'s meditation on AIDS and neighborhood suggests that the space of the death drive might provoke as many "social" as anti-social forms of relation. Indeed, in Kaja Silverman's reading of the death drive, it is in fact in its grip that our widest and wildest impulses for attachment and relationality occur.[16] *Deeply There* places the possibility of death and the possibility of intimacy into the same space. The willingness to release these forms and desires from opposite sides of the room is an animating principle of any sociality worth its salt.

To reckon with the complex experience of social work means reckoning with its force as both support and constraint. What a pleasure; what a pain. Whether imagined in our ambivalent relation to kinship systems or our ambivalent relation to social institutions, all of these affects seem destined to accompany the choreography of the supporting act. But navigating that ambivalence seems necessary to perform our connection to the future now of people whom we may never know. Navigating that ambivalence on both intimate and public scales structures both the force and the provisionality of the promises we make to intimates and to strangers. To avow support is to expose the conditions of unconditional love. So too it remains key to sustaining our public life as, in fact, living.

NOTES

PROLOGUE: PACING IN PUBLIC

1 Carlos Motta, "Relations in Real Time: A Conversation with Maria Lind," *Sjónauki* 3 (2008): 1. Online at www.carlosmotta.com/writings/MariaLind. pdf (accessed December 3, 2010). See, too, Maria Lind and Hito Steyeri, *The Greenroom: Reconsidering the Document in Contemporary Art* (New York and Berlin: Lukas and Sternberg, 2009).

2 Hans-Thies Lehmann, *Postdramatic Theatre*, trans. Karen Jurs-Munby (New York: Routledge, 2006): 68. For other recent reflections on visual aesthetics in relation to theatre, see Maaike Bleeker, *Visuality in the Theatre: The Locus of Looking* (London: Palgrave Macmillan, 2008); Erika Fischer-Lichte, *The Transformative Power of Performance: A New Aesthetics* (London and New York: Routledge, 2008); James M. Harding, *Cutting Performances: Collage Events, Feminist Artists, and the American Avant-garde* (Ann Arbor, MI: University of Michigan Press, 2009).

3 Claire Doherty, "The New Situationists," in *Contemporary Art: From Studio To Situation*, 8–13 (London: Black Dog, 2004).

4 Nicolas Bourriaud, *Relational Aesthetics* (Dijon: Les Presses du Réel, 1998): 14.

5 See Elinor Fuchs's invocation of Maeterlinck in her discussion of the landscape play in *The Death of Character* (Bloomington, IN: Indiana University Press, 1996).

6 Walter Benjamin quoted in Kuppers, Petra, *Disability and Contemporary Performance: Bodies on Edge* (New York: Routledge, 2004): 1.

7 Ibid., 2.

8 Vivian Sobchack, "Choreography for One, Two, and Three Legs (A Phenomenological Meditation in Movements)," *Topoi* 24 (Spring 2005): 55–66.

9 Ibid., 62.

10 Ibid., 63.

11 Robert Smithson, "Pointless Vanishing Points," in *Robert Smithson: The Collected Writings*, ed. Jack Flam (Berkeley, CA: University of California Press, 1996): 72.

12 Nancy Fraser, "Rethinking the Public Sphere: A Contribution to the Critique of Actually Existing Democracy," in *Habermas and the Public Sphere*, ed. Craig Calhoun, 107–142 (Cambridge, MA: MIT Press, 1992): 134, 136.

13 Michael Warner, *Publics and Counterpublics* (New York: Zone Books, 2002), 124.

1 PERFORMANCE, AESTHETICS, AND SUPPORT

1 For examples of elaboration in both the post-studio and the post-dramatic, see Claire Doherty, ed., *Contemporary Art: From Studio to Situation* (London: Black Dog Publishing, 2004) and Hans-Thies Lehmann, *Postdramatic Theatre,* trans. Karen Jurs-Munby (London: Routledge, 2006).

2 Fred Moten, *In the Break: The Aesthetics of the Black Radical Tradition* (Minneapolis, MN: University of Minnesota Press, 2003): 247.

3 Richard Sennett, *The Fall of Public Man* (originally published by New York: Knopf, 1977; reprinted by New York: W. W. Norton and Company, 1992).

4 For earlier reflections on social practice, see Shannon Jackson "Social Practice," *Performance Research: Lexicon Special Issue* (September 2006) and "What is the 'Social' in Social Practice? Comparing Experiments in Performance," in *Cambridge Handbook of Performance Studies,* ed. Tracy C. Davis (Cambridge: Cambridge University Press, 2008). Examples of other studies that will be engaged throughout this book include Claire Bishop, *Participation* (Cambridge, MA: MIT Press, 2006); Ted Purves, ed., *What We Want is Free: Generosity and Exchange in Recent Art* (Albany, NY: SUNY Press, 2005); Grant Kester, *Conversation Pieces: Community and Communication in Modern Art* (Berkeley, CA: University of California Press, 2004); Claire Doherty, *Situation* (Cambridge, MA: MIT Press, 2009).

5 For related reflections on theatre, performance, and visual art history, see Shannon Jackson, "Theatre . . . Again," *Art Lies* 60 (2008), online at www.artlies.org/article.php?id=1682&issue=60&s=1 (accessed December 3, 2010), and "Performing Show and Tell: Disciplines of Visual Culture and Performance Studies," *Journal of Visual Culture* 4: 2 (2005): 163–177, and "When 'Everything Counts'": Experimental Performance and Performance Historiography," in *Representing the Past,* eds. Thomas Postlewait and Charlotte Canning (Iowa City, IA: University of Iowa Press, 2010).

6 Tino Sehgal, for example, is one of many relational artists who reject a theatrical language in the analysis of his "situations"; Nicolas Bourriaud is often concerned to distance relational aesthetic practices from performance in *Relational Aesthetics* (Dijon: Les Presses du Réel, 1998).

7 Alain Badiou, Bernard Blistene, and Yann Chateigne, *A Theater without Theater* (Barcelona: Museu D'Art Contemporani de Barcelona, 2007).

8 J. L. Austin, *How to Do Things with Words,* eds. J. O. Urmson and Marina Sbisà (Cambridge, MA: Harvard University Press, 1975, second edition): 24.

9 Michael Fried, "Art and Objecthood," *Artforum* 5 (1967): 12–23; Patricia Falguières, "Playground," in Patricia Falguierès, Manuel J. Borja-Villel, and Bernard Blistene, *A Theater Without Theater,* 28–34 (Barcelona: Actar Produccions, 2007): 28.

10 For a contemporary art historical study that uses the language of contingency, see Martha Buskirk, *The Contingent Object of Contemporary Art* (Cambridge, MA: MIT Press, 2003).

11 Kristin Ross, *May '68 and Its Afterlives* (Chicago, IL: University of Chicago Press, 2002).

12 Herbert Marcuse, *One Dimensional Man: Studies in the Ideology of Advanced Industrial Society* (Boston, MA: Beacon Press, 1991); Luc Boltanski and Eve Chiapello, *The New Spirit of Capitalism* (New York: Verso, 2007).

13 Brian Holmes, *Unleashing the Collective Phantoms: Essays in Reverse Imagineering* (Brooklyn, NY: Autonomedia, 2008).

14 Anthony Giddens, *The Third Way: The Renewal of Social Democracy* (Cambridge: Polity Books, 1999).

15 Ulrich Beck and Elisabeth Beck-Gernsheim, *Individualization* (London: Sage, 2002); Ulrich Beck, *The Risk Society: Towards a New Modernity* (Thousand Oaks, CA: Sage Publications, 1992).

16 Alexander Alberro and Sabeth Buchmann, eds., *Art After Conceptual Art* (Cambridge, MA: MIT Press, 2006); John C. Welchman, *Institutional Critique and After* (New York: Distributed Art Publishers, Inc., 2007); see "exit strategy" section in Alexander Alberro and Blake Stimson, *Institutional Critique: An Anthology of Artist Writings* (Cambridge, MA: MIT Press, 2009).

17 Benjamin Buchloh, "Conceptual Art 1962–1969: From the Aesthetics of Administration to the Critique of Institutions," *October* 55 (1990): 105–143.

18 Claire Bishop et al., "Panel Discussion," in *The Art of Welfare*, eds. Marta Kuzma and Peter Osborne, 115–132 (Oslo: Office for Contemporary Art Norway, 2006): 118.

19 Rosalind Deutsche, *Evictions: Art and Spatial Politics* (Cambridge, MA: MIT Press, 1996); Miwon Kwon, *One Place After Another: Site Specific Art and Locational Identity* (Cambridge, MA: MIT Press, 2004); Alexander Alberro, *Art After Conceptual Art* (Cambridge, MA: MIT Press, 2006); Julia Bryan-Wilson, *Art Workers: Radical Practice in the Vietnam War Era* (Berkeley, CA: University of California Press, 2009).

20 For an example of a work that articulates a similar concern, see Jane Blocker, *What the Body Cost: Desire, History, and Performance* (Minneapolis, MN: University of Minnesota, 2004).

21 For a philosophical exploration of this figure, see Alice Rayner, "Rude Mechanicals and the Spectres of Marx," *Theatre Journal* 54: 4 (2002): 535–554.

22 *Oxford English Dictionary*, s.v. "support."

23 AbdouMaliq Simone, "People as Infrastructure: Intersecting Fragments in Johannesburg," *Public Culture* 16: 3 (Fall 2004): 407–429.

24 Clement Greenberg, "Modernist Painting," in *The New Art: A Critical Anthology*, ed. Gregory Battcock (New York: E. P. Dutton & Co., Inc., 1966): 68–69. The first version of the essay, using the term "support," appeared in *Forum Lectures* (Washington, DC: Voice of America, 1960).

25 Hal Foster, *The Return of the Real* (Cambridge, MA: MIT Press, 1996); Shannon Jackson, "Practice and Performance," in *Professing Performance* (Cambridge: Cambridge University Press, 2004): 109–145.

26 Michael Fried, *Art and Objecthood* (Chicago, IL: University of Chicago Press, 1998): 154–155.

27 W. J. T. Mitchell, *What Do Pictures Want?: The Lives and Loves of Images* (Chicago, IL: University of Chicago Press, 2006): 198.

28 Bourriaud, *Relational Aesthetics*, 14.

29 Louis Althusser, "Ideology and Ideological State Apparatuses," in *Lenin and Philosophy and Other Essays*, trans. Ben Brewster (London: New Left Books,

1971; originally published in *La Pensée in* French in 1970): 123–173; Ernesto Laclau and Chantal Mouffe, *Hegemony and Socialist Strategy: Towards a Radical Democratic Politics,* second edition (London: Verso, 2001).

30 See, for instance, David Harvey, *Spaces of Global Capitalism: A Theory of Uneven Development* (London: Verso, 2006) and Neil Smith, "Contours of a Spatialized Politics: Homeless Vehicles and the Production of Geographic Scale," *Social Text* 10: 4 (1992): 19–33.

31 For references that only begin to suggest the enormity of this project, see Michel Foucault, *Discipline and Punish: The Birth of the Prison* (1975, 1977 in English; reprinted London: Verso, 1995); *The History of Sexuality,* trans. R. Hurley (1984; reprinted New York: Vintage, 1995); and *"Society Must Be Defended": Lectures at the College de France, 1975–1976,* trans. David Macey (New York: Picador, 2003).

32 Once again, for an introduction to a wide-ranging project, see Judith Butler, *Gender Trouble: Feminism and the Subversion of Identity* (New York: Routledge, 1990); *Bodies That Matter: On the Discursive Limits of Sex* (New York: Routledge, 1993); and *The Psychic Life of Power: Theories of Subjection* (Stanford, CA: Stanford University Press, 1997).

33 Jasbir K. Puar, *Terrorist Assemblages: Homonationalism in Queer Times* (Durham, NC: Duke University Press, 2007): 174.

34 Nancy Fraser and Linda Gordon, "A Genealogy of Dependency: Tracing a Keyword of the U.S. Welfare State," *Signs* 19: 2 (Winter 1994): 309–336; Wendy Brown, *States of Injury: Power and Freedom in Late Modernity* (Princeton, NJ: Princeton University Press, 1995); Mimi Abramovitz, *Under Attack, Fighting Back: Women and Welfare in the United States,* second edition (New York: Monthly Review Press, 2000) and *Regulating the Lives of Women: Social Welfare Policy from Colonial Times to the Present,* revised edition (Cambridge, MA: South End Press, 1999); Gwendolyn Mink, *Whose Welfare?* (Ithaca, NY: Cornell University Press, 1999); Theda Skocpol, *Protecting Soldiers and Mothers: The Political Origins of Social Policy in the United States* (Cambridge, MA: Harvard University Press, 1995).

35 Judith Butler and Shannon Jackson, "What Makes Performance Possible?" (co-authored lecture, Colorado College, October 2009).

36 Peggy Phelan, *Unmarked: The Politics of Performance* (New York: Routledge, 1993): 146.

37 Ibid., 149.

38 Ruth Wilson Gilmore, "Tossed Overboard: Katrina, Incarceration, and the Politics of Abandonment," paper presented at the American Studies Association, Washington, DC, November 6, 2005.

39 Alan Read, *Theatre, Intimacy, and Engagement: The Last Human Venue* (London: Palgrave, 2008): 43.

2 QUALITY TIME

1 Shannon Flattery, *Touchable Stories,* website, online at www.touchablestories. org (accessed December 3, 2010); emphasis in original.

2 Quoted in Santiago Sierra, Eckhard Schneider, and Kunsthaus Bregenz, "300 Tons," in *Santiago Sierra: 300 Tons and Previous Works* (New York: König, 2004): 33.

3 In the United States, important analyses of community engagement come from figures such as Linda Frye Burnham, Ann Kilkelly, and Robert H. Leonard, eds., *Performing Communities: Grassroots Ensemble Theaters Deeply Rooted in Eight U.S. Communities* (Oakland, CA: New Village Press, 2006); Jan Cohen-Cruz, *Local Acts: Community-Based Performance in the United States* (New Brunswick: Rutgers University Press, 2005); Arlene Goldbard, *New Creative Community: The Art of Cultural Development* (Oakland, CA: New Village Press, 2006); and others identified with the Community Arts Network and Imagining America. Other important community performance works include Baz Kershaw's early study, *Welfare State International, Engineers of the Imagination 1982* (London: Methuen, 1990), his *The Politics of Performance: Radical Theatre as Cultural Intervention* (New York: Routledge, 1992), and his *Theatre Ecology: Environments and Performance Events* (London: Cambridge University Press, 2007); also Petra Kuppers, *Community Performance: An Introduction* (London: Routledge, 2007).

4 For critiques of the normative dimension of community discourse, see Jean-Luc Nancy, *The Inoperative Community*, ed. Peter Connor (Minneapolis, MN: University of Minnesota Press, 1991) and Miranda Joseph, *Against the Romance of Community* (Minneapolis, MN: University of Minnesota Press, 2002). For an example of a skeptical analysis of community engagement in an aesthetic sphere, see Hal Foster, "Artist as Ethnographer," in *Return of the Real* (Cambridge, MA: MIT Press, 1996): 171–204, as well as Miwon Kwon's engagement with Foster's essay throughout *One Place After Another: Site-Specific Art and Locational Identity* (Cambridge, MA: MIT Press, 2004). Grant Kester works to reconcile community art work with post-Minimalist formal questions in *Conversation Pieces: Community and Communication in Modern Art* (Berkeley, CA: University of California Press, 2004). Other important contributions to similar social and formal conversations in public art, activism, and performance include Suzanne Lacy, ed., *Mapping the Terrain: New Genre Public Art* (Seattle, WA: Bay Press, 1994); Nina Felshin, *But Is It Art? The Spirit of Art As Activism* (Seattle, WA: Bay Press, 1994); Michael McKinnie, *City Stages: Theatre and Urban Space in a Global City* (Toronto: University of Toronto Press, 2007); Nick Kaye, *Site-Specific Art: Performance, Place, and Documentation* (New York and London: Routledge, 2000); and Jill Dolan, *Utopia in Performance: Finding Hope at the Theater* (Ann Arbor, MI: University of Michigan Press, 2005).

5 Nicolas Bourriaud, *Relational Aesthetics* (Dijon: Les Presses du Réel, 1998): 14.

6 Ibid., 39.

7 Emmanuel Levinas, *Totality and Infinity: An Essay on Exteriority*, trans. Alphonso Lingis (Pittsburgh, PA: Duquesne University Press, 1969): 294.

8 Bourriaud, *Relational Aesthetics*, 23.

9 My thanks to Anne Walsh and Anne Wagner for thinking with me about the effects of Gonzalez-Torres's work.

10 Claire Bishop, "Antagonism and Relational Aesthetics," *October* 110 (Fall, 2004): 51–79; Liam Gillick, "Contingent Factors: A Response to Claire Bishop," *October* 115 (Winter, 2006): 95–107; and Claire Bishop, "The Social Turn: Collaboration and its Discontents," *Artforum* 44 (February, 2006): 178–183.

11 Bishop, "Antagonism and Relational Aesthetics," 74, 75.

12 Chantal Mouffe, ed., *Deconstruction and Pragmatism* (London: Routledge, 1996).
13 Bishop, "The Social Turn," 181.
14 Ibid., 183.
15 Ibid., 183.
16 Bishop, "Antagonism and Relational Aesthetics," 52, 53, 60, 61.
17 Bishop, "The Social Turn," 182.
18 Theodor Adorno, "Commitment," in *The Essential Frankfurt School Reader*, eds. Andrew Arato and Eike Gebhardt (New York: Continuum, 1982): 300–318.
19 Ibid., 308.
20 Ibid., 316, 317.
21 Ibid., 317.
22 Ernesto Laclau and Chantal Mouffe, *Hegemony and Socialist Strategy: Towards a Radical Democratic Politics*, second edition (London: Verso, 2001): 123.
23 Ibid., 125.
24 Ibid., 125.
25 Ibid., 125.
26 Quoted in Ibid., 106.
27 Ibid., xiv–xv.
28 Ibid., xvi.
29 Jacques Rancière, *Hatred of Democracy*, trans. Steve Corcoran (London: Verso, 2007): 40.
30 Jacques Rancière, *The Politics of Aesthetics*, English edition (New York: Continuum, 2004). French edition published as *Le Partage du Sensible: Esthétique et Politique* (Paris: La Fabrique, 2000).
31 Jacques Rancière, "*The Emancipated Spectator*," *Artforum* XLV, No. 7 (March, 2007): 271–277, 277.
32 Ibid., 274.
33 Bishop, "Antagonism and Relational Aesthetics," 57.
34 Ibid., 69; Bishop, "The Social Turn," 185.
35 Bishop, "Antagonism and Relational Aesthetics," 79.
36 Ibid., 65; Bishop, "The Social Turn," 182.
37 Bishop, "The Social Turn," 184.
38 Grant Kester, "Another Turn," *Artforum* 44: 9 (May, 2006): 22–23, 23.
39 Ibid., 23.
40 Bishop, "Antagonism and Relational Aesthetics," 77; Bishop, "The Social Turn," 179.
41 Jennifer Roche, "Socially Engaged Art, Critics and Discontents: An Interview with Claire Bishop," *Community Arts Network* website. Online at www.communityarts.net/readingroom/archivefiles/2006/07/socially_engage.php (accessed December 3, 2010).
42 Claire Bishop et al., "Panel Discussion," in *The Art of Welfare*, eds. Marta Kuzma and Peter Osborne, 115–132 (Oslo: Office for Contemporary Art Norway, 2006): 118.
43 Jennifer Roche, "Socially Engaged Art, Critics and Discontents."
44 Bishop, "Antagonism and Relational Aesthetics," 77; Bishop, "The Social Turn," 182; Bishop, "Antagonism and Relational Aesthetics," 74; Bishop, "The Social Turn," 183.

45 Bishop, "The Social Turn," 182.
46 Gillick, "Contingent Factors," 100.
47 Ibid., 102.
48 Ibid., 100.
49 Sonja Kuftinec, "Introduction: Surveying the Terrain," in *Staging America: Cornerstone and Community-Based Theater* (Carbondale, IL: Southern Illinois University Press, 2003): 1–22.
50 Sara Brady, "Welded to the Ladle: *Steelbound* and Non-Radicality in Community-Based Theatre," *The Drama Review* 44: 3 (Fall, 2000): 51–74.
51 Ibid., 52.
52 Ibid., 61.
53 Ibid., 65; Baz Kershaw, *The Politics of Performance: Radical Theatre as Cultural Intervention* (New York: Routledge, 1992): 224.
54 Brady, "Welded to the Ladle," 54.
55 Ibid., 64.
56 Ibid., 64.
57 Ibid., 67.
58 See the documents assembled in Andrew Quick, *The Wooster Group Work Book* (London: Routledge, 2007).
59 See, Alan Read, "On the Social Life of Theatre," in *Theatre, Intimacy, Engagement: The Last Human Venue*, 15–80 (London: Palgrave, 2008); Joe Kelleher, *Theatre and Politics* (London: Palgrave, 2009); Nicholas Ridout, *Theatre and Ethics* (London: Palgrave, 2009).
60 Michael Fried, *Art and Objecthood* (Chicago, IL: University of Chicago Press, 1998): 155.
61 Ibid., 153.
62 Quoted in Ibid., 153. Robert Morris's "Notes on Sculpture" was originally published in three parts in *Artforum* (February and October, 1966).
63 Fried, *Art and Objecthood*, 154–155.
64 Neil Smith, "Contours of a Spatialized Politics: Homeless Vehicles and the Production of Geographic Scale," *Social Text* 10: 4 (1992): 19–33.
65 Robert Morris, "Notes on Dance," *Tulane Drama Review* 10: 2 (1965): 183.
66 Shannon Jackson, "*Touchable Stories* and the Performance of Infrastructural Memory," in *Remembering: Oral History and Performance,* ed. Della Pollock (New York: Palgrave Macmillan, 2005): 45–66.
67 Adorno, "Commitment," 312.
68 Andrea Giunta and Peter Kahn, *Avant-Garde, Internationalism, and Politics: Argentine Art Since the Sixties,* trans. Peter Kahn (Durham, NC: Duke University Press, 2007); Alexander Alberro, "Another Relationality," lecture presented at "Catalysts and Critics: Art of the 1990s," Symposium at the Guggenheim Museum, 2008.
69 Quoted in Mark Spiegler, "When Human Beings Are the Canvas," *Artnews* (June, 2003). Online at www.artnews.com/issues/article.asp?art_id=1335 (accessed December 3, 2010).
70 Phoebe Hoban, "How Far is Too Far?" *Artnews* 107: 7 (Summer 2008). Online at www.artnews.com/issues/article.asp?art_id=2522 (accessed December 3, 2010). My thanks to Jennifer Doyle for her thoughts about this episode.

71 Brady, "Welded to the Ladle," 65.
72 Bishop, "Antagonism and Relational Aesthetics," 61.
73 Gillick, "Contingent Factors," 100.
74 Roche, "Socially Engaged Art, Critics and Discontents."
75 Cora Hook, "Letters to the Editor," *The Drama Review* 45: 3 (Fall, 2001): 15.
76 Fred Moten, *In the Break: The Aesthetics of the Black Radical Tradition* (Minneapolis, MN: University of Minnesota Press, 2003): 247.

3 HIGH MAINTENANCE

1 Amelia Jones, "Introduction," in *The Feminism and Visual Culture Reader*, 1–6 (New York: Routledge, 2003): 1.
2 Mierle Laderman Ukeles, "Interview." Coordinated by Erin Salazer, Bronx Museum TGC Magazine (Spring/Summer 2006): 16. Online at www. feldmangallery.com/media/ukeles/general%20press/2006_ukeles_ tgc-bx%20museum.pdf (accessed December 3, 2010).
3 Mierle Laderman Ukeles, "Leftovers/It's About Time for Fresh Kills," *Cabinet* (Spring 2002): 1–2, 1.
4 Regina Cornwell, "Reinventing Maintenance with Artist Mierle Ukeles," *Women's Media Center* (December 14, 2006): n.p. For an analysis of storage as a conceptual art practice, see, Gina Schmeling, "Storage as Practice in Art and Garbage," MA Thesis in Humanities and Social Thought, New York University (2007).
5 Mierle Laderman Ukeles, "A Journey: Earth/City/Flow," *Art Journal* (Summer 1992): 12–14, 12.
6 George Baker, "Introduction to 'Antagonism and Relational Aesthetics' by Claire Bishop," *October* 110 (Fall, 2004): 49–50. For further reference sources for late twentieth-century feminist art, see Helena Reckitt and Peggy Phelan, eds., *Art and Feminism* (London: Phaidon Press, 2001) and the catalogue accompanying the celebrated WACK exhibition, Cornelia Butler and Lisa Gabrielle Mark, eds., *WACK: Art and the Feminist Revolution* (Cambridge, MA: MIT Press, 2007).
7 *Oxford English Dictionary*, s.v. "prop."
8 Andrew Sofer, *The Stage Life of Props* (Ann Arbor, MI: University of Michigan Press, 2003): 12.
9 Tom McDonough, ed., *Guy Debord and the Situationist International: Texts and Documents* (Cambridge, MA: MIT Press, 2004): 9.
10 Ibid., 38.
11 Frederic Jameson, *The Prison-House of Language* (Princeton, NJ: Princeton University Press, 1974): 58, quoted in McDonough, *Guy Debord*.
12 Samuel J. Wagstaff Jr., "Talking with Tony Smith: 'I view art as something vast,'" *Artforum* 5: 4 (December 1966): 14–19.
13 Robert Smithson, "Pointless Vanishing Points," in *Robert Smithson: The Collected Writings*, ed. Jack Flam (Berkeley, CA: University of California Press, 1996): 54.
14 Tom Finkelpearl, "Interview: Mierle Laderman Ukeles," in *Dialogues in Public Art*, 295–322 (Cambridge, MA: MIT Press, 2000): 301.
15 Ibid., 301.
16 Ibid., 301.

17 Ibid., 301.
18 Ibid., 303.
19 Ibid., 301.
20 Ibid., 302.
21 Ibid., 302.
22 Jeffrey Kastner, "The Department of Sanitation's Artist in Residence," *The New York Times* (May 19, 2002). Online at www.nytimes.com/2002/05/19/arts/design/19KAST.html (accessed December 3, 2010).
23 Mierle Laderman Ukeles, "Manifesto for Maintenance Art 1969! Proposal for exhibition 'Care,'": 1–4, 1. Copyright Mierle Laderman Ukeles, 1969; reprinted in Lucy Lippard, *Six Years: The Dematerialization of the Art Object* (New York: New York University Press, 1979): 220–221.
24 Ibid., 1.
25 Ibid., 1–2.
26 Saba Mahmood, *Politics of Piety: The Islamic Revival and the Feminist Subject* (Princeton, NJ: Princeton University Press, 2005): 14.
27 Ukeles, "Manifesto," 1.
28 Ibid., 2.
29 Ibid., 2.
30 Ibid., 2.
31 Jill Johnston, "Dance Quote Unquote," in *Reinventing Dance in the Sixties: Everything Was Possible,* ed. Sally Banes, 98–104 (Madison, WI: University of Wisconsin Press, 1999): 100.
32 Helen Molesworth, "House Work and Art Work," in *Art After Conceptual Art*, ed. Alexander Alberro and Sabeth Buchmann, 66–84 (Cambridge, MA: Generali Foundation and MIT Press, 2006): 74; originally published in Michael Newman and Jon Bird, *Rewriting Conceptual Art* (London: Reaction Books, 1999).
33 For an example of a feminist response to a critique of feminism's fracturing of revolutionary art practice, see Rosalyn Deutsche's reading of Tom Crow in the last chapter of *Evictions: Art and Spatial Politics* (Cambridge, MA: MIT Press, 1965).
34 Ukeles, "Interview," 14–15.
35 Miwon Kwon, *One Place After Another: Site-Specific Art and Locational Identity* (Cambridge, MA: MIT Press, 2004): 23.
36 Ibid., 19–24. Emphasis in original.
37 John Chandler and Lucy R. Lippard, "The Dematerialization of Art," *Art International* (February 20, 1968): 31–36.
38 Peggy Phelan, *Unmarked: The Politics of Performance* (London; New York: Routledge, 1993).
39 Marcel Duchamp, "Utiliser un Rembrandt comme planche à repasser" (proposition originally dated 1972).
40 McDonough, *Guy Debord*, 103–104.
41 Ibid., 104.
42 Ibid., 105.
43 Ibid., 105.
44 Kastner, "The Department of Sanitation's Artist in Residence," italics added.
45 Molesworth, "House Work and Art Work," 78. Ukeles notes that this performance was documented by the camera, not staged for the camera.
46 Ibid.

47 Ukeles, "Interview," 16.
48 Kastner, "The Department of Sanitation's Artist in Residence," 1.
49 Ukeles, "Leftovers."
50 Ibid.
51 Ukeles, "Interview," 19. The performance *Cleansing the Bad Names* opened the Touch Sanitation Show at the Ronald Feldman Gallery, 1984.
52 Ibid.
53 Ibid.
54 Ukeles, "A Journey: Earth/City/Flow."
55 Ibid., 12.
56 Ibid., 12.
57 Ibid., 12.
58 Baile Oakes, ed., *Sculpting with the Environment: A Natural Dialogue* (New York: Van Nostrand Reinhod, 1995); quoted in Cornwell, "Reinventing Maintenance with Artist Mierle Ukeles."

4 STAGED MANAGEMENT

1 Patricia Falguières, "Playground," in Patricia Falguierès, Manuel J. Borja-Villel, and Bernard Blistin, *A Theater Without Theater* (Barcelona: Actar Produccions, 2007): 28–34, 33.
2 Ibid., 185.
3 Clement Greenberg, "Modernist Painting," *The New Art: A Critical Anthology*, ed. Gregory Battcock (New York: E. P. Dutton & Co., Inc., 1973): 68–69.
4 Among the many accounts of Fried and Greenberg's effects on theatrical discourse, see Amelia Jones, "Live Art in Art History: A Paradox?" *The Cambridge Companion to Performance Studies*, ed. Tracy C. Davis, 151–165 (Cambridge: Cambridge University Press, 2008). For further studies of how live art challenges this frame in ways that bear upon the discourse of social practice, see Rebecca Schneider, *The Explicit Body in Performance* (London and New York: Routledge, 1997); Jane Blocker, *What the Body Cost: Desire, History, and Performance* (Minneapolis, MN: University of Minnesota Press, 2004); Amelia Jones, *Body Art: Performing the Subject* (Minneapolis, MN: University of Minnesota Press, 1998).
5 Michael Fried, "Art and Objecthood," *Artforum* 5 (1967): 153.
6 T. J. Clark, "Greenberg's Theory of Art," *Critical Inquiry* 9: 1 (September 1982): 139–156.
7 Ibid., 156.
8 See Andrea Fraser, "From a Critique of Institutions to an Institution of Critique," *Artforum* 44: 1 (September, 2005): 100–106 for one account of these elusive origins.
9 James Meyer, *What Happened to Institutional Critique?* (New York: American Fine Arts Co., 1993); Alexander Alberro's "Introduction: The Way Out is the Way In" in *Art After Conceptual Art*, eds. Alexander Alberro and Sabeth Buchmann, 13–26 (Cambridge, MA: MIT Press, 2006); Alexander Alberro and Blake Stimson, eds., *Institutional Critique: An Anthology of Artists' Writings* (Cambridge, MA: MIT Press, 2009); John C. Welchman, *Institutional Critique and After* SoCCAS Symposium Vol. ll. Edited by John C. Welchman. Essays by Alexander Alberro, Jens Hoffmann, Andrea Fraser,

Renee Green, Isabelle Graw, Lauri Firstenberg, et al. (Zürich: JRP/Ringier, 2006).

10 Sabine Breitwieser, "Photography between Documentation and Theatricality: Speaking Within, Alongside, and Through Photographs," in *Allan Sekula: Performance Under Working Conditions*, ed. Sabine Breitwieser, 12–19 (Vienna: Generali Foundation/Hatje Cantz, 2003): 15.

11 Breitwieser, "Photography between Documentation," 18.

12 Breitwieser, *Allan Sekula* (includes interview with Benjamin Buchloh), 21–22.

13 Allan Sekula, "Aerospace Folktales, 1973," in Breitwieser, *Allan Sekula*, 92–163.

14 Ibid., 116.

15 Ibid., 93.

16 Ibid., 129.

17 Ibid., 149.

18 Ibid., 150.

19 Ibid., 151.

20 Bertolt Brecht, *Brecht on Theatre*, trans. and ed. John Willett (London: Methuen, 1964): 37. For a provocative excavation of Brecht and Benjamin's intellectual collaboration, see Freddie Rokem, "Walter Benjamin and Bertolt Brecht discuss Franz Kafka," in *Philosophers and Thespian: Thinking Performance*, 118–140 (Stanford, CA: Stanford University Press, 2010).

21 See Kaja Silverman, "Suture," in *The Subject of Semiotics*, 194–236 (New York: Oxford University Press, 1983).

22 For more on "emotional" or "affective labor," see Arlie Russell Hochschild, *The Managed Heart: Commercialization of Human Feeling* (Berkeley, CA: University of California Press, 1985): 137–161 and Michael Hardt and Antonio Negri, *Empire* (Cambridge, MA: Harvard University Press, 2000): 292–293, 364–365. Hardt and Negri initially reflected on this movement in *Labor of Dionysus: A Critique of the State-Form* (Minneapolis, MN: University of Minnesota Press, 1994).

23 Allan Sekula, "In conversation with Benjamin Buchloh," in Breitwieser, *Allan Sekula*, 22–55, 25.

24 Allan Sekula, "This Ain't China," in Breitwieser, *Allan Sekula*, 197–99.

25 Hochschild, *The Managed Heart*.

26 Ibid., 207.

27 Benjamin Buchloh, "Since Realism There Was . . . (On the Current Conditions of Factographic Art)," in *Art and Ideology*, ed. Marcia Tucker, 5–20 (New York: New Museum of Contemporary Art, 1984): 10.

28 Allan Sekula, "In conversation with Benjamin Buchloh," 43.

29 Ibid. Sergei Tretiakov, "From the Photoseries to the Long-Term Photographic Observation," *Prolatarskoje* 4 (1931), quoted in Benjamin H. D. Buchloh, "From Faktura to Factography," *October* 30 (Autumn 1984): 82–119.

30 Walter Benjamin, "Author as Producer," in *Reflections: Essays, Aphorisms, Autobiographical Writings*, trans. Edmond Jephcott, ed. Peter Demetz, 222–238 (New York: Schocken Books, 1978): 223.

31 As Tretiakov suggested in his essay "From the photographic Series to the systematic Investigation" in 1931, this involvement with a new audience will have to gradually increase their participation and emphasize the necessity of self-representation of these audiences.

That requires more than the token commitment that previous art practices have offered to different audiences by splashing the work with hints of popular culture, for example, participatory gadgets, or by dressing it up in a crude proletarian materiality. Allan Sekula's work, School is a Factory, 1979–80, for example, was primarily conceived for display and interaction with the audiences of students at community colleges, since the work investigated the interrelationships between the interests and needs of corporations in certain areas of California and the education programs that the community colleges in that area offered.

(Buchloh, "Since Realism there was," 10)

32 Benjamin, "The Author as Producer," 222.
33 Andrea Fraser, "Museum Highlights: A Gallery Talk," *October* 57 (Summer 1991): 104–122, 104–106.
34 Alexander Alberro, "Introduction: Mimicry, Excess, Critique" in *Museum Highlights: The Writings of Andrea Fraser*, ed. Alexander Alberro (Cambridge, MA: MIT Press, 2007): xxll–2.
35 Fraser, "Museum Highlights: A Gallery Talk," 106.
36 Ibid., 106.
37 Ibid., 106.
38 Ibid., 107, quoting Robert Montgomery Scott and Anne d'Harnoncourt, "From the President and the Director," *Philadelphia Museum of Art Magazine* (Spring 1988).
39 Unpublished V-Girls scripts courtesy of Marianne Weems, Martha Baer, Andrea Fraser, Jessica Chalmers, and Erin Cramer. See also, Martha Baer et al., "The V-Girls: A Conversation with October," *October* 51 (Winter 1989): 115–143.
40 C. Carr, "Revisions of Excess: The V-Girls, Blue Man Group," in *On Edge: Performance at the end of the Twentieth Century*, revised edition, 177–179 (Middletown, CT: Wesleyan University Press, 2008): 177.
41 Brecht, *Brecht on Theatre*, 136.
42 Ibid., 140.
43 Ibid., 198.
44 Pierre Bourdieu, "Revolution and Revelation," in *Museum Highlights: The Writings of Andrea Fraser*, ed. Alexander Alberro, xii–xiv (Cambridge, MA: MIT Press, 2007): xiii.
45 Brecht, *Brecht on Theatre*, 139. For another interview where Fraser makes reference to "acting" in her pieces, see Judith Batalion, "On and Off the Page: An Interview with Andrea Fraser," *Immediations* 2: 2 (2009).
46 Elin Diamond, *Unmaking Mimesis* (New York: Routledge, 1997): 53.
47 Patrice Pavis, *Languages of the Stage: Essays in the Semiology of the Theatre* (New York: Performing Arts Journal Publications, 1982): 88. Quoted in Diamond, *Unmaking Mimesis*, 53.
48 Andrea Fraser, *Museum Highlights: The Writings of Andrea Fraser*, ed. Alexander Alberro (Cambridge, MA: MIT Press, 2005): 100.
49 Ibid., 101.
50 Ibid., 104.
51 Andrea Fraser, *Museum Highlights: The Writings of Andrea Fraser*, 83–84.
52 Andrea Fraser, "From the Critique of Institutions to an Institution of Critique," *Artforum* (September 2005): 100–106.

53 Ibid., 104.
54 Andrea Fraser, "An Artist's Statement (1992)," in *Museum Highlights: The Writings of Andrea Fraser*, 3.
55 Fraser, *Museum Highlights: The Writings of Andrea Fraser*, 77.
56 Ibid., 121.
57 Ibid., 123–140.
58 Ibid.
59 Thomas Lawson, "Allan McCollum Interviewed by Thomas Lawson," in *Allan McCollum*, ed. William S. Bartman (Los Angeles, CA: A.R.T. Press, 1996): 2.
60 Martha Buskirk, *The Contingent Object of Contemporary Art* (Cambridge, MA: MIT Press, 2003): 184.
61 Fraser, *Museum Highlights: The Writings of Andrea Fraser*, 34.
62 Andrea Fraser, "May I Help You?" Online at p.5 of the Petzel Gallery website at http://i1.exhibit-e.com/petzel/95f61adf.pdf (accessed January 12, 2011).
63 Ibid., 12–13.
64 Ibid., 8.
65 Alberro, "Introduction: Mimicry, Excess, Critique," xxvi.
66 Andrea Fraser, "What is Institutional Critique?" in John C. Welchman, *Institutional Critique and After* (New York: Distributed Art Publishers, Inc., 2007): 307.
67 Judith Rodenbeck invokes Alex Potts's term in reference to the reception of Andrea Fraser's work in her lecture, "Working to Learn Together: The Case of Manifesta 6," delivered at "Expertise: Medium-Specificity and Interdisciplinarity," Tel Aviv University, June 2009.
68 Falguières, "Playground," 31.
69 Lynn Zelevansky, "From Inside the Museum: Some Thoughts on the Issue of Institutional Critique," in *Institutional Critique and After*, ed. John C. Welchman, 171–182 (Zürich: JRP/Ringier, 2006).
70 Documentation notes from author visit (April 13, 2007).
71 Documentation notes from author visit (April 13, 2007).
72 Mark H. C. Bessire, *William Pope.L: The Friendliest Black Artist in America* (Cambridge, MA: MIT Press, 2002): 220.
73 Ibid., 236.
74 William Pope.L, "Sandwich Lecture #8," in *Live: Art and Performance*, ed. Adrian Heathfield and Hugo Glendinning (New York: Routledge, 2004).
75 Bessire, *William Pope.L*, 231.
76 Quoted in C. Carr, "In the Discomfort Zone," in Bessire, *William Pope.L*, 49.
77 Quoted in Kristine Stiles, "Thunderbird Immolation: Burning Racism," in Bessire, *William Pope.L*: 36.
78 Ibid., 37.
79 Ibid., 36.
80 Darby English, *How to See a Work of Art in Total Darkness* (Cambridge, MA: MIT Press, 2007): 293.
81 William Pope.L., in conversation with the author (Spring 2006).
82 Stiles, "Thunderbird Immolation: Burning Racism," 41.
83 C. Ondine Chavoya, "William Pope.L: Interview," in *The Interventionists: Users' Manual for the Creative Disruption of Everyday Life*, eds. Nato Thompson and Gregory Sholette, 40–42 (Cambridge, MA: MIT Press, 2004): 40.

84 Bessire, *William Pope.L*, 223.
85 Ibid., 224–225.
86 English, *How to See a Work*, 229.
87 Quoted in Ibid., 22.
88 Ibid., 230.
89 See Neil Smith, "New City, New Frontier," in *Variations on a Theme Park: The New American City and the End of Public Space*, ed. Michael Sorking (New York: Hill and Wang, 1996); Renu Cappelli, "Inadmissible Presence: Objecthood, Spectacle, and the Theatricality of Race" (Ph.D. dissertation, University of California, Berkeley, 2007): 120–150.
90 Bessire, *William Pope.L*, 223 and Ondine Chavoya, "William Pope.L: Interview," 40.
91 English, *How to See a Work*, 282–283.
92 André Lepecki, *Exhausting Dance: Performance and the Politics of Movement* (New York: Routledge, 2006): 97.
93 Lowery Stokes Sims, "Interview with William Pope.L," in Bessire, *William Pope.L*, 64–65.
94 Bessire, *William Pope.L*, 184–214.
95 Ibid., 184–214.
96 For more studies that explore the intersection of performance and photography, see Amelia Jones, *Self/Image: Technology, Representation, and the Contemporary Subject* (London: Routledge, 2006), and forthcoming books by Rebecca Schneider, under the theme of "still living," and Laura Levin, under the theme of "blending into the background."

5 TECH SUPPORT

1 T. J. Clark, *Farewell to an Idea: Episodes from a History of Modernism* (New Haven, CT: Yale University Press, 2001): 9.
2 Mark Landler, "Hi, I'm in Bangalore, (but I can't say so)," *The New York Times* (March 21, 2001): A1, C4.
3 Elinor Fuchs used this phrase when articulating her objectives for *The Death of Character*, and I continue to find it helpful. See Elinor Fuchs, *The Death of Character: Perspectives on Theater after Modernism* (Bloomington, IN: Indiana University Press, 1996).
4 Michael Hardt and Antonio Negri, *Multitude: War and Democracy in the Age of Empire* (New York: Penguin, 2004): 108.
5 Saskia Sassen interviewed by Dale Leorke, "Power, Mobility, and Diaspora in the Global City," *Platform: A Journal of Media and Communication* 1 (July 2009): 103–108, 103.
6 Saskia Sassen, "Embeddedness of Electronic Markets: the Case of Global Capital Markets," in *The Sociology of Financial Markets*, eds. Karin Knorr Cetina and Alex Preda, 17–37 (Cambridge: Oxford University Press, 2005).
7 Hardt and Negri, *Multitude*, 109.
8 AbdouMaliq Simone, "People as Infrastructure: Intersecting Fragments in Johannesburg," *Public Culture* 16: 3 (Fall 2004): 407–429.
9 Ernesto Laclau and Chantal Mouffe, *Hegemony and Socialist Strategy: Towards a Radical Democratic Politics*, second edition (London: Verso, 2001): 98–99.
10 Ibid., 111.

11 Tara McPherson, "Reload: Liveness, Mobility and the Web," in *New Media, Old Media: A History and Theory Reader*, eds. Wendy Hui Kyong Chun and Thomas Keenan, 199–209 (New York: Routledge, 2005): 200, 202.

12 Ibid., 202.

13 Charles McNulty, "A Dizzying Global Vision," *Los Angeles Times* (February 29, 2004). Online at http://articles.latimes.com/2004/feb/29/entertainment/ca-mcnulty29 (accessed December 3, 2010).

14 Wendy Hui Kyong Chun, "Introduction: Did Somebody Say New Media?" in *New Media, Old Media: A History and Theory Reader*, eds. Wendy Hui Kyong Chun and Thomas Keenan, 1–10 (New York: Routledge, 2005): 8.

15 Ibid., 3.

16 Alisa Solomon, "Off to See the Wizardry," *The Village Voice* (April 30, 2002): XLVII.17.

17 Marianne Weems, "Call Centers—Trip to Bangalore," Weems *Alladeen* production files.

18 Mary-Jane Jacob, ed., *Gordon Matt-Clark: A Retrospective* (Chicago, IL: Museum of Contemporary Art, 1985).

19 Landler, "Hi, I'm in Bangalore," A1, C4.

20 Ibid., A1, C4.

21 Early script material *Alladeen* (April 22, 2002). Weems production files shared with author.

22 Marianne Weems (Artistic Director, The Builders Association), interview with the author (January 20, 2009).

23 Marianne Weems (Artistic Director, The Builders Association), in discussion with the author, (June 10, 2008).

24 Moe Angelos (performer, The Builders Association), in discussion with the author, (June 11, 2008).

25 Hans-Thies Lehmann, *Postdramatic Theatre*, trans. Karen Jurs-Munby (New York: Routledge, 2006): 68.

26 Dave Weich, "Pico Iyer's Mongrel Soul," interview with Pico Iyer (March 27, 2000); saved and underlined in Weems production note files, shared with the author. Online at www.powells.com/authors/iyer.html (accessed December 3, 2010).

27 Jennifer Parker-Starbuck, "Lost in Space? Global Placelessness and the Non-Places of *Alladeen*," in *Performance and Place*, eds. Leslie Hill and Helen Paris (London: Palgrave Macmillan, 2006): 162. See also Parker-Starbuck's "Global Friends: The Builders Association at BAM," *Performing Arts Journal* 26: 2 (2004): 96–102.

28 Parker-Starbuck, "Lost in Space," 162.

29 Margo Jefferson, "On the Other End of the Phone, Workers Stripped of Their Identities," *The New York Times* (December 4, 2003). Online at www.nytimes.com/2003/12/04/theater/theater-review-other-end-phone-workers-stripped-their-identities.html (accessed December 3, 2010).

30 McPherson, "Reload," 202.

31 Eva Behrendt, "I Have to Let It Out," trans. Michael Roberts, *Theater Heute* (December 17, 2007). Online at www.signandsight.com/features/1623.html (accessed December 3, 2010).

32 Peter Weiss, "Notizen zum dokumentarischen Theater" ("Notes on Documentary Theatre") (1968) quoted in Thomas Irmer, "A Search for New Realities: Documentary Theatre in Germany," *The Drama Review* 50: 3-T191 (Fall, 2006): 16–27, 18.

33 Irmer, "A Search for New Realities," 16–27, 17.

34 Ibid., 19–20.

35 RiminiProtokollTube, *Mnemopark. A Mini Train World-Rimini Protokoll (Stefan Kaegi)*, video (March 17, 2009). Online at www.youtube.com/watch?v=ivZoFCbEnVU (accessed December 3, 2010).

36 However, this is where it becomes difficult to separate reality and fiction as the actual and the imaginary shift, interact and overlap: the audience does not know where drama begins and real life stops; it is unable, and also not intended, to know where this line should be drawn.

Taken from Peter Michalzik, "Portrait: Rimini Protokoll," trans. Martin Pearce, Goethe-Institut Website. Online at www.goethe.de/kue/the/reg/reg/mr/rim/por/enindex.htm (accessed June 11, 2009).

37 Sara Brady, "Cargo Sofia: A Bulgarian Truck Ride through Dublin," *The Drama Review* 51: 4 (Winter 2007): 162–167 and Rimini Protokoll website, "Helgard Haug." Online at www.rimini-protokoll.de/website/en/about_hh.html (accessed December 3, 2010).

38 Patrice Blaser, "I Try to Speak about Reality" (includes interview with Helgard Haug, Stefan Kaegi and Daniel Wetzel), from the Rimini-Protokoll website (January 29, 2004). Online at www.rimini-protokoll.de/website/en/article_2572.html (accessed December 3, 2010).

39 RiminiProtokollTube, *Mnemopark. A Mini Train World.*

40 Lehmann, *Postdramatic Theatre*, 68.

41 Claire Bishop, "Live Installations and Construction Situations: The Use of 'Real People' in Art," in *The Art of Welfare*, eds. Marta Kuzman and Peter Osborne, 61–86 (Oslo: Office for Contemporary Art, 2006): 62.

42 Ulrich Fischer, "Rimini Protokoll Takes Dramatiker des Jahres Award for Its Karl Marx Project," Rimini Protokoll website (June 19, 2007). Online at www.rimini-protokoll.de/website/en/article_3060.html (accessed December 3, 2010).

43 Philippa Wehle, "Border Crossings: Avignon Festival, July 6–27, 2006," *PAJ: A Journal of Performance and Art* 29: 1 (2007): 80–87, 81–2.

44 Ibid.

45 Susan Foster, "The Cellphone as Stage/The City as Dance: Performance in the Transnational Metropole" in *Tanz, Metropole, Provinz* Special Issue on the Metropolis, eds. Yvonne Hardt and Kirsten Maar, 229–247 (Hamburg: Lit Verlag, 2007).

46 Brigid Grauman, "A Passage to India," *The Times* (June 16, 2008): 20.

47 Ibid.

48 Rimini Protokoll website, "Cargo Sofia-X: A Bulgarian Truck-Ride through European Cities." Online at www.rimini-protokoll.de/website/en/project_108.html (accessed December 3, 2010).

49 Ibid.

50 Sara Brady, "Cargo Sofia: A Bulgarian Truck Ride Through Dublin," *The Drama Review* 51: 4 (Winter 2007): 162–167, 163–4.

51 Ibid., 164.

52 Blaser, "I Try to Speak about Reality," n.p.

53 Christine Madden, "Art of Thinking Outside and Inside the Box," *The Irish Times* (April 28, 2007): 6. Online at www.rimini-protokoll.de/website/en/article_2133.html (accessed December 3, 2010).

54 Michael Fried, *Art and Objecthood* (Chicago, IL: University of Chicago Press, 1998): 155.
55 Madden, "Art of Thinking Outside and Inside the Box," 6.
56 Behrendt, "I Have to Let It Out," n.p.
57 Lehmann, *Postdramatic Theatre*, 167.

6 WELFARE MELANCHOLIA

1 Betty Ann Jordan, "Rooms with a View," *Toronto Life*, April 2006. Online edition at http://torontolife.com/features/rooms-with-a-view/ (accessed December 3, 2010).
2 Wendy Brown, "Neoliberalism and the End of Liberal Democracy," in *Edgework: Critical Essays in Knowledge and Politics*, 37–60 (Princeton, NJ: Princeton University Press, 2005): 42.
3 Victoria Miro Gallery, "Press Release: Elmgreen and Dragset: Too Late," (October 2008).
4 My reference to the aesthetics of administration obviously comes from Benjamin Buchloh, "Conceptual Art 1962–1969: From the Aesthetics of Administration to the Critique of Institutions," *October* 55 (1990): 105–143.
5 Hans Ulrich Obrist, "Performative Constructions: Interview with Hans-Ulrich Obrist" (interview by Michael Elmgreen and Ingar Dragset), in *Powerless Structures*, catalogue (1998): n.p. Online at www.nicolaiwallner.com/artists/micing/text1.html (accessed December 3, 2010).
6 Ibid.
7 Ibid.
8 Ibid.
9 For a survey of queer conjunctions in performance art, see Holly Hughes and David Román, eds., *O Solo Homo: The New Queer Performance* (New York: Grove Press, 1998).
10 Obrist, "Performative Constructions."
11 Brian Sholis, "Interview: Michael Elmgreen and Ingar Dragset," *Ten Verses* (June 1, 2003). Online at www.briansholis.com/interview-michael-elmgreen-and-ingar-dragset/ (accessed December 3, 2010).
12 Ibid.
13 Quoted in John McGee, "Elmgreen & Dragset: Suspended Space," *Metropolis: Japan's No. 1 English Magazine* 456 (October 2003). Online at http://archive.metropolis.co.jp/tokyo/456/art.asp (accessed December 3, 2010).
14 Ibid., n.p.
15 Obrist, "Performative Constructions."
16 Erin Manns, "Artworker of the Week #55" (includes interview with Elmgreen and Dragset), *Kultureflash* (November, 2005). Online at www.kultureflash.net/archive/142/priview.html (accessed May 2009).
17 Daniel Birnbaum, "White on White: The Art of Michael Elmgreen and Ingar Dragset," *Artforum* (April 2002): 99–101, 101.
18 Obrist, "Performative Constructions," n.p. With Gonzalez-Torres,

> we hung out and spoke a lot about how gay people suddenly discovered the use of Minimalism, as the ultimate kind of infiltration into the history of high art . . . So dealing with Minimalism was a kind of challenge for a gay person—also to break the stereotype image of gay people being, you know, interested in camp and being very feminine in their way of expressing themselves.

19 A park in Aarhus, Denmark, became the site of a gay cruising pavilion; its form mimicking the architecture of galleries while mixing private with public and to bring before visitors the activities that are often conducted in parks, however surreptitiously.

Sholis, "Interview," n.p.

20 Birnbaum, "White on White," 99.
21 Ibid., 101.
22 Obrist, "Performative Constructions," n.p.
23 Patricia Falguières, "Playground," in Patricia Falguières, Manuel J. Borja-Villel, and Bernard Blistin, *A Theater Without Theater*, 28–34 (Barcelona: Actar Produccions, 2007). For other helpful meditations on institutional critique and the threat of its institutional absorption, see James Meyer, *What Happened to the Institutional Critique?* (New York: American Fine Arts, Co., 1993). Reprinted in *Kontext Kunst*, ed. Peter Weibel, 239–256 (Cologne: Dumont, 1993); Julia Bryan Wilson, "A Curriculum of Institutional Critique," in *The New Institutionalism*, ed. Jonas Ekberg, 89–109 (Oslo: OCA/Verksted, 2003); Simon Sheikh, "Notes on Institutional Critique," *Transform.eipcip.net* (2006): 1–3, online at http://transform.eipcp.net/transversal/0106/sheikh/en#redir (accessed December 3, 2010); as well as Andrea Fraser's "From the Critique of Institutions to an Institution of Critique," *Artforum* (September 2005): 100–106.
24 Brown, "Neoliberalism and the End of Liberal Democracy," 40.
25 Ibid., 46.
26 Ibid., 53.
27 Ibid., 53.
28 Sholis, "Interview."
29 Michael Elmgreen and Ingar Dragset, "London, July 9, 2008," *Art Review* (October 2008).
30 Brown, "Neoliberalism and the End of Liberal Democracy," 53.
31 Alex Coles, "Exhibitions: Michael Elmgreen and Ingar Dragset," *Art Monthly* 294 (March 2006): 294.
32 Tony Blair, "Speech to the EU Parliament," June 23, 2005, *Number10.gov.uk*. Online at www.number10.gov.uk/Page7714 (accessed December 3, 2010).
33 Elmgreen and Dragset note: "Important social issues undergo a certain kitchification through these talk and quiz shows, which might pretend to care about the subject matters that they deal with but in fact they leave you as viewer completely ignorant and passive," Manns, "Artworker of the Week #55."
34 Michael Elmgreen, Ingar Dragset, et al., *Michael Elmgreen and Ingar Dragset: The Welfare Show* (Köln: Walther Konig, 2006).
35 Peter Osborne, "Elmgreen and Dragset's *The Welfare Show:* A Historical Perspective," in *The Art of Welfare*, eds. Marta Kuzma and Peter Osborne, 19–40 (Oslo: Office for Contemporary Art Norway, 2006): 39.
36 Manns, "Artworker of the Week #55," n.p.
37 Claire Bishop, "Live Installations and Construction Situations: The Use of 'Real People' in Art," in *The Art of Welfare*, eds. Marta Kuzma and Peter Osborne, 61–86 (Oslo: Office for Contemporary Art Norway, 2006); see also Bishop's other contributions to the discussion of social practice in *October* and *Artform*.
38 Brian Sholis, "Noblesse Oblige," *Artforum* (May 29, 2005). Online at http://artforum.com/diary/id=9054 (accessed December 3, 2010).

39 Manns, "Artworker of the Week #55," n.p.
40 Sholis, "Noblesse Oblige," n.p.
41 Ibid., n.p.
42 Ibid., n.p.
43 Claire Bishop et al., "Panel Discussion," in *The Art of Welfare*, eds. Marta Kuzma and Peter Osborne, 115–132 (Oslo: Office for Contemporary Art Norway, 2006): 130.
44 Victor Norman, "Crumbling from Within: The Microfoundations of Welfare States," in *The Art of Welfare*, eds. Marta Kuzma and Peter Osborne, 97–114 (Oslo: Office for Contemporary Art Norway, 2006): 100.
45 Thomas Hylland Eriksen, "Response to Victor Norman," in *The Art of Welfare*, eds. Marta Kuzma and Peter Osborne, 115–32 (Oslo: Office for Contemporary Art Norway, 2006): 114.
46 Bishop et al., "Panel Discussion," 118.
47 Ibid., 124.
48 Ibid., 124.
49 Brown, "Neoliberalism and the End of Liberal Democracy," 53.
50 Rachel Campbell-Johnston, "We Were Only Being Boring," *Times Online* (January 24, 2006). Online at: http://entertainment.timesonline.co.uk/tol/arts_and_entertainment/article718165.ece (accessed December 3, 2010).
51 Soren Johansen, "Michael Elmgreen and Ingar Dragset: The Welfare Show," *Londontown.com*: London Events (January 2006). Online at www.londontown.com/LondonEvents/MichaelElmgreenandIngarDragsetTheWelfareShow/7096f/Michael_Elmgren_and_Ingar_Dragset:_The_Welfare_Show (accessed May 2009).
52 Manns, "Artworker of the Week #55," n.p.
53 Jordan, "Rooms with a View," n.p.
54 Helena Grdadolnik, "Welfare State," *Canadian Architect* (April 2006): 74. Online at www.cdnarchitect.com/issues/ISarticle.asp?aid=1000203195.
55 Lynn Zelevansky, "From Inside the Museum: Some Thoughts on Institutional Critique," in *Institutional Critique and After*, ed. John C. Welchamn, 171–182 (Zürich: JRP/Ringier, 2006).
56 Colin Martin, "Art: The Welfare Show," *BMJ* 332: 429 (February 18, 2006): n.p. Online at www.bmj.com/cgi/content/full/332/7538/429-a (accessed May 2009).
57 Andrea Demchuk, "The Welfare Fate," *The Rubicon* (May 31, 2006): 15–22. Online at http://therubicon.org/2006/05/the-welfare-fate/#more-47 (accessed December 3, 2010).
58 Coles, "Exhibitions," 294.
59 Adrian Searle, "The Lost World," *The Guardian* (January 31, 2006). Online at: www.guardian.co.uk/culture/2006/jan/31/3 (accessed December 3, 2010).
60 Bunny Smedley, "What's *The Welfare Show* Got To Do with the Welfare State?" Social Affairs Unit Weblog (February 17, 2006). Online at www.socialaffairsunit.org.uk/blog/archives/000784.php (accessed December 3, 2010).
61 Ibid.
62 Manns, "Artworker of the Week #55."
63 Coles, "Exhibitions," 294.
64 Searle, "The Lost World," n.p.
65 Claire Bishop, "Live Installations," 62–63.

66 Allan Pred, *Even in Sweden: Racisms, Racialized Spaces, and the Popular Geographical Imagination* (Berkeley, CA: University of California, 2000). In response to this concern, Elmgreen and Dragset have commented:

> It is correct that racial issues could have been addressed more explicitly in the exhibition. And probably many other issues as well. Homosexuality or gay rights are also not addressed in the actual show, for instance. Neither are women's rights or equality issues. It was never our point to make an illustrative exhibition that depicts the reality of a welfare system. Both our title "The Welfare Show" and the layout of the exhibition indicated that what the audience would meet would be fiction. It was more psycho drama than documentary.

67 Peter Duhon, "Frieze Week 2008: Affected by Financial Crisis?" *Art Comments* (October 16, 2008). Online at http://artcomments.blogspot.com/2008/10/frieze-week-2008-affected-by-finanicial.html (accessed December 3, 2010).
68 Roberta Smith, "Frieze Art Fair Feels a Big Chill," *The New York Times* (October 17, 2008): C1; Carole Cadwalladr, "Before the Bubbly Stops Flowing . . .," *The Guardian* (October 19, 2008). Online at www.guardian.co.uk/artanddesign/2008/oct/19/friezeartfair-art (accessed December 3, 2010).
69 Tim Etchells, "Drama Queens," *Timetchells.com*. Online at www.timetchells.com/index.php?option=com_tag&tag=Drama%20Queens&task=view&Itemid=9 (accessed December 3, 2010).
70 Victoria Miro Gallery, "Press Release: Elmgreen and Dragset: Too Late," October, 2008.
71 Michael Elmgreen and Ingar Dragset, "Elmgreen and Dragset: The Incidental Self," Review Artist Publication, distributed with *Art Review* 26 (October 2008).

7 UNFEDERATED THEATRE

1 Theodor W. Adorno, "Commitment," in *The Essential Frankfurt School Reader*, eds. Andrew Arato and Eike Gebhardt, 300–318 (New York: Continuum, 1982): 312.
2 Paul Chan, "*Waiting for Godot* in New Orleans: An Artist Statement," (2005): 3. Online at www.nationalphilistine.com/nola/Godot_artist_statement_final.pdf; www.nationalphilistine.com/nola/Community_book_center_artist_rountable.mp3 (accessed December 3, 2010).
3 See for instance, Miranda Joseph, *Against the Romance of Community* (Minneapolis, MN: University of Minnesota Press, 2002).
4 Ulrich Beck and Elisabeth Beck-Gernsheim, *Individualization* (London: SAGE, 2002): 3.
5 Ibid., 24.
6 Michel Feher, "Self-Appreciation; or, the Aspirations of Human Capital," *Public Culture* 21: 1 (2009): 21–41.
7 Beck and Beck-Gernsheim, *Individualization*, 24.
8 Feher, "Self-Appreciation," 41.
9 Tim Griffin, "Tim Griffin on *Waiting for Godot*: Paul Chan in New Orleans," *Artforum International* 46: 4 (December 2007): 51.
10 Calvin Tomkins, "Shadow Player," *The New Yorker* (May 26, 2008): 40–45, 40.

11 Scott Rothkopf, "Embedded in Culture," *Artforum International* (Summer 2006): 304–311, 304.
12 Ibid., 306.
13 Andrea Bellini, "Paul Chan: Where Form Ends and Content Begins," *Flash Art* (March/April 2005): 68–70, 69.
14 Rothkopf, "Embedded in Culture," 304.
15 Ibid., 305.
16 Tomkins, "Shadow Player," 41.
17 Ibid., 40.
18 Katrina vanden Heuvel, "Messing with Mother Nature," *The Nation*, September 19, 2005.
19 Ruth Wilson Gilmore, "Tossed Overboard: Katrina, Incarceration, and the Politics of Abandonment," paper presented at the American Studies Association, Washington, DC, November 6, 2005.
20 Paul Chan, "*Waiting for Godot* in New Orleans: An Artist Statement," 2.
21 Ibid. 2–3.
22 Paul Chan, "The Art of Renewal," Radio Philistine, 2007. Online at www.nationalphilistine.com/nola/Community_book_center_artist_rountable.mp3.
23 Chan, "*Waiting for Godot* in New Orleans: An Artist Statement," 3.
24 For a wide-ranging account of art and activist work after Katrina, see Amy Koritz and George J. Sanchez, eds., *Civic Engagement in the Wake of Katrina* (Ann Arbor, MI: University of Michigan Press, 2009).
25 See Annemarie Bean, ed., *A Sourcebook of African-American Performance: Plays, People, Movements* (London: Routledge, 1999).
26 Quoted in Creative Time, "Creative Time Presents Paul Chan's *Waiting for Godot in New Orleans*," Creative Time press release (2007): 2. Online at www.creativetime.org/press/releases/2007/paul_chan.pdf (accessed December 3, 2010).
27 Bellini, "Paul Chan," 70.
28 Quoted in Rothkopf, "Embedded in Culture," 305.
29 Bellini, "Paul Chan," 68.
30 Adorno, "Commitment," 312–314.
31 Ibid., 317.
32 Paul Chan, "Fearless Symmetry," *Artforum International* (March 2007): 260–261, 260.
33 Chan, "*Waiting for Godot* in New Orleans: An Artist Statement," 5.
34 Nato Thompson, interview with the author (June, 2008).
35 Ibid., n.p.
36 Ibid.
37 Ibid.
38 Ibid.
39 James Clifford, "On Ethnographic Allegory," in *Writing Culture: The Poetics and Politics of Ethnography*, eds. James Clifford and George E. Marcus, 98–140 (Berkeley, CA: University of California Press, 1986).
40 Yates McKee, "Haunted Housing: Eco-Vanguardism, Eviction, and the Biopolitics of Sustainability in New Orleans," *Grey Room* 30 (Winter 2008): 84–113.
41 Chan, "*Waiting for Godot* in New Orleans: An Artist Statement," 4.
42 Ibid., 4.

43 Paul Chan, "Next Day, Same Place: After Godot in New Orleans," *The Drama Review* 52: 4 (Winter 2008): 2–3.
44 Paul Chan, "Key Words One Month After the Project," National Philistine website. Online at www.nationalphilistine.com/nola/Godot_Chan_keywords.pdf (accessed December 3, 2010).
45 Paul Chan, "*Waiting for Godot* Casebook for Teachers in Nola," National Philistine website. Online at www.nationalphilistine.com/nola/GODOT_CASEBOOK.pdf (accessed December 3, 2010). See also Paul Chan, ed., *Waiting for Godot in New Orleans: A Field Guide* (New York: CreativeTimeBooks, 2010), published just as *Social Works* was going to press.
46 Paul Chan, "What Are People Waiting for in the Neighborhood of Gentilly," National Philistine website. Online at www.nationalphilistine.com/nola/What_are_people_waiting_for_in_Gentilly.doc (accessed December 3, 2010).
47 Ibid.
48 Ibid.
49 Ibid.
50 Paul Chan, interview with author (June 22, 2009).
51 Holland Cotter, "Godot Finds Home in Gutted New Orleans," *International Herald Tribune* (December 7, 2007), Features.
52 Quoted in Calvin Tomkins, "Shadow Player," *The New Yorker* (May 26, 2008): 40–45, 45.
53 Ibid., 45.
54 Rothkopf, "Embedded in Culture," 306.
55 Beck and Beck-Gernsheim, *Individualization*, 3.
56 Nato Thompson, interview with the author (June, 2008), n.p.
57 Paul Chan, interview with author via email (April 10, 2009).
58 Nato Thompson, interview with the author (June, 2008), n.p.

EPILOGUE: DEPENDENT CARE

1 Alison Knowles, "By Alison Knowles" (A Great Bear Pamphlet). (New York: Something Else Press, 1965).
2 Michael Warner, *Publics and Counterpublics* (New York: Zone Books, 2002): 120.
3 Alison Knowles, electronic correspondence with the author (May 20–21, 2009).
4 Ibid.
5 Knowles, "By Alison Knowles."
6 Documentation of unpublished interviews (2001) provided by Hannah Higgins to the author; see also Hannah Higgins, *Experience Fluxus* (Berkeley, CA: University of California Press, 2002): 101–105.
7 For more discussion of children in Societas Raffaello and in other theatrical work, see Alan Read, *Theatre, Intimacy, Engagement The Last Human Venue* (London: Palgrave, 2008), especially 157–172; Nicolas Ridout, *Stagefright, Animals, and Other Theatrical Problems* (Cambridge: Cambridge University Press, 2006) as well as his essay "Performance and Democracy," in *The Cambridge Companion to Performance Studies*, ed. Tracy C. Davis (Cambridge: Cambridge University Press, 2008): 11–22; Joe Kelleher and

Nicholas Ridout, eds., *The Theatre of Societas Raffaello Sanzio* (London: Routledge, 2007).

8 See where Michael Warner cites his 1992 personal correspondence with Muñoz in his "Introduction" to *Fear of a Queer Planet* (Minneapolis, MN: University of Minnesota Press, 1993): xxx n22.

9 José Esteban Muñoz, *Cruising Utopia: The Then and There of Queer Futurity* (New York: New York University Press, 2009): 96.

10 Roderick Ferguson, *Aberrations in Black: Toward a Queer of Color Critique* (Minneapolis, MN: University of Minnesota Press, 2004).

11 Judith Halberstam, "The Anti-Social Turn in Queer Studies," *Graduate Journal of Social Science* 5: 2 (2008): 140–156; Susan Fraiman, *Cool Men and the Second Sex* (New York: Columbia University Press, 2003).

12 See for instance the special issue of *South Atlantic Quarterly* 106: 3, "After Sex? On Queer Writing Since Queer Theory," eds. Janet Halley and Andrew Parker (2007).

13 Documentation of *Deeply There* (restaged 2006) provided to the author by Joe Goode.

14 See, for example, Kath Weston's *Families We Choose: Lesbians, Gays, Kinship*, revised edition (New York: Columbia University Press, 1997), as well as Judith Butler's *Antigone's Claim: Kinship Between Life and Death* (New York: Columbia University Press, 2000). Importantly, in responding to Biddy Martin's, "Extraordinary Homosexuals and the Fear of Being Ordinary," *Differences* 6: 2/3 (1994): 101–125, Michael Warner and Lauren Berlant do not define queer extraordinariness as "anti-social," but as alternatively social, as "non-standard intimacies" and forms of "world-making." Lauren Berlant and Michael Warner, "Sex in Public," in *Publics and Counterpublics*, 187–208 (New York: Zone Books, 2002): 198, 199.

15 Berlant and Warner, "Sex in Public," 199.

16 Kaja Silverman, *Flesh of My Flesh* (Stanford, CA: Stanford University Press, 2009).

BIBLIOGRAPHY

Abramovitz, Mimi. *Regulating the Lives of Women: Social Welfare Policy from Colonial Times to the Present*, revised edition. Cambridge, MA: South End Press, 1999.

——. *Under Attack, Fighting Back: Women and Welfare in the United States*, second edition. New York: Monthly Review Press, 2000.

Adorno, Theodor W. "Commitment." In *The Essential Frankfurt School Reader*, edited by Andrew Arato and Eike Gebhardt. New York: Continuum, 1982: 300–318.

Alberro, Alexander. "Another Relationality." Paper presented at "Catalysts and Critics: Art of the 1990s." Symposium at the Guggenheim Museum, 2008.

——. *Art After Conceptual Art*. Cambridge, MA: MIT Press, 2006.

——. "Introduction: Mimicry, Excess, Critique." In *Museum Highlights: The Writings of Andrea Fraser*, edited by Alexander Alberro. Cambridge, MA: MIT Press, 2007: xxll–2.

——. "Introduction: The Way Out is the Way In." In *Art After Conceptual Art*, edited by Alexander Alberro and Sabeth Buchmann. Cambridge: MIT Press, 2006: 13–26.

—— and Blake Stimson. *Institutional Critique: An Anthology of Artist Writings*. Cambridge, MA: MIT Press, 2009.

—— and Sabeth Buchmann, eds. *Art After Conceptual Art*. Cambridge, MA: MIT Press, 2006.

Althusser, Louis. "Ideology and Ideological State Apparatuses." In *Lenin and Philosophy and Other Essays*, translated by Ben Brewster. London: New Left Books, 1971: 123–173; originally published in *La Pensée* in French in 1970.

Angelos, Moe (performer, The Builders Association). Discussion with the author, June 11, 2008.

Austin, J. L. *How to Do Things with Words*, edited by J. O. Urmson and Marina Sbisà. Cambridge, MA: Harvard University Press, 1975, second edition.

Badiou, Alain, Bernard Blistene, and Yann Chateigne. *A Theater without Theater*. Barcelona: Museu D'Art Contemporani de Barcelona, 2007.

Baer, Martha, Erin Cramer, Jessica Chalmers, Andrea Fraser, Marianne Weems, Herb Rohrback, Werner Sanchez, Pip Winthrop and Raul A. Cantella. "The V-Girls: A Conversation with October." *October* 51 (Winter 1989): 115–143.

Baker, George. "Introduction to 'Antagonism and Relational Aesthetics' by Claire Bishop." *October* 110 (Fall, 2004): 49–50.

Batalion, Judith. "On and Off the Page: An Interview with Andrea Fraser." *Immediations* 2: 2 (2009).

Bean, Annemarie, ed. *A Sourcebook of African-American Performance: Plays, People, Movements.* London: Routledge, 1999.

Beck, Ulrich. *The Risk Society: Towards a New Modernity.* Thousand Oaks, CA: Sage Publications, 1992.

Beck, Ulrich and Elisabeth Beck-Gernsheim. *Individualization.* London: SAGE, 2002.

Behrendt, Eva. "I Have to Let It Out," translated by Michael Roberts. *Theater Heute* (November 11, 2007). Online at www.signandsight.com/features/1623.html (accessed December 3, 2010).

Bellini, Andrea. "Paul Chan: Where Form Ends and Content Begins." *Flash Art*, March/April 2005: 68–70.

Benjamin, Walter. "Author as Producer." In *Reflections: Essays, Aphorisms, Autobiographical Writings*, translated by Edmond Jephcott, edited by Peter Demetz. New York: Schocken Books, 1978: 222–238.

Berlant, Lauren and Michael Warner, "Sex in Public." In *Publics and Counterpublics*, 187–208. New York: Zone Books, 2002.

Bessire, Mark H. C. *William Pope.L: The Friendliest Black Artist in America.* Cambridge, MA: MIT Press, 2002.

Birnbaum, Daniel. "White on White: The Art of Michael Elmgreen and Ingar Dragset." *Artforum* (April 2002): 99–101.

Bishop, Claire. "Antagonism and Relational Aesthetics." *October* 110 (Fall, 2004): 51–79.

——. "Live Installations and Construction Situations: The Use of 'Real People' in Art." In *The Art of Welfare*, edited by Marta Kuzman and Peter Osborne. Oslo: Office for Contemporary Art, 2006: 61–86.

——. *Participation.* Cambridge, MA: MIT Press, 2006.

——. "The Social Turn: Collaboration and its Discontents." *Artforum* 44 (February, 2006): 178–183.

——, Ingar Dragset, Michael Elmgreen, Thomas Hylland Eriksen, Marta Kuzma, Victor D. Norman, and Peter Osborn. "Panel Discussion." In *The Art of Welfare*, edited by Marta Kuzman and Peter Osborne. Oslo: Office for Contemporary Art Norway, 2006: 115–132.

Blair, Tony. "Speech to the EU Parliament," June 23, 2005. *Number10.gov.uk.* Online at www.number10.gov.uk/Page7714.

Blaser, Patrice. "I Try to Speak about Reality." Rimini Protokoll website. January 29, 2004. Online at www.rimini-protokoll.de/website/en/article_2572.html (accessed December 3, 2010).

Bleeker, Maaike. *Visuality in the Theatre: The Locus of Looking.* London: Palgrave Macmillan, 2008.

Blocker, Jane. *What the Body Cost: Desire, History, and Performance.* Minneapolis, MN: University of Minnesota Press, 2004.

Boltanski, Luc and Eve Chiapello. *The New Spirit of Capitalism.* New York: Verso, 2007.

Bourdieu, Pierre. "Revolution and Revelation." In *Museum Highlights: The Writings of Andrea Fraser,* edited by Alexander Alberro. Cambridge, MA: MIT Press, 2005: xiii–xiv.

Bourriaud, Nicolas. *Relational Aesthetics.* Dijon: Les Presses du Réel, 1998.

Brady, Sara. "Cargo Sofia: A Bulgarian Truck Ride Through Dublin." *The Drama Review* 51: 4 (Winter 2007): 162–167.

——."Welded to the Ladle: *Steelbound* and Non-Radicality in Community-Based Theatre." *The Drama Review* 44: 3 (Fall, 2000): 51–74.

Brecht, Bertolt. *Brecht on Theatre*, translated and edited by John Willett. London: Methuen, 1964.

Breitwieser, Sabine, ed. *Allen Sekula: Performance Under Working Conditions.* Vienna: Generali Foundation/Hatje Cantz, 2003.

——. "Photography between Documentation and Theatricality: Speaking Within, Alongside, and Through Photographs." In *Allen Sekula: Performance Under Working Conditions,* edited by Sabine Breitwieser. Vienna: Generali Foundation/Hatje Cantz, 2003: 12–19.

Brown, Wendy. "Neoliberalism and the End of Liberal Democracy." In *Edgework: Critical Essays in Knowledge and Politics.* Princeton, NJ: Princeton University Press, 2005: 37–60.

——. *States of Injury: Power and Freedom in Late Modernity.* Princeton, NJ: Princeton University Press, 1995.

Bryan-Wilson, Julia. *Art Workers: Radical Practice in the Vietnam War Era.* Berkeley, CA: University of California Press, 2009.

Buchloh, Benjamin."Conceptual Art 1962–1969: From the Aesthetics of Administration to the Critique of Institutions." *October* 55 (1990): 105–143.

——. "From Faktura to Factography," *October* 30 (Autumn 1984): 82–119.

——. "Since Realism There Was . . . (On the Current Conditions of Factographic Art)." In *Art and Ideology*, edited by Marcia Tucker. New York: New Museum of Contemporary Art, 1984: 5–20.

Burnham, Linda Frye, Anne Kilkelly, and Robert H. Leonard, eds. *Performing Communities: Grassroots Ensemble Theaters Deeply Rooted in Eight U.S. Communities.* Oakland, CA: New Village Press, 2006.

Buskirk, Martha. *The Contingent Object of Contemporary Art.* Cambridge, MA: MIT Press, 2003.

Butler, Cornelia and Lisa Gabrielle Mark, eds. *WACK: Art and the Feminist Revolution.* Cambridge, MA: MIT Press, 2007.

Butler, Judith. *Antigone's Claim: Kinship Between Life and Death.* New York: Columbia University Press, 2000.

——. *Bodies that Matter: On the Discursive Limits of Sex.* New York: Routledge, 1993.

——. *Gender Trouble: Feminism and the Subversion of Identity.* New York: Routledge, 1990.

——. *The Psychic Life of Power: Theories of Subjection.* Stanford, CA: Stanford University Press, 1997.

—— and Shannon Jackson. "What Makes Performance Possible?" Lecture, Colorado College, October 2009.

Cadwalladr, Carole. "Before the Bubbly Stops Flowing . . ." *The Guardian*, October 19, 2008, C1. Online at www.guardian.co.uk/artanddesign/2008/oct/19/friezeartfair-art (accessed December 3, 2010).

Campbell-Johnston, Rachel. "We Were Only Being Boring." *Times Online*, January 24, 2006, Online at http://entertainment.timesonline.co.uk/tol/arts_and_entertainment/article718165.ece (accessed December 3, 2010).

Cappelli, Renu. "Inadmissible Presence: Objecthood, Spectacle, and the Theatricality of Race." Ph.D. dissertation, University of California, Berkeley, 2007.

Carr, C. "In the Discomfort Zone." In *William Pope.L: The Friendliest Black Artist in America*, edited by Mark Bessire. Cambridge, MA: MIT Press, 2002: 48–53.

——. "Revisions of Excess: The V-Girls, Blue Man Group." In *On Edge: Performance at the end of the Twentieth Century*, revised edition. Middletown, CT: Wesleyan University Press, 2008: 177–179.

Chan, Paul. "The Art of Renewal." Radio Philistine. 2007. Online at www.nationalphilistine.com/nola/Community_book_center_artist_rountable.mp3.

——. "Fearless Symmetry." *Artforum International* (March 2007): 260–261.

——. Interview with author, June 22, 2009.

——. Interview with author via email, April 10, 2009.

——. "Key Words One Month After the Project." National Philistine website. Online at www.nationalphilistine.com/nola/Godot_Chan_keywords.pdf (accessed December 3, 2010).

——. "Next Day, Same Place: After Godot in New Orleans." *The Drama Review* 52: 4 (Winter 2008): 2–3.

——. "*Waiting for Godot* Casebook for Teachers in Nola." National Philistine website. Online at http://nationalphilistine.com/nola/GODOT_CASEBOOK.pdf.

——, ed. *Waiting For Godot In New Orleans: A Field Guide*. New York: Creativetimebooks, 2010.

——. "*Waiting for Godot* in New Orleans: An Artist Statement." 2005. Online at www.nationalphilistine.com/nola/index.html (accessed December 3, 2010).

——. "What Are People Waiting for in the Neighborhood of Gentilly." National Philistine website. Online at www.nationalphilistine.com/nola/What_are_people_waiting_for_in_Gentilly.doc (accessed December 3, 2010).

Chandler, John and Lucy R. Lippard. "The Dematerialization of Art." *Art International* (February 20, 1968): 31–36.

Chavoya, C. Ondine. "William Pope.L: Interview." In *The Interventionists: Users' Manual for the Creative Disruption of Everyday Life*, edited by Nato Thompson and Gregory Sholette. Cambridge, MA: MIT Press, 2004: 40–42.

Chun, Wendy Hui Kyong. "Introduction: Did Somebody Say New Media?" In *New Media, Old Media: A History and Theory Reader*, edited by Wendy Hui Kyong Chun and Thomas Keenan. New York: Routledge, 2005: 1–10.

Clark, T. J. *Farewell to an Idea: Episodes from a History of Modernism*. New Haven, CT: Yale University Press, 2001.

——. "Greenberg's Theory of Art." *Critical Inquiry* 9: 1 (September 1982): 139–156.

Clifford, James. "On Ethnographic Allegory." In *Writing Culture: The Poetics and Politics of Ethnography*, edited by James Clifford and George E. Marcus. Berkeley, CA: University of California Press, 1986: 98–140.

Cohen-Cruz, Jan. *Local Acts: Community-Based Performance in the United States.* New Brunswick: Rutgers University Press, 2005.

Coles, Alex. "Exhibitions: Michael Elmgreen and Ingar Dragset." *Art Monthly* 294 (March 2006): 294.

Cornwell, Regina. "Reinventing Maintenance with Artist Mierle Ukeles." *Women's Media Center* (December 14, 2006): n.p.

Cotter, Holland. "Godot Finds Home in Gutted New Orleans." *International Herald Tribune* (December 7, 2007), Features.

Creative Time. "Creative Time Presents Paul Chan's *Waiting for Godot in New Orleans*." Creative Time press release. 2007. Online at www.creativetime.org/press/releases/2007/paul_chan.pdf (accessed December 3, 2010).

Deeply There. Restaged 2006. Documentation provided to the author by Joe Goode.

Demchuk, Andrea. "The Welfare Fate." *The Rubicon* (May 31, 2006): 15–22. Online at http://therubicon.org/2006/05/the-welfare-fate/#more-47 (accessed December 3, 2010).

Deutsche, Rosalind. *Evictions: Art and Spatial Politics.* Cambridge, MA: MIT Press, 1996.

Diamond, Elin. *Unmaking Mimesis.* New York: Routledge, 1997.

Doherty, Claire, ed. *Contemporary Art: From Studio to Situation.* London: Black Dog Publishing, 2004.

——. "The New Situationists." In *Contemporary Art: From Studio to Situation*, 8–13. London: Black Dog Publishing, 2004: 8–13.

——. *Situation.* Cambridge, MA: MIT Press, 2009.

Dolan, Jill. *Utopia in Performance: Finding Hope at the Theater.* Ann Arbor, MI: University of Michigan Press, 2005.

Duhon, Peter. "Frieze Week 2008: Affected by Financial Crisis?" *Art Comments*, October 16, 2008. Online at http://artcomments.blogspot.com/2008/10/frieze-week-2008-affected-by-finanicial.html (accessed December 3, 2010).

Elmgreen, Michael and Ingar Dragset. "London, July 9, 2008." *Art Review* (October 2008).

——. "Elmgreen and Dragset: The Incidental Self." Art Review Artist Publication, distributed with *Art Review* 26 (October 2008). Online at http://archive.balticmill.com/index.php?itemid=39711 (accessed December 3, 2010).

——, Howard Becker, Renee Green, Jens Haaning, Stephans Schulmeister, Armin Thurher, and Werner Vogt. *Michael Elmgreen and Ingar Dragset: The Welfare Show.* Köln: Walther Konig, 2006.

English, Darby. *How to See a Work of Art in Total Darkness.* Cambridge, MA: MIT Press, 2007.

Eriksen, Thomas Hylland. "Response to Victor Norman." In *The Art of Welfare*, edited by Marta Kuzma and Peter Osborne. Oslo: Office for Contemporary Art Norway, 2006: 115–132.

Etchells, Tim. "Drama Queens," *Timetchells.com*. Online at www.timetchells. com/index.php?option=com_tag&tag=Drama%20Queens&task=view& Itemid=9 (accessed June 9, 2010).

Falguières, Patricia. "Playground." In Patricia Falguierès, Manuel J. Borja-Villel, and Bernard Blistene. *A Theater Without Theater*. Barcelona: Actar Produccions, 2007: 28–34.

Feher, Michel. "Self-Appreciation; or, the Aspirations of Human Capital," translated by Ivan Ascher. *Public Culture* 21: 1 (2009): 21–41.

—— and Eric Alliez. "The Luster of Capital," translated by Alyson Waters. *Zone* 1 and 2 (1987): 315–359.

Felshin, Nina. *But Is It Art? The Spirit of Art As Activism*. Seattle, WA: Bay Press, 1994.

Ferguson, Roderick. *Aberrations in Black: Towards a Queer of Color Critique*. Minneapolis, MN: University of Minnesota Press, 2004.

Finkelpearl, Tom. "Interview: Mierle Laderman Ukeles." In *Dialogues in Public Art*. Cambridge, MA: MIT Press, 2000: 295–322.

Fischer, Ulrich. "Rimini Protokoll Takes Dramatiker des Jahres Award for Its Karl Marx Project." Rimini Protokoll website (June 19, 2007). Online at www.rimini-protokoll.de/website/en/article_3060.html (accessed December 3, 2010).

Fischer-Lichte, Erika. *The Transformative Power of Performance: A New Aesthetics*. London and New York: Routledge, 2008.

Flattery, Shannon. *Touchable Stories* website. Online at www.touchablestories.org. (accessed September, 7, 2007).

Foster, Hal. "Artist as Ethnographer," in *Return of the Real* (Cambridge, MA: MIT Press, 1996): 171–204.

——. *The Return of the Real*. Cambridge, MA: MIT Press, 1996.

Foster, Susan. "The Cellphone as Stage/The City as Dance: Performance in the Transnational Metropole." In *Tanz, Metropole, Provinz* Special Issue on the Metropolis, edited by Yvonne Hardt and Kirsten Maar. Hamburg: Lit Verlag, 2007: 229–247.

Foucault, Michel. *Discipline and Punish: The Birth of the Prison* (1975), 1977 in English; reprinted London: Verso, 1995.

——. *The History of Sexuality*, translated by R. Hurley (1984); reprinted New York: Vintage, 1995.

——. *"Society Must Be Defended": Lectures at the College de France, 1975–1976*, translated by David Macey. New York: Picador, 2003.

Fraiman, Susan. *Cool Men and the Second Sex*. New York: Columbia University Press, 2003.

Fraser, Andrea. "From a Critique of Institutions to an Institution of Critique." *Artforum* 44: 1 (September, 2005): 100–106.

——. "May I Help You?" Petzel Gallery website, 5. Online at http://i1.exhibit-e.com/petzel/95f61adf.pdf.

——. "Museum Highlights: A Gallery Talk." *October* 57 (Summer, 1991): 104–122.

——. *Museum Highlights: The Writings of Andrea Fraser*, edited by Alexander Alberro. Cambridge, MA: MIT Press, 2007.

———. "What is Institutional Critique?" In John C. Welchman. *Institutional Critique and After*. New York: Distributed Art Publishers, Inc., 2007.

Fraser, Nancy. "Rethinking the Public Sphere: A Contribution to the Critique of Actually Existing Democracy." In *Habermas and the Public Sphere*, edited by Craig Calhoun, 107–142. Cambridge, MA: MIT Press, 1992.

——— and Linda Gordon. "A Genealogy of Dependency: Tracing a Keyword of the U.S. Welfare State," *Signs* 19: 2 (Winter 1994): 309–336.

Fried, Michael. *Art and Objecthood*. Chicago, IL: University of Chicago Press, 1998.

———. "Art and Objecthood." *Artforum* 5 (1967): 12–23.

Fuchs, Elinor. *The Death of Character: Perspectives on Theater after Modernism*. Bloomington, IN: Indiana University Press, 1996.

Goldbard, Arlene. *New Creative Community: The Art of Cultural Development*. Oakland, CA: New Village Press, 2006.

Giddens, Anthony. *The Constitution of Society: Outline of the Theory of Structuration*. Berkeley, CA: University of California Press, 1986.

———. *The Third Way: The Renewal of Social Democracy*. Cambridge: Polity Books, 1999.

Gillick, Liam. "Contingent Factors: A Response to Claire Bishop." *October* 115 (Winter, 2006): 95–107.

Gilmore, Ruth Wilson. "Tossed Overboard: Katrina, Incarceration, and the Politics of Abandonment." Paper presented at the American Studies Association, Washington, DC, November 6, 2005.

Giunta, Andrea and Peter Kahn. *Avant-Garde, Internationalism, and Politics: Argentine Art Since the Sixties*, translated by Peter Kahn. Durham, NC: Duke University Press, 2007.

Grauman, Brigid. "A Passage to India." *The Times* (June 16, 2008): 20.

Greenberg, Clement. "Modernist Painting." In *The New Art: A Critical Anthology*, edited by Gregory Battcock. New York: E. P. Dutton & Co., Inc., 1973: 68–69.

Grdadolnik, Helena. "Welfare State." *Canadian Architect* (April, 2006). Online at www.cdnarchitect.com/issues/ISarticle.asp?aid=1000203195 (accessed December 3, 2010).

Griffin, Tim. "Tim Griffin on Waiting for Godot: Paul Chan in New Orleans." *Artforum International* 46: 4 (2007).

Greenberg, Clement. *Forum Lectures*. Washington, DC: Voice of America, 1960.

———. "Modernist Painting." In *The New Art: A Critical Anthology*, edited by Gregory Battcock. New York: E. P. Dutton & Co., Inc., 1973: 68–69.

Halberstam, Judith. "The Anti-Social Turn in Queer Studies." *Graduate Journal of Social Science* 5: 2 (2008): 140–156.

Halley, Janet and Andrew Parker, eds. "After Sex? On Queer Writing Since Queer Theory." A Special Issue of *South Atlantic Quarterly* 106: 3 (2007).

Harding, James M. *Cutting Performance: Collage Events, Feminist Artists, and the American Avant-garde*. Ann Arbor, MI: University of Michigan Press, 2009.

Hardt, Michael and Antonio Negri. *Empire*. Cambridge, MA: Harvard University Press, 2000.

278

——. *The Labor of Dionysus: A Critique of the State-Form.* Minneapolis, MN: University of Minnesota Press, 1994.

——. *Multitude: War and Democracy in the Age of Empire.* New York: Penguin, 2004.

Harvey, David. *Spaces of Global Capitalism: A Theory of Uneven Development.* London: Verso, 2006.

Heuvel, Katrina vanden. "Messing with Mother Nature." *The Nation* (September 19, 2005).

Higgins, Hannah. *Experience Fluxus.* Berkeley, CA: University of California Press, 2002.

——. Unpublished interviews (2001) provided by Hannah Higgins to the author.

Hoban, Phoebe. "How Far is Too Far?" *Artnews* 107: 7 (Summer, 2008). Online at www.artnews.com/issues/article.asp?art_id=2522 (accessed December 3, 2010).

Hochschild, Arlie Russell. *The Managed Heart: Commercialization of Human Feeling.* Berkeley, CA: University of California Press, 1985.

Holmes, Brian. *Unleashing the Collective Phantoms: Essays in Reverse Imagineering.* Brooklyn, NY: Autonomedia, 2008.

Hook, Cora. "Letters to the Editor." *The Drama Review* 45: 3 (Fall, 2001): 15.

Hughes, Holly and David Romàn, eds. *O Solo Homo: The New Queer Performance.* New York: Grove Press, 1998.

Irmer, Thomas. "A Search for New Realities: Documentary Theatre in Germany." *The Drama Review* 50: 3-T191 (Fall, 2006): 16–27.

Jackson, Shannon. "Performing Show and Tell: Disciplines of Visual Culture and Performance Studies." *Journal of Visual Culture* 4: 2 (2005): 163–177.

——. "Practice and Performance." In *Professing Performance.* Cambridge: Cambridge University Press, 1998: 109–145.

——. "Social Practice." *Performance Research: Lexicon Special Issue* (September 2006).

——. "Theatre . . . Again." *Art Lies* 60 (2008). Online at www.artlies.org/article.php?id=1682&issue=60&s=1 (accessed December 3, 2010).

——. "*Touchable Stories* and the Performance of Infrastructural Memory." In *Remembering: Oral History and Performance,* edited by Della Pollock. New York: Palgrave Macmillan, 2005: 45–66.

——. "What is the 'Social' in Social Practice? Comparing experiments in Performance." In *Cambridge Handbook of Performance Studies,* edited by Tracy Davis. Cambridge: Cambridge University Press, 2008.

——. "When 'Everything Counts': Experimental Performance and Performance Historiography." In *Representing the Past,* edited by Thomas Postlewait and Charlotte Canning. Iowa City, IA: University of Iowa Press, 2010.

Jacob, Mary-Jane, ed. *Gordon Matta-Clark: A Retrospective.* Chicago, IL: Museum of Contemporary Art, 1985.

Jameson, Frederic. *The Prison-House of Language.* Princeton, NJ: Princeton University Press, 1974.

Jefferson, Margo. "On the Other End of the Phone, Workers Stripped of Their Identities." *The New York Times* (December 4, 2003). Online at www.nytimes.

com/2003/12/04/theater/theater-review-other-end-phone-workers-stripped-their-identities.html (accessed December 3, 2010).

Johansen, Soren. "Michael Elmgreen and Ingar Dragset: The Welfare Show." *Londontown.com*, January 2006, London Events. Online at www.londontown. com/LondonEvents/MichaelElmgreenandIngarDragsetTheWelfareShow/ 7096f/Michael_Elmgren_and_Ingar_Dragset:_The_Welfare_Show (accessed May 2009).

Johnston, Jill. "Dance Quote Unquote." In *Reinventing Dance in the Sixties: Everything Was Possible*, edited by Sally Banes. Madison, WI: University of Wisconsin Press, 1999: 98–104.

Jones, Amelia. *Body Art: Performing the Subject*. Minneapolis, MN: University of Minnesota Press, 1998.

——. "Introduction." In *The Feminism and Visual Culture Reader*. New York: Routledge, 2003: 1–6.

——. "Live Art in Art History: A Paradox?" In *The Cambridge Companion to Performance Studies*, edited by Tracy C. Davis. Cambridge: Cambridge University Press, 2008: 151–165.

——. *Self/Image: Technology, Representation, and the Contemporary Subject*. London: Routledge, 2006.

Jordan, Betty Ann. "Rooms with a View." *Toronto Life* (April, 2006). Online edition at http://torontolife.com/features/rooms-with-a-view/ (accessed December 3, 2010).

Joseph, Miranda. *Against the Romance of Community*. Minneapolis, MN: University of Minnesota Press, 2002.

Kastner, Jeffrey. "The Department of Sanitation's Artist in Residence." *The New York Times* (May 19, 2002). Online at www.nytimes.com/2002/05/19/arts/ design/19KAST.html (accessed December 3, 2010).

Kaye, Nick. *Site-Specific Art: Performance, Place, and Documentation*. New York and London: Routledge, 2000.

Kelleher, Joe. *Theatre and Politics*. London: Palgrave, 2009.

—— and Nicholas Ridout, eds. *The Theatre of Societas Raffaello Sanzio*. London: Routledge, 2007.

Kershaw, Baz. *The Politics of Performance: Radical Theatre as Cultural Intervention*. New York: Routledge, 1992.

——. *Theatre Ecology: Environments and Performance Events*. London: Cambridge University Press, 2007.

——. *Welfare State International, Engineers of the Imagination. 1982*. London: Methuen, 1990.

Kester, Grant. "Another Turn." *Artforum* 44: 9 (May, 2006): 22–23.

——. *Conversation Pieces: Community and Communication in Modern Art*. Berkeley, CA: University of California Press, 2004.

Knowles, Alison. "By Alison Knowles," A Great Bear Pamphlet. New York: Something Else Press, 1965.

——. Electronic correspondence with the author. May 20–21, 2009.

Koritz, Amy and George J. Sanchez, eds. *Civic Engagement in the Wake of Katrina*. Ann Arbor, MI: University of Michigan Press, 2009.

Kuftinec, Sonja. "Introduction: Surveying the Terrain." In *Staging America: Cornerstone and Community-Based Theater*, 1–22. Carbondale, IL: Southern Illinois University Press, 2003.

Kuppers, Petra. *Community Performance: An Introduction*. London: Routledge, 2007.

——. *Disability and Contemporary Performance: Bodies on Edge*. New York: Routledge, 2004.

Kwon, Miwon. *One Place After Another: Site-Specific Art and Locational Identity*. Cambridge, MA: MIT Press, 2004.

Laclau, Ernesto and Chantal Mouffe. *Hegemony and Socialist Strategy: Towards a Radical Democratic Politics*, second edition. London: Verso, 2001.

Lacy, Suzanne, ed. *Mapping the Terrain: New Genre Public Art*. Seattle, WA: Bay Press, 1994.

Landler, Mark. "Hi, I'm in Bangalore (but I can't say so)." *The New York Times* (March 21, 2001): A1, C4.

Lawson, Thomas. "Allan McCollum Interviewed by Thomas Lawson." In *Allan McCollum*, edited by William S. Bartman. Los Angeles, CA: A.R.T. Press, 1996.

Lehmann, Hans-Thies. *Postdramatic Theatre*, translated by Karen Jurs-Munby. London and New York: Routledge, 2006.

Leorke, Dale. "Power, Mobility, and Diaspora in the Global City." *Platform: A Journal of Media and Communication* 1 (July 2009): 103–108.

Lepecki, André. *Exhausting Dance: Performance and the Politics of Movement*. New York: Routledge, 2006.

Levinas, Emmanuel. *Totality and Infinity: An Essay on Exteriority*, translated by Alphonso Lingis. Pittsburgh, PA: Duquesne University Press, 1969.

Lind, Maria and Hito Steyerl. *The Green Room: Reconsidering the Document in Contemporary Art*. New York and Berlin: Lukas and Sternberg, 2009.

Lippard, Lucy. *Six Years: The Dematerialization of the Art Object*. New York: New York University Press, 1979.

Mahmood, Saba. *Politics of Piety: The Islamic Revival and the Feminist Subject*. Princeton, NJ: Princeton University Press, 2005.

Madden, Christine. "Art of Thinking Outside and Inside the Box." *Irish Times* (April 28, 2007): 6. Online at www.rimini-protokoll.de/website/en/article_2133.html (accessed December 3, 2010).

Manns, Erin. "Artworker of the Week #55." *Kultureflash* (November 2005). Online at http://kultureflash.net/archive/142/priview.html (accessed May 2009).

Marcuse, Herbert. *One Dimensional Man: Studies in the Ideology of Advanced Industrial Society*. Boston, MA: Beacon Press, 1991.

Martin, Biddy. "Extraordinary Homosexuals and the Fear of Being Ordinary." *Differences* 6: 2/3 (1994): 101–125.

Martin, Colin. "Art: The Welfare Show." *BMJ* 332: 429 (February, 18, 2006): n.p. Online at www.bmj.com/cgi/content/full/332/7538/429-a (accessed May 2009).

McDonough, Tom, ed. *Guy Debord and the Situationalist International: Texts and Documents.* Cambridge, MA: MIT Press, 2004.

McGee, John. "Elmgreen and Dragset: Suspended Space." *Metropolis: Japan's No. 1 English Magazine* 456 (October 2003). Online at http://archive. metropolis.co.jp/tokyo/456/art.asp (accessed December 3, 2010).

McKee, Yates. "Haunted Housing: Eco-Vanguardism, Eviction, and the Biopolitics of Sustainability in New Orleans." *Grey Room* 30 (Winter 2008): 84–113.

McKinnie, Michael. *City Stages: Theatre and Urban Space in a Global City.* Toronto: University of Toronto Press, 2007.

McNulty, Charles. "A Dizzying Global Vision." *Los Angeles Times* (February 28, 2004). Online at http://articles.latimes.com/2004/feb/29/entertainment/ ca-mcnulty29.

McPherson, Tara. "Reload: Liveness, Mobility and the Web." In *New Media, Old Media: A History and Theory Reader*, edited by Wendy Hui Kyong Chun and Thomas Keenan. New York: Routledge, 2005: 199–209.

Meyer, James. *What Happened to the Institutional Critique?* New York: American Fine Arts Co., 1993. Reprinted in *Kontext Kunst*, edited by Peter Weibel. Cologne: Dumont, 1993: 239–256.

Michalzik, Peter. "Portrait: Rimini Protokoll," translated by Martin Pearce. Goethe- Institut website. Online at www.goethe.de/kue/the/reg/reg/mr/ rim/por/enindex.htm (accessed June 11, 2009).

Mink, Gwendolyn. *Whose Welfare?* Ithaca, NY: Cornell University Press, 1999.

Mitchell, W. J. T. *What Do Pictures Want?: The Lives and Loves of Images.* Chicago, IL: University of Chicago Press, 2006.

Molesworth, Helen. "House Work and Art Work." In *Art After Conceptual Art*, edited by Alexander Alberro and Sabeth Buchmann. Cambridge, MA: Generali Foundation and MIT Press, 2006: 66–84.

Morris, Robert. "Notes on Dance." *Tulane Drama Review* 10: 2 (1965): 183.

——. "Notes on Sculpture." *Artforum* (February and October, 1966).

Moten, Fred. *In the Break: The Aesthetics of the Black Radical Tradition.* Minneapolis, MN: University of Minnesota Press, 2003.

Motta, Carlos. "Relations in Real Time: A Conversation with Marian Lind." *Sjónauki* 3 (2008): 1. Online at www.carlosmotta.com/writings/MariaLind. pdf (accessed December 3, 2010).

Mouffe, Chantal, ed. *Deconstruction and Pragmatism.* London: Routledge, 1996.

Muñoz, José Esteban. *Cruising Utopia: The Then and There of Queer Futurity.* New York: New York University Press, 2009.

Nancy, Jean-Luc. *The Inoperative Community*, edited by Peter Connor. Minneapolis, MN: University of Minnesota Press, 1991.

Newman, Michael and Jon Bird. *Rewriting Conceptual Art.* London: Reaction Books, 1999.

Norman, Victor. "Crumbling from Within: The Microfoundations of Welfare States." In *The Art of Welfare*, edited by Marta Kuzma and Peter Osborne. Oslo: Office for Contemporary Art, 2006: 97–114.

Oakes, Baile, ed. *Sculpting with the Environment: A Natural Dialogue.* New York: Van Nostrand Reinhod, 1995.

Obrist, Hans-Ulrich. "Performative Constructions: Interview with Hans-Ulrich Obrist." *Powerless Structures,* catalogue (1998). Online at www.nicolaiwallner. com/artists/micing/text1.html (accessed December 3, 2010).

Osborne, Peter. "Elmgreen and Dragset's *The Welfare Show*: A Historical Perspective." In *The Art of Welfare,* edited by Marta Kuzma and Peter Osborne. Oslo: Office for Contemporary Art Norway, 2006: 19–40.

Parker-Starbuck, Jennifer. "Global Friends: The Builders Association at BAM." *Performing Arts Journal* 26: 2 (2004): 96–102.

——. "Lost in Space? Global Placelessness and the Non-Places of *Alladeen*." In *Performance and Place,* edited by Leslie Hill and Helen Paris. London: Palgrave Macmillan, 2006.

Pavis, Patrice. *Languages of the Stage: Essays in the Semiology of the Theatre.* New York: Performing Arts Journal Publications, 1982.

Phelan, Peggy. *Unmarked: The Politics of Performance.* New York: Routledge, 1993.

Pope.L, William. In conversation with the author (Spring 2006).

—— "Sandwich Lecture #8." In *Live: Art and Performance,* edited by Adrian Heathfield and Hugo Glendinning. New York: Routledge, 2004.

Pred, Allan. *Even in Sweden: Racisms, Racialized Spaces, and the Popular Geographical Imagination.* Berkeley, CA: University of California, 2000.

Puar, Jasbir K. *Terrorist Assemblages: Homonationalism in Queer Times.* Durham, NC: Duke University Press, 2007.

Purves, Ted, ed. *What We Want is Free: Generosity and Exchange in Recent Art.* Albany, NY: SUNY Press, 2005.

Quick, Andrew. *The Wooster Group Work Book.* London: Routledge, 2007.

Rancière, Jacques. *Hatred of Democracy,* translated by Steve Corcoran. London: Verso, 2007.

——. "The Emancipated Spectator." *Artforum* XLV, No. 7 (March, 2007): 271–277.

——. *The Politics of Aesthetics.* New York: Continuum, 2004, English edition; French edition published as *Le Partage du Sensible: Esthétique et Politique.* Paris: La Fabrique, 2000.

Rayner, Alice. "Rude Mechanicals and the Spectres of Marx." *Theatre Journal* 54: 4 (2002): 535–554.

Read, Alan. *Theatre, Intimacy, and Engagement: The Last Human Venue.* London: Palgrave, 2008.

Reckitt, Helena and Peggy Phelan, eds. *Art and Feminism.* London: Phaidon Press, 2001.

Ridout, Nicholas. "Performance and Democracy." In *The Cambridge Companion to Performance Studies,* edited by Tracy C. Davis. Cambridge: Cambridge University Press, 2008: 11–22.

——. *Stagefright, Animals, and Other Theatrical Problems.* Cambridge: Cambridge University Press, 2006.

——. *Theatre and Ethics.* London: Palgrave, 2009.

RiminiProtokollTube. *Mnemopark. A Mini Train World-Rimini Protokoll (Stefan Kaegi)*. Video (March 17, 2009). Online at www.youtube.com/watch?v= ivZoFCbEnVU.

Rimini Protokoll website, "Cargo Sofia-X: A Bulgarian Truck-Ride through European Cities." Online at www.rimini-protokoll.de/website/en/project_ 108.html (accessed June 3, 2010).

——. "Helgard Haug." Online at www.rimini-protokoll.de/website/en/about_ hh.html (accessed December 3, 2010).

Roche, Jennifer. "Socially Engaged Art, Critics and Discontents: An Interview with Claire Bishop." *Community Arts Network* website. Online at www. communityarts.net/readingroom/archivefiles/2006/07/socially_engage.php (accessed December 3, 2010).

Rodenbeck, Judith. "Working to Learn Together: The Case of Manifesta 6." Paper delivered at the "Expertise: Medium-Specificity and Interdisciplinarity" Conference. Tel Aviv University, June 2009.

Rokem, Freddie. "Walter Benjamin and Bertolt Brecht discuss Franz Kafka." In *Philosophers and Thespian: Thinking Performance*. Stanford, CA: Stanford University Press, 2010: 118–140.

Ross, Kristin. *May '68 and Its Afterlives*. Chicago, IL: University of Chicago Press, 2002.

Rothkopf, Scott. "Embedded in Culture." *Artforum International* (Summer 2006): 304–311.

Sassen, Saskia. "Embeddedness of Electronic Markets: the Case of Global Capital Markets." In *The Sociology of Financial Markets*, edited by Karin Knorr Cetina and Alex Preda. Cambridge: Oxford University Press, 2005: 17–37.

Schmeling, Gina. "Storage as Practice in Art and Garbage," MA Thesis in Humanities and Social Thought, New York University, 2007.

Sierra, Santiago, Eckhard Schneider, and Kunsthaus Bregenz. "300 Tons." In *Santiago Sierra: 300 Tons and Previous Works*. New York: König, 2004.

Schneider, Rebecca. *The Explicit Body in Performance*. London and New York: Routledge, 1997.

Scott, Montgomery and Anne d'Harnoncourt. "From the President and the Director." *Philadelphia Museum of Art Magazine* (Spring 1988).

Searle, Adrian. "The Lost World." *The Guardian* (January 31, 2006). Online at www.guardian.co.uk/culture/2006/jan/31/3 (accessed December 3, 2010).

Sekula, Allen. "Aerospace Folktales, 1973." In *Allen Sekula: Performance Under Working Conditions*, edited by Sabine Breitwieser. Vienna: Generali Foundation/Hatje Cantz, 2003: 92–163.

——. "In conversation with Benjamin Buchloh." In *Allen Sekula: Performance Under Working Conditions*, edited by Sabine Breitwieser, 22–55. Vienna: Generali Foundation/Hatje Cantz, 2003.

——. "This Ain't China." In *Allen Sekula: Performance Under Working Conditions*, edited by Sabine Breitwieser. Vienna: Generali Foundation/Hatje Cantz, 2003: 197–199.

Sennett, Richard. *The Fall of Public Man*. Originally published by New York: Knopf, 1977; reprinted by New York: W. W. Norton and Company, 1992.

Sheikh, Simon. "Notes on Institutional Critique." Tranform.eipcip.net (2006): 1–3. Online at http://transform.eipcp.net/transversal/0106/sheikh/en#redir (accessed December 3, 2010).

Sholis, Brian. "Interview: Michael Elmgreen and Ingar Dragset." *Ten Verses.* (2003). Online at www.briansholis.com/interview-michael-elmgreen-and-ingar-dragset/ (accessed December 3, 2010).

——. "Noblesse Oblige." *Artforum* (May 29, 2005). Online at http://artforum.com/diary/id=9054 (accessed December 3, 2010).

Silverman, Kaja. *Flesh of My Flesh.* Stanford, CA: Stanford University Press, 2009.

——. "Suture." In *The Subject of Semiotics.* New York: Oxford University Press, 1983): 194–236.

Simone, AbdouMaliq. "People as Infrastructure: Intersecting Fragments in Johannesburg," *Public Culture* 16: 3 (Fall 2004): 407–429.

Sims, Lowery Stokes. "Interview with William Pope.L." In *William Pope.L.: The Friendliest Black Artist in America,* edited by Mark Bessire. Cambridge: MIT Press, 2002: 62–67.

Skocpol, Theda. *Protecting Soldiers and Mothers: The Political Origins of Social Policy in the United States.* Cambridge, MA: Harvard University Press, 1995.

Smedley, Bunny. "What's the Welfare Show Got to Do with the Welfare State?" Social Affairs Unit Weblog, February 17, 2006. Online at http://socialaffairsunit.org.uk/blog/archives/000784.php (accessed December 3, 2010).

Smith, Neil. "Contours of a Spatialized Politics: Homeless Vehicles and the Production of Geographic Scale," *Social Text* 10: 4 (1992): 19–33.

——. "New City, New Frontier." In *Variations on a Theme Park: The New American City and the End of Public Space,* edited by Michael Sorking. New York: Hill and Wang, 1996.

Smith, Roberta. "Frieze Art Fair Feels a Big Chill." *The New York Times* (October 17, 2008): C1.

Smithson, Robert. "Pointless Vanishing Points." In *Robert Smithson: The Collected Writings,* edited by Jack Flam. Berkeley, CA: University of California Press, 1996.

Sobchack, Vivian. "Choreography for One, Two, and Three Legs (A Phenomenological Meditation in Movements)." *Topoi* 24 (Spring 2005): 55–66.

Solomon, Alisa. "Off to See the Wizardry." *The Village Voice* (April 30 2002): XLVII.17.

Sofer, Andrew. *The Stage Life of Props.* Ann Arbor, MI: University of Michigan Press, 2003.

Spiegler, Mark. "When Human Beings Were the Canvas." *Artnews* (June, 2003). Online at www.artnews.com/issues/article.asp?art_id=1335 (accessed December 3, 2010).

Stiles, Kristine. "Thunderbird Immolation: Burning Racism." In *William Pope.L. The Friendliest Black Artist in America,* edited by Mark Bessire. Cambridge, MA: MIT Press, 2002.

Thompson, Nato. Interview with the author, June 2008.

Tomkins, Calvin. "Shadow Player." *The New Yorker* (May 26 2008): 40–45.

Tretiakov, Sergei. "From the Photoseries to the Long-Term Photographic Observation." *Prolatarskoje* 4 (1931): n.p.

Ukeles, Mierle Laderman. "Interview." Coordinated by Erin Salazer, Bronx Museum *TCG* (Spring/Summer 2006): 14–21.

—— "A Journey: Earth/City/Flow." *Art Journal* (Summer 1992): 12–14.

——. "Leftovers/It's About Time for Fresh Kills." *Cabinet* (Spring 2002): 1–2.

——. "Manifesto for Maintenance Art 1969! Proposal for Exhibition 'Care'": 1–4. Copyright Mierle Laderman Ukeles, 1969; reprinted in Lucy Lippard. *Six Years: The Dematerialization of the Art Object.* New York: New York University Press, 1979: 220–221.

Victoria Miro Gallery. "Press Release: Elmgreen and Dragset: Too Late." October 2008.

Von Becker, Peter. *Theater Heute.* Vol. 1 (1990): 1.

Wagstaff Jr., Samuel J. "Talking with Tony Smith: 'I view art as something vast.' " *Artforum* 5: 4 (December, 1966): 14–19.

Warner, Michael. "Introduction." In *Fear of a Queer Planet.* Minneapolis, MN: University of Minnesota Press, 1993.

——. *Publics and Counterpublics.* New York: Zone Books, 2002.

Weems, Marianne. "Call Centers—TRIP to Bangalore," *Alladeen* production files.

——. Discussion with the author, June 10, 2008.

——. Early script material (April 22, 2002). *Alladeen* production files shared with author.

——. Interview with the author, January 20, 2009.

Wehle, Philippa. "Border Crossings: Avignon Festival, July 6–27, 2006." *PAJ: A Journal of Performance and Art* 29: 1 (2007): 80–87.

Weich, Dave. "Pico Iyer's Mongrel Soul." Interview with Pico Iyer (March 27, 2000). Online at www.powells.com/authors/iyer.html (accessed December 3, 2010).

Welchman, John C., ed. *Institutional Critique and After.* Zürich: JRP/Ringier, 2006.

Weston, Kath. *Families We Choose: Lesbians, Gays, Kinship,* revised edition. New York: Columbia University Press, 1997.

Wilson, Julia Bryan. "A Curriculum of Institutional Critique." In *The New Institutionalism,* edited by Jonas Ekberg. Oslo: OCA/Verksted, 2003: 89–109.

Zelevansky, Lynn. "From Inside the Museum: Some Thoughts on the Issue of Institutional Critique." In *Institutional Critique and After,* edited by John C. Welchman. Zürich: JRP/Ringier, 2006: 171–182.

INDEX

substrate 1, 31, 32, 38, 44–45, 201,
237; intersubjectivity as 34, 45, 77
support: anxiety about 207; base
34–35, 80–81, 147–149, 157,
223, 231; disavowal of support 31;
Marxist base 145; supporting act
30–31, 34, 36–37, 108, 162, 247;
support structure 196;
undermounted 31, 33–34, 71,
147, 159; *see also* prop; gravity

Takemoto, Tina 13
tech support *see* Builders Association,
The; Rimini Protokoll; technology
technology 40, 109, 149, 151–155,
160–163, 172; Internet 174, 179;
low–tech 75, 144
Teiger, David 216
Temporary Services 11
theatre: Brechtian theatre and post-
Brechtian theatre 29, 93, 147,
148, 161, 181; documentary
theatre 167–169; extreme theatre
182–183; global theatre 164;
Lecoq tradition 184; poor theatre
113; theatrical readymades
169–170
theatricality 19–20, 40, 59, 105,
107–108, 112–113, 116, 128,
176, 183, 187, 201; anti-theatrical
discourse 20, 80; "original
theatricality" 104, 137, 188;
sculptural theatricality 186; *see also*
spectacle
"third way" 27, 36, 52, 188, 192,
194, 224, 237; *see also* Giddens,
Anthony
Thompson, Nato 135, 142,
225–227, 236; *The Interventionists*
138, 225
time: time-based works 1, 14, 40,
45, 66, 71, 158, 183; time-
delaying 199; timed entrapment
177; time zones 157, 159; *see also*
duration; real (real-time)

Tiravanija, Rirkrit 1, 34, 38, 45, 47,
54, 56, 98
Touchable Stories 39, 43–44, 59–60,
64–69, 73–74, 243; *see also*
Flattery, Shannon; oral history
tour: and touring 16, 143, 145, 166,
172, 178, 191, 196, 198–199,
219, 226, 234; Andrea Fraser as
Jane Castleton 117, 119,
123–124, 126; international tour
173, 180
transport 55, 72, 115, 174, 178,
214, 234; history of 109;
transportable work 16;
transportation 24, 188

Ukeles, Mierle L. 39, 75–103, 106,
203, 243; *Care* 101–102; *Public
Offerings: Made by All, Redeemed
by All* 76, 79; *Touch Sanitation* 76,
99, 102; *Transfer* 95–97, 102, 203
Transfer Station 100; *see also*
maintenance art; waste
undocumented migrant 36
unemployment 24, 110, 134, 184,
188, 194, 201–203 *see also* labor;
welfare
use: re-use 19, 45, 63, 68, 75, 79,
161, 173, 182, 216; the user
172–173; *see also* waste
utility: public utilities 24, 188, 210,
213–214, 237; of the readymade
98; of siting food 140; as value
50, 54

V-Girls *see* feminism
Vawter, Ron: *Roy Cohn/Jack Smith*
152
video 16, 18, 75, 89, 143–144,
150–151, 154–155, 167, 176,
217: video chat 164–165; video
documentation 134, 155; video
game 149, 216; video installation
163
Virilio, Paul 158

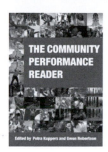